# SPORTSMAN'S BEST

## BOOK & DVD SERIES

FS Books:
## Sportsman's Best: Inshore Fishing
## Sportsman's Best: Offshore Fishing
## Sportsman's Best: Snapper & Grouper
## Sportsman's Best: Sailfish

## Sport Fish of Florida
## Sport Fish of the Gulf of Mexico
## Sport Fish of the Atlantic
## Sport Fish of Fresh Water
## Sport Fish of the Pacific

## Baits, Rigs & Tackle
## Annual Fishing Planner
## The Angler's Cookbook

## Florida Sportsman Magazine
## Shallow Water Angler Magazine
## Florida Sportsman Fishing Charts
## Lawsticks
## Law Boatstickers

Author, Jerold "Buck" Hall
Edited by Joe Richard and Florida Sportsman Staff
Art Director, Drew Wickstrom
Illustrations by Joe Suroviec
Copy Edited by Jerry McBride
Photos by Joe Richard, William Boyce, Pat Ford, Ronald C. Modra

www.floridasportsman.com

# OFFSHORE FISHING

# CONTENTS

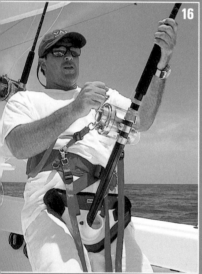

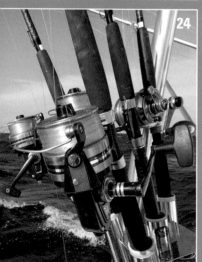

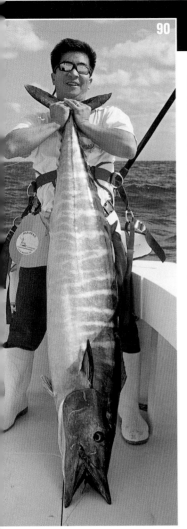

90

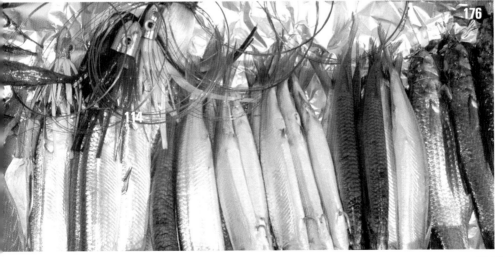

176

114

The snap of an outrigger clip
instantly changes everything.
Only in offshore fishing can
you go from boredom to bed-
lam in just seconds.

# Vastness and Blue Water

Three details become apparent, whether you're making the move from coastal or inland fishing, or starting from scratch.

One, the sheer vastness of blue water.

Two, the sheer vastness of the financial investment.

If you're not already gasping for air, number three will catch you by surprise and leave you utterly breathless.

Nothing—not NASCAR, not pro football, not even the stock market—can fully prepare you for the shock of a seeing a quarter-ton marlin spring up behind the boat.

But field editor Buck Hall, and others on the FS team, will at least try.

The goal of *"Sportsman's Best: Offshore Fishing"* is to help you evaluate those three details. You'll learn how to read the water and determine the best strategies for a variety of pelagic species, from king mackerel to blue marlin. Just being in the right zone is more than half the battle. What is the ideal water temperature, current and bottom contour? How will you judge those features?

We'll tell you in the following pages.

You'll also gain a better understanding of what you need, and don't need, in terms of tackle, gear and rigs. There are bluewater diehards who spend almost as much, or more, on their boats than on their homes. You may fall into that category, and want to know exactly how to rig your prized piece of fiberglass real estate. Then again, you might wish to economize your gear, or perhaps charter a vessel for that special trip. Either way, there's a mind-boggling array of stuff to consider: outriggers, downriggers, kite reels, radar systems, trolling reels, release tools, fancy lures, leaders, and the list goes on.

*SB Offshore Fishing* covers all those vital areas.

Last but not least, thumbing through the stunning photographs and colorful tales, you might, just might, find the nerve to react to those incredible moments when everything comes together.

—Jeff Weakley, Editor, *Florida Sportsman*

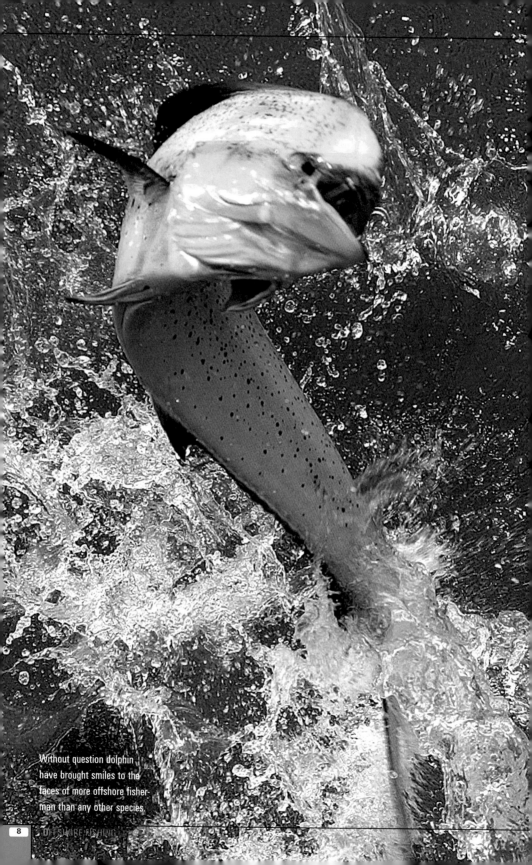

Without question dolphin have brought smiles to the faces of more offshore fisherman than any other species.

# Welcome to Offshore Fishing

The first time blue water erupts in your bait spread and line pours from the reel, adrenaline surges and you're hooked. Screaming drags and bluewater fish jumping high in the air are what dreams are really made of. If you've experienced it first hand, you know what I mean. If not, you're in for a serious treat.

The challenge of landing a top-of-the-food-chain pelagic fish has  anglers heading offshore in record numbers. Whether a mackerel specialist, sailfish junkie, canyon or Gulf captain on an overnight quest for blue marlin, more anglers than ever are joining the offshore fishing fraternity.

Imparting knowledge is what has driven writers and editors of *Florida Sportsman* magazine for many years, so it only makes sense they've chosen to bring to you the definitive book on bluewater angling, *Sportsman's Best: Offshore Fishing*. Filled with hundreds of photos and illustrations, this book also carries an action-packed, 60 minute DVD to further illustrate finer points with entertaining and informative lessons.

I've related a lot of quirks, shortcomings and embarrassing moments in magazine articles over the years, but I'll let you in on a little secret: I'm an offshore fishing addict. They say admission is the first step to recovery, but I've declined the remaining steps. So be it.

I try to learn something new during every trip, and it's what keeps this sport so fresh. That was a major appeal for writing this book— learning new techniques while riding with a variety of captains. I've had the good fortune to fish alongside and swap stories with some of the best fishermen, on nearly every type of offshore trip, and you'll be glad to know that I was taking notes. I hope you enjoy this book and DVD, but more importantly, take this information and apply it offshore.

Here's to seeing you on the water.

—Capt. Buck Hall

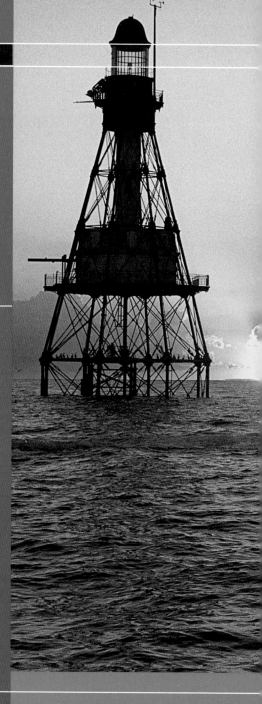

# The Appeal of Offshore Fishing

Offshore fishing once was a sport reserved only for the privileged. For those of us who grew up reading amazing tales by Ernest Hemingway, Zane Grey or Miami's Phillip Wylie, there is good news: it's now accessible to virtually anyone. Once it gets into your blood, you'll relish every minute of each trip. The bad news? You'll feel a real ache when you're stuck on dry land during calm weather, especially on weekends. Even after a tough trip, there is always that next morning full of promise, that you'll have a great trip that could light up the pages of *Florida Sportsman* magazine. What they call an epic day. That's the appeal of offshore fishing—the ocean is different each day, and once you have the urge, it's very hard to let go.

**The U.S. has some of the most productive fishing grounds in the world.**

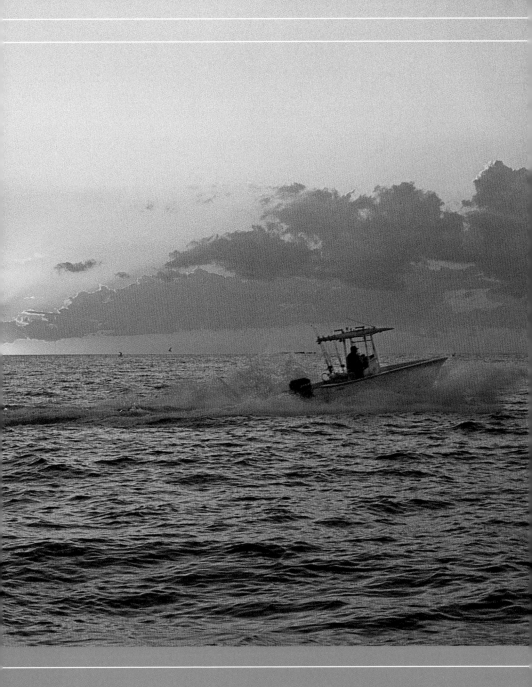

As Bruce Springsteen used to say, "Everybody's got a hungry heart."
That goes doubly so for offshore fishermen, who crave those calm
weekends filled with promise and expectation.

# Are Fishermen Born that Way?

Like many anglers, I grew up fishing freshwater ponds and rivers around my house. Older now, I no longer spend long hours fishing for catfish and bass. One thing that hasn't changed is my passion for fishing. My fishing interests have shifted south toward the coast, but the thrill of seeing a blue marlin greyhounding off the transom surely isn't greater than catching my biggest channel cat at the age of 11. They both kept me up all night! It's all about passion and that's the one constant you find in all true fishermen.

**It's all about passion and that's one constant you find in all true fishermen. Offshore anglers are certainly no exception.**

Offshore anglers are no exception to this rule.

I grew up reading books and short stories by Ernest Hemingway, marveling at his world that seemed so foreign and out-of-reach. I thought you had to have a big boat in some exotic locale to get in the game of bluewater fishing. As it turns out you don't need a million dollar boat, of course. And the U.S. is home to some of the most fertile fishing grounds in the world, from the west coast to the east coast

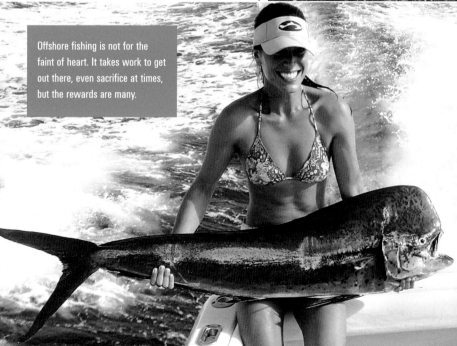

Offshore fishing is not for the faint of heart. It takes work to get out there, even sacrifice at times, but the rewards are many.

and right here in my own backyard, the Gulf of Mexico.

Average Americans, mostly men at the time, were first introduced to the sport through Hemingway's articles for *Esquire* magazine in the 1930's. It was a little before my time, but the allure was as strong then as it is now. The difference is that now offshore fishing is accessible to every fisherman and woman. "Papa" Hemingway was ahead of his time introducing women to the sport, though some might argue he had ulterior motives.

The most popular tale of offshore fishing is of course Hemingway's *Old Man and the Sea*. I read it as a kid and at first didn't fully get the beauty of the story. Reading it again and again adds new parts that I can relate to from personal experience. It might be remembering the color of sargassum at night on a billfish trip— or watching a mako shark rip into a fish before

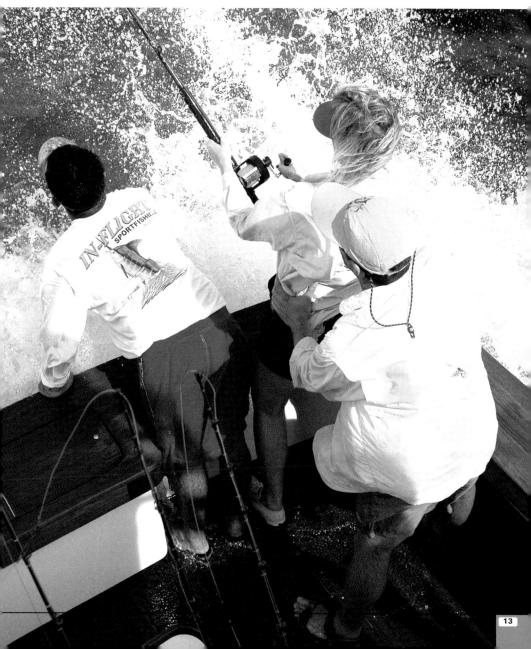

**Only in offshore fishing is there the chance—and all you can ask for is the chance—to encounter something truly epic out there.**

it can be landed, but those memories never leave the mind.

Offshore fishing is the ultimate test of preparation, tackle and angler ability. Trips with average fish come and go, but offshore fishing is unique in its ability to dazzle and baffle at the same time. Where else can you combine the acrobatics of sailfish and dolphin with the size, speed and strength of grander blue marlin and bluefin tuna? Only in offshore fishing is there the chance—and all you can ask for is the chance—to encounter something truly epic.

My first amazing encounter offshore was with my brother-in-law Philip, battling a 180-pound bull shark in my small boat. The question of the moment was, why are we shark fishing in a 17-foot boat? That was replaced hours later with, "what do we do with him now?" Phil has since passed away after a long battle with cancer, but I'll never forget the look on his face when the fish rolled up boatside and he asked me that question. His sweaty face was beaming, part Cheshire cat grin and part, "I hope he knows what to do now." I didn't of course, but we figured it out and nobody got chewed up.

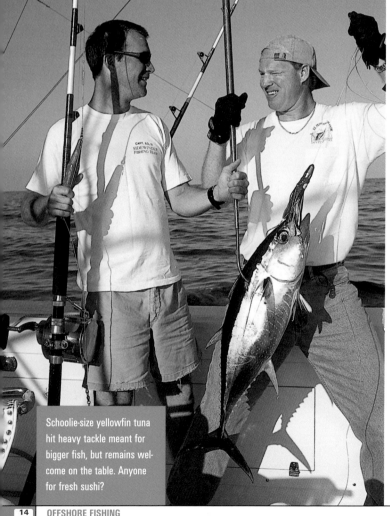

Schoolie-size yellowfin tuna hit heavy tackle meant for bigger fish, but remains welcome on the table. Anyone for fresh sushi?

I started venturing farther offshore, bottom fishing and then catching cobia and king mackerel. I've never been one to keep a lot of fish, only what I could eat or cook fresh for friends, which is a trait I'm thankful for. That trait got me away from solely bottom fishing and caused me to look for opportunities to find other fish. That first day of trolling artificials in my little center console was choice: we couldn't get away from the schoolie dolphin. A lesson was learned, more important than the blackened dolphin fishwiches eaten that night. It wasn't so hard to find new fish out there, if you tried something new.

Every type of fishing has a common thread, which is sim-

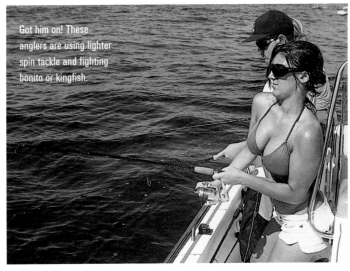

Got him on! These anglers are using lighter spin tackle and fighting bonito or kingfish.

ply this: There is no substitute for time on the water. You can and should read as much about offshore fishing as you can get your hands on; I still do. Magazines, Internet articles and books pepper my house and it drives my wife crazy that she's not allowed to throw them away. "You never know when I might need to re-read one of the articles!" She rolls her eyes and acquiesces, but it's an honest argument. However, all the reading in the world will only turn you envious, if you don't get out on the water and fish it yourself.

**Offshore fishing is addictive and if you live on the coast, a light southeast wind will drive you crazy, trying to line up a boat for the weekend.**

Success on catching those first king mackerel was great, after attending a seminar and using tactics and tackle described there. After that, some intense moments watching how to prepare for that first solo billfish trip, especially on how to properly rig ballyhoo baits and crimp leaders.

For the purposes of this book, we're describing offshore fishing starting with king mackerel and working our way up to the billfish family. By no means is this all-inclusive for every locale around the world, but it will provide you with a comprehensive guide to the most sought after big-game fish.

Offshore fishing is addictive, infectious and if you live on the coast like me, those days where a crystal blue sky is met with a light southeast wind drive you absolutely crazy if you're stuck on dry land. Welcome to the world of offshore fishing and my apologies to your friends and family if they don't get into it. They'll miss you. **SB**

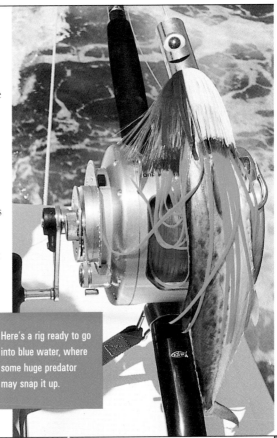

Here's a rig ready to go into blue water, where some huge predator may snap it up.

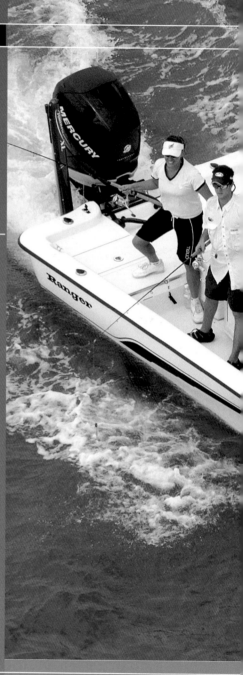

# Assessing the
# Options

**A**ssessing your options is the first step to planning a successful trip offshore. Advances in technology now allow small boats to compete in the same water as much larger ones. Similar advances in navigation electronics, satellite weather monitoring and radar allow small boat anglers the confidence to safely navigate far off the coast. Access to websites, online fishing reports and copious knowledge of offshore fish habits have increased the skill levels of countless anglers. Knowledge of underwater geography, thanks to modern electronics, only makes the job of finding fish easier. Integrate these advances with a capable and fun crew, and you have all the ingredients for a successful trip offshore.

Options are plentiful. Take your boat and crew to the limits, but do it safely. When you find your objective exceeds the safe limits of your boat and crew, it's time to find a bigger boat. Offshore waters are there to fish and explore, because adventure awaits.

**Common sense should prevail during any time spent on the water and *especially* offshore.**

This crew is loaded and ready, cruising only a couple of miles offshore where kingfish and sailfish are commonly found.

# What are Your Options?

The first step in sizing up your options is figuring out what you can accomplish safely and reasonably with your boat. It's great to be able to fish Lloyd's Ridge, more than 130 miles south of Destin, Florida, but it's not practical to try it with a 21-foot center console. Likewise, fishing the beach for king mackerel can be done more efficiently in a center console than with a 54-foot sportfisherman.

Pushing your limits as an angler is something you should do on a regular basis. If you're not learning while you're fishing, you're missing out on a great opportunity. But pushing the limits of your boat is another thing altogether. Common sense should prevail with every situation on the water. Trying to fish your 18-foot boat in 8-foot seas is neither productive or safe. Likewise, fishing for blue marlin in 90 feet of green water will be about as productive as trying to find kingfish on a rip in 2,000 feet of cobalt water. It's not going to

**There isn't a hard-and-fast rule when it comes to asking yourself: How far o**

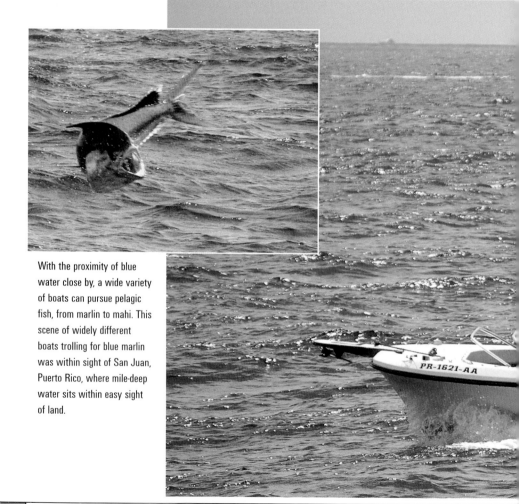

With the proximity of blue water close by, a wide variety of boats can pursue pelagic fish, from marlin to mahi. This scene of widely different boats trolling for blue marlin was within sight of San Juan, Puerto Rico, where mile-deep water sits within easy sight of land.

happen more than once in a lifetime.

There isn't a hard-and-fast rule when it comes to asking yourself: "How far out can I safely take my boat?" It would certainly make things easier, of course, if it did exist. Many fishermen out there have pushed this envelope a little too far at times. Every time I hear one of these stories, there are two consistent elements; youth and ego. We were too young to pay attention to the dangers and too proud to realize that we shouldn't have gone out so far. Every story ends in a similar fashion, with a white-knuckled ride home and some loved one vowing to never let you on the water again.

A good rule of thumb for distance is to use no more than 1/3 of your fuel getting to the fishing grounds, saving 1/3 for a day of fishing (and gradually working your way back), and saving 1/3 as a reserve. You might need that extra fuel if you encounter stormy weather, head-on seas or if engine trouble prevents running at an efficient speed. If you have a 200-mile range on your 21-foot center console, running straight out 66 miles is pushing the envelope, so to speak. But a 40-mile run down the beach to a hot sailfish bite, within sight of the beach, is a no-brainer for a boat of this size. As long as you know what your options

an I safely take my boat? There are many factors to first consider.

## Two things that have changed the playing field is the attitude of fishermen regarding what they can safely do offshore, and their boats.

are, there are fish within reach of your abilities as an angler and what that boat can really accomplish.

Two things that have changed the playing field dramatically are the attitude of fishermen regarding what they can safely do offshore, and the boats themselves. Center consoles aren't just for bottom fishing anymore; seaworthy models as small as 21 feet are sporting twin engines and the larger models are true bluewa-

Gulf anglers, for the most part, have a tough row to hoe (so to speak) when trying to reach deep blue water.

ter day-trippers. Some of these boats have triple outboard engines and are capable of 50 to 70 knots, and carry at least 300 gallons of fuel. Couple this with the proliferation of information we now know about different species of fish and how to catch them, and you have a recipe for sure-fire hookups. A perfect example of this is the late fall and early winter run of giant bluefin tuna off the North Carolina coast.

In truly deep water, a big bluefin hookup on anything other than 80- to 130-pound gear will end with the angler humbled and someone looking for another spool of line. But off the beaches of North Carolina, these beasts migrate north in December and January and feed in shallow water before heading across the Atlantic to the Mediterranean Sea. Hooking these fish in depths like 110 feet means they cannot sound into bottomless water and dump your 50-wide reel. Local anglers readily fight these fish in shallow water on 30- and 50-pound tackle, using sturdy center console boats. Given their proximity to the beaches, the shallow water and the technique of running these fish down from the bow of their boat, their odds of success are pretty good. There is no sure-fire method of success for any fish, and when you're tangling with fish that can break the 10-tub mark (1,000 pounds), all bets are off.

## Geography Often Dictates Options

It would be nice to say that if you have the right boat, you can reach and catch any fish you want—but the odds are against that absolute. I'm not going to catch sailfish in the upper Gulf on a regular basis and the folks on the East Coast don't have the luxury of oil rigs to help concentrate yellowfin tuna. Geography will also dictate what

species are available to you.

The limitations of fishing nearshore for species like kings and sailfish are that you're likely to only catch a few species of fish with consistency. But the upside is that you can become very good at targeting specific fish and this talent never ceases to amaze. It's impressive to watch an experienced angler working over a wreck teeming with fish, put baits out that will attract and catch only that desired species—at least most of the time. I say mostly because this covers the exceptions, like a deranged amberjack hitting a skirted ballyhoo being trolled at eight knots or a blue marlin

Moments of triumph: Happy anglers visiting blue water with trophy-size blackfin tuna, and a blue marlin finally brought alongside the boat.

crashing a big popping plug meant for a feisty blackfin tuna. It's happened before and certainly will again.

When we say geography, it can get misleading. It may take a Gulf angler 35 miles or more to get into 600 feet of water, while a fisherman from Key West or Miami can reach that depth in just a few minutes. We have to think of geography as including the depth of the water. Depths under 300 feet are likely to hold sails, kingfish, dolphin and wahoo. Bottom that

**It may take Gulf boats up to 80 miles to get out into 600 feet, while a boat from Key West or Miami can reach that same depth in a half hour. Gulf anglers often are faced with overnight trips, if they visit deep water.**

Blackfin tuna busting baitfish at the Hump off Islamorada, Florida. This spot is within sight of Alligator Light and shallow water.

**Experienced anglers among the crew are almost a gift, people who can spot trouble before it develops, and also catch plenty of fish.**

lurks in the 300- to 600-foot mark are fair game for most any bluewater predator, and depending on how dramatic the ledges and dropoffs, can be extremely productive. However, depths greater than 600 feet are on the leading edge of real bluewater fishing. Once you hit the 600-foot or 100-fathom mark, which is considered the edge of the continental shelf, anything goes.

## Equipment and Crew

So you know what your boat is capable of and know where you want to fish, but have you assessed your tackle? Most quality 20-pound conventional or spinning gear will handle kings, sails and dolphin. Targeting big wahoo, given the size of the lures and just how big they get, is going to require bigger tackle. And, if you go after marlin or tuna on less than sturdy conventional tackle, such as 50-pound gear at a minimum,

you're asking for disappointment. Whatever your game plan is, make sure you have equipment to back it up. This goes for proper terminal tackle, gaffs, fish bags and everything else. Don't let your ego write checks you can't cash. Don't misunderstand, the average boat and angler are fully capable of besting bluewater fish, but planning and preparation become increasingly important with big fish. And that leads us to your crew.

It never ceases to amaze that, no matter how big your boat or what day of the week, people have so much trouble putting together a reliable, functioning crew. Like the salty old Cayman captain kept muttering in Peter Matthiessen's great book, *Far Tortuga*: "It's hard to get a good crew, these days..."

Sometimes you just have to take whoever is available, but give some thought to making up a crew before heading way offshore. One offer

to fish came from a very novice private boat captain. Not only was he what they call a "potlicker" in East Texas, at running this medium-size sportfisher, the owner he worked for knew very little about his own vessel. They wanted to learn more about targeting wahoo and dolphin, and soon enough we would be heading offshore.

The weather had been calm all week, but the night before we left it turned really rough, which often happens. Sloppy seas and scattered, nasty thunderstorms don't make for a comfortable trip with an inexperienced crew. That can even be a recipe for disaster, with the wrong crew. I backed out of the trip at 4 a.m., when the weather report didn't get any better. (It's easy today to log on to excellent weather websites with offshore buoys and radar, while still in your jammies). I felt a little guilty at first before going back to bed, but knew it was the right thing to do. My friend understood; he agreed and cancelled the trip. The last place you want to be with an inexpe-

rienced captain, or an owner new to fishing with a green crew, is way offshore in bad weather.

Whether kingfishing or billfishing, understand who your crew is and know their experience level. Make sure everyone is clear about their duties and responsibilities on the boat, especially when a fish is hooked. If you're the captain, the responsibility falls on you to make sure everyone returns to port safely. Hopefully they had a good time, as well. Assess your options from boat to crew and you'll have a better trip when you get out there to that favorite spot. Or tide rip.

So what are your options? Will you slow-troll live baits nearshore for kings or sails? Do you have enough boat to make it to the 100-fathom curve safely? Will you troll artificial lures or a combination of skirted natural baits? Will you live-bait big tuna and billfish around the oil rigs or will you high-speed troll for wahoo in the Gulf Stream? These options will be discussed in the following chapters. SB

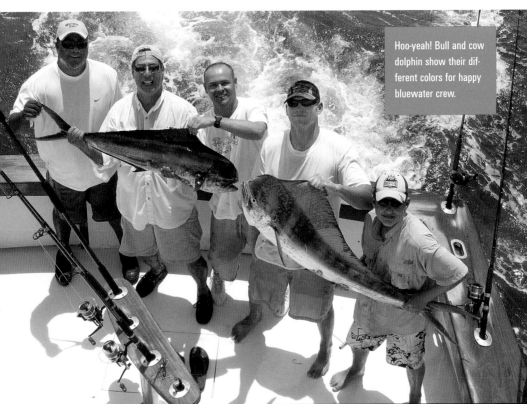

Hoo-yeah! Bull and cow dolphin show their different colors for happy bluewater crew.

## CHAPTER 3

# Offshore Tackle

**W**hen it comes to offshore tackle the options range from fundamental and functional to very expensive. The good news is that you don't have to break the bank to acquire adequate offshore gear. While the initial purchase is significant, properly using and maintaining that new tackle will help it last for years and catch many fish—a good investment.

More than once, I've seen fishermen spend 100 grand or more on a boat and then buy the cheapest tackle in the store—or tackle that doesn't begin to fit the job required of them. The owners then complain they're replacing equipment and losing fish because their gear doesn't function properly. Go figure. You can still buy quality gear without going into debt; just do your homework first. The important thing is to make sure you have the right equipment for the job. Having a set of 80-wide reels is great, but if you mostly go after sailfish, you'll need tackle a great deal lighter. Also, don't overlook quality, used equipment. Some folks are just junkies for the latest and greatest tackle, but when properly maintained, quality used tackle will last for a number of years.

You don't want to skimp when rigging tackle for serious offshore fishing.

**See DVD for more on offshore tackle.**

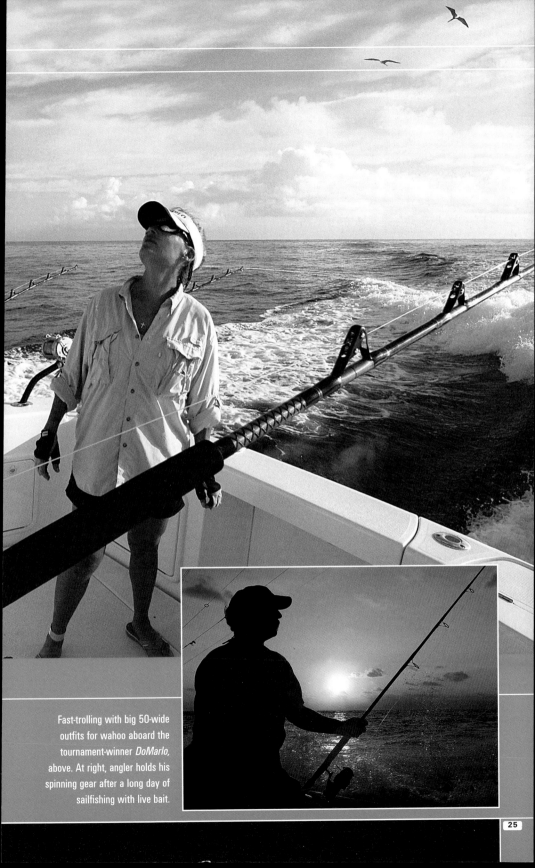

Fast-trolling with big 50-wide outfits for wahoo aboard the tournament-winner *DoMarlo*, above. At right, angler holds his spinning gear after a long day of sailfishing with live bait.

# Conventional Offshore Reels

For the majority of species you'll target, conventional reels are the gear of choice. "Conventional" in tackle jargon means revolving spool, your basic trolling reel, as opposed to a spinning reel or fly reel. You'll find conventional gear divided into two families. The lighter tackle family encompasses gear from 15- to 25-pound class, which is primarily for targeting smaller offshore species such as mackerel, dolphin and sailfish. The term "class" of course refers to the line test or breaking strength most appropriate for the capacity and mechanical characteristics of a given reel.

The next family starts at 30-pound and increases to 50-pound, 80-pound and then 130-pound class. These reels handle everything from big bottomfish to that "grander" (1,000-pound) blue marlin we all dream of.

The main differences really fall into three categories: retrieval speed, line capacity and drag strength. You could catch a blue marlin on 12-pound-test, with enough line on the reel, the drag set properly and if you were a trifle lucky. The smaller classes of reels have a smaller line capacity and lighter drag strengths, but they are generally faster in their retrieve speeds. While larger reels have superior line capacity and drag strength, they are generally much slower. Try keeping up with a hooked wahoo speeding toward your boat on an 80-wide reel, and you'll find out firsthand.

A 50-pound class reel, for example, holds roughly 850 yards or 2,550 feet of 50-pound line. A 130-class reel will take about 1,000 yards of 130-pound line. You might think you'll never need this much line, but a big, alarmed yellowfin can easily dump a 50-pound

## Larger reels have superior line capacity and drag strength, but they're generally much slower.

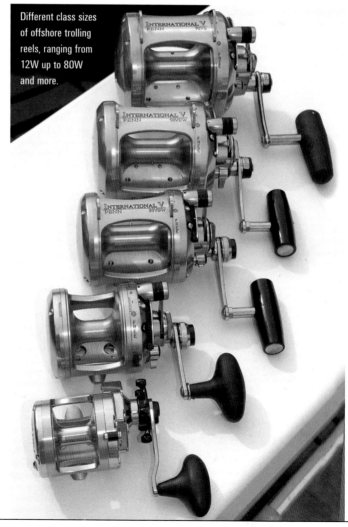

Different class sizes of offshore trolling reels, ranging from 12W up to 80W and more.

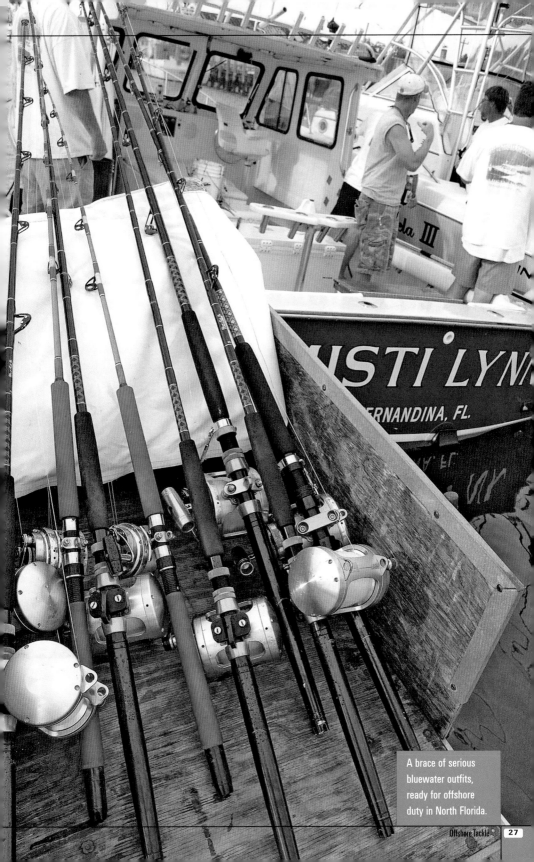

A brace of serious bluewater outfits, ready for offshore duty in North Florida.

## It's important your reels have enough line; you're giving hooked fish a head start when trolling.

reel. A large bluefin or marlin can certainly do the same to an 80W reel, if so inclined. Combine the power and speed of these fish with the fact that your boat is trolling along at 6 to 8 knots or faster, and that line can vanish from the spool in a hurry. You're giving the fish a head start while you clear the other lines, so it's imperative you have enough line on the reel to get the job done. A wide-frame reel obviously carries much more line than a narrow frame. "Wide" reels—you often see anglers referring to "50-wides" and "80-wides"—are large capacity reels built for battling big pelagic fish.

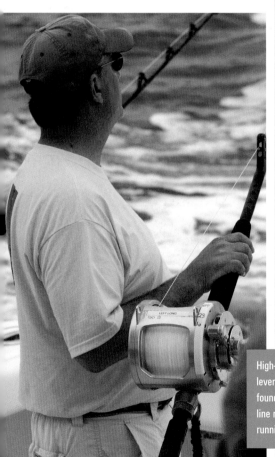

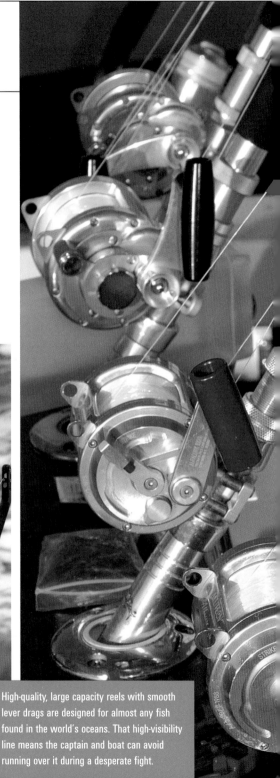

High-quality, large capacity reels with smooth lever drags are designed for almost any fish found in the world's oceans. That high-visibility line means the captain and boat can avoid running over it during a desperate fight.

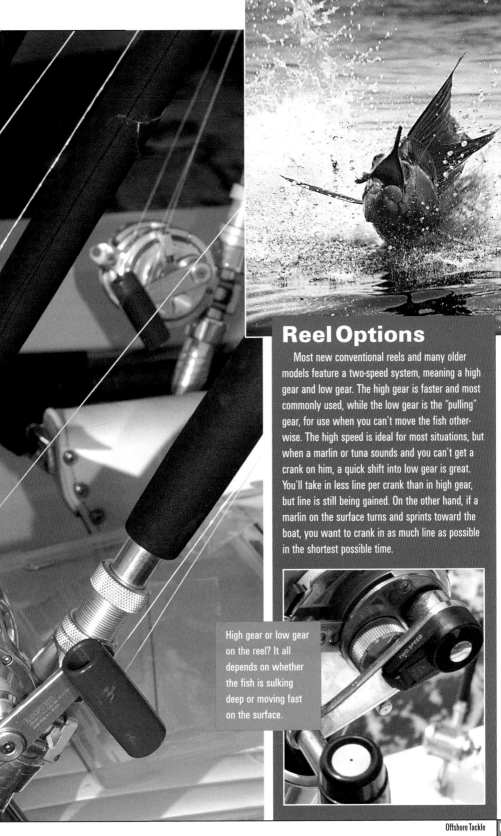

## Reel Options

Most new conventional reels and many older models feature a two-speed system, meaning a high gear and low gear. The high gear is faster and most commonly used, while the low gear is the "pulling" gear, for use when you can't move the fish otherwise. The high speed is ideal for most situations, but when a marlin or tuna sounds and you can't get a crank on him, a quick shift into low gear is great. You'll take in less line per crank than in high gear, but line is still being gained. On the other hand, if a marlin on the surface turns and sprints toward the boat, you want to crank in as much line as possible in the shortest possible time.

High gear or low gear on the reel? It all depends on whether the fish is sulking deep or moving fast on the surface.

# Drag Settings

There will always be some competing discussion on drag settings, but the most common refrain is that you should have your drag set to no more than one third of your line's breaking strength. That 30-pound line should have the drag set at no more than

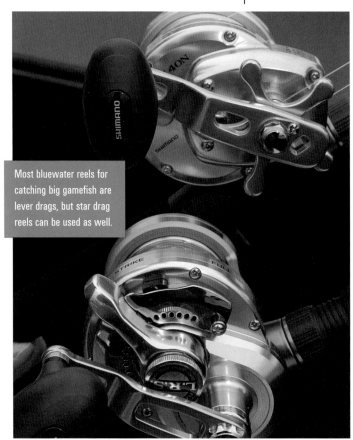

Most bluewater reels for catching big gamefish are lever drags, but star drag reels can be used as well.

10 pounds, for example. Use 50-pound line at 16 pounds and 80-pound line at 26 pounds. Some anglers argue that 25 percent drag is enough and they won't get an argument from me. There isn't a magic number, but one-third is a good rule of thumb. More experienced anglers may set their drags higher, perhaps 40 percent of line strength, but only set the lever drag up to three-quarter of strike drag. This allows flexibility to increase the drag during

the fight, but it also allows for mistakes. For example, during the one of a hundred or so times you're clearing and re-deploying your bait spread, someone forgets and sets your line at full strike. That's usually when Mr. Big hits; if so, your lure will likely go south with a broken line. For situations like this, using masking tape or red electrical tape applied to the side of the reel, with drag settings marked with a sharpie, can be extremely helpful.

A lever drag reel offers a smoother drag, with more precision available in setting the drag, even when back at the dock. The older star drag design has caught a great many offshore fish in its day, but now is more relegated to bottom fishing.

I'm usually not inclined to increase the drag during a fight, particularly if the fish has a significant amount of line out. The increased friction of line underwater has already increased the drag and the smaller diameter of the spool has, too. If you feel like you need to add a little pressure to the drag, you can always use some judicious thumb pressure on the side of the spool or pinch down on the line with a thumb. This is "feel" technique, and it's something learned with experience over time.

It's pretty simple to set your drag by using an ordinary hand scale. Attach the mainline to the hook on the hand scale and smoothly but firmly pull the line with the rod arched as though you are hooked up to a fish. The pressure is greatest at this angle. If you set the drag at this point, you'll know that your drag settings won't increase as angles and situations

**...g setting; the lever drag is smoother.**

change during the fight. Tune and repeat until you get the desired drag setting.

Drag settings depend on your targets, too. Kings and wahoo have bony mouths, but will pull hooks easily if you button the drags down too much. Lighter drag settings on these fish will serve you well. If you're trying to get a 10/0 stainless hook through the bill of a 600-pound marlin, light drags will only serve to frustrate you and cause foul language on the boat. Offshore fishing is much like English class: As soon as you learn a new rule, they tell you about those 14 exceptions to the rule. (And yes, there will be a test on this material.) Luckily for us, the test happens offshore, where it's open book and graded on a curve.

> **PRO TIP** DRAGS

# Warm 'em Up

Ever wonder what those guys are doing at the dock, with one tugging line off the reel and the other reeling it back in, from up in the cockpit? They're warming their reel drags before setting them. If your reel drags are cold or "sticky" when you set them, the setting on your hand scale won't be accurate, once they do heat up.

To warm up your drags, set your reel at full strike and with either a gloved hand or your scale, pull firmly but smoothly against the drag in a sweeping arm motion. Depending on how much you exaggerate the motion, this will pull off about

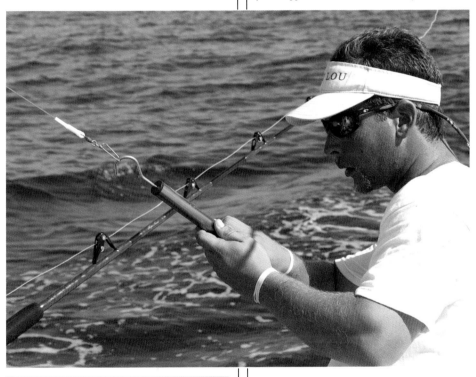

The mate above on the tournament-winning vessel *Prisa* based out of San Juan, Puerto Rico is testing reel drags with a hand scale while they're already offshore, preparing to set out another bait. It's more recent information on a reel's drag setting, compared with that morning, back at the dock.

6 to 8 feet of line. Have a buddy reel the slack up after each pull, and repeat. Do this 15 to 20 times per reel (relax; it will only take about 30 seconds per reel) before you set them, and that should be sufficient. Using a hand scale like the one above, you'll be even more accurate.

# Spinning Gear

**B**ehind every good man there's a better woman, or so they say. Every good set of conventional gear should be complemented by a proper set of spinning outfits. It's a fact that some species of fish are more readily targeted with spinning gear, though this is the exception and not the rule in offshore fishing. That 15- to 30-pound spin gear is essential on

**Some species of fish are more readily targeted with spinning gear, though this is an exception.**

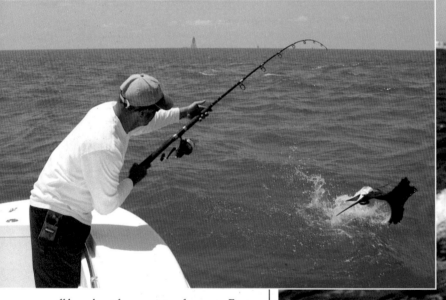

Working a sailfish 360 degrees around a center console boat, with good spinning gear.

an offshore boat for a variety of reasons. First, there will be times when you want to catch live bait, which can range from cigar minnows to bonito, blue runners or small tunas. Spin gear is the superior choice for all of these. Second, sometimes a trolling spread just doesn't turn a fish on, while live or dead pitch baits will fire him up. Many times big dolphin will hold under a weed patch and won't chase out to the spread, but a ballyhoo/circle hook/spinning combination is often deadly here. That big wahoo holding beneath a floating 5-gallon

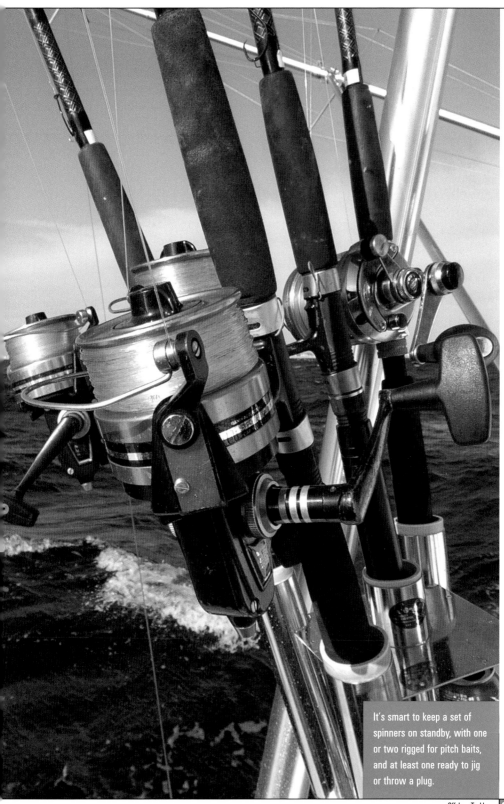

It's smart to keep a set of spinners on standby, with one or two rigged for pitch baits, and at least one ready to jig or throw a plug.

bucket might not come up and hit a trolled bait, but a diamond jig with a small wire leader dropped down a couple hundred feet and vertically jigged might just make him mad enough to do something about it. And finally, sometimes it's just more fun to cast to the fish and catch them on lighter tackle. White marlin are notorious for nosing through every bait in the spread without finding a hook, but a naked ballyhoo on a stout spinning rod will often show him the way.

While fishing during Memorial Day one year, we spotted a whale shark off the bow of our 40-foot sportfisher. We excitedly trolled our bait spread up and down both sides of this 35-foot beast without a single looker; we started to think she might be alone. But we finally noticed a pair of big bull dolphin underneath her that obviously weren't interested in trolled baits. We quickly switched guns and put a pair of spinning rods loaded with ballyhoo on the fish, one of which was worth a little more than

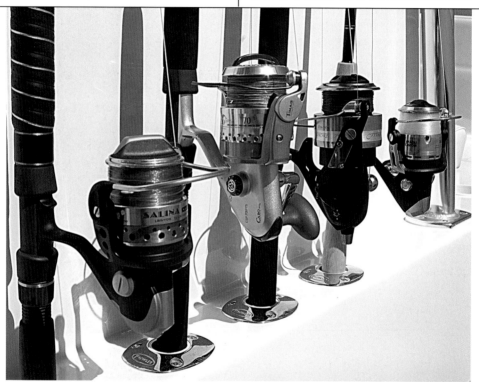

A few years ago only a select group of tackle companies offered large (20-pound) spinning reels. Today several companies are selling high-end quality reels. The key for selecting an offshore spin reel is line capacity, drag washer size and makeup, as well as overall sturdiness.

$8,000 back at the tournament scales.

Spin gear takes a second seat on most blue-water boats, of course, but there are options for anglers who show a preference for heavy duty spinning gear. Reel manufacturers like Shimano, Daiwa, Van Staal and Penn have upped the ante with their heavy duty models like the Stella 20000 and VS300, which can hold better than 300 yards of 30-pound monofilament (that can equate to nearly 500 yards of 80-pound braided line). Couple this

with monster drags of 43 to 58 pounds, and you can really do battle with most bluewater fish. There's a place for light spinning gear off-shore, but this gives you an idea of what's available.

Catching small tuna on 50-pound trolling gear isn't really challenging. Pulling out the spinning gear and a topwater popper to watch big blackfins or even yellowfins explode on them is awesome. But if you didn't have spin gear ready, you just might be eating hamburg-

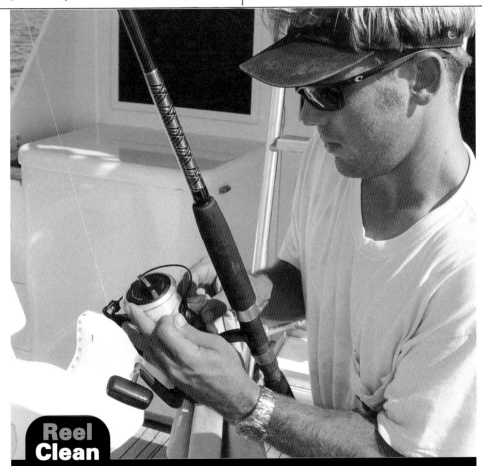

## Reel Clean

Everyone knows to clean and soap those reels properly before storing them. But what they often don't tell you at the tackle store is to back off on those drags when storing reels. Drags are pads or washers that provide the necessary amount of friction to apply pressure on your fish. Like brake pads on your vehicle, they wear out. Don't exacerbate the situation; lay off the drags when you store reels. Do so for no other reason than it might keep you away from the tackle repair shop, which is always backed up for several weeks. Be sure to clean and dry your reel before backing off the drag for storage. Pressure on the drag components helps prevent moisture from seeping into the system.

# Lines and Leaders

Once you have your gear picked out, the most critical choice after that is select quality line to fill the reel. Most of the time, that line will be monofilament. The good news is that there are a host of quality line manufacturers out there, and your local tackle store won't stock a bad one. Ande, Stren, Trilene, Sufix, Momoi and many others make quality line. Though some have specialty colors or IGFA certifications, brand is less relevant than keeping your line in good shape.

Having fresh line on your reels is important, and taking care of that line is even more so. Spooling up several hundred or even a thousand yards at a time can get expensive, so it's critical that you take care of your line and get the most out of it. It's best to store the line and reels away from sunlight, as UV rays damage your

**Having fresh line on your reels is important, and taking care of that line is critical in order to get the most from it.**

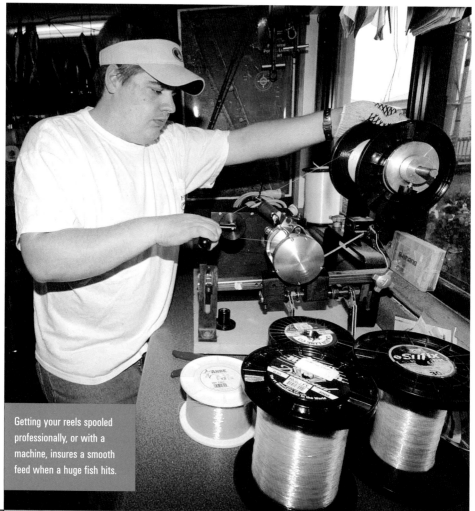

Getting your reels spooled professionally, or with a machine, insures a smooth feed when a huge fish hits.

line over time. It's also good to keep them out of extreme temperatures, hot or cold. Storing them in the garage isn't nearly as good as keeping them inside the house. My wife hates the reels inside the house, but when I explained to her that keeping them in the garage means changing my line more frequently, and shared with her how much it costs to spool up a set of 50-wides, that hall closet suddenly sounds like a real bargain.

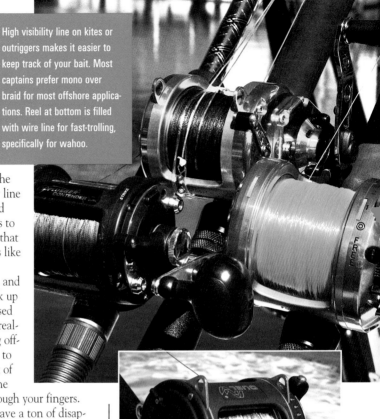

High visibility line on kites or outriggers makes it easier to keep track of your bait. Most captains prefer mono over braid for most offshore applications. Reel at bottom is filled with wire line for fast-trolling, specifically for wahoo.

When transporting rods and reels, you'll sometimes pick up a nick or ding to the exposed line on the spool without realizing it. So, before heading offshore, it makes good sense to peel off the first 20-40 feet of line and pack it back on the spool while running it through your fingers. Something so simple can save a ton of disappointment down the road. Kinks, twists and backlashes all take their toll, so make a conscious effort to watch for potential weak points in your line. Peeling off 50 feet of line to cut out a bad kink isn't wasteful, it's smart. Just make sure you dispose of the line properly.

Braids and "superlines" have changed the way a lot of people fish. While these lines haven't changed mainstream offshore fishing, they have added some pretty cool twists. Mainly, they've allowed their thin diameter and superior strength to be utilized in specific applications. For example, a standard 6/0 reel will hold about 475 yards of 30-pound monofilament. But if you load a backing of 30-pound mono on for the first 100 yards, then pack it with 80-pound braided line (that has a diameter of 20-pound monofilament), you give yourself more line capacity, more strength to set the drag higher if you need to and you've turned a common bottom-fishing reel into an inexpensive offshore reel that will handle most types of offshore fish. This is a nice way to try your hand at offshore fishing without spending a small fortune. The same application can be made with the heavy duty spinning gear mentioned earlier, if you want to tackle some monsters on spin gear. The key thing to remember is that your line is stronger by simply changing out the monofilament for braided line, but your drag is the same. Don't lock it down, thinking it will handle it. You may have the gears stripped, or get the rod or yourself yanked overboard. Also remember that braided line is tough on ceramic guides, so make sure that before you "braid up" that you do a little more research on the whole program.

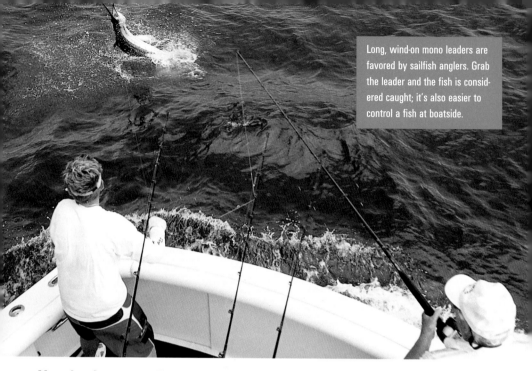

Long, wind-on mono leaders are favored by sailfish anglers. Grab the leader and the fish is considered caught; it's also easier to control a fish at boatside.

**Your leader, as well as leadering the fish, is the final link to your landing that fish. Make it count.**

## Leaders

Leaders and leader materials are another subject of offshore fishing where opinions will vary and arguments will abound, but ultimately it comes down to your personal preference. It's pretty simple when you're deciding on what size wire to fish for king mackerel, but when you enter the discussion on trolling leaders and the best methods, it's a different story. Some captains run long leaders, 25 feet or more, while others tie double lines on the main line and run shorter leaders in the 12- to 15-foot

range. Still others prefer wind-on leaders and crimp merely 6 to 8 feet of additional leader material. Let's be clear on this; there is no right or wrong method. You will catch fish with each method. It all boils down to your preference.

The most common method of attaching leaders is by tying a strong snap swivel onto your line, and the leaders that accompany your lures will have crimped loops that snap into place. This allows you the freedom to open up the snap swivel and simply remove and drop in a different lure with relative ease. It also means that you'll need to have someone wiring the fish as it comes to the boat. Longer leaders mean that you'll have to take care with this excess material on deck when your fish spooks and makes another run. Snared legs and arms in heavy leader material, attached to a big fish, can get ugly in a hurry.

Wind-on leaders are just what they sound like, heavier leader material attached to your main line via an Albright, Bristol or other line-to-leader knot, that can be reeled onto your spool. Some manufactured wind-on leaders use a hollow-core Dacron sleeving connection, similar to the Chinese finger cuffs enjoyed by kids, while others

are connected via loop to loop connections. At the end of the 20 to 30 feet of leader, you either crimp on a heavy snap swivel, barrel swivel or a stainless steel solid ring. Using a snap swivel here allows you to change baits a little more quickly. Many anglers prefer wind-on leaders because they've seen snap swivels open up during a fight, resulting in lost fish. A barrel swivel or solid ring means that you'll have to crimp on each lure when you change it out, but it's not as much work as it sounds like. The big plus with wind-on leaders is that you can reel on a fish until he's right at the boat. There's less risk of tangling objects on deck than with long leaders, and you don't need a deckhand to wire the fish.

While wind-on leaders are generally used for heavier classes of tackle and tournament situations, you can just as easily splice a top shot of 50-pound fluorocarbon leader onto your 20-pound-class king mackerel reels with a low-profile Albright or Yucatan knot. This allows you to use a shorter wire leader to entice bites from spooky fish and still have protection from these tail-whipping torpedoes.

Once you decide how you'll attach those leaders, you need to decide on whether you want to use monofilament leader material or fluorocarbon. Fluoro is much more expensive but nearly invisible underwater. There are anglers who will only run fluorocarbon leaders for billfish, while others keep pulling mono leaders. Again, it's a matter of personal preference and they'll both catch fish. Where I have seen a marked preference for fluorocarbon over monofilament is when live-baiting for marlin and tuna. These situations often call for lighter leaders than trolling, and you need every ounce of strength and abrasion resistance when fighting big fish.

Wire leader is another matter.

King fishermen, almost every last one of them, use dark "piano" wire of varying strengths and diameters. The same wire was once used on sailfish in Southeast Florida, perhaps because so many kingfish grabbed the same baits.

Today, the sail pros use mono or fluoro, and don't seem to care if a kingfish snips off a hook.

Heavier, braided wire is used for pelagic trolling, where wahoo are a threat to cutting off expensive plastic trolling baits. Braided wire isn't so quick to kink, as piano wire does. Braided will also take an extreme beating during a fight with marlin or tuna that often consumes hours.

## Matching up Your Leaders

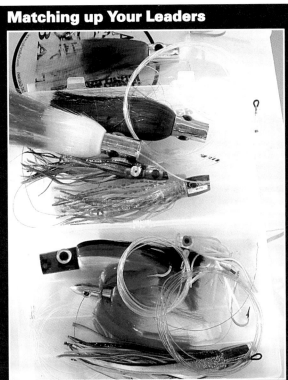

Whether you choose monofilament or fluorocarbon, one thing that isn't up for argument is how you should size your leaders. Much like hooks being sized to baits, your leader size should match the size baits you are trolling. A Junior Ilander lure with a matching ballyhoo will run great on a 150- or 200-pound leader, but it won't have enough weight or action to run right with 400-pound leader material.

# Rods

A variety of tackle is certainly necessary, when spending a day offshore–regardless of the targeted species.

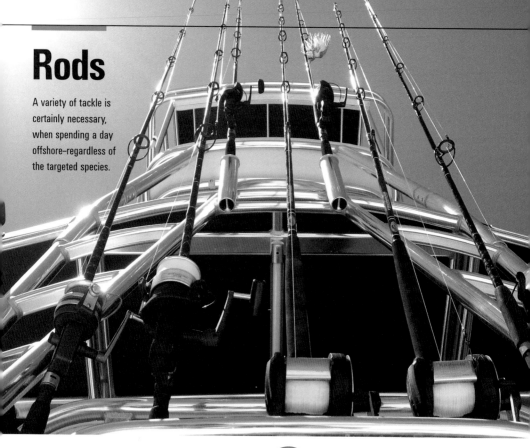

**Many medium and heavier action spinning rods sport large wire guides these days, which some anglers feel helps with casting.**

Chances are that you won't buy your rods and reels without making sure they're a good match, but understanding some basics will help you. The key to any rod is good components. You can have the best quality blank available, but if it's paired with guides that are sub-par, then you have a sub-par rod. The good news is that you can buy quality rods off the shelf. While many tackle stores can build you custom rods—and many are top quality rod builders, too—you don't have to go custom to get quality.

Standup rods (also called straight butt rods) are the norm for conventional reels in the 20- to 50-pound class. Standup boat

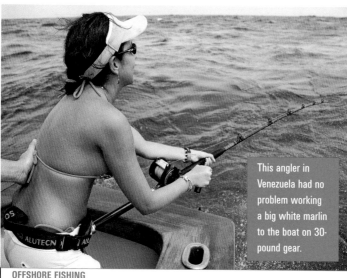

This angler in Venezuela had no problem working a big white marlin to the boat on 30-pound gear.

rods are generally 5½ to 6 feet in length, with a tip and five guides for conventional trolling reels. Specialized kingfish and sailfish rods, however, will be in the 7- to 8-foot range and may have as many as 11 guides on them.

Larger classes of reels, from 80- to 130-pound class, are often outfitted with bent-butt rods. These rods are generally a bit longer in length than standard boat rods, 6½ to 7 feet, with 5 to 6 guides plus the tip. Bent-butt rods do two things that standup rods don't. First, for your corner or flatline baits, the height of the rodtip is lowered, so the baits ride in the water a little more level. Second, bent-butt rods lower the reel for better access by the angler. They ride lower on your waist, in a more natural position for cranking the reel handle.

Bent-butt rods with their different pumping action, are designed for fighting chairs—which are generally mounted on bigger boats. The angler is seated during the entire fight. The same rods can be used on the boat's gunnel, but are left mounted. The angler sits on the gunnel and winches the fish in.

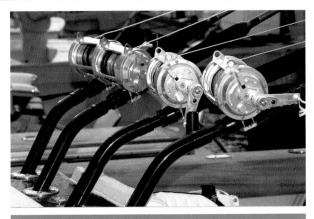

Bent-butt rods are the greatest invention since sliced bread, for anglers who battle big fish from a fighting chair. It's a far more efficient lifting action, compared with straight-butt rods.

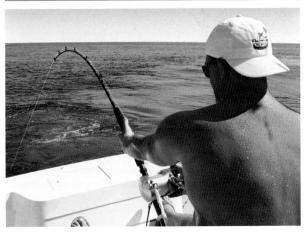

This isn't seen often, except when wire-lining for wahoo. The fish is winched in while the boat idles along in forward gear, the mate grabs the long leader, and the fish is either snatched in the tuna door or gaffed.

Spinning rods must also be matched to the size reel you want to place on them. While your conventional rods will more than likely be fiberglass blanks, many spinning rods are graphite. Graphite has much improved sensitivity, which is a big plus for some anglers, but it's more brittle than glass and will break. Subject to bruising and later breaking, they may snap when trying to horse a fish into the boat. Spinning rods are designed for casting, so the larger the eyes on the rod, the less resistance your line will experience when casting the lure. That means increased distance. Many

medium and heavier action spinning rods sport large wire guides these days, which some anglers feel helps with casting distance.

With any trolling rods, you want to make sure to attach safety lines to them. On one trip, we had a center rigger rod take flight and go swimming when a fish hit. The center rigger clip didn't release and the safety line saved us about a thousand dollars in equipment, not to mention missing out on some bad luck. Offshore fish often take flight as soon as they feel the hook, so it doesn't take a release clip malfunction to pull your rod and reel skyward. Play it safe and keep that tackle locked down. Strong safety lines are often clipped to the reel, and these have prevented the loss of expensive gear—even salvaging the fish.

# Fly Tackle

**N**ot so long ago, if you toted a fly rod down the dock to board an off-shore sportfisher, the captain and crew would make you walk the plank. Or leave, anyway. But there is a time and place for fly fishing offshore. Nowadays, it's not only accepted, it's a specialty for a growing number of skippers and anglers both in the U.S. and abroad. Tuna, king mackerel, dolphin and bonito lead the hit list, and sailfish and small marlin are targeted and frequently caught off Central and South America. But when it comes to tackle, you can't tread lightly.

because casting technique is secondary out there. Machined fly reels are a must; they have superior drags and frame integrity to withstand strong runs and the marine elements. Today's reels with large-arbor designs provide maximum line pick-up with every crank, and line backing capacity in the 250- to 500-yard range for long-running gamefish.

Floating fly lines have their place for sight-casting, to chummed-up or teased fish at or near the surface. However, full sinking lines and sinking shooting heads are employed when the bite happens deeper in the water column, often over

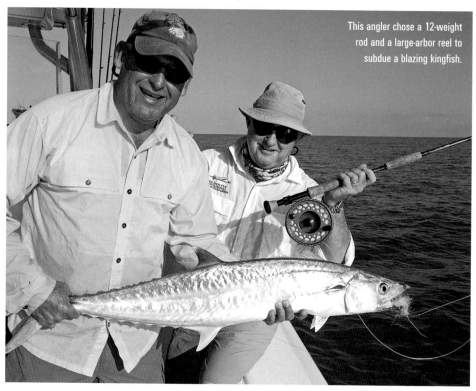

This angler chose a 12-weight rod and a large-arbor reel to subdue a blazing kingfish.

This not the place for freshwater trout tackle. Fly rods in the 9- to 15-weight range cover the bases offshore, from schoolie dolphin to sailfish and marlin. Most veterans arm themselves with good stiff "fighting sticks," or "rhino chasers"

wrecks or a reef. Leaders can be simple, level strands of monofilament or fluoro-carbon, or built to IGFA specifications, with proper class tippets and bite tippets for "legal" catches and world-record con-sideration.

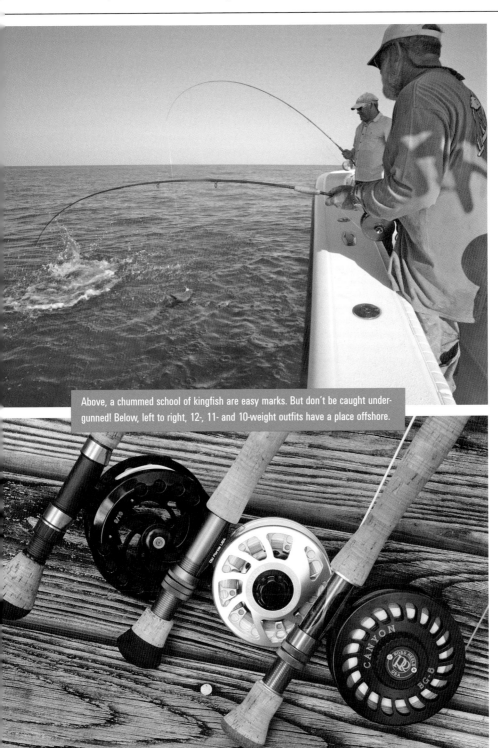

Above, a chummed school of kingfish are easy marks. But don't be caught under-gunned! Below, left to right, 12-, 11- and 10-weight outfits have a place offshore.

# Belts and Harnesses

If you're fishing standup gear, you should have a mix of rod belts and harnesses on board, depending on the fish you hook up. Many folks prefer to just pop on a simple "gut bucket" to fight dolphin, wahoo and smaller fish. But larger fish on standup gear require a proper harness for optimum results. Make no mistake; you can fight any size fish on standup

You distract the angler and risk losing the fish, and you negate the advantages of fighting a fish on standup when your gear isn't fitting correctly. You'll just tire the angler out and make things harder. Make sure that you take the time to size the harness to the anglers, and if you don't have enough to go around, don't worry. In between strikes, size them to fit the angler that's next up in the rotation. I'm convinced the main reason people don't like fishing standup is that they've had a bad experience with it. Fighting a big fish on standup can be a great experience, but you have to do your homework and it does take a bit of practice.

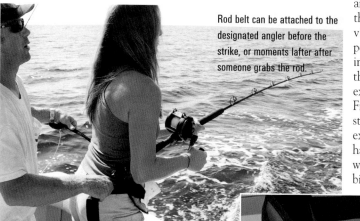

Rod belt can be attached to the designated angler before the strike, or moments lafter after someone grabs the rod.

**Fighting a fish on standup can be a great experience, but you have to do your homework, and practice.**

gear, provided you are outfitted accordingly. Dennis Braid, of Braid Products, has made a living convincing folks about this truism. Braid is an evangelist for standup fishing and part of it is because he sells standup gear, but there is a pride to it as well. I've seen several anglers "drink the tea" and choose to fight fish with standup gear, regardless of size. There is an ego element that comes when you best a fish on standup; it's more of a one-on-one fight this way, as well.

With harnesses, it pays to have more than one on the boat. If you have to make adjustments during mid-fight, two things happen:

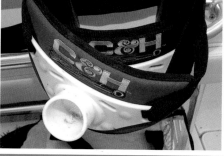

Different rod belts are either strapped on or slapped on, according to their design. They're easy to use, preventing serious bruises to the stomach area.

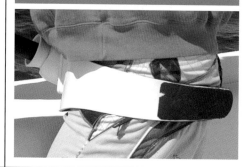

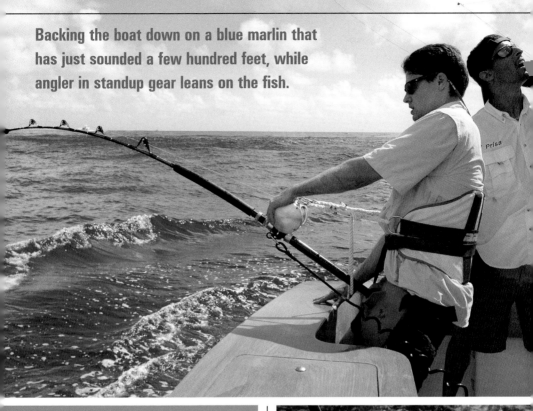

Backing the boat down on a blue marlin that has just sounded a few hundred feet, while angler in standup gear leans on the fish.

Standup gear above and at right allows angler to fight a big marlin without using a chair. With good back support, you can even rest while the fish has gone deep. Below, using a quality rod belt helped land this white marlin.

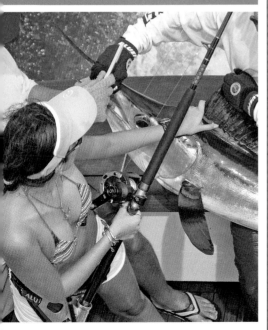

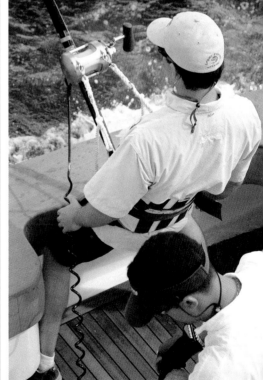

# Terminal Tackle

**P**robably the best advice you can get when it comes to terminal tackle is never skimp when it comes to the small stuff. Your equipment is only as good as the weakest link that connects you to the fish. It

You don't have to use stainless steel hooks offshore; others will work—but they'll have to be replaced much more often. And if you button down your drag with a non-stainless hook, it just might straighten. Those generic swivels that cost half of what the SPRO or SAMPO swivels cost will work just as well, perhaps. However, you don't want to risk losing a big fish to save 40 cents. That cheap swivel can

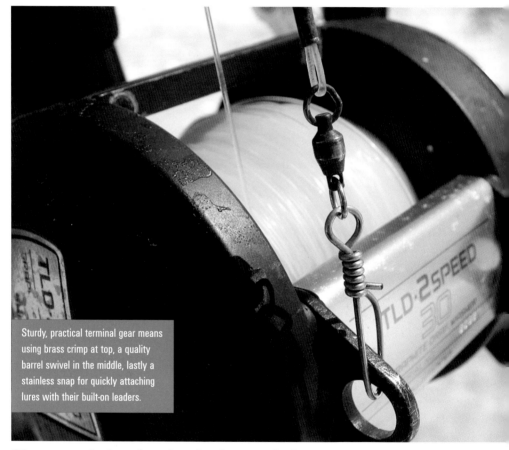

Sturdy, practical terminal gear means using brass crimp at top, a quality barrel swivel in the middle, lastly a stainless snap for quickly attaching lures with their built-on leaders.

## Give as much thought when buying terminal tackle as you would when purchasing bigger items such as rods, reels and lures.

doesn't make much sense if you take your $1,000 rod and reel, load it with line, leader and a $60 lure, only to use a cheap snap swivel that doesn't hold up. You can apply that same logic to using a spool of line that's been sitting open in your garage, oxydizing for two years; it's just not smart.

put a monstrous twist in your line, too. Give as much thought when buying terminal tackle as you would when purchasing bigger items such as rods, reels and lures. They all depend on each other, just like the team of anglers on your boat.

## Barrel Swivels

These little gems are used to connect both mono and wire leaders to main line, where it isn't feasible to crimp. They allow your lure or bait to swim and move naturally, without twisting line. Quality swivels are a must for offshore fishing.

## Snap Swivels

Snaps are either crimped or tied to your main line on the reel. They open to attach those long, 12-foot leaders rigged to each trolling lure. This little snap and barrel device prohibits line twist, while allowing for a fast, non-wasteful transfer from one lure to the next. Always size that snap swivel to your bigger leader and intended quarry, instead of that lighter main line. Marlin may straighten a smaller snap.

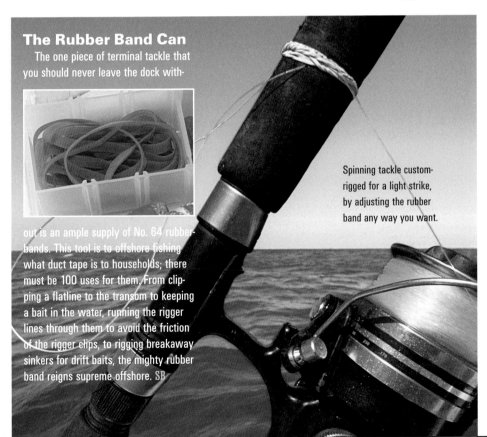

## The Rubber Band Can

The one piece of terminal tackle that you should never leave the dock with- out is an ample supply of No. 64 rubber bands. This tool is to offshore fishing what duct tape is to households; there must be 100 uses for them. From clipping a flatline to the transom to keeping a bait in the water, running the rigger lines through them to avoid the friction of the rigger clips, to rigging breakaway sinkers for drift baits, the mighty rubber band reigns supreme offshore. SB

Spinning tackle custom-rigged for a light strike, by adjusting the rubber band any way you want.

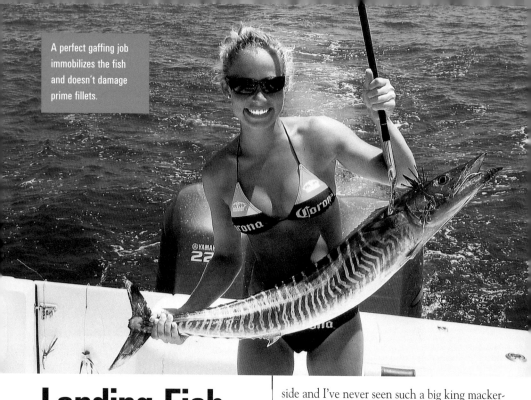

A perfect gaffing job immobilizes the fish and doesn't damage prime fillets.

# Landing Fish

It's important when fishing offshore to have more than one of everything, right? Never was this more evident than a few years ago in Louisiana, while fishing a king mackerel tournament. On the first day of the tournament our only 8-foot gaff was lost overboard, leaving us with just a 4-foot gaff. Wouldn't you know that the first fish of the second day came to the boat quickly and to the bow, of all places. I realized the fish was green, but it rolled up on its

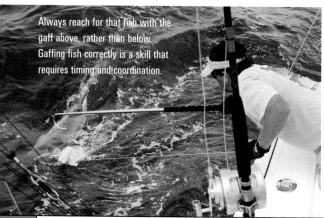

Always reach for that fish with the gaff above, rather than below. Gaffing fish correctly is a skill that requires timing and coordination.

side and I've never seen such a big king mackerel; my adrenaline got the best of me. Reaching over the bow of our 31-footer, I one-handed the gaff and held onto the rail with the other. The fish promptly humiliated me and slammed me down on the boat, ripping the gaff from my hand and snapping the line as she swam away.

There are about a hundred things I did wrong in this scenario, and I even had a little help. First, when gaffing any fish that could still be feisty (or "green"), make sure that you at least give yourself a chance. Never gaff a good fish with one hand. If you're working the gaff, you should also have a pair of gloves. Aboard a big sportfisher, either gaff off to the side or back of the boat; they're the same distance to the water. On a center console boat, however, the worst place to gaff a fish is from the bow, where you are much higher than at the stern. That doesn't mean you can't do it, just don't pull a "buck" mistake, as it has since become known among close friends.

The help in losing that kingfish came because the angler did not back off on the drag. He knew it would have made a difference, but we didn't do a good job of commu-

nicating. I took it for granted that a little king mackerel was an easy gaff-stick, but a 50-pound king should have your respect when stalking it with a gaff.

You should not only have a spare gaff, but a gaff the right size for the fish you're targeting. A gaff with a two-inch-wide hook can handle fish bigger than you might think. If you try to gaff a fish with a hook that's too big, it's hard to stick the fish properly and you might just miss it altogether. On many trips, laziness causes fish to be lost. A gaff man will mistakenly grab a four-inch hook and try to stick a 25-pound wahoo, only to have the fish slide through the gaff and swim away. It's embarrassing, but avoidable. Like hooks and baits, gaffs should be sized to your quarry. Any spare gaff at *all* allows a second

chance at a tired and probably wounded fish. A 49-pound kingfish was stuck and landed in a tournament off Galveston with a cheap, wooden gaff, after the big aluminum gaff had been yanked overboard and lost minutes earlier by the same fish. That king was worth $32,000 in cash.

It's important to have a flying gaff on board, too, while fishing blue water, should you be fortunate enough to run into a big tuna or swordfish. Flying gaffs have a detachable hook that is cleated to your boat prior to sticking the fish. Once the fish is stuck in the shoulder— if you make a good shot—then he is cleated to the boat and can be handled with a large standard gaff or extra wide hook gaff like a Top Shot. It's very important to make sure that the safety line attached to the head of your flyer does not have someone between it and the gunnel or transom. You raise the stakes when you break out the big gaffs; the level of caution exercised should be raised, as well. SB

Gaffs are stronger and thinner than they once were, with better handles. They're also available in a variety of lengths. Strong landing nets are used offshore for releasing fish, below. At right is the ultimate, a flying gaff with rope attachment.

# CHAPTER 4

# Offshore Strategies

**S**trategies vary from one boat crew to another. Some prefer slow-trolling live bait, others won't leave the dock without their favorite trolling lures and a supply of fresh ballyhoo. Whatever strategy you choose, it begins with preparation. It also requires constant practice and time spent on the water. Your strategy actually depends mainly on the offshore species targeted, where you fish and several other factors covered in this chapter.

There are really only a few basic strategies for offshore fishing. They include conventional trolling, high-speed trolling, slow-trolling live bait with or without downriggers, kite fishing and drift-fishing. There are, however, endless variations of these basic techniques. If you fished with 10 different offshore teams for the same species of fish, each would approach the task differently. That means you can always learn something by fishing on other boats.

**The single most important factor for success offshore is time spent on the water.**

See DVD for more on strategies.

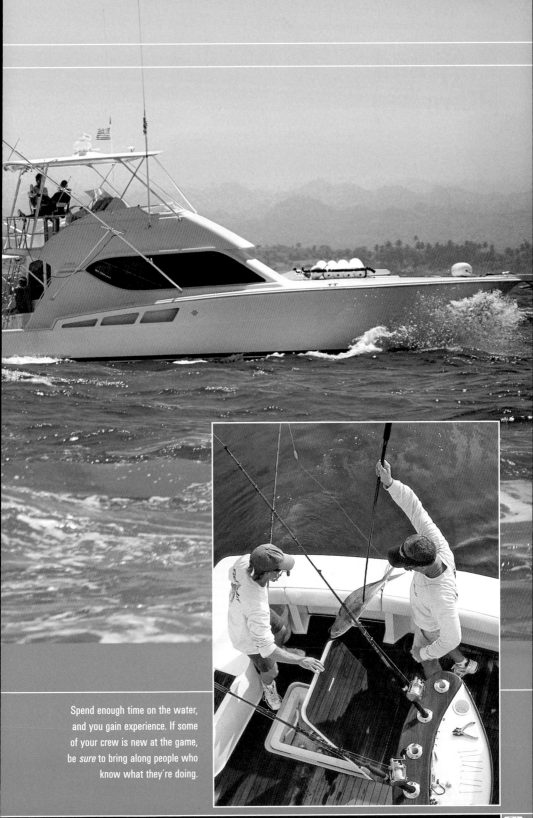

Spend enough time on the water, and you gain experience. If some of your crew is new at the game, be *sure* to bring along people who know what they're doing.

# Prep and Planning

**Y**ou won't know what type of offshore fishing really appeals to you until you try them all. That's a great excuse for not coming into work: "But I haven't tried using kites for sailfish yet!" Imagine what the boss would say.

Any trip offshore, whether for kings or blue marlin, should always have its share of dock talk before the boat ever gets cranked. Don't put too much weight on the term "dock," however. Today the Internet has become a virtual dock for many anglers, particularly for those who trailer their boats, since the only docks they encounter are either at the ramp or gas dock. For weekend anglers, the few fishermen lucky enough to get out during the week can be a blessing for those with only one shot on Saturday or Sunday. Professional captains who share their fishing reports at tackle shops,

## Today the Internet has become a virtual dock for many anglers, particularly

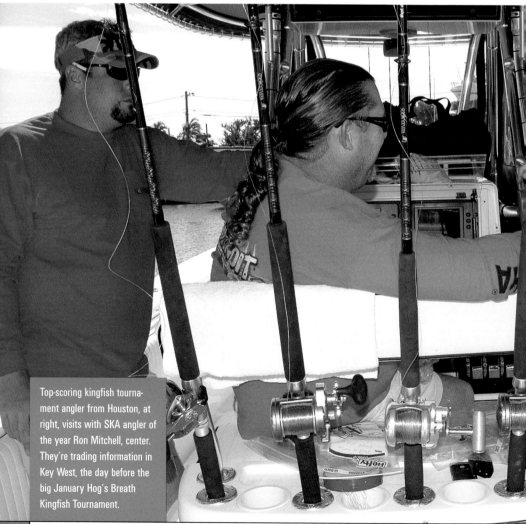

Top-scoring kingfish tournament angler from Houston, at right, visits with SKA angler of the year Ron Mitchell, center. They're trading information in Key West, the day before the big January Hog's Breath Kingfish Tournament.

docks or the Internet can also be a wealth of knowledge for local tactics and strategies.

Whether in person or on the Internet, sharing information between anglers can mean the difference between striking out or striking gold. Sites like the *Florida Sportsman* fishing forum, www.floridasportsman.com, and a host of local and regional fishing forums have become a true medium for anglers to share information and help put one another on the bite. These sites also bring together many new friends who otherwise never would have met or fished together. It's

also good advertising for captains who share information about their trips, whether they were productive or not—instead of just advertising those amazing trips. For recreational anglers, it's just good mojo for boat crews who share information.

For professional anglers and weekend anglers alike—regardless of their offshore experience—the "prep and planning" they put into a trip very often have a big effect on the quality and end result of each trip. You can plan all you want and still get skunked for various reasons, but you won't be second-guessing, because you know you did your homework. Some people believe that getting skunked is the price you pay for the great trips.

**se who trailer their boats.**

Trading information on the Internet is very practical these days. "Angelfish" on the *Florida Sportsman* forum at home and outdoors.

# Conventional Trolling

Everything is "perfect." Crewman signals the spread of artificial baits is now set and running true.

**V**irtually all offshore species, at least the gamesters, are caught using conventional trolling methods. That means trolling a spread of artificials and skirted baits between 6 and 10 knots. Trolling has sometimes been described as hours of boredom followed by minutes of pure mayhem, but this isn't always so. While you have lulls in trolling, many bites are missed and opportunities lost because anglers aren't paying attention to their bait spread. Watching a fish feed is the most awesome aspect of fishing, and trolling on the surface allows the opportunity to do so on a regular basis. It takes diligence to monitor your bait spread, make adjustments and keep those lines clear of floating seaweed or grass. However, the first time you see a bill appear in your spread, or watch the water explode as your reel starts dumping line, you won't forget.

Trolling produces the majority of offshore fish in many parts of the world and that's the big reason so many captains drag baits in their wake. While the size of your boat and crew may dictate how big that baitspread can be, the premise is the same. The point of any trolling spread is to imitate a bait school, provide predators the chance for a quick meal and for you, to provoke a strike. Bait schools have leaders, stragglers, even fish in between, so your bait spread should have these as well.

A mixture of artificials and naturals is probably the most productive spread, but there are situations when dragging either one is warranted. A spread of all artificial baits will allow you to cover more ground and troll a bit faster. Pulling only artificials is also a proven tactic for targeting specific fish—like wahoo, tuna and blue marlin. Again, while lures and tactics change, the bait spread premise is the same

Crew of a Pensacola boat poised and ready, as they troll past a weedline.

and we'll address targeting certain species.

Running natural baits such as ballyhoo adds extra attraction to your spread, but requires more attention to detail. There are negative factors with natural bait; they wash out or sometimes won't want to swim properly. They attract smaller fish that nip and tear them up. Yet, there's a good reason natural trolling baits are such a staple on nearly every bluewater boat fishing today, and you shouldn't leave the

dock without them: they catch big fish.

Whether you're fishing boats big or small, standard trolling spreads (see illustration on page 57) can be the most productive way to target bluewater fish. I use the word "standard" rather reluctantly, because trolling isn't a science. It's actually a mad science to billfishermen and folks can get downright snippy about their bait spreads, if you suggest making any changes to them. Some boat crews start with

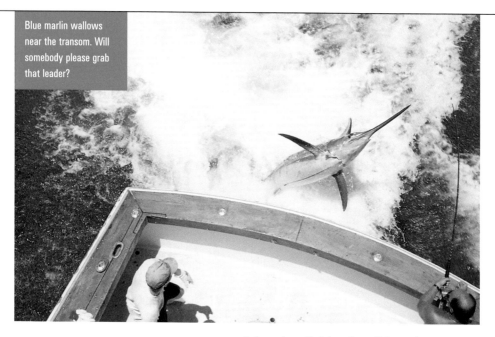

Blue marlin wallows near the transom. Will somebody please grab that leader?

**If you don't leave a lure in the water long enough to fish, you're not giving it a chance.**

the same spread every time and deviate very little. Others constantly change baits, lures and teasers. Having fished on many different boats, I can tell you both methods work. However, consistency will produce more fish than constantly changing baits.

With practice and time on the water, you'll find a comfortable spread of lures that you like to pull. You'll get better results from certain lures (we all do) and you'll keep them in your spread. So it's a self-fulfilling prophecy that these lures keep producing. Find an offshore boat that doesn't have a blue/white Ilander bait and you'll be the first one. If you keep pulling a variety of baits, you'll catch fish. Don't be afraid to mix it up. However, if you don't leave a lure in the water long enough to fish, you're not giving it a chance.

## High-Speed Trolling

Successful bluewater captains are often forced to fish completely open water. The lack of tide rips, weeds and debris is the last thing any bluewater fisherman wants to deal with, but it's part of fishing. Rather than pick up your lines and run to check out another spot, you can take the natural baits out of your spread and troll artificials that run properly at higher speeds. It's a proven method for searching out a bite and covering more ground without pulling lures from the water. The only time to pick up and run to another spot is if you are fishing an

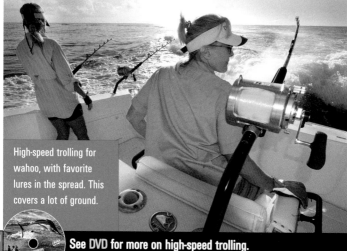

High-speed trolling for wahoo, with favorite lures in the spread. This covers a lot of ground.

**See DVD for more on high-speed trolling.**

# Standard Trolling Spread

**1. Left Long:** Shorter of the two outrigger baits

**2. Left Flat:** Bait trolled off one of the transom corners, shorter of the two corner baits, use release clips if dropback wanted

**3. Center Bait:** Longest line, usually run out of the center outrigger or simply run from the center of the transom or chair

**4. Right Flat:** Longer of the corner baits, use release clip if dropback wanted

**5. Right Long:** Longer of the two outrigger baits

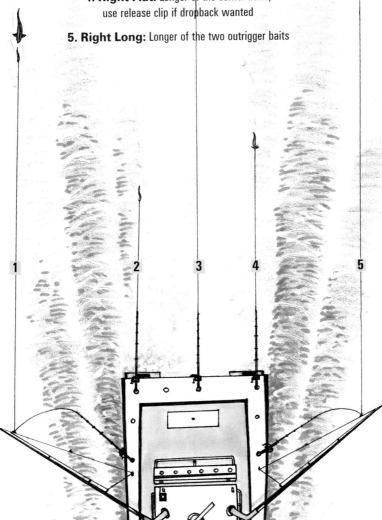

area that is devoid of any signs of life. If you don't have bait in the area, you won't have fish. Short of another boat calling you over to some awesome weedline or a smoking hot bite, keep those lines in the water and adjust your speed.

Wahoo, tuna, dolphin and billfish will strike at higher speeds, and some captains argue that you can't troll too fast for them. The important thing to remember, whether you're just picking up a couple of knots or you're trolling at 15, is to make sure your lures are running properly. This often involves in-line trolling weights up to 48 ounces to keep the lures in

If you're in the zone, easing along and keeping your baits swimming forward, be ready for that strike.

the water, heavy steel or chrome jethead lures, and swimming lures designed to run at higher speeds. Wahoo bombs—Schneiders, Wide Ranges, Yo-Zuri Bonitas, Braid Marauders and other high-speed specialists are great.

The spread concept doesn't change much here, though you're likely to run five lines instead of six. Your job again is to mimic a bait school and get those predators interested.

## Slow-trolling Live Baits

The same practice of slow-trolling live bait for king mackerel will also produce sails, tuna, dolphin, wahoo and marlin. In fact, on many occasions, slow-trolling live bait is the preferred approach for big marlin. The key differences here are tackle, presentation and geography.

While 20-pound gear is perfect for mackerel and even sailfish, you're not likely to land many sails on the wire leader required for kings. Using the same gear and bait in the same area will produce sailfish and dolphin, but you'll want to switch out your wire leaders and treble hooks for fluorocarbon and circle hooks. All these fish eat cigar minnows,

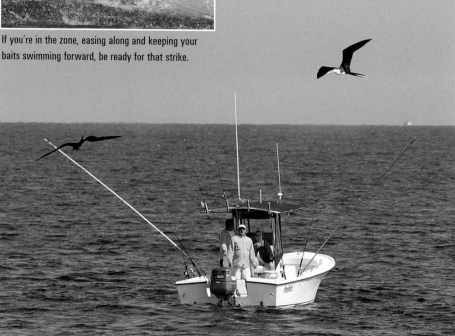

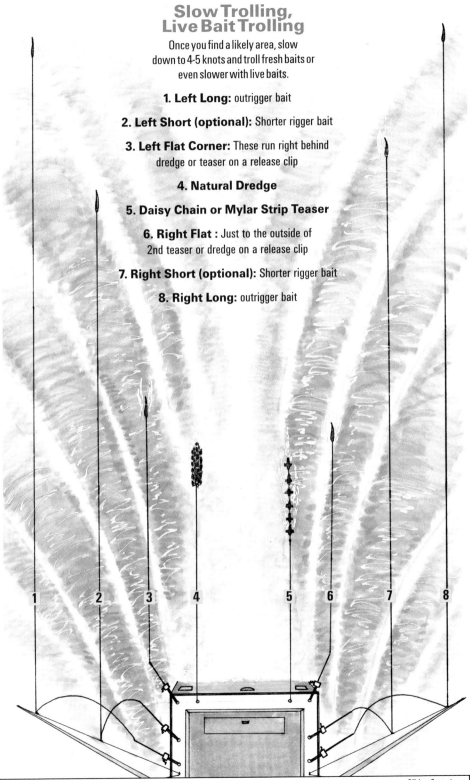

# Slow Trolling, Live Bait Trolling

Once you find a likely area, slow down to 4-5 knots and troll fresh baits or even slower with live baits.

**1. Left Long:** outrigger bait

**2. Left Short (optional):** Shorter rigger bait

**3. Left Flat Corner:** These run right behind dredge or teaser on a release clip

**4. Natural Dredge**

**5. Daisy Chain or Mylar Strip Teaser**

**6. Right Flat :** Just to the outside of 2nd teaser or dredge on a release clip

**7. Right Short (optional):** Shorter rigger bait

**8. Right Long:** outrigger bait

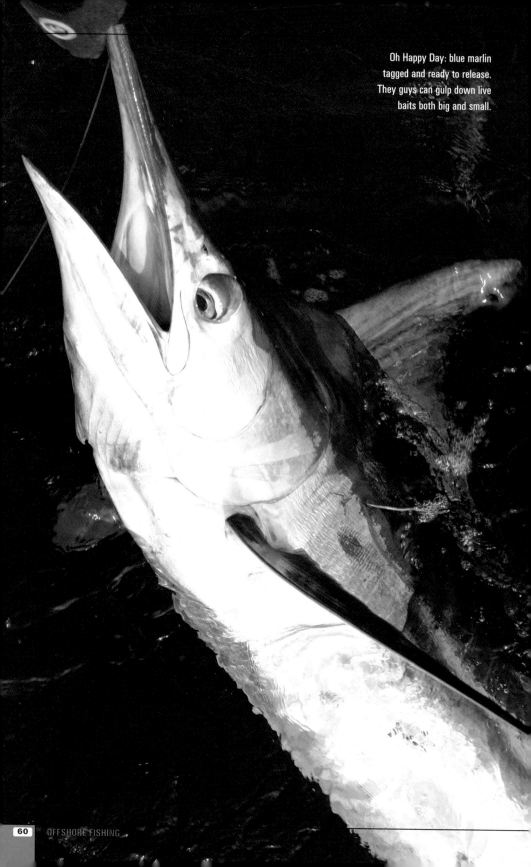

Oh Happy Day: blue marlin tagged and ready to release. They guys can gulp down live baits both big and small.

threadfins and blue runners, but how and where they are presented dictates the action.

When your depth and geography change, your equipment should too. Live-baiting with big baits and undersized gear is a recipe for disappointment. That 50- to 80-pound gear will serve you better in situations where the chance of hooking big tuna or marlin is much more likely. Bigger gear and bait necessitate using bigger leaders and hooks, too. That 120-pound fluorocarbon seems like overkill for coastal sailfish and probably is, but it's only a starting point for live-baiting in deeper blue water. Some captains will start out with heavier leaders such as 300-pound, and move to lighter leaders if the bite isn't happening. Others begin with light gear and rely on skill to land big fish on lighter gear. Match hook with bait: A 10-inch blue runner will look awkward with a 12/0 Jobu Big Game hook through his nose.

Slow-troll live baits when you know where the fish are. It's mostly done over wrecks, reefs, ledges and offshore structure such as oil rigs or buoys, because you can't travel far at low speed. It also works around weedlines, rips and temperature breaks: That fishy-looking weedline loaded with bait, with conditions right for a big bite, might produce with a live bait.

Once while fishing a Gulf billfish tournament, our crew was in this exact predicament. After several frustrating runs past a gorgeous weedline, we stopped and caught a dozen big blue runners and a 3-pound dolphin, using light tackle. We bridled the dolphin and a pair of blue runners onto three heavier rods. We sent the

dolphin out on the center rigger, while the pair of runners swam smartly from the outriggers. Seconds later, that unhappy dolphin was *deep* in the gullet of a 400-pound blue marlin.

Slow-trolling with lighter gear in shallow water means running five or six different baits: Two flatlines, two downrigger lines, a long center and a shotgun bait. Often the downrigger baits are ribbonfish. Sometimes we use a dead Spanish mackerel or cigar minnow. In contrast, live-baiting larger items like skipjack tuna, bonito, blackfin tuna or small dolphin will find you pulling only two to four lines— ideally two outrigger lines, a long center bait and a medium center bait.

It's important to remember that for any type of slow-trolling, mix up that bait spread when possible. Always try to use different bait species. The same goes for fishing way offshore—having a spread of small blackfin tuna is great, but if you mix in a medium-size hardtail with a blackfin and a skipjack, you're offering predators a clear choice of great baits.

Sometimes the one bait that is different from the rest gets crushed first. Mixing up bait *sizes* can mean the difference between fresh fish for dinner or a plate of rice and beans. **SB**

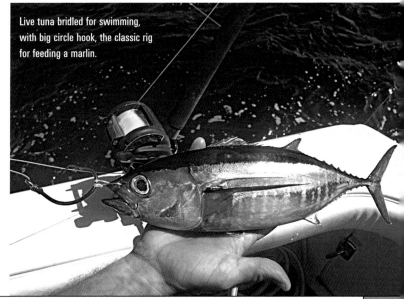

Live tuna bridled for swimming, with big circle hook, the classic rig for feeding a marlin.

# Kite Fishing

**K**ite fishing has its roots in Pacific tuna fishing, but is perhaps now most widely associated with the South Florida sailfish fleet. The technique allows you to fish live bait, dead bait and artificials while slow-trolling, drifting or at anchor. However, kites offer something that no other type of fishing

rods over and big blue marlin are hanging out under kites as you read this. So how does it work? The best way to describe a kite rig is to imagine a giant center rigger that you can actually position and run multiple lines from.

Fishing kites manufactured by AFTCO, Bob Lewis, SFE and others are designed specifically for presenting baits on top of the water. They are flown behind your boat if you are trolling slowly or anchored, and off to one side when drift fishing. Each is connected to a short, stubby specialized rod with just a couple of eyes, which allow you to reel in small swivels, like you would a wind-on

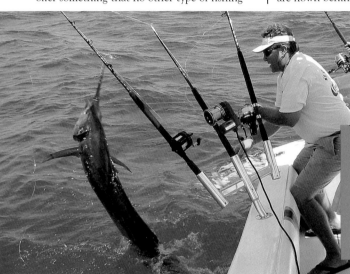

Angler leaders a sailfish at close range, just behind his kite reel and multiple setup. Drawing below shows various aspects of a two bait setup for one kite.

does: they allow you to present your baits to the fish with little or no terminal tackle in the water. The most exciting part of kite fishing is that you are forced to watch your baits closely, since they're dangling right on top of the water. You get to see almost every strike, and that's a good thing.

Kite fishing does take practice and it isn't recommended that you start off trying to run multiple kites right off the bat. With a little practice you can add another method of fishing that can differentiate you from the other boats nearby, and make your baits irresistible to passing predators.

What fish, you ask? The only fish attracted to kite baits are predators that feed near the surface. That would include all offshore game species. Serious offshore anglers are constantly learning and trying new things, including using kites. This means that kingfish pros are using kites and scoring big, tuna specialists are doubling

**See DVD for more kite fishing techniques.**

leader. They're powered by both manual or electric reels. The electrics make life a lot easier when trying to retrieve a kite when fish are jumping and the crew is suddenly animated. The kite reel's sole purpose is to reel the kite in and let it out. Manual reels are often older Penn reels retired from fishing. Keep in mind that a lot of adjustments are made during a day offshore. Spend the money and invest in an electric reel.

A common kite rig will consist of two release clips that are rigged onto either braided or Dacron line (recommended for strength and more diameter). The release pins are spaced at desired intervals, typically 50 to 100 feet. Each clip is designed to slide over the line, secured

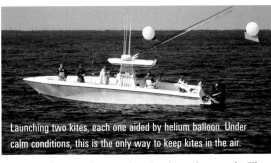

Launching two kites, each one aided by helium balloon. Under calm conditions, this is the only way to keep kites in the air.

by swivels spaced at the desired intervals. This means that adjusting the spacing for your clips will take a little more work, but they are reliable. Snap-on release clips are also available; they allow you to space your clips as desired, depending on sea conditions, boat traffic and how you want to fish specific baits.

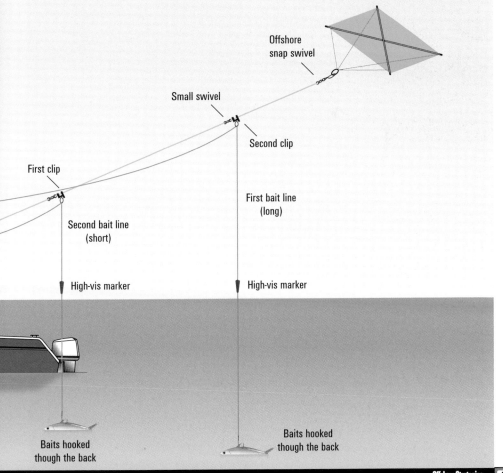

Offshore snap swivel

Small swivel

Second clip

First clip

First bait line (long)

Second bait line (short)

High-vis marker

High-vis marker

Baits hooked though the back

Baits hooked though the back

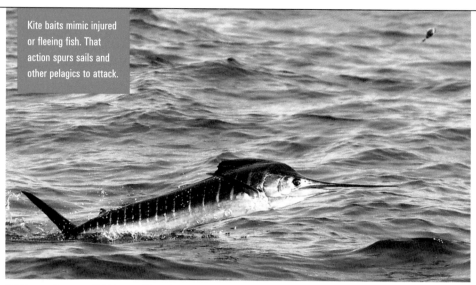

Kite baits mimic injured or fleeing fish. That action spurs sails and other pelagics to attack.

# Rigging Kite Baits

On location, speed and efficiency of rigging baits makes the difference between a caught fish and a lost fish. Practice the drill plenty, so that when you're among feeding sails, you'll be ready.

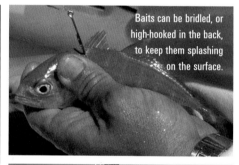

Baits can be bridled, or high-hooked in the back, to keep them splashing on the surface.

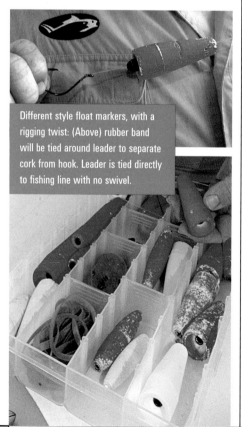

Different style float markers, with a rigging twist: (Above) rubber band will be tied around leader to separate cork from hook. Leader is tied directly to fishing line with no swivel.

This marker is rigged above a snap swivel, for ease of switching leaders and to prevent line twist.

# Getting Your Kite Airborne

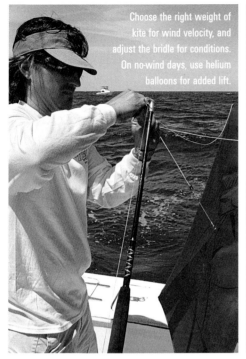

Choose the right weight of kite for wind velocity, and adjust the bridle for conditions. On no-wind days, use helium balloons for added lift.

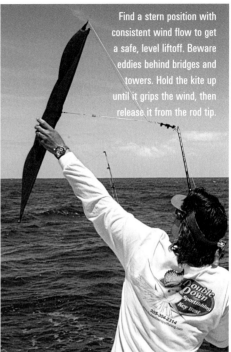

Find a stern position with consistent wind flow to get a safe, level liftoff. Beware eddies behind bridges and towers. Hold the kite up until it grips the wind, then release it from the rod tip.

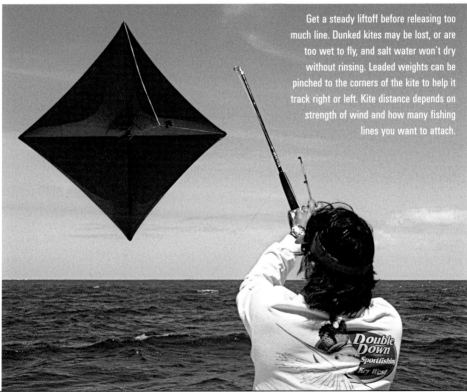

Get a steady liftoff before releasing too much line. Dunked kites may be lost, or are too wet to fly, and salt water won't dry without rinsing. Leaded weights can be pinched to the corners of the kite to help it track right or left. Kite distance depends on strength of wind and how many fishing lines you want to attach.

# Drift Fishing

When you think of drift-fishing, what comes to mind? Most anglers visualize drifting over a shallow, inshore flat, or perhaps within sight of the beach for sails or mackerel. But drift fishing can utilize different tackle in many different situations.

Why drift? It has a couple of unique advantages. First, it gives you the advantage of stealth; whether seeking sailfish, swordfish or spooky open water tuna, a quiet boat can make a real difference. High-stakes kingfish tournaments are commonly won by boats with their engines turned off. Second, and maybe most welcomed, it doesn't burn gas. With gas prices what they are these days, no one is complaining about turning the engines off. Drifting for only four hours of a 10-hour fishing day can really save you some spare change; enough for steak dinners and cocktails at the end of the day, with change to spare.

Step one in drift-fishing is figuring out your drift, relative to the area preferred. If trying to fish a reefline and the current is carrying you parallel to it, just set up on the upcurrent end, put your baits out and cut the engines. If it's a general area you're fishing, say for swords in some canyon, you might drift for hours in a weak current. In a strong current, however, such as the Gulf Stream, a good drift might consist of only 30 minutes before repositioning for another drift.

If you're planning on drift fishing, regardless of depth, a sea anchor is a nice addition. It can be attached amidships to turn a center console beam to the sea for kite fishing or fishing multiple lines off the sides. Attached to the bow of a sportfisher, it keeps the boat out of the trough in a rough sea and your lines fished cleanly off the back of the boat. Center consoles are ideal drift boats because of their 360-degree fishability. You can fish kite baits off the downwind side, flatlines off the upwind side and a line or two staggered almost straight down in the water column.

Drifting live or dead baits is really your choice, but staggering your baits throughout the water column allows you to effectively work more of the water column than just kite fishing baits and flatlines alone. You don't need to use downriggers to fish the depths, though you can as long as you monitor your baits to keep them out of the cable. The easiest way is to simply attach sinkers of different weights and lowering your lines at varied intervals.

Drifting is another way of solving the same problem that everyone else is trying to solve, locating fish and getting them to bite. It can be ultra-effective given the right situation because of its multi-dimensional approach. Live baits, dead baits and even artificials can be fished using this method and you can cover a lot of geography and the water column as well. No wonder it's so popular; it produces fish, often when other methods don't.

A deep line is just the ticket when sailfish aren't cooperating on the surface. For example, on a calm summer day when nothing seems to

## Balloon Your Surface Baits

Another option for surface baits is to simply rig a balloon above a live bait and sling it out there. The balloon will pop when a predator hits, and will remain on the line if properly tied. Sturdy baitfish can pull balloons for a good while before getting tired, and their whereabouts are never in doubt.

**See DVD for more on balloon rigs.**

be happening, deep baits have saved many trips. Deploy subsurface baits with various swivel rigs and downriggers. The only problem with swivel rigs is that the lead remains attached and when a hooked fish jumps, will swing back and forth, perhaps working the hook loose. With downriggers, a live bait may swim around the cable. A breakaway egg sinker is best, by using a short piece of number 32 or 64 rubber band. Pull a loop of leader, roughly 10 feet from the bait, through one end of the sinker. Put the rubber band through the loop of leader and pull both ends of mono loop back into the center of the egg sinker. By pulling the doubled leader and the rubber band into the lead,

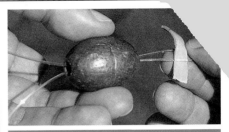

Breakaway egg sinker rigged with rubber band pops free during fight with sailfish.

the snug fit will keep the lead in place on the leader. Any strain on both ends of the leader coming out of the lead will pull the rubber band through and release the sinker. You are then free to fight the fish with the outcome unaffected by additional weight.

**Center consoles are ideal drift boats because of their 360-degree fishability.**

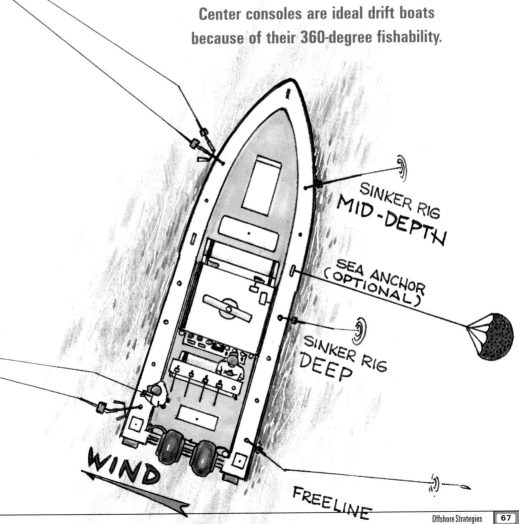

SINKER RIG MID-DEPTH

SEA ANCHOR (OPTIONAL)

SINKER RIG DEEP

WIND

FREELINE

# riggers and Planers

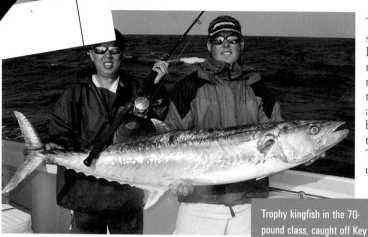

Two live baits at the same depth can cross lines and make a real mess. So use a dead ribbonfish on one of them. Actually, I always put a dead ribbonfish down first on the deeper 'rigger. That really worked for us last year."

If Ron doesn't get a strike within 30 minutes, it's time to change depth. "I'll move a downrigger ball up or down 5 to 10 feet, change it up," he says. "Kingfish might be holding in a thermocline and don't want to leave their comfort zone. We also get a lot of strikes while changing depth. You see that a lot just while changing baits, too. That different vertical movement triggers strikes. So don't be afraid to constantly change. For some reason we

Trophy kingfish in the 70-pound class, caught off Key West during winter with Capt. Bill Delph, at right.

Today you seldom see a serious kingfish boat without downriggers. Tournament veteran pro Ron Mitchell prefers mono instead of cable on his, because if a big fish wraps it, you won't lose the fish—just the "cannonball." A fast retrieving electric downrigger will bring it up automatically, helping clear the water of obstructions before a big fish can cause mischief.

"If you don't run at least one downrigger, you're only fishing about 10 percent of the water column," Ron says. "I run two. You need to get the baits down. My three biggest kings last year came from downriggers. Our biggest fish was in the Keys, and it hit 90 feet down with the bottom at 100 feet. We typically keep a bait close to bottom like that, with the second downrigger maybe 20 feet below the surface. If kings that day are 20 feet below the surface, we'll set both downriggers at that depth, but with only one live bait. Why?

## Don't be afraid to change your depths while trolling.

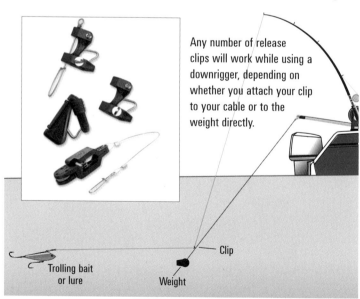

Any number of release clips will work while using a downrigger, depending on whether you attach your clip to your cable or to the weight directly.

Clip

Trolling bait or lure

Weight

**See DVD for more on fishing the water column.**

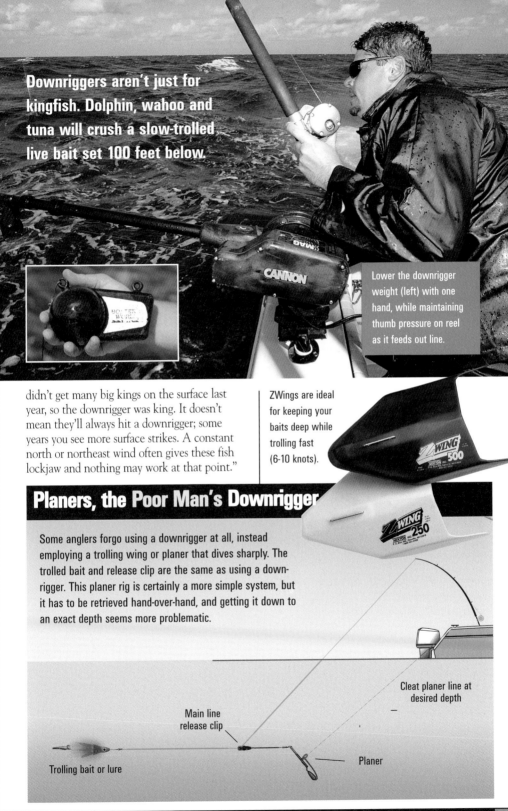

Downriggers aren't just for kingfish. Dolphin, wahoo and tuna will crush a slow-trolled live bait set 100 feet below.

Lower the downrigger weight (left) with one hand, while maintaining thumb pressure on reel as it feeds out line.

didn't get many big kings on the surface last year, so the downrigger was king. It doesn't mean they'll always hit a downrigger; some years you see more surface strikes. A constant north or northeast wind often gives these fish lockjaw and nothing may work at that point."

ZWings are ideal for keeping your baits deep while trolling fast (6-10 knots).

## Planers, the Poor Man's Downrigger

Some anglers forgo using a downrigger at all, instead employing a trolling wing or planer that dives sharply. The trolled bait and release clip are the same as using a downrigger. This planer rig is certainly a more simple system, but it has to be retrieved hand-over-hand, and getting it down to an exact depth seems more problematic.

Cleat planer line at desired depth

Main line release clip

Trolling bait or lure

Planer

# Reading the Water

Reading the water is probably the most critical item in offshore fishing. Anyone can read a satellite printout and figure out where the best temperature breaks and weedlines are. Anglers can also spot oil rigs up to 12 miles away, and tie up or troll. Wrecks and canyons won't move, either. However, a captain who can read the water is someone who consistently catches more fish. It isn't just about water clarity and color, but processing information from your electronics, seabirds in the sky, signs of marine life. Correctly reading the water means detecting signs of fish life that other fishermen may be completely unaware of.

Being first to spot a choice weedline is great, but that doesn't mean you'll catch fish there; it only means you'll get the first shot. Elsewhere, that innocuous-looking water slick might not seem like much, but a pod of baitfish below, spotted on the depthfinder, might just produce the marlin of a lifetime. Jumping or feeding pelagic fish on the horizon might also be missed, if your crew doesn't keep a sharp lookout.

**There's nothing more important in offshore fishing than being able to interpret water conditions.**

Two sailfish, part of a wolfpack heading south in the Gulf Stream off Southeast Florida. Run into one of these packs, and you can find action like you've never dreamed of.

# Spotting Fish is the Difference

I can't tell you the number of times when a sharp lookout has made the difference on a fishing trip.

Reading the water is critical to offshore fishing. While several services and web sites can provide satellite imagery, sea surface temperatures (SST), altimetry and chlorophyll

**Good visibility can easily make the difference in finding that one detail that can make your trip.**

should keep your eyes peeled. For anglers unused to that nautical term, it means removing any covering of the eyes that might impede vision. The phrase dates back to around 1850.

Modern polarized sunglasses are essential in detecting and deciphering details. Not only do they enhance vision by cutting down on glare, they prevent sun damage and reduce eye fatigue. Good visibility can easily make the difference in finding that one detail that can make your trip, or going "O-Fer" for the day. Anglers may claim amber or grey lenses are best, while others prefer mirrored or one brand versus another. Situations and conditions might make one better than the other, but they're all improvements over the naked eye. Here's a tip: That old scratched-up pair should be hidden away somewhere in your gear bag or camera case so that when you drop yours or lose them—and you will—you'll have a spare.

So what is meant by "reading the water?" It means constantly scanning the horizon and watching the electronics. It means keeping lookout 360 degrees around the boat to the horizon for subtle and not-so-subtle changes in the water color or temperature, and for floating debris, rips, current pushes and weedlines in the distance. It may sound elementary, but it's also important to watch for bait and fish jumping, or bird activity.

Look through the eyes of this angler and you'll see the difference in wearing a good pair of sunglasses. Cutting through glare is *vital* when hunting surface fish.

(green water) content, there is nothing like a pair of eyes scanning the horizon. No subscriber service out there can spot a free-jumping blue marlin or locate a floating tree 500 yards off your port side. The additional height of a tower provides superior visibility over an express boat or center console deck, but regardless of the boat, you and the crew

A few years back, I joined some friends out of Orange Beach, Alabama on a trip. We were making an offshore run of about 70 miles, but we pulled up about 10 miles short of our designated starting point when we saw a big hole

Buck Hall scans the water near Pensacola for early-season cobia. Height and sunglasses are the ticket here.

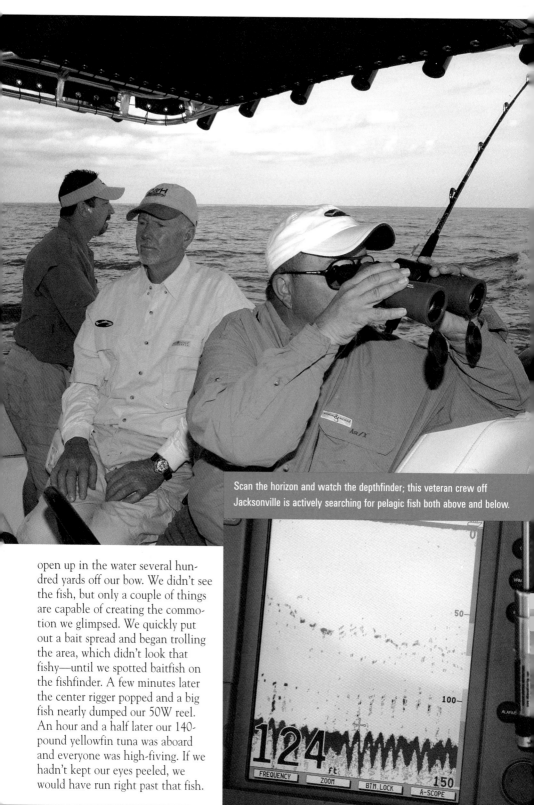

Scan the horizon and watch the depthfinder; this veteran crew off Jacksonville is actively searching for pelagic fish both above and below.

open up in the water several hundred yards off our bow. We didn't see the fish, but only a couple of things are capable of creating the commotion we glimpsed. We quickly put out a bait spread and began trolling the area, which didn't look that fishy—until we spotted baitfish on the fishfinder. A few minutes later the center rigger popped and a big fish nearly dumped our 50W reel. An hour and a half later our 140-pound yellowfin tuna was aboard and everyone was high-fiving. If we hadn't kept our eyes peeled, we would have run right past that fish.

**Boats are successful because of their teamwork and their teams get the credit, so everyone is responsible for watching the entire horizon.**

Generally the captain's job is to observe the water in front of the boat, watch the bait spread and study the bottom machine for bait schools and predator fish below. He's responsible for the entire operation, but he needs help in order for your team to be a success. You won't hear successful boats claiming that so-and-so caught a blue marlin or huge kingfish. It was a team effort. Boats are successful because of their teamwork and their teams get the credit. It takes a crew to do the job successfully, and that means everyone is responsible for watching the entire horizon. Many times a fish will run through the spread and not eat until you drop the lure back and hit him on the head with it or "try to take it away from him." If you're not watching the bait spread— maybe watching television, napping or soaking up air conditioning instead— you'll miss some fish. A second set of eyes in the tower or at the helm is generally welcome and if you see something productive before he does, you can remind the captain of that, next time he barks or bellows about one of the lines being grassed up.

First trip out into blue water, I had plenty of the usual questions. Then, a good one: "What am I looking for, exactly?" Our taciturn captain simply replied, "You'll know it when you see it." And he was right, look for anything different. We rolled up on a weedline about an hour later, set up on the clean side of the grass and continued trolling, catching several nice dolphin.

That seems pretty simple: Find a weedline or floating structure and troll it, but they aren't always out there and sometimes they just don't produce fish. (Oil rigs in the Gulf, of course, are more easily found and attract fish often for many years, until dismantled or moved.) You can't always count on finding weeds, pushes, tidelines or floating structure, since it all moves. That makes it all the more important to stay observant constantly.

A floating pallet, large patch of weed or a steep underwater ledge is easy to categorize as an offshore beacon that should be holding fish. However, defining and spotting water conditions such as rips, pushes and slicks is a little trickier.

A brief flurry on the horizon might be missed, without the crew paying attention.

# Slicks

Slicks on the water can be very productive and at the same time, nondescript-looking offshore anomalies. Some folks drive right past and never give them a second look. Slicks can be caused by other boats, algae blooms or other factors. Sometimes they're caused by bait schools. Whether that bait is milling around or being chased by predators,

just the fact there is bait in the area is a good sign; bigger fish are likely in the area. Even billfish. One friend caught her first white marlin, just after we turned off an ill-formed weedline to follow a little slick that looked promising. She's now a big fan of bait slicks.

Slicks at first may seem more impressive than they really are. Often a mix of sunlight and clouds will catch the water at the right angle and you'll swear the mother of all weedlines is waiting only a quarter mile off the port bow. The problem is that it remains at the same distance. A well-defined slick may be nothing more than a calm patch of water with wind moving around it, perhaps after a shower. In calm water, these haunts may contain submerged sargassum weed or dead current pushes that have expired, but may often still hold fish. As sargassum dies off or gets old, it submerges and as current pushes give out, the foam and flotsam they accumulated spread out. These slicks in open water may just be the fishiest things around. Compared to well-defined rips, they aren't much to look at, admittedly. Boat captains much prefer first shot at a floating log or cobalt rip, but investigating these slicks when other boat crews turn up their noses can make a difference. It's certainly enough difference for a seasoned captain to investigate.

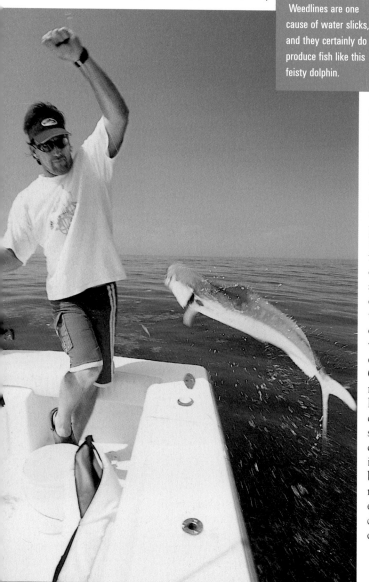

Weedlines are one cause of water slicks, and they certainly do produce fish like this feisty dolphin.

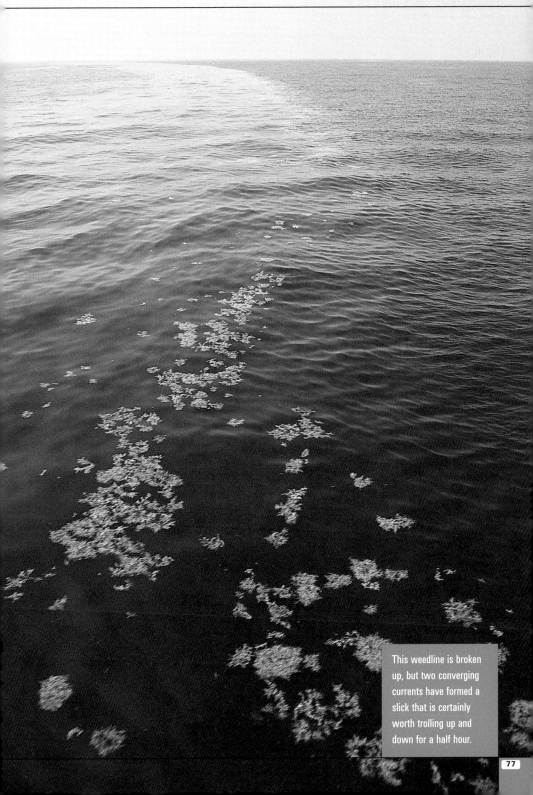

This weedline is broken up, but two converging currents have formed a slick that is certainly worth trolling up and down for a half hour.

# Rips/Pushes

**F**oamy pushes and rips can show up fast and appear out of nowhere; but if you don't know what to look for, you can go right past them. They may not have any grass or debris in them and might simply appear as disturbed areas of water without a color change, where a current is pushing in a different direction. Wave heights on both sides of the rip may well be different—sometimes two feet or more, if one of the currents is running straight into a decent wind. They may appear as cloudy water meeting clean, or muddy river water clashing with blue water. They may be small or go on for miles. One thing for sure, they hold fish. And the key to finding them is keeping a sharp lookout.

In the DeSoto Canyon off Pensacola one summer, we spotted something irregular and white in the distance near the end of a two-day tournament. It easily caught our eye and we turned the boat. It was a current push; we watched it form up even better, as we trolled up and down that little 1/2-mile push, with only one mystery bite. Our day was fast ending and we didn't have time for this one to form. However, in only 30 minutes it went from a weak little line of foam to a considerable push that had moved almost a 1/2-mile north. It began to collect weeds, debris and it would only be a matter of time before predator fish began to accumulate. It was a shame we couldn't give it more time, but the point here is that water conditions can change rapidly offshore and you have to pay attention.

A push or rip is caused when two opposing surface currents collide. It often shows up as a disturbance of water rippling on the surface in either a small area or running along for some distance. When two surface currents collide, the colder water sinks and pushes warm water to the surface, bringing with it plankton that tiny baitfish thrive on. Larger baitfish and predators arrive and so goes the cycle of life on the ocean. If you're cruising the Gulf of Mexico, these currents are generally not as strong or as wide-reaching as the Gulf Stream in the Atlantic, so they require more eye work to spot. The Gulf Stream is one of the strongest ocean currents known and can be up to 30

**Water conditions can change rapidly offshore and you have to pay close attention.**

COLDER SURFACE WATERS SINK CAUSING WARMER WATER TO RISE AND FORM RIPS OR PUSHES...

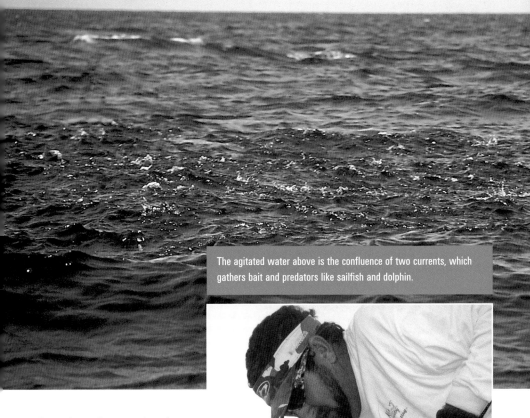

The agitated water above is the confluence of two currents, which gathers bait and predators like sailfish and dolphin.

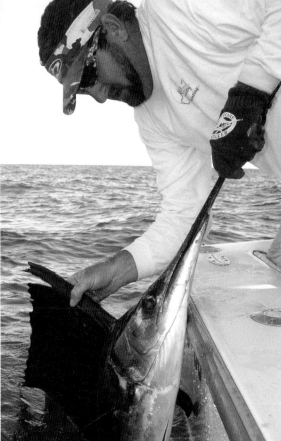

miles wide, pushing north at five knots on a good day. That's a blistering pace for a current. While most surface currents are caused by wind, temperature changes and differences in salinity can also cause these currents. Whenever you encounter a push or rip or current offshore, it pays to keep your eyes on your temperature gauge and bottom machine to indicate any changes that may be noteworthy.

If a push is confined to a relatively small area, keep a sharp eye on your bottom machine. You may mark a ledge or structure, even a wreck below, deflecting bottom currents to the surface, creating an upwelling. If it does run on for some distance, it's likely an opposing current or temperature break, both of which should make your fish alarm go off.

# Debris

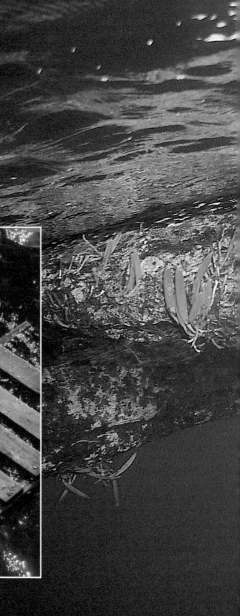

**G**ive a man a fish and he'll eat for a day. Find a good piece of floating debris off-shore, and there's a good chance he'll be eating fish for a week. Most debris found floating offshore is associated with dolphin, wahoo and tuna, but even billfish hang around this stuff. Anything, even a 5-gallon bucket floating offshore, will at some point hold an entire ecosystem of fish beneath it. And the

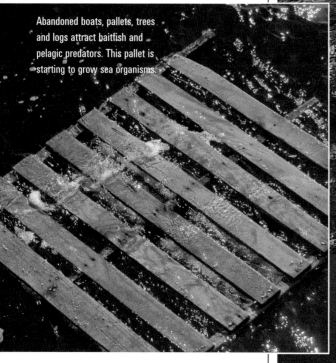

Abandoned boats, pallets, trees and logs attract baitfish and pelagic predators. This pallet is starting to grow sea organisms.

key isn't how big the debris is, but how long it has been in the water. Large pieces of debris that are relatively clean may not produce much, as they haven't had enough time to attract baitfish and larger pelagic fish. But a slimy old cooler lid, floating offshore for weeks or months, has put many a smile on sunburned faces. How about an entire tree, complete with marine growth, with clouds of different bait-fish? Imagine the predators lurking under that. As the tree slowly drifts inshore into green water, those bluewater, pelagic fish are

## The key isn't how big the debris is, bu

replaced by coastal pelagics, mostly tripletail and cobia.

Debris offshore can take the form of almost anything. Discarded tow ropes left floating can spell disaster if they get caught in your running gear (another reason to keep a sharp lookout).

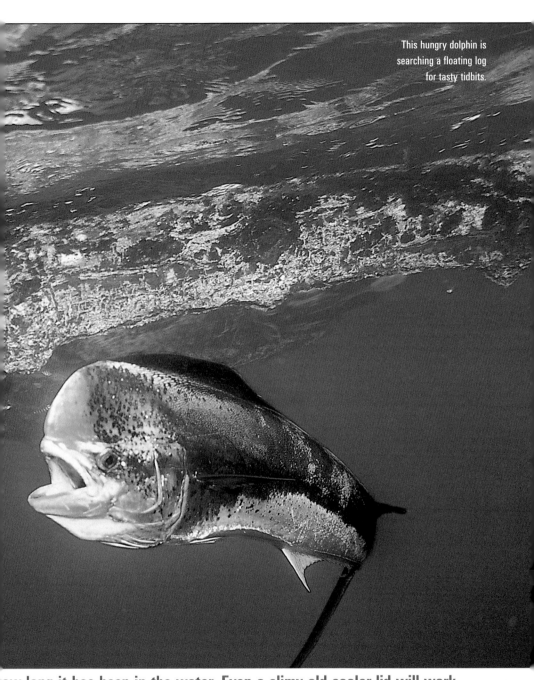

This hungry dolphin is searching a floating log for tasty tidbits.

**ow long it has been in the water. Even a slimy old cooler lid will work.**

However, found floating alone or in a clump of sargassum, big ropes are havens for fish.

After hurricanes you'll find all sorts of debris floating offshore, including air compressors, refrigerators, doors, trees, demolished boats, planks, even heavy dock pilings. Sometimes there is too much out there to navigate safely at high speed, and certainly not after dark. (That's a good reason why overnight offshore trips are made at slow speed, perhaps 10 knots, arriving at sunrise). Ask any bluewater captain and he'll confirm that more fish are caught

**We watched in envy as a sportfisher on the other side of the debris had three 80-wide reels double over. They had found the bluefin tuna.**

around floating wood than any item offshore.

While fishing an iffy weedline offshore, we spotted a wooden pallet just ahead and got pretty excited with all the panicky baitfish skipping around it. Our anticipation turned into awe, as the water exploded with a 500-pound bluefin tuna taking flight. That tuna wasn't alone. Wahoo in the 20- to 25-pound range also jumped repeatedly, trying to avoid

this monster's gaping jaws. Our port rigger snapped tight as we passed the ruckus and while we hoped it was the big bluefin, it was only a double-header of gaffer-size wahoo. We watched in envy though, as a sportfisher on the other side of the debris had three 80W reels double over. They had found tuna and several hours later did manage to bring one bluefin to the boat. So, never discount a floating pallet as only attractive to dolphin.

If you encounter large debris, such as a capsized boat or something that can really damage a passing vessel, by all means fish it to the point of exhaustion, but call the Coast Guard. They may deem it appropriate to add to their Notice To Mariners list of navigational hazards. They'll alert your friends, as well. You wouldn't want another vessel plowing into it after dark, and cause a potential sinking.

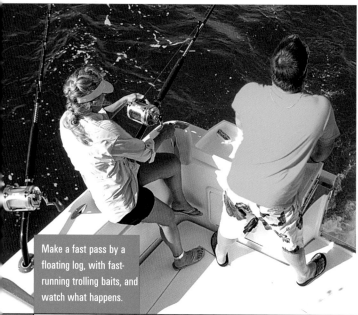

Make a fast pass by a floating log, with fast-running trolling baits, and watch what happens.

Tripletail and dolphin are the most prominent species to take up temporary residence beneath floating debris.

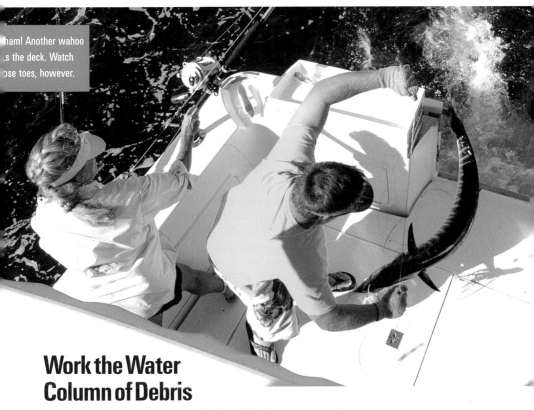

ham! Another wahoo s the deck. Watch ose toes, however.

## Work the Water Column of Debris

A key thing to remember with any floating debris is to cover the water column. Trolling several passes around debris is important, approaching from different angles, but don't forget to probe deeper into the water column. If you don't have a mixture of subsurface baits in the spread already, put out a lipped, diving plug, wahoo bomb or jethead lure and give it a pass or two. If you have a downrigger, an Ilander/ballyhoo combination runs perfectly down in the column. If you don't have a downrigger or planer, stop a couple hundred feet from the debris and let your lures sink. This means letting them out an extra 50 to 100 feet so they can get down in the column, but it's worth a shot. SB

# Weedlines

Perhaps the easiest thing to identify off-shore is a solid, floating weedline. Sargassum weed is colored a golden hue and it really is a treasure to find, an entire ecosystem of offshore fish. Small, ill-defined weed in patchy, scattered lines or even old and washed out lines are all welcome to an offshore angler who just crossed miles of empty water.

The most welcome sight of all is a well-formed weedline, with clean, cobalt water on one side and dirty green on the other. These are referred to as "mega-rips." There are certain days when the planets line up just right; you roll up on a weedline like this and no other boats are in sight. The critical success factor here isn't just the grass, (though it's essential), it's the movement of the line.

Captain Myles Colley skippers the *Dataman*, a 68-foot custom sportfisher out of Pensacola. "The best weedlines are those where muddy

water meets clean, with a nice line of grass," he says, "but the real key is that it's moving. In the Gulf, lines moving north seem to produce better, but any movement is welcome."

The *Dataman* crew and owner Tim Falzone are a well respected billfishing team; with them we tagged two blue marlin and caught several yellowfin tuna. What impressed me most was their earnestness when pursuing fish. For example, one often sees dolphin along a

## Trolling Weedlines

Weedlines form where currents converge and develop into their own little ecosystem when bait-fish find it. These same weedlines are coveted by bluewater fishermen the world over, who know predator fish are usually nearby. Most fishermen are content to troll down the clean side of a weed-line, staying just far enough from the line to keep the rigger bait from getting "grassed up" with hook-fouling sargassum weed. Remaining snug against that weedline will cause you to miss a lot

Troll the weedlines for a few minutes, and you often have to clean baits of any snagged weeds. This angler keeps a close watch on his baits while the captain parallels the weed-line in cleaner water.

weedline, ducking away from the bait spread and sinking out of sight. A nice dolphin pulled the same trick on us; instead of giving up, Colley pulled the boat off the weedline for a few minutes and made a wide circle headed in the same direction the fish was swimming. Rigging a pitch bait, we cruised down the line and waited for the mahi to pop up again. He showed up minutes later, and ate a live pinfish.

Whether you're fishing a mega-rip, a weak and sketchy weedline, a floating piece of debris or a foamy push, you can employ many different tactics to catch fish. Remember, something that works in one fishery may work in another. Don't hesitate to try something new. Tossing dolphin a frantic pinfish sounds very similar to stalking cobia along the beach. You can troll diving plugs along a slick in open water, too— as well as a piece of debris or a weedline. Mix it up and watch your catch rate increase.

of fish that could be hanging off at a short distance. Many predators don't stay beneath the grass; they don't need it for protection. They're cruising up and down and attacking little critters in the weedline. The most experienced captains often venture several hundred yards from the lines, however.

A well-defined weedline usually has one side that is cleaner—meaning less scattered grass—than the other. Once you've fished the clean side, bite the bullet and make sure you have folks ready to clear weed from lines, and get over on the other side. Unless the water is really dirty or formed along a strong temperature break, you can bet your favorite lure there's a fish lurking on the other side.

Color changes and rips might not have any weeds at all. They might be a foamy "push" where cloudy water meets clean blue water. Or they can be as dramatic as a "river rip" off East Louisiana, where brown, muddy water hits cobalt blue. Regardless of makeup, these current rips can be fished similar to weedlines. Whether you troll up and down or a zigzag pattern, spend time around these lines. That blue marlin holding 200 yards off the rip won't get a chance at your baits if you camp on top of it.

# Water Conditions

Every time I hear the question, "Where's the blue water?" I wince. Not because I don't want to know where clean blue water is, but because it may be irrelevant. Regardless of water color, you can still catch fish. On some days the hot bite is inshore, in an area that doesn't fit the definition of offshore water at all. Many anglers have spent

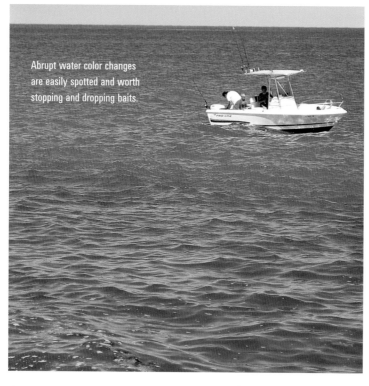

Abrupt water-color changes are easily spotted and worth stopping and dropping baits.

their days trolling beautiful water, only to hear their buddies back inshore yelling about a banner day in "dirty water."

For example, Steve Kaiser and Wally Coupe fish a 23-foot center console called *Venture*. These guys are in their mid-70s and early 80s, respectively. One can only hope to fish as long and successfully as these two have, but their story is relevant here. They have a 23-foot

boat that has to travel roughly 30 miles to deep enough water to have a good shot at finding billfish. Their range is limited, so they have to fish those depths, regardless of what the water quality looks like. Picking up and running 50 miles to a hot bite isn't an option, so they simply "fish small." They concentrate on their patch of water, work it intensely and stay alert for any signs that might indicate fish. When your options are limited, you make the most of it. That means paying close attention to the water.

Fishing small also applies to trolling in a pack of other boats. When confronted with the certainty of crowded fishing, often during tournaments, watch for key items others haven't noticed. A small murky push only 200 yards long is hard to spot in an ocean of water. The same goes for a temperature break along the beach or a big school of bait—but if you can find it when others haven't, it can be a real trip-maker.

When heading offshore, it's a big plus if you have an idea what the water looks like there, before arriving. It's great to put a text-book offshore trip together, but in reality we go fishing when the weekend arrives, when Mother Nature allows or when we can scrape up a crew. You can only fish the waters within reach, but that doesn't mean you can't get information before leaving the dock. Phone numbers of favorite oil rigs way offshore certainly help, if you fish the western Gulf of Mexico, but fee-based services are more practical for most anglers.

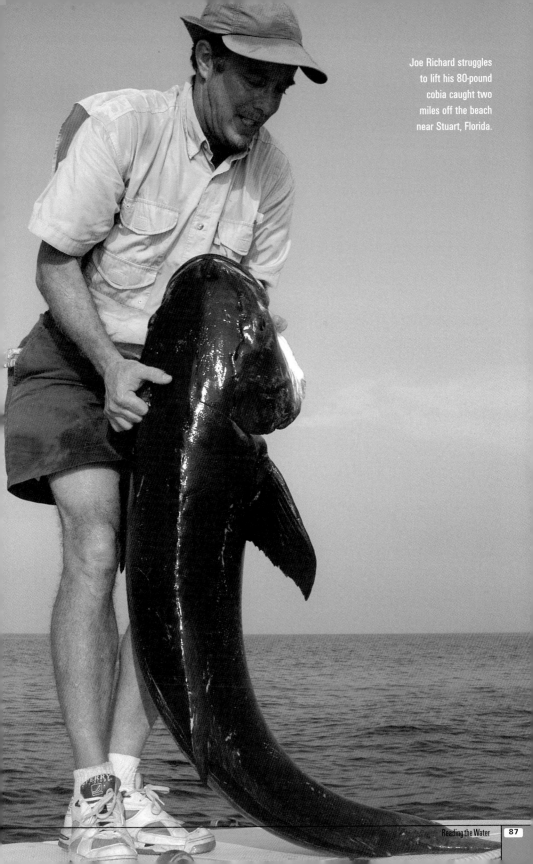

Joe Richard struggles to lift his 80-pound cobia caught two miles off the beach near Stuart, Florida.

# The Eyes Have It

**A temperature map providing longitude and latitude is great.**

There are several fee-based services on the market providing detailed information about water color, currents, sea surface temperature, altimetry and salinity. These sites are forecasting services, so there is no guarantee that you'll find fish while using them. However, they do interpret available data. That interpretation allows you to form intelligent guesses on which areas to target, and hopefully saves you fuel by skipping what is likely unproductive stretches of water.

Roffer's Ocean Fishing Forecasting

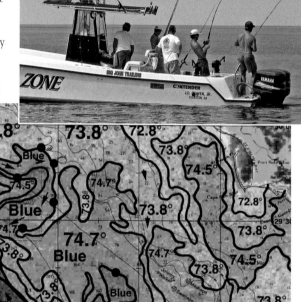

Kingfish crew hooked up. If this is a tournament, you can bet they studied offshore infrared maps before leaving the dock.

puter experts and fishermen to interpret the data and provide you with their forecast on where the fish should be. They put this infor-

Service was founded in 1973 by Dr. Mitchell Roffer. ROFFS, as it is referred to, uses satellite imagery to determine sea surface temperature, water color, current direction and current boundaries, which it then overlays onto a topographic map. This information alone is incredibly valuable for offshore anglers, who can also use it to rule out some areas, saving time and fuel. What sets ROFFS apart from the other products is their analysis of the information. They employ oceanographers, com-

mation into "hot spots," with latitude and longitude to give you their best bets to find the fish. For over 30 years, they have been a service to both recreational and commercial fishing interests. They're a familiar product to bluewater anglers.

Newer in the game is Hilton's Offshore Navigator. Tom Hilton started with printed atlases that covered the Gulf of Mexico. Since then he's gone electronic with a subscription-based service that allows anglers to make their

own interpretations of the data. There is a tutorial and an explanation of what each element means to fishing and how they affect fish, but ultimately you get to do the forecasting yourself. Information on altimetry (sea surface height that shows upwelling and downwelling currents), sea surface temperature, salinity and chlorophyll (water color) is provided, and you can overlay these products with provided Hilton's Waypoints. A unique feature of the service (since it is interactive) is the ability to model over time and animate the imagery. For example, you can select the best seven Sea Service Temperature images over the last week, (several are taken a day) and animate them to see the tendencies over the past week.

Do your homework before leaving the house. You don't want to wander around offshore when action is just over the horizon.

Since Hilton got started in the Gulf of Mexico, it's natural there is a lot of focus on fishing oil rigs. To that end, a list of fixed platforms and floating, drilling rigs in deeper water is provided as well. His service has expanded to cover the entire East Coast, Mexico and several regions of Central and South America.

There are several other fee-based services on the market, so do your research. Once completing that research, determine which product is best suited to your needs.

There are many sites that provide the basic SST, altimetry and chlorophyll information for the area you fish. This information is publicly available, but it will only provide you with raw data. They don't include a forecasting element, topographic overlay or interpretation. You may decide that is unnecessary or not in your budget. The information is out there on the Internet, and only continues to expand.

Reading the water sounds simple enough and it can be. But learning to read the water and interpret the information gleaned from websites and fee services

takes some practice. Keeping a log of the information will help you in the future, but don't forget your past, either. Tom Hilton shared a story of a charterboat client of his, where a captain reviewed his logbook for the past 18 months. He picked out the location and dates for 25 billfish that were caught. When he searched the archived data on his catches, he realized that 23 of the fish were caught in areas where the altimetry measured -10 to -20. Only two were caught outside of these areas. All were caught in water temperatures ranging from 78 to 87 degrees. You can bet that captain will narrow his focus a little in the future, on where to catch his billfish. S B

## Fee Based Services

Roffers http://roffs.com/
Hiltons Realtime Navigator http://www.realtime-navigator.com/

## Free Sites

http://www.nws.noaa.gov/om/marine/home.htm
http://www.wunderground.com/MAR/
http://marine.rutgers.edu/mrs/
http://coastal.er.usgs.gov/
http://imars.marine.usf.edu/

# Structure

Structure is crucial to bluewater fishing, because the ocean floor is mostly empty sand or mud. On this marine desert, any structure protruding above bottom plays a significant role in concentrating fish. Even in deep water, the sea floor plays a direct role in whether or not fish will concentrate in the area. Several types of structures are relevant to offshore fishing, from bottom wrecks and natural reefs, to offshore superstructures like oil and natural gas platforms, deepwater ledges and canyons.

Trolling is the norm, when targeting pelagic fish around any structure above or below the water. However, there are situations where you can use different strategies such as kite fishing, drifting, mooring or anchoring, all aimed at fish congregating around structure.

For example, kingfish tournaments are often won by boats anchored over natural live bottom or wrecks, patiently chumming and waiting. Tuna "chunking" may be done by anchoring as well, near a canyon's edge or above an underwater "hump."

A variety of lines can be set out while at anchor, including kites, floats and bottom lines. Sailfish, blackfin tuna, wahoo and dolphin are commonly caught this way in South Florida. The same goes for drift-fishing an appealing stretch of bottom to cover more ground, often while using a drift parachute. As for mooring, countless boats in the Gulf of Mexico spend their days and shorten their fuel bills by simply tying up to one of thousands of platforms.

**Pelagic fish simply love underwater structures, from oil rigs to canyons.**

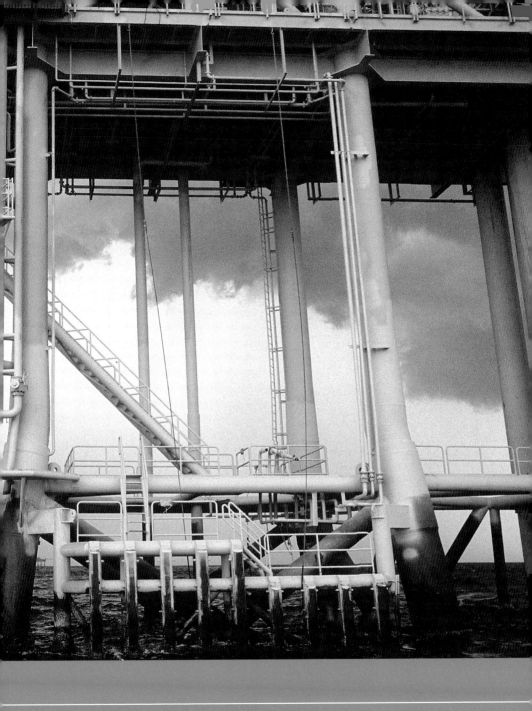

Production platforms in the Gulf offer fish
a break in the current, food and shelter.
Boat crews find a destination visible 12
miles away in good weather, concentrated
fish, bait, shade, some shelter and even
solid footing in an emergency.

# Wrecks and Reefs

How you approach fishing offshore wrecks and reefs will depend largely on the size and makeup of that structure. If you're fishing relatively smaller structures such as barges, Army tanks, concrete culverts, or small areas of natural bottom, then you would fish it differently by camping above it. Fishing an expansive area of natural bottom would require more exploring by drift-fishing or trolling.

The big difference is how much time you should put into fishing one spot. The aircraft carrier *USS Oriskany* was sunk 22 miles off Pensacola, Florida in about 220 feet of water. It has been called the world's biggest artificial reef deliberately sunk for fish habitat. The *Oriskany* is huge, big enough to create an upwelling in the current, and you could easily spend an entire day fishing the site. In terms of relative size, however, it's a small structure

The aircraft carrier *U.S.S. Oriskany* was sunk off Pensacola, the biggest artificial reef deliberately sunk in the world.

when you compare it to some areas of live bottom. Or deepwater oil rigs with a dozen buoys, each set a quarter mile away around the horizon. Or ledges and ridges that run along the 100-fathom curve and even beyond.

Most anglers won't sit on a small spot all day, and they probably shouldn't. Many prefer instead to "run and gun," visiting several spots. For that reason, slow drifting and trolling are more popular among kingfish anglers and the sailfish fleet. Anchoring would rank as third most popular option.

Kingfish tournament pro Capt. Joe Winslow heads up the team *Hooligan* out of North Carolina. Joe's success on the tournament circuit may be more notable for the different ways he catches his fish than anything else.

The *Hooligan* team takes chances and tries different tricks, while other crews just keep trolling the same spots the same way. "We've made a career out of taking chances on spontaneous opportunities," Winslow reveals. This might mean stopping on a bait school or even investigating a new area because a big sea turtle was hovering around. Turtles usually hang around wrecks and live bottom (napping beneath them) and if Winslow doesn't have anything marked in that area, it might be worth a look. It might also mean anchoring and chumming while other boats around them just keep trolling.

Winslow added, "When conditions call for it, we'll get on the [anchor] hook, if the fish are structure-oriented or maybe holding up near the jetties or inlets. The real key to anchoring and chumming isn't so much about location or what type of chum to use, it's

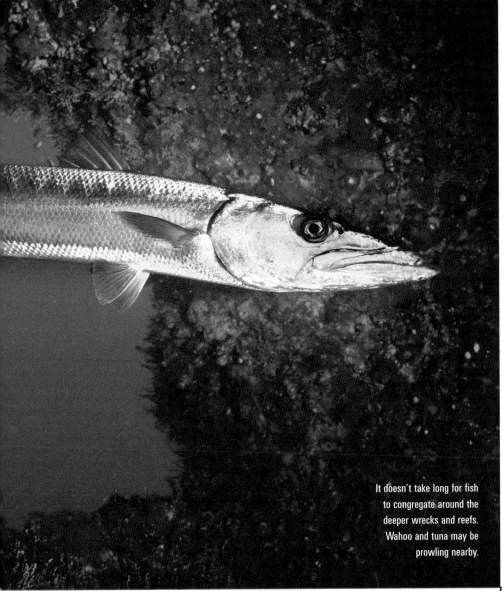

It doesn't take long for fish to congregate around the deeper wrecks and reefs. Wahoo and tuna may be prowling nearby.

knowing when to give it up. Some days we'll just burn it up, with fish biting on the grind [chum] with other boats trolling around us not doing as well. Other days, under the exact same conditions, the bites just won't come. You never know."

When you decide to anchor and chum, one thing truly critical for success is a moving current. The objective when anchored upcurrent of a wreck, reef or inlet is to draw fish to your baits. If you don't have current, you won't be successful in chumming them up. Or even floating baits back on corks or balloons, unless the wind is blowing.

Anchoring can be tricky at first and especially in a pack of boats. Keep lots of rope and chain ready; you don't want to drag anchor through choice bottom, scattering fish. A 3:1 ratio of anchor line-to-depth is something you should always have available, and even more line if wind and weather call for it. A fast current calls for plenty of rope and chain, not to mention an adequate anchor. Sloppy seas may call for more, if seas are running with the cur-

# Pelagics on the Wrecks

Wrecks aren't just for snapper and grouper fishing. Anchoring on the upcurrent side of a wreck or artificial reef puts you in a great position to target striking fish such as kingfish, tunas, wahoo and in some areas even billfish. The schools of sardines, jacks and other small fish that hang around such structure are better fish-attractors than any live chum or trolled teaser rig.

The limiting factors are depth and current. Generally, sites in 80 to 200 feet of water produce the greatest variety of ocean-grade pelagics, whereas shallow ones are the domain of cobia, Spanish mackerel and the like. Unfortunately, strong currents are sometimes present in the bluewater depths, requiring an unworkable length of anchor rode to hold. The best situation is just enough current to slide you back, to where the transom is a few hundred feet upcurrent of the wreck—and where your flatline baits will be carried toward the structure. Rigging your anchor with 10 to 15 feet of chain reduces the typical scope, such that in reasonable current, you can stay put with less than a 3:1 ratio of rode-to-depth. This is advantageous not only to minimize the amount of anchor line you need to carry, but also to keep your boat on a "tight leash," such that shifting winds and current don't swing you far from the best spot. If the current is honking and it's clear your anchor setup is going to require more rode (not to mention sweat) than you have to spare, try a different approach, like drifting or slow-trolling.

At anchor, you can try a number of techniques. One favored in South Florida and the Keys is chumming with live pilchards. Pitch a couple of chummies off the transom now and then; some will stay under the boat, while others will swim erratically downcurrent. Your hooked baits, in a decent current, will act just like slow-trolled baits: Hook 'em in the nose or dorsal surface, so they'll swim into the current, and not drown. Put a bait or two down deep, with a crimp-on sinker, or sliding sinker bottom-fishing rig.

Experienced big-game wreck fishermen make up their rode in 50- to 100-foot sections, connecting each with a spliced eye and a stainless

rent. Many captains keep enough anchor line for a 5:1 ratio, and of the right diameter. (Thicker isn't always better; it's a bigger drag in the current.) Also, be sure to have an adequate amount of anchor chain, as your lead from the anchor to the rope. Fifteen feet of chain is a good rule of thumb for a mid-size center console. Heavier boats carry more or use heavier chain links. Sufficient chain actually helps set your anchor properly by pulling flush with the bottom, and can save a ton of frustration when trying to "get on the hook" in strong current and sandy bottom.

When fishing larger areas (acres) of natural bottom, where staying upcurrent isn't as much of an issue, many anglers would rather explore by trolling or drifting a spread or baits—depending on water conditions. The key strategy here is to spread your baits out and work the water column, since all of these targeted pelagic fish will prowl from top to bottom. That's the thing about structure: It attracts these fish from top to bottom. Fish accordingly.

# Drifting and Trolling

spring clip. This way, if you have to chase down a sailfish or other big one, you can quickly unclip a segment of the rode, and clip on a poly anchor ball (which is a must for retrieving a big-water hook) to mark your spot, for when you return. Many other suggestions on anchoring systems appear in *Sportsman's Best: Snapper and Grouper*.

If anchoring seems like too much trouble, it's not a bad idea to simply line up a drift or trolling course over a favorite wreck or artificial reef, such as a pile of bridge rubble. This has produced many whopper kingfish throughout the species' range, and has long been a productive approach for sailfish in southern Florida. Savvy anglers will use a drift-sock to slow their drift and keep them over the strike zone longer.

In warm waters, barracuda can be a problem on some reefs; if cutoffs on baits or hooked fish are a problem, try moving farther away from the site. Often kings and tuna will hold in the vicinity of a wreck—sometimes hundreds of yards away—as opposed to right over the superstructure, where the "tax man" (barracuda) lives.

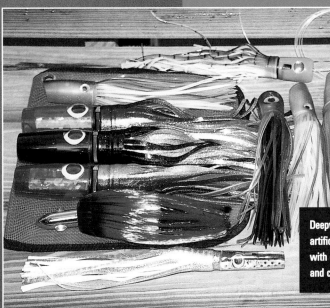

Deepwater wrecks can be trolled with artificials or live baits on top and also with downriggers. Lastly, try anchoring and chumming.

# Offshore Buoys

**S**ome boat captains fish around the NOAA weather buoys offshore, many of which are located in deep water, far from land. The poster child for this work would be Capt. Ed Dwyer, who since 1987 has been running 112 miles off Cape Canaveral to a buoy anchored beyond the Gulf Stream current. For years, Ed had the buoy to himself and no doubt saw many wonderful things out there. The buoy back then (still named 41010) was 30 feet in diameter and anchored in 2,700 feet of water. Bait and pelagic fish ganged up around the structure. Today the buoy is smaller and boat-shaped, for less drag in the current,

and the fish are mainly drawn to the big algae-covered rope, which attracts bait.

Ed still fishes there, but on a calm weekend he shares it with a dozen or more boats, many of them go-fast center consoles. Even commercial longliners. He's long given up on it being his own spot, and teaches a seminar in Port Canaveral each March on how to fish the buoy. Often, 150 people show up at the annual seminar, most of them new people with center console or catamaran boats. He has advice on fishing around this particular buoy.

"With a north wind you really have to be careful, crossing an average of 50 miles of north-flowing Gulf Stream current," he advises. Get caught in a cold front, and you've got nowhere to hide. The best season overall is April through July. During April-May the dol-

## Yellowfin tuna and other pelagics congregate around floating buoys in

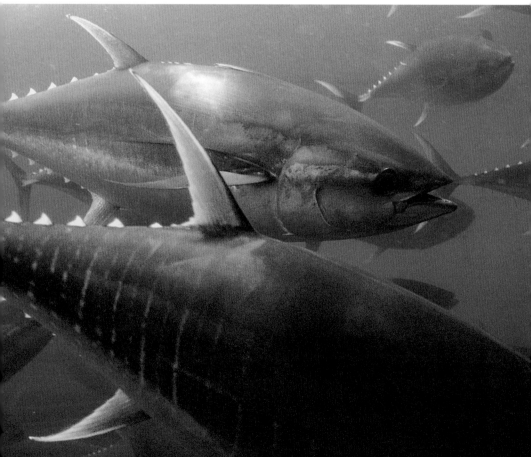

phin really stack up there. Yellowfin tuna start in March, but it's a tough crossing then. April is better weather. There are of course lots of boats out there in calm summer weather.

"During autumn, you have to pick your day," Dwyer noted. "Autumn and winter, you'd better be really careful in a small boat. You can pull the buoy up on the NOAA web site. The water temperature is critical, too. If it's 79-81 degrees, then suddenly jumps to 84, you've got a temperature edge out there, and it's time to go. The current at the buoy runs NE to SW and is not part of the Gulf Stream. It's the current on the Other Side, the name of my boat.

"Big yellowfin tuna hang around that buoy, and you would swear they're residential. They see the same techniques (ballyhoo and lure

combos) used by a number of boats, and they quit hitting. We catch them using other tricks. Back in the day, it didn't matter what you used out there. It's amazing how tuna schools seem to become knowledgeable. Everyone has radar now, to find birds, so the tuna see lots of boats.

"As a general tip, you catch your fish a half-mile upcurrent of the buoy. A pack of birds will sit a half-mile upcurrent, and that's where the big mooring rope surfaces. It floats and can be a hazard to navigation. If you run up and hit it in the dark, it could be big trouble. A slack current causes lots of floating rope, so watch out; it must be two miles long.

"Blue marlin are there to feed on residential skipjack, rainbow runners, small tuna and blue runners. The first boat there usually gets a tripletail. Sharks are a pain, mostly oceanic whitetips, big bull and blacktip sharks, too. May through July is the best marlin time. We've caught whites and sails there, too. You can catch a slam around that buoy."

Ed usually fishes around the buoy first, then looks for birds. The first boat there generally gets it going. Today there are triple- and quadruple-outboard boats racing out there, sometimes a dozen on the weekend.

There are many other offshore buoys, of course, including the 23-mile buoy also off Canaveral. Several off Hatteras in the Carolinas, too, are beyond the Gulf Stream. A valuable web site showing buoys from South Georgia to Mobile, Alabama is: www.ndbc.noaa.gov

**eeper water, feeding on anything they can find.**

Yellowfin tuna swarm far from land, congregating around the only structure in the current for miles. Shown below is a NOAA weather buoy with data accessible back at home.

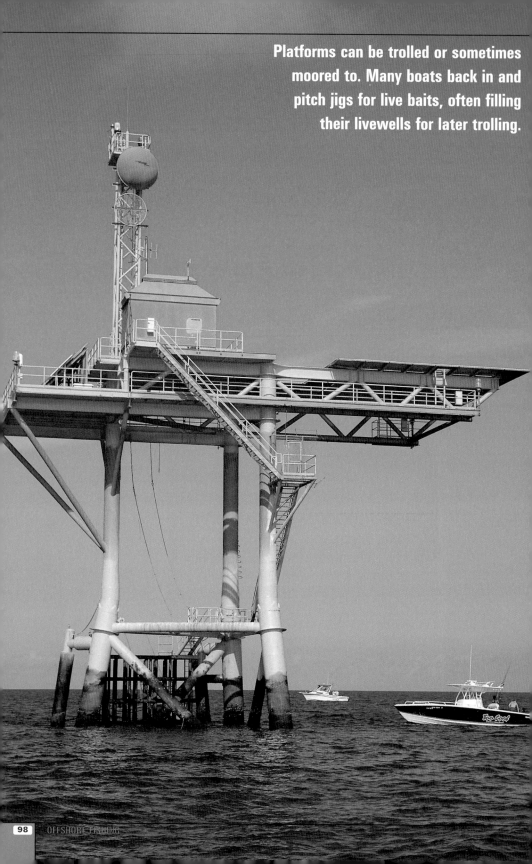

Platforms can be trolled or sometimes moored to. Many boats back in and pitch jigs for live baits, often filling their livewells for later trolling.

# Fishing Offshore Rigs

If you are fortunate enough to fish in the upper Gulf of Mexico, you may already know that thousands of oil and gas platforms off Alabama, Mississippi, Louisiana and Texas are home to every sea critter—from lowly bottom crawlers to mighty apex predators such as blue marlin and mako sharks. The "rigs" are so abundant and easily accessible to a large number of fishermen and women, they're now fished heavily in marlin and kingfish tournaments, among others. A growing number of rigs are being placed in mile-deep, blue water and they attract pelagic fish such as tuna, dolphin, wahoo and billfish. These towering behemoths really do round out a great fishery in the upper Gulf. They're not just for local boats; crews from as far east as Panama City make the trek to fish them, now that boats have gotten bigger, faster and perhaps more fuel efficient. If you see a boat with plastic fuel drums, very likely they're making a multi-day trip far offshore to the rigs and weedlines. Or crossing the Gulf of Mexico.

If you plan on tackling rigs in the northern Gulf, an inexpensive rig chart will make a fine companion to your chartplotter. The location of specific rigs, with latitude, longitude and more detailed information can be found online at sites like www.rodnreel.com. They list all the rigs in a searchable database, and even separate out the deepwater structures for you. They also indicate the age of the structure and whether or not it is a manned rig with a heliport, for example.

Before fishing the "rigs" or platforms, you'll find the same scenario discussed in Chapter 2: Assessing the Options. Platforms in the 50- to 200-foot depths will be perfect targets for king mackerel, though sails or wahoo in the shallower depths are relatively rare, unlike the East Coast. Rigs in the

200- to 400-foot range hold a few kings depending on the time of year, but as you get deeper, your chances for wahoo and other pelagics increase steadily. The deepwater rigs in 1,000 feet and more are blue marlin haunts and huge fish attracting devices (FADs) for many other pelagics.

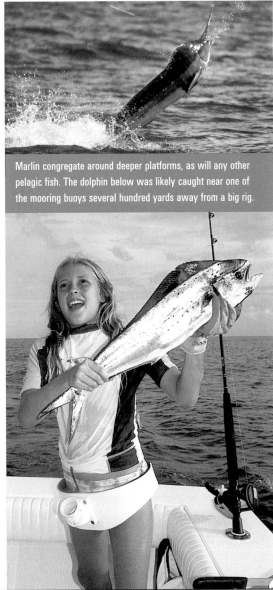

Marlin congregate around deeper platforms, as will any other pelagic fish. The dolphin below was likely caught near one of the mooring buoys several hundred yards away from a big rig.

# Shallow Water Wrecks and Rigs

**K**ingfish trollers approach the rigs and wrecks in similar fashion. They'll employ a spread of baits, making sure to cover as much of the water column as possible. To do this effectively, you want to make use of one or two downriggers. With live blue

A good starting position with downriggers is to cut the water column into thirds. If you are in 90 feet of water, start with your downrigger baits at 30 feet and 60 feet. If you notice that bait schools are holding at different depths around the rigs, or over any submerged struc-

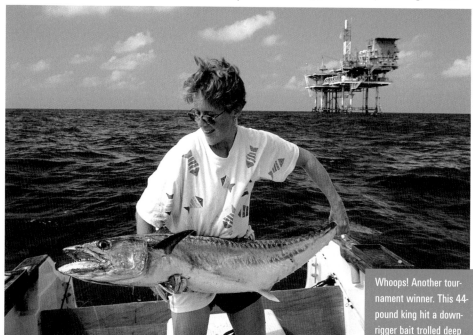

Whoops! Another tournament winner. This 44-pound king hit a downrigger bait trolled deep around platform in 70 feet of water.

runners usually abundant, that's the bait of choice on many days, but mixing in a live bluefish, big mullet or fresh-dead ribbonfish has delivered quality kingfish for professional and recreational anglers alike.

A standard kingfish trolling spread will have a pair of live baits on the flatlines, staggered at roughly 75 to 125 feet behind the boat. Next, you'll want baits on the downriggers, where depth settings will determine how deep you can fish. Finally, put a live bait in the prop-wash. It's a pretty simple five-rod spread, but it's a bread and butter pattern that has been tried and tested for thousands of hours from Texas to North Carolina.

ture for that matter, adjust your downrigger depths accordingly. Some folks will run a downrigger bait just a few feet off the bottom. Most people regard kingfish as topwater feeders and they are. However, on some days they prefer to sulk deep, perhaps because of rough seas or a north wind, which in the northern Gulf can really slow down the bite. When you see these fish skyrocketing on baitfish, they do so from below and most often in calm weather. What better vantage point for these fish to ambush prey from below, than to cruise at mid-depth or lower—which for trollers is reachable only with a downrigger.

**Most people regard kingfish as topwater feeders and they are. However, on**

Some folks like to mix in a ribbonfish or silver eel on one of their downrigger baits and some absolutely hate to pull them. Professional anglers Dan and Ronda Abshire fall somewhere in the middle. The Abshires have won many tournaments and are former SKA National Champions. Dan holds the current Mississippi State Record for king mackerel at 64.50 pounds, breaking an SKA record. Ronda is a former SKA Lady Angler of the Year. Competitive king mackerel fishing is a family affair for the Abshires and they've been at it since the 1990s.

"Kings are competitive feeders and sometimes just getting one fish to bite will turn on the rest of them," Dan says. "Most of the time our big bites don't happen on an eel, but sometimes that's the bait that gets a smaller fish to bite— and then the bite turns on." Again, whether your baits are live, dead or artificial, your job with a trolling spread is to replicate a bait school and provide predators with an easy meal.

Keep in mind that few boats actually trolled for kingfish around Gulf oil rigs, except for some charterboats, until the kingfish tournaments caught on in the late 1990s. Most rig fishermen simply tied up and began bottom fishing, while setting out an unweighted "freeline" or two astern, if the current was moving. Often they used whatever live fish were brought up from bottom, fresh-dead pogies and sand trout from shrimpboat cull. In this way, countless big kingfish were caught without burning extra fuel, often while winning tournaments.

Oil rigs as well as shallow-water wrecks attract fish from top to bottom, so it's easy to cover the water column for a variety of species. Casting jigs or heavy spoons, for example, covers it all if you start deep. Just mix up your offerings to trigger the bite.

# Offshore Platform Host to Many Fish

In warm waters, the shallowest structures may offer a mix of tripletail and cobia.

**ome days they prefer to sulk far below.**

# Deepwater Rigs and Wrecks

**D**eepwater rigs are often thought of as an absolute oasis in the open ocean. Often they live up to this promise—particularly after you pull up satellite data that show few temperature breaks across much of the Gulf. Without a discernable rip, temperature break or weedline, the idea of fishing "dead

of sea life. Once while winter fishing for tuna and wahoo off Louisiana, we opted not to fish the "short rigs" because we worried about angler traffic being too heavy. We opted to fish alone and caught some nice tuna and a decent mid-70s wahoo. Our catch was respectable until a small center console returned that

**Sunken wrecks and rigs attract a variety of sea life. Top predators are pelagic fish and sharks, that feed on smaller fish.**

Sunken aircraft carrier *U.S.S. Oriskany*, above, provides ample shelter for choice blue runner baitfish. The wreck should attract pelagic predators like the wahoo at right.

water" is daunting to some captains. Make a run to those deepwater rigs in the Gulf, and you needn't worry about the vagaries of offshore water.

For some anglers, the run to deepwater rigs starts at 70 miles or better, but if you're fishing out of South Pass, Louisiana, those rigs sitting in 1,000 feet of water are a mere 11 miles offshore, within easy sight of the jetty. That's where in calm weather, small boats get a shot at big fish. These same rigs will get fishing pressure, but they're massive above and below the water line, which means they support a lot

evening from the same 12-mile rigs we'd passed up, with a pair of trophy 'hoos weighing 99 and 101 pounds...

Fishing deepwater rigs does have pros and cons. Unlike shallow-water rigs, which may be clustered with dozens of structures within a 10-mile radius, deepwater rigs, especially those anchored in mile-deep water, are far more isolated. Making a move from one to another

Anchoring and chumming over a wreck gives anglers a shot at tuna, wahoo and sailfish, just for starters.

# Baitfish Make Wrecks and Reefs the Gifts that Keep Giving

ly isn't time to go spot or troll of there? You can't a but you also have to between. If it means an h hours trolling, do you want to not fishing? What does the water it clean, dirty or show signs of marir Maybe it's a good time to do some high trolling and split the difference, but one thi for sure: If the rig you are fishing seems dead, its time to move on. Find a field of a dozen or more production platforms in clean enough water, and you can visit many of them —until you find a hot bite going on.

er targeting king mackerel, cobia or fish, a huge benefit of most platforms offshore is their con- baitfish. You don't have to nding transient weedlines or ater schools of bait; the shelter baitfish over and he gift that keeps on giv- f the year you can get e rigs and depth doesn't water or 50, you can sho. is bait the key to a pelagic an indicator of pred-

or rig in 65 feet baitfish, you hing there for (cobia and

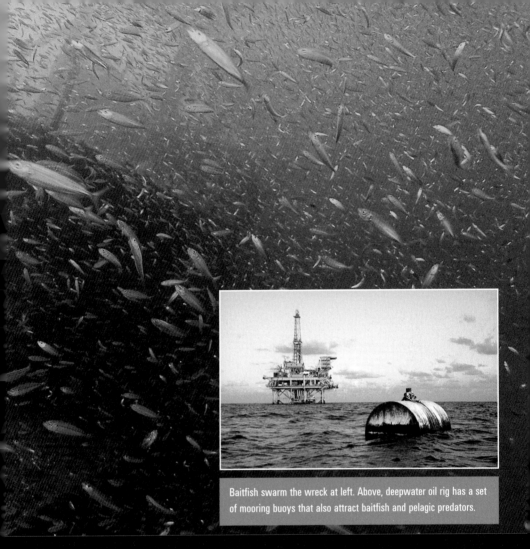

Baitfish swarm the wreck at left. Above, deepwater oil rig has a set of mooring buoys that also attract baitfish and pelagic predators.

kingfish). If you stop at another rig in similar depth with the same result, then you need to change the depth and distance from the coast. Find bait and you'll find predators, but it isn't always simple to catch bait. Baitfish, believe it or not, can be difficult to catch, just like bigger predators. Sometimes baitfish show a marked preference for a certain bait rig. Other days they'll do their best kamikaze impression and eat anything.

The sabiki rig is a nice little tool for loading up your livewell, but when fishing the rigs, don't use the little gold hook rigs. You'll do better with larger sabikis with 20- to 30-pound main line and 15- to 20-pound droppers. Those light sabiki rigs from the East Coast, meant for cigar minnows, Spanish sardines, greenies and other baits of that size, are easily torn to pieces on the first cast around most oil rigs. Two-pound blue runners, amberjacks and their close cousins, almaco jacks, will shred them sometimes on the surface. Even with larger, 40-pound mono sabikis, losses are expected.

Many anglers choose to go with bigger bait hooks, like a 1/4- to 1-ounce Mylar or bucktail jig or metal jigs (like crippled herring) that have a single hook. Single, sturdy jig hooks are much easier to remove from baitfish when handling large, frisky baits—though sabikis or other multi-hook rigs will fill the well faster. By using larger jigs, you generally catch larger baits. Big runners that weigh 2 to 3 pounds are not uncommon, though most of them will be in the 10- to 14-inch range. There isn't a pelagic fish in the ocean that won't gobble up a runner. SB

# Deepwater Ledges and Humps

Anybody see tuna? Another day at the Islamorada Hump, where blackfin tuna school almost on a year-round basis.

## Humps and seamounts cause currents to collide with solid bottom.

Bottom features along the 100-fathom curve and beyond aren't about structure holding baitfish. It's about ledges, walls, humps and pinnacles affecting the current flow and causing upwellings. The steeper the ledges and more dramatic the relief in these deeper areas, the more likely you'll encounter billfish, wahoo, tuna and dolphin.

Ledges in the 400- to 600-foot range will not only hold offshore target species, they'll cause little gold mines of small eddys and currents that spin off. These areas are small, only a few hundred yards long, and probably won't show up on satellite images. If you find one, record these spots with your electronics and in that logbook.

When fishing ledges, you can really become dependent on your chartplotter. There's good reason for that: the tighter the bathymetric lines on your chart, the steeper these ledges or underwater hills. The sharper relief over a given area improves the odds that bait and predators will be waiting there. Your bottom machine set for deep scan can be just as critical here. Marking bait schools near the surface

Chunking menhaden or any local baitfish is the ticket to tuna action.

is important, but finding a steep rock or new hump in the area can spell success.

Humps are areas of large relief that rise up out of deep water around it, like the Islamorada or Marathon humps in the Florida Keys, or the popular Midnight Lump off Louisiana. The latter is surrounded by 400 feet of water and rises to just under 200 feet. The Islamorada Hump is surrounded by 600-foot depths and rises to 400. There are many natural humps peppering offshore charts, and these are where offshore currents collide with solid bottom that consists of salt domes or seamounts. That sends small, helpless organisms upward, setting the aquatic food chain in motion.

You can choose to troll these areas with typical bait spreads, kite-fish them, deep-drop jigs or live bait, or simply anchor and chum, which is what Louisiana's Midnight Lump is famous for.

Regardless of which season these spots are great for, they're offshore beacons and hold pelagic fish.

Offshore canyon fishermen usually don't dwell on structure. But if you have a 3D-feature on your chartplotter, or do a Google image search on the canyon you want to visit, you'll notice there is indeed fishing structure, though it may be far below. Despite the depth, it does have an effect on fishing. Whether the canyon begins fairly shallow and narrow like the Hudson Canyon off New York, or starts fairly deep and widespread like DeSoto Canyon in

the Gulf of Mexico, these deepwater troughs are home to prized, pelagic fish.

Anglers visiting the canyons still utilize conventional methods of offshore fishing. Even anchoring in 600 feet of water in Tom's or Hudson canyons is a popular method for chunking for tuna. When trolling, employ similar spread patterns and baits. However, instead of watching your chartplotter and fishfinder keenly, as with shallower ledges, you'll rely more on satellite data during preparation—and keeping a sharp eye on the water.

The key to learning and improving at any kind of fishing is understanding how different types of fishing utilize the same skills. Many types of fishing seem very different, but when you peel back the onion, so to speak, they're really similar. You aren't learning completely new skills, just how to apply what you know to a new style of fishing. For example, having a good eye while sight-fishing redfish back inshore can be an invaluable skill to have. Especially when you're scanning the horizon while canyon fishing on a vast expanse of water. Spotting that small piece of debris or slight color change in the distance can be a trip-saver while offshore. Another example would be tipping your rod when a tarpon goes airborne; it's the same when sailfish or dolphin get airborne.

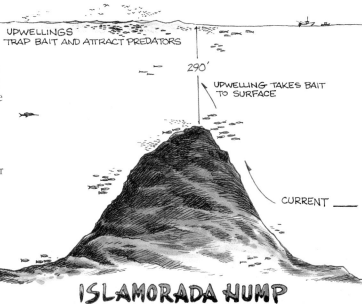

UPWELLINGS
TRAP BAIT AND ATTRACT PREDATORS

290'

UPWELLING TAKES BAIT TO SURFACE

CURRENT

ISLAMORADA HUMP

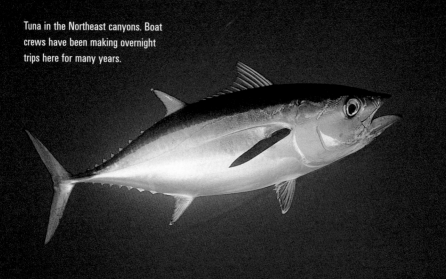

Tuna in the Northeast canyons. Boat crews have been making overnight trips here for many years.

# Canyon Captains Know the Program

Captain John Sowerby from Caveman Sportfishing Charters in Morehead City, North Carolina has been canyon fishing for many years, often out of Cape May, New Jersey during the peak season there. Here's what he has to say about this phenomena of fishing natural bottom structure, big canyons for pelagic fish:

"There's a reason why underwater canyons attract so many fish," says Sowerby. "Warm water eddies push up against the canyon walls and the bait gathers along the walls, as the eddies create upwellings holding bait. The warmer water has high concentrations of chlorophyll that plankton feed on—and the cycle just moves up the food chain from there. This holds true for tuna, but marlin prefer the warmer Gulf Stream current, out beyond the 100-fathom line. Swordfish, meanwhile, can be found wherever there is lots of bait holding down deep, such as squid. We get bluefin tuna in the 60- to 170-pound range inside, along the 20-fathom line and yellowfin along the 30-fathom line if bait is present. If squid and sand eels are around, tuna will be there.

"The tuna can be from 45 out to 100 miles, depending where you fish from in New Jersey. The southern ports are closer to the canyons and the closest to Cape May is 60 miles, but we don't keep the boat there until late August, as there is usually a decent tuna bite inside the 30-fathom line.

"Lots of northern New Jersey boats anchor to canyon fish, but from southern New Jersey ports, they mostly drift-fish canyons. Captains anchor when the current is swift and drift when there is light winds and little current. We carry 2,000 feet of anchor line, so we can anchor in 600 to 800 feet. We use 40 feet of chain.

"Best baits are live squid, sardines and butterfish, all used to chunk as chum. We are using

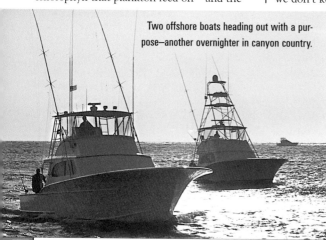

Two offshore boats heading out with a purpose—another overnighter in canyon country.

mostly 30-pound-class tackle or 50 at the most, loaded with 80- and 130-hollow core Spectra line, with 100 yards of mono as a top shot. Many boats troll but many more tuna are caught while chunking. Most of our customers prefer to chunk but we do troll at times.

"The Gulf Stream is well over 140 miles off NJ and I don't know any boats that fish it. Cold weather fronts have no bearing on our fishing, as they don't arrive during our canyon season, for the most part. Canyon fishing there is over for 90 percent of the boats by late September or early October. The cold fronts come later in the fall. They have a short offshore season, about 3 to 4 months for most boats.

"Swordfishing is really coming back up here and many are now fishing for them at night using large squid down about 150-200 feet or so. We use the bottom machine to mark fish, but we also fish spots where we have the best temperature break with good clean water."

Captain Len Belcaro publishes the *Big Game Fishing Journal* and ran a charterboat out of Manasquan Inlet in New Jersey, fishing the canyons for about 20 years. His views:

"These Northeast canyons are notches in the continental shelf from the Canadian line to Cape Hatteras. The Gulf Stream current is the reason these canyons are so productive during summer and early fall. Not the Gulf Stream itself; that takes a bend offshore at Cape Hatteras in North Carolina, where it's only 25 miles offshore, then out to over 300 miles off New Jersey, New York and Massachusetts. In those states, the long-distance offshore guys wait for Gulf Stream spinoffs in the form of warm eddies, that deliver warm, cobalt blue Gulf Stream water onto the shelf.

"From Hydrographer's Canyon to the Point off Oregon Inlet, and all canyons in between, these cracks in the continental shelf hold major schools of baitfish that feed on nutrients raised into the upper water column, by eddy currents striking the walls of the canyons. With the proper water conditions, these canyons become a food-rich environment for blue and white marlin, swordfish, sharks and tuna that roam its corridors.

"Working the bait pods from the 'flats' inshore of the 100-fathom curve to the deep water offshore of the 100, trolling and night-chunking are the most productive fishing procedures along the shelf. With so many target species roaming these waters, the excitement when trolling the canyons is never knowing what will jump on those artificials or rigged baits behind the boat. From bigeye to billfish, wahoo to mahi-mahi, even an occasional mako or huge bluefin show up.

"When the trolling day is over, that's when the excitement really begins. While trolling, it's best to remember bait encountered that day. Any area along the flats inside the 100-fathom curve in 400 to 600 feet of water, where bait schools can be seen on the recorder—that's where the anchor hook should be dropped at day's end. It requires 1,200 to 1,800 feet of line, an anchor with a fair length of chain, and a ball with a release clip and anchor ring to make short work of raising the anchor.

"After the anchor is set and holding, the trolling rods are tucked away for the evening. The standup tackle is readied, along with frozen flats (boxes) of butterfish.

"Night tuna chunking is one of the most productive ways to land yellowfin, albacore (longfin) and an occasional bigeye tuna. When water temperatures begin to climb in July and August, tuna move deeper into the water column to maintain a comfortable body temperature. But tuna have the ability to regulate their body temps when need be— and there is nothing like a stream of chunked-up pieces of butterfish to coax them up. With three or four standup rods rigged with whole or chunked butterfish fed out with the chunks, it doesn't take long before the action arrives. Multiple hookups are common at night and hooking a single tuna means a school is close by. An evening's chunking can catch 20 to 30 tuna in the 50- to 90-pound class." SB

> **Multiple hookups are common; an evening's chunking can catch 20 to 30 tuna in the 50- to 90-pound class.**

# CHAPTER 7

# Weather and Tide Offshore

There is a long-running joke that the weatherman is the only guy who can go to work, be wrong every day and still keep his job. While it might be true, it really isn't fair to the weatherman. Weather is a fickle science, to be sure, but offshore crews have to stay on their toes. Remove the security blanket of solid ground, and you'd better check and double-check before heading offshore.

If there is one place where you don't want to be caught guessing, it's on the water beyond sight of land. With the technology available today, weather isn't the mystery it once was, but things change quickly on the water. Offshore anglers have to be prepared for the explosive, volatile whims of Mother Nature. After all, the hottest bite in the world isn't worth jeopardizing the safety of a boat crew. Do your homework and stay alert on the water, for a safe future of fast action offshore.

**Judging the weather takes personal observation, experience and forecasting.**

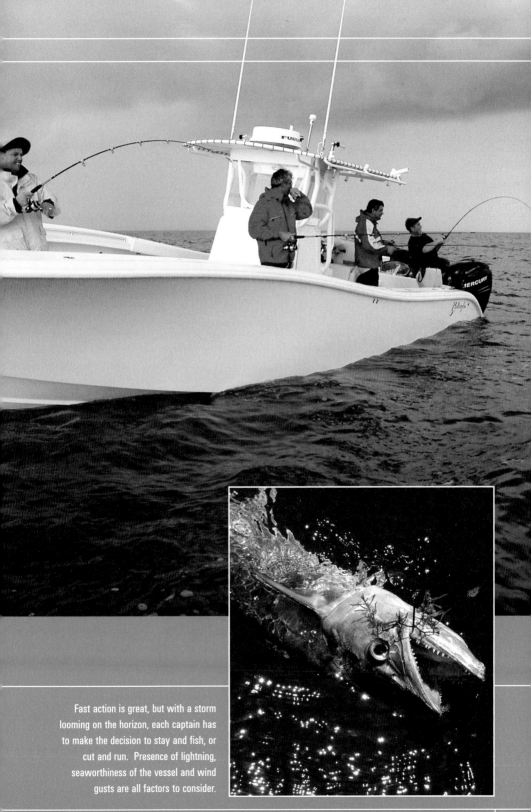

Fast action is great, but with a storm looming on the horizon, each captain has to make the decision to stay and fish, or cut and run. Presence of lightning, seaworthiness of the vessel and wind gusts are all factors to consider.

# Weather Plays a Role

## Ever take a beating from conditions offshore? Many have.

**M**y trip to remember was a Saturday kingfish tournament, where we were greeted with flat calm seas and an enthusiasm we thought nothing could stifle. Our three-man crew was determined to show the "go-fast" tournament boats that a small boat crew could throw a fat fish on the docks and take our rightful place in the winner's cir-

cle. We were experienced, but what's the old saying: Our egos wrote checks our bodies couldn't cash? Something like that. We ventured out a little too far and didn't pay atten-

tion to warning signs that bad weather was approaching. It could be said (with some justification) that we had a chip on our shoulder.

After heading down the coast over 70 miles, we were fishing about 18 miles south of the beach, when the wind started blowing more briskly. The sky offshore was turning an ugly purple and we knew it meant bad weather, but it was only noon and we had a point to make. The wind picked up and we decided we'd better start making our way back when the big fish hit. The water around our starboard flatline bait frothed and we collectively yelled, "Fish on!" as the reel dumped line for what seemed an eternity. This was the bite we'd made the long run for. In our excitement and hubris, we didn't care about the weather fast approaching; this was a big fish. After a 15-minute battle, that kingfish came to the gaff, was dragged aboard and soon was snug in the fishbag. That's when we turned around to see black skies upon us. An offshore storm quickly wrapped around us and for about four solid hours we took the pounding of our lives. It was one of those white-knuckled, soaking wet rides, unsure at times whether we would ever make it back to dry land in one piece. Let alone the tournament scales. We made it back unharmed, though you couldn't say we did it safely. Chalk it up to youthful enthusiasm or more accurately, stupidity, but our fish took third place and we were happy, even if we looked like drowned rats. That was many years ago and I vowed never to put myself in that position again. Let it be said as well, that tourna-

Good quality rain gear is a must for every offshore angler, when the weather turns sour.

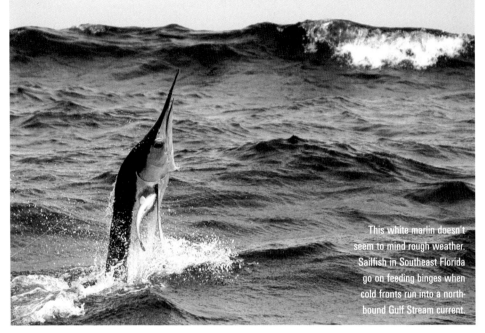

This white marlin doesn't seem to mind rough weather. Sailfish in Southeast Florida go on feeding binges when cold fronts run into a north-bound Gulf Stream current.

ment fishing offshore does have the tendency to make captains stretch things to the limit. Huge prizes and egos are often at stake, but lives have been lost offshore in the process.

These days, you have far more weather information at hand to prevent potentially dangerous situations. Boats even carry the Internet and subscribe to satellite weather, for constant updates. It's infinitely better than just watching the horizon like the ships of yore. Of course, ignoring the horizon and a fast-developing summer thunderstorm can be foolhardy; they may develop faster than the Internet can report.

Anyone with years of offshore trips has a story. We only tell it and laugh about how ignorant it was. In the same vein, every-one jokes about weather-guessers never being able to get a forecast correct. In reality, no one can forecast Nature with 100 percent accuracy. For your own sake as a guest of Mother Nature, it's quite important to remain vigilant while offshore.

> Today's weather forecasting is phenomenal compared with 30 years ago, but you still have to stay on your toes for sudden changes.

Make sure you understand how weather affects your fishing, and what you can do to take advantage of weather patterns. It's even more important to do your homework—checking forecasts, satellite imagery and offshore weath-er buoys before leaving the dock and, better yet, prior to leaving the house.

Understand the changing weather around you to make sure it's safe on the water. Instead of relying on a marina owner who, perhaps anxious for business on a Saturday and despite 18 knots of wind, says on the phone, "It's fish-able!" You can make your own deductions with today's advanced weather monitoring programs.

Keep in mind that the wind shifts with the

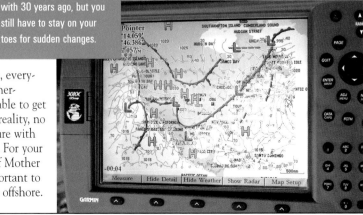

arrival of each cold front, turning clockwise on the horizon. If a nagging west wind is blowing, you may very well see a black donut soon appearing to the north, a cold front. After the front wears down, the north or northeasterly wind shifts to the east, sometimes blowing for days. With luck, a wind shift to the south will bring good fishing weather and turn on the bite. With a southwest wind, it's time to start thinking about the next cold front cycle. And so the weather spins in a clockwise fashion, around the compass. You remember the compass, back before GPS navigational aids? Some of the newer captains have skipped the compass, going high-tech, which sometimes alarms older captains. Ignore the compass and wind quadrant directions, and you might be facing a stiff headwind back to port. Better to plan ahead before heading offshore.

## Tides and Offshore Fishing

When we talk about tides and fishing, most anglers associate that with inshore fishing. Offshore fishing is certainly not immune to the influences of tide. Tides are more noticeable in areas where fishing is relatively close to shore, for example sailfishing off South Florida, wahoo trolling off Bahamas reefs, kingfishing near Atlantic beaches, or striped marlin fishing off the Pacific coast of Mexico. Tides are the life force of our coastal waters.

So what are tides and what causes them?

**As a general rule, most fish feed better on a moving tide, either rising or fallin**

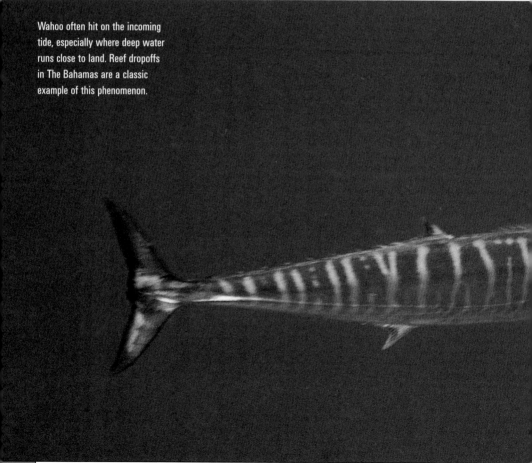

Wahoo often hit on the incoming tide, especially where deep water runs close to land. Reef dropoffs in The Bahamas are a classic example of this phenomenon.

Think of tides as an extremely long wave with an exaggerated wave period. The gravitational pull of the sun and moon, along with inertia created by each, causes tidal bulges that follow these two as Earth and moon rotate in their respective orbits. Tides run on a lunar day, which is 24 hours and 50 minutes. The water you fish will demonstrate one of three types of tidal activity: diurnal, semidiurnal or mixed semidiurnal. A diurnal tide cycle simply means that you'll have a single high and a single low tide each day, like most areas of the Gulf of Mexico. Semidiurnal tide cycles are evident when you have two

Keep a tide chart around the house; a quick glance reveals the day's tides, and predicted peak feeding times for fish.

**thers have a preference, like wahoo.**

highs and two lows of relative similarity each day. That means if your first high tide has a height of 2.5 feet, then your second will have a very similar height. The Atlantic seaboard and most of the Caribbean are under a semidiurnal tide cycle. Finally, the west coast of the United States and Mexico experience mixed semidiurnal tides. They not only get a pair of highs and lows, but they will have different sizes each lunar day. (Source www.noaa.gov)

Now that science class is over, what does this have to do with offshore fishing? Quite a lot, as it turns out. In coastal areas that have strong tides, pelagic fish are attuned to water movement and its role as food conveyor. Picture schooling kingfish awaiting sardines at a bay entrance during the flush of outgoing tide. Behavior like this is less evident in the deepwater canyons well offshore, of course, but the majority of coastal areas in North America are dramatically affected by tidal movement.

As a general rule, most fish feed better on a moving tide, whether rising or falling. Applying the science primer we just went over, you'll have a period of calm current every 6 hours in a semidiurnal cycle and every 12 hours in a diurnal cycle. Fishing your favorite spots halfway between these tide changes should yield the best results, as the water will be moving at peak velocity. If you focus your time offshore in areas and times that historically have been most productive, you'll see the dividends.

For anglers in South Florida or the Bahamas, for example, if you know that the outgoing tide peaks at 2 p.m, you can fish well offshore for dolphin, billfish or tuna during the

**Several types of fish show a predilection for feeding on a full moon, both at night and during the day, which you probably wouldn't expect.**

morning, but it would pay dividends to return back to the nearshore wahoo spots to target these fish that are fired up by a strong, incoming tide. This scenario is common in areas where deep water lies close to shore.

Spring and neap tides occur roughly every 14 days, or seven days apart on the first and third quarters. Spring tides occur when the Earth, sun and moon are in alignment and neap tides occur when they are at right angles. Spring tides occur on the new and full moon, when the combined effect of the sun's and moon's gravitational pull cause the highest of the high tides for the month. Neap tides occur about seven days after the spring tides, where the gravitational pulls sort of cancel each other out and the tides are nominal, or the lowest tide ranges for the month. Each month there

are two of these. Spring tides are the strongest and neap tides the weakest of all. One is considered the best and the other the worst. In an ideal world, which would you choose to fish? In reality, most of us fish when we can. A calm Saturday after weeks of wind—that's when most anglers head offshore.

## Moon Phases

If you can admit there is at least a little science to tidal effects on fishing, you can also argue there is a science to moon phases and their impact on offshore fishing. Most would agree it's a mad science. After extensive research on the effects moon phases have on billfish— and offshore fishing in general—the only real conclusions are obvious. Swordfish really do prefer a full moon and across the globe, offshore fishermen have preferences and catch records that contradict each other. The good news is that empirical data spanning the entire world confirm that offshore fish bite on every phase of the moon. In certain areas, some captains argue the quarter moon is better. Others prefer the four days before and after a new moon. Still others claim there is no correlation—just go fishing.

Several types of fish show a predilection for feeding on a full moon, both at night which you'd expect and during the day, which you probably wouldn't expect. Swordfish are the most famous offshore full moon feeders, but most fish take advantage of the celestial night light. There are even studies that show dolphin (mahi-mahi) spend their nights well below the surface. Since these fish are some of the most voracious feeders and grow at an amazing pace, one may assume they feed at night, too. Curiously enough, there are fishermen who firmly believe dolphin do not bite as readily around the full moon, perhaps because they fed under the moonlight the night before. Swordfish, however, are nocturnal by nature and because of their reaction to overhead light, you often find them right off the back of

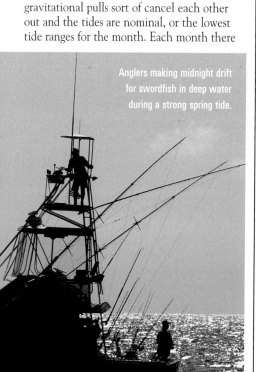

Anglers making midnight drift for swordfish in deep water during a strong spring tide.

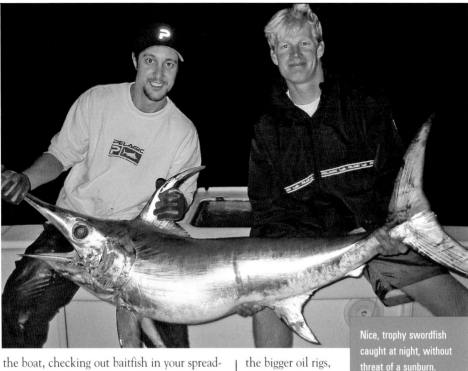

Nice, trophy swordfish caught at night, without threat of a sunburn.

the boat, checking out baitfish in your spreader lights. Anglers fishing the Straits of Florida generally report that swordfish move up to feed near the surface on a dark moon. The fishermen deploy baits deeper than usual on the full moon.

Captain Jeremy Williams skippers a 54-foot sportfisherman out of Perdido Key, Florida and has a penchant for swordfishing. Credited as one of the first Gulf Coast captains to actively target and tag swordfish in the DeSoto Canyon, Williams has learned a thing or two about how the moon phases affect broadbills. "If you can find the fish, they do bite better on a full moon, or a few days just before. But if the fishing is tougher, a new moon is often the better bite, because your lights are more effective on a dark sky."

Swords aren't the only fish prowling on a full moon. Tuna will often join the party, as will mako sharks, wahoo and even rare deepwater catches like escolar and pomfret, for which Williams's anglers set IGFA records in 2004.

Kingfish will bite at night, especially if a boat with a generator or an oil rig carries sufficient lights overhead. Cobia feed under these conditions, as well and sometimes without lights around the wrecks. Gulf anglers know the bigger oil rigs, with huge floodlights and lots of prowling squid and flyingfish on the surface, will host feeding kingfish and surface cobia on and off all night. The darker, smaller rigs with flashing beacons are often worthless for nightfishing for kings. Drifting headboats with sufficient lights off Southeast Florida have long enjoyed night-time action for kings. Anchor up over a wreck in 100 feet and crank up the lights, and there's no telling what fish will appear.

The moon plays a part, as well, even during the day. Captain George LaBonte, a veteran offshore captain out of Jupiter, Florida and author of *Sportsman's Best: Sailfish*, has perfected the art of catching daylight wahoo during the full moon period. He prefers the week on each side of the big moon, uses wire lines and deep baits, and has proven time and again that maybe there is a little science to this. Having witnessed his fishing firsthand, it truly is an artform. Aboard his boat *Edge*, we boated a cooler full of wahoo using his techniques. We were back at the docks in time to clean our fish and have them prepared at a lunch counter. This guy understands his fishing grounds and applies some proven techniques.

# Fishing Through Rough Seas

The definition of rough seas depends on a couple of things; the size and capability of your boat and your definition of what is rough or uncomfortable. It's been proven you can fish and catch them in really rough weather. Some fish actually show a preference for bumpy weather and a dropping barometer, but using common sense is paramount when venturing offshore.

While fishing offshore one summer, I woke up hovering for a moment, about 12 inches above the bunk. The dream I was having came to an abrupt halt as I was slammed to the floor. A cacophony of unsecured items crashed around me inside the 63-foot Bertram. It was dark, I was trying to get some sleep and the guys at the helm were doing their best to keep us comfortable in those unexpected 6- to 8-foot seas. We weren't too worried about our safety. However, during the trip we monitored the VHF radio, listening to the crews from a pair of 26-foot center consoles, caught in a bad summer thunderstorm that took us all by surprise.

The two small boats were more than 80 miles offshore, tuna fishing around deepwater oil rigs off the coast of Alabama. Fishing was now the last thing on the minds of these two captains, as the fear in their voices was evident over the crackling, static-filled airwaves; they

The two boats weathered the storm and made it home unharmed, though they were surely shaken. You can't say that the two captains did anything wrong; seas were calm and the radar clear at the start of their trip. The blip on the radar screen didn't seem daunting at first and they just had the misfortune of being caught by that storm. It just happens. How you react to a storm makes the difference between getting home safely or not.

That wonderful radar won't detect a windstorm that carries no rain, however. Back in 1995, 41 boats headed offshore at night for a weekend-long summer kingfish tournament out of Freeport, Texas.

## In a bad lightning storm it pays to lower your outriggers and antennas.

wanted nothing more than to get home safely. I watched in relative comfort and said a small prayer for those guys, while witnessing the most amazing display of lightning. Rough seas are one thing when you're sitting in an enclosed bridge of a large sportfisherman. Add the mother of all lightning storms and put yourself on the deck of a center console out there, and life suddenly begins to look a little sketchy.

Those boats running east ran head-on into a cold front that was bending west, from a tropical storm lurking off Tampa. Cold wind smashed into the fleet without warning, and seas were soon an estimated 20 feet, running in at least two directions. The crew on a 42-foot Hatteras reported nothing on the radar, but their boat was soon a mess, limping to the nearest port on one engine, a crew member

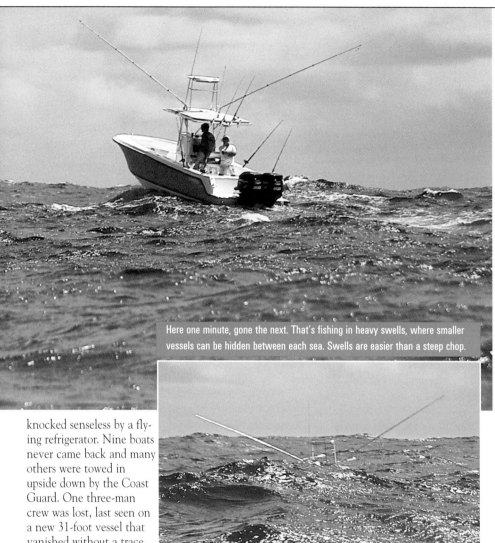

Here one minute, gone the next. That's fishing in heavy swells, where smaller vessels can be hidden between each sea. Swells are easier than a steep chop.

knocked senseless by a flying refrigerator. Nine boats never came back and many others were towed in upside down by the Coast Guard. One three-man crew was lost, last seen on a new 31-foot vessel that vanished without a trace.

Freakish storms aside, you should consider having radar when venturing offshore. Besides fog or heavy rain limiting visibility, radar usually gives early warning if rain is involved. You can choose to handle approaching thunderstorms by running, if you have the warning time. Or you can even choose to run into the weather to shorten the amount of time you'll be in choppier seas; they often calm down after the cloud passes by.

If you do find yourself offshore in choppy seas, take some precautions when working the cockpit and moving around the boat. With center consoles, you're almost never too far away from a handhold on the T-top, bow rail or leaning post, but the open cockpit of a

sportfisher can get a little tricky. Rough weather and a rogue wave can toss you out of the cockpit of any boat, if you're not careful. Make sure all of your rods and reels are lashed down, of course, but also make sure that if you're going to clear lines, change baits or grab a rod with a fish on, that you have a handhold planned or your knees tucked against the gunwale or transom. Getting back to the chair or into standup gear will be tougher under rough conditions, so make sure you have a mental plan and practice what will happen when a fish hits. With standup gear, it works great to have the next angler in rotation with his gear already on. And, if you plan on climbing up to

**Rough weather and a rogue wave can toss you out of the cockpit of almost any boat, if you're not careful. You have to be vigilant.**

the helm or into the tuna tower, you'd better think twice in rough seas. It's a lot easier to take your time and get up the ladder, but when a fish is hooked up and your adrenaline is running, you have to get down that same wet, bumpy ladder, with a lot of hard fiberglass to land on. Ask yourself beforehand: "Do I really need to be out of the cockpit?"

If someone does fall overboard, hit the MOB button immediately, stop or turn the boat, and throw the swimmer something buoyant to hang on to, before making a rescue attempt. If the captain falls overboard, don't assume someone else can maneuver the boat

well enough to effect a pickup in choppy seas. Small, clip-on EPIRBs are practical. Even a smoke flare would be precious, for someone who has fallen overboard. In the event of stormy weather, it's always best to have the crew strap on life jackets with those reflective gray tapes that reflect searchlights. Without a lifejacket, you haven't much of a chance after a half hour.

## Weather Research and Services

In areas where there are dramatic coastline changes like the east coast of Florida or North

# Roughin' It   Riding a beanbag chair completely takes the strain ou

Dying probably would make you feel better, but then you'd miss the morning bite. So the ardent mariner needs a remedy for seasickness on hand any time he leaves the dock. And don't think that because you're a seasoned salt, it can't happen to you.

Marine beanbag boat chairs feel like a life saver when the boat is pounding in heavy seas, or when an angler is feeling poorly.

Fortunately, there are ways around it.

The basics require no medicine, just a bit of common sense. Here are a few pointers.

1. For breakfast, opt for a little fruit and cere-

al rather than greasy ham and eggs.

2. Sit or stand near the stern of the boat, on the cockpit level. The farther forward you ride, the rougher it feels, and ditto for seats on the flying bridge or tower.

3. Stay well away from any nasty smells aboard, including the chum bucket and the exhaust from diesels or outboards.

4. Stay outside—avoid the temptation to go below and lie down, which will assuredly make you feel much worse—as well as creating a cleanup problem.

5. Keep your eyes on the horizon—don't read, and don't stick your head down into a livewell or engine room for extended periods.

6. Try drinking a carbonated diet soda—for some, this settles the stomach. A stomach-settler like Alka-Seltzer can also help.

7. Caffeine seems to help some people, either coffee or cola.

When it comes to medications, over-the-counter medications like Dramamine and Bonine work for some, but not all. They tend to make some users feel slightly drugged or drowsy, and aren't recommended for people with medical problems including glaucoma. They're most effective if you take one the night before and one the next morning.

Carolina, seas can be completely different just 15 or 20 miles up or down the coast. Knowing the wind, seas and expected forecast for the day's fishing can mean that instead of taking a beating down south, an hour-long run up the Intracoastal Waterway could spell better seas and fishing. Sites like www.ndbc.noaa.gov can give you buoy reports, www.nws.noaa.gov/om/marine/zone/usamz.htm will give you coastal marine forecasts and your local weather sites like www.weather.com, www.accuweather.com and www.wunder-ground.com can tell you the overall weather forecast. If you put this information together, you should be able to make an educated decision on where to fish, what type of weather to expect and whether you should fish at all. SB

## of your hips, knees, back and feet.

Scopalamine, a prescription patch, does a good job for most. The patch goes behind the ear. To be effective, the patch should be applied the night before you leave the dock, building up the dose in your system. It won't work if you don't put it on offshore. Again, there are side effects for some users.

Some people claim relief from taking powdered ginger capsules the night before and the morning of a trip. Ginger ale and ginger snap cookies have been popular, too.

A watch-like device called the ReliefBand shows promise of really doing the job, with no side effects for most. You simply strap the watch over a patch of lubricant on the inside of your wrist, and set the amount of charge. The device sends a gentle shock into your wrist every few seconds, and that stimulus somehow affects the nerves in the inner ear and the brain, blocking nausea. It sounds like another electronic mosquito repellent, but these things seem to work for most people. The drawback is cost, about $95, but once you buy the device you can use it indefinitely, changing the 3-volt lithium batteries after 144 hours of use at the lower levels, more frequently at higher levels.

Cheaper alternatives are wrist bands like the Magnaband, $25, and the TravelAid Band, $10, which help apply manual pressure. SB

# Get to K
# Your Se

Here's an actual o
41009-Canavera
of Cape Canaveral, Florida. (taken
http://www.ndbc.noaa.gov ) Relatively light winds are great, and even the seas at 2.3 feet are fine, but the real indicator here is the Dominant Wave Period of 7 seconds. That means that every 7 seconds, you'll experience a wave that averages 2.3 feet, which isn't too bad.

| | |
|---|---|
| Wind Direction (WDIR): | W (270 deg true) |
| Wind Speed (WSPD): | 9.7 kts |
| Wind Gust (GST): | 11.7 kts |
| Wave Height (WVHT): | 2.3 ft |
| Dominant Wave Period (DPD): | 7 sec |
| Average Period (APD): | 4.2 sec |
| Atmospheric Pressure (PRES): | 29.86 in |
| Pressure Tendency (PTDY): | +0.05 in (Rising) |
| Air Temperature (ATMP): | 79.0 °F |
| Water Temperature (WTMP): | 81.3 °F |

By the same token, let's look at this scenario from the Pacific Coast, where the seas are significantly higher at 5.6 feet. But take a look at the period, 13 seconds. You'll find a much more comfortable ride in this sea, though larger, because it's a big ground swell. Thirteen seconds is an eternity between waves and swells. It's a given that long wave periods can be very comfortable to fish in, but you must be especially careful transiting inlets or shoal areas under these conditions. A placid swell offshore can become a rage of whitewater in shallow water. Best to observe from a safe distance, then time your approach in between the sets of waves.

| | |
|---|---|
| Wind Direction (WDIR): | NNW (340 deg true) |
| Wind Speed (WSPD): | 7.8 kts |
| Wind Gust (GST): | 9.7 kts |
| Wave Height (WVHT): | 5.6 ft |
| Dominant Wave Period (DPD): | 13 sec |
| Average Period (APD): | 6.5 sec |
| Mean Wave Direction (MWDIR): | WNW (287 deg true) |
| Atmospheric Pressure (PRES): | 29.92 in |
| Pressure Tendency (PTDY): | -0.04 in (Falling) |
| Air Temperature (ATMP): | 59.2 °F |
| Water Temperature (WTMP): | 58.8 °F |

# Favorite
# Offshore Species

**O**ffshore species, for our purposes, fall into three general classes of pelagic fish. First is the world-wide billfish family, then the popular trio of kingfish, dolphin and wahoo, followed by the tuna family, that range very widely in size.

Numbers-wise, "KDW" have probably put more smiles on anglers' faces than any other combination of fish. Accessibility is a recurring theme in this book and theirs is unmatched. Kingfish are celebrated by not one, but two separate tournament circuits in the United States. Dolphin are the most popular pelagic fish among boat crews, and wahoo are considered the finest tablefare. The latter two species span the globe.

The tuna family has a cult-like following, spawned by their impressive, brute strength. From the humble bonito and blackfin to the trans-Atlantic bluefin, these fish will test your equipment, backs and endurance. Pound for pound, tuna are very tough to beat.

Every member of the billfish family continues to mystify anglers the world over with their spectacular acrobatics, brilliant colors and famous battles up to 18 hours. These fish inspire anglers, artists and writers the world over.

**Billfish inspire anglers, artists and writers the world over with their spectacular acrobatics.**

**See DVD** for more on some of your favorite offshore gamefish.

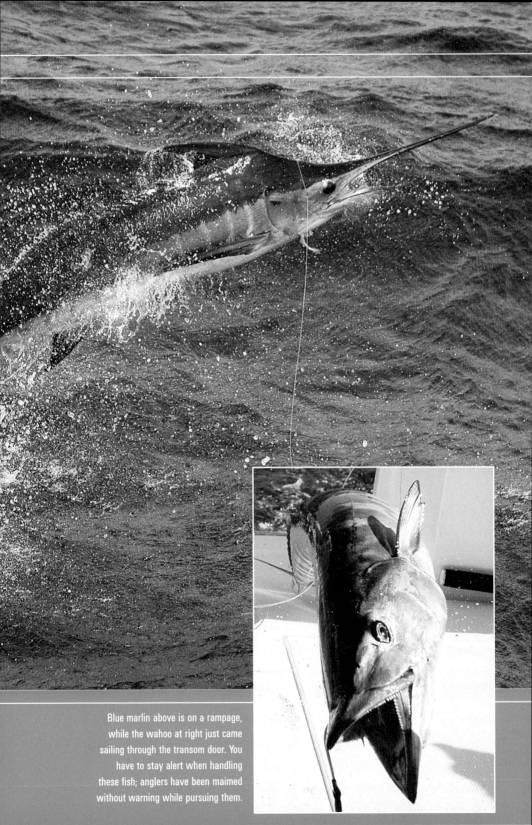

Blue marlin above is on a rampage, while the wahoo at right just came sailing through the transom door. You have to stay alert when handling these fish; anglers have been maimed without warning while pursuing them.

# Kingfish Dolphin Wahoo

**The "KDW" is certainly the most popular group of offshore pelagic fish, especially for anglers fishing from 20- to 26-foot boats.**

Kingfish, dolphin and wahoo make up a triad of pelagic fish prolific in the world's oceans. Several large species of mackerel (whether *Scomberomerus cavalla*, the king, or close cousins) are found in the Atlantic and Pacific. In the U.S. from Texas to North Carolina, kingfish have their own professional tournament circuits, with a new generation of big, center console boats chasing them down. Books have been written and TV shows produced, dedicated to these powerful and abundant coastal pelagic fish.

The world-wide dolphin is voracious, colorful and amazingly acrobatic. Couple that with a high metabolism, which means it feeds almost constantly, and you've got the most dependable action of any bluewater fish. It's also a huge hit with the public and great on the table; tournaments in South Florida and the Keys now target them exclusively. The chartreuse, blue and yellow colors streaking through the air leave an indelible mark on the memory.

What do you call a big blue mackerel that grows big enough to eat many king mackerel? A wahoo, of course. That familiar shape isn't the only similarity a wahoo has to king mackerel. They're ultra-fast, become airborne and will slice through mono line and even some wire. They also have an entire array of fast-running lures specifically designed for them. Unlike king mackerel, wahoo have fine, white meat, considerd by many to be the best-tasting of all fish.

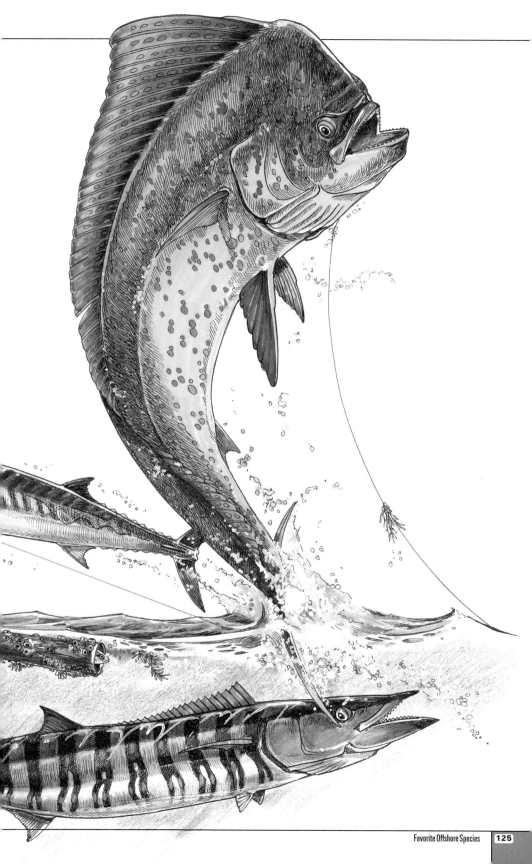

# King Mackerel

**Countless new anglers have had their thumbs burned by these fish.**

For some anglers, nothing gets the blood pumping like high-flying king mackerel. These acrobatic speedsters are often spotted taking flight, hitting baitfish as they leave

the water, or landing on top of them on the re-entry, along the entire U.S. coast from Texas to the Carolinas. King mackerel truly are everyone's sportfish. They're available close to shore, and they are relatively easy to catch on live baits like frisky blue runners, mullet and menhaden. But after catching a few you'll soon realize that, unless you're after an excellent, fresh fish dinner of smaller kings of 12 pounds or less, it's the bigger fish that create excitement. Schoolie-size kings just won't do it. For

## Kingfish by Season

Kingfish winter in warmer waters and head north during the spring and summer months.

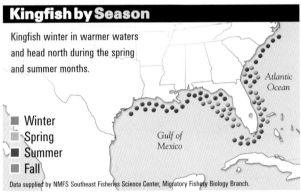

- ■ Winter
- ■ Spring
- ■ Summer
- ■ Fall

Data supplied by NMFS Southeast Fisheries Science Center, Migratory Fishery Biology Branch.

that, you need to catch a "smoker."

Truly big kingfish have been aptly nick-named smokers because of their lightning-fast run and the ability to "smoke off" several hundred yards of line in a matter of seconds, often leaving anglers with burned thumbs. Countless newbie anglers have been burned by these fish. The term smoker is relative, but generally anything over 40 pounds qualifies without raising eyebrows. These bigger kings, with the 40-

pound tournament winners averaging close to 14 years old, should be released if possible. Why? There is a health advisory against eating them, because of high mercury content. Clip the leader or even "tail-grab" and unhook those 30- and 40-pounders, for quick release. Save them for tomorrow's spawning duty or perhaps winning big bucks in some tournament.

## Conventional Tactics

King mackerel are structure-oriented, schooling fish. You'll find them on wrecks, reefs and other structure right off the beach, out to about 300 feet of water. There have been studies showing that the Gulf of Mexico and Atlantic fish are really two distinct groups. The Gulf family migrates between Texas and the lower Atlantic coast of Florida. Some Gulf fish migrate back and forth to Mexico. The Atlantic family splits its time wintering in the Florida Straits, south of Key West, then moving north, summering off the Carolinas.

These fish simply won't tolerate swimming around live baitfish without hammering them. Bluefish, menhaden, hardtails (blue runners), mullet, threadfin herring, goggle-eyes, sardines, cigar minnows and most anything swimming—even their smaller Spanish cousins—are in trouble when placed in front of toothy mackerel. Presenting these baits in a slow-trolling spread, either over or around structure, is the most effective way to target smoker kings. They're opportunistic feeders, and often slash their baits in half first, usually attacking from below. Because of this pattern, most successful anglers utilize a stinger rig, or more aptly put, a double hook rig, made of singlestrand wire and a pair of hooks. The first hook goes across the bait's nose or lips. The

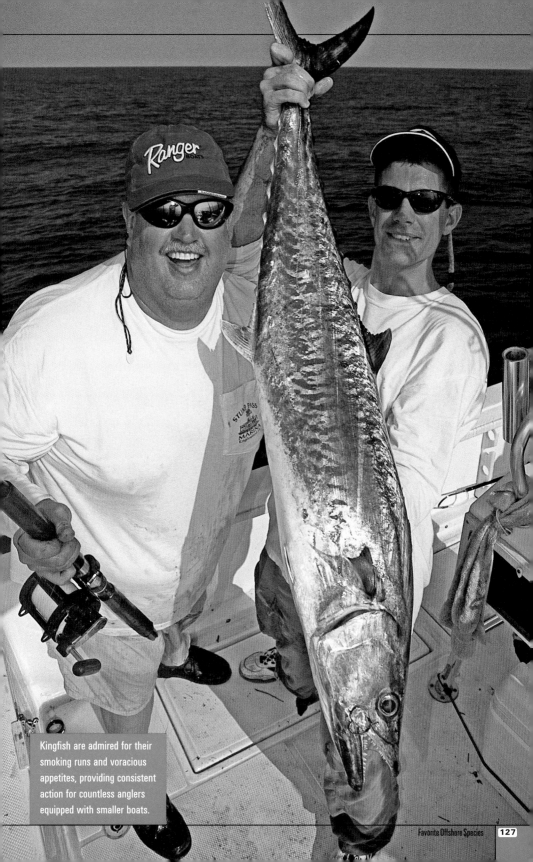

Kingfish are admired for their smoking runs and voracious appetites, providing consistent action for countless anglers equipped with smaller boats.

second hook is pinned just behind the dorsal fin, to catch the king when he slashes the prey in half. With the stinger, make sure to leave enough slack for the bait to swim normally.

Choose leaders and hooks based on the type and size of your bait. Also consider water clarity and how hot the bite is. If you're fishing in dirty green water, you can get away with bigger wire (60- to 70-pound test) and larger hooks. In very clean water or if the bite is slow, using smaller 30- to 40-pound wire is probably a good choice.

Trolling live baits for king mackerel is

really a bump-trolling technique, shifting the engine in and out of gear, or deploying a sea anchor to slow your progress. You can't pull livies more than a few knots without dragging them to death very quickly. The simplicity of the livebait spread is also the beauty of it. The goal of any spread is to give the fish the impression of a bait school and the opportunity for an easy meal. By just moving these baits forward enough to keep the lines tight, you'll keep these targets in the king's strike zone longer. And you'll know when a

A variety of baits work for kingfish, and these toothy speedsters offer lots of excitement for a great many anglers from North Carolina to Texas.

## Catching big kings is a skill that comes with time, but the nice thing is that anyone can do it.

king gets near the spread, whether he takes flight or not. Your baitfish will suddenly become very nervous. By watching the rodtip, you can often pick out which bait will be attacked first.

Trolling doesn't have to be with live baits.

A dead cigar minnow rigged behind a "duster" or Mylar skirt has probably accounted for more kingfish catches than any other bait. It's easy to rig, doesn't require catching live bait and it works consistently. You can run it from a planer, downrigger or simply toss it out behind the boat while bottom fishing. Ribbonfish trolled on a downrigger will trigger strikes, often when nothing else will. Some folks like to mix in a dead Spanish mackerel, as well. Lipped plugs like MirrOlures and Stretch 25s catch their share of kings, as do spoons and planer or wireline combinations. The kingfish isn't the most discriminating carnivore in the ocean, but they don't grow to be smokers by being stupid. Catching big kings consistently is a skill that comes with time and requires a little thinking outside the box.

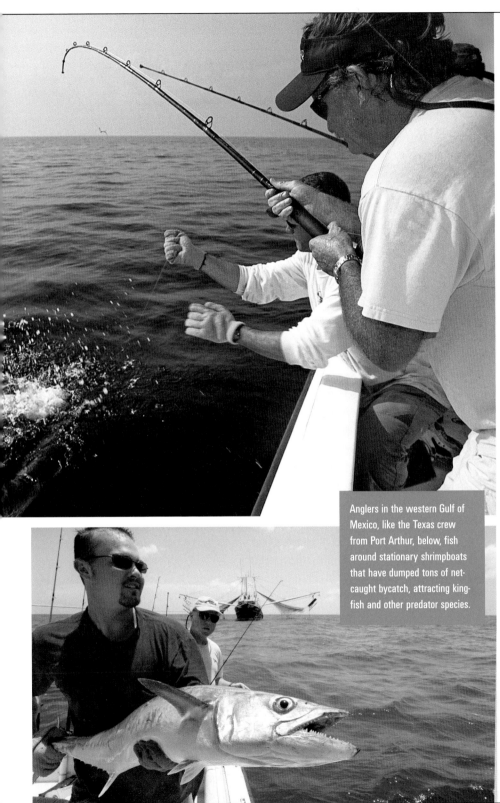

Anglers in the western Gulf of Mexico, like the Texas crew from Port Arthur, below, fish around stationary shrimpboats that have dumped tons of net-caught bycatch, attracting kingfish and other predator species.

# Attention to Detail is Key for Pro Anglers

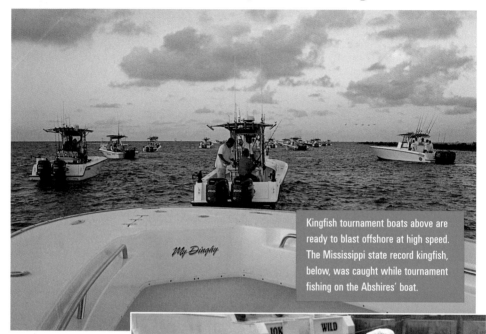

Kingfish tournament boats above are ready to blast offshore at high speed. The Mississippi state record kingfish, below, was caught while tournament fishing on the Abshires' boat.

Captain Joe Winslow is no stranger to competitive kingfishing. He's won 11 tournaments since 1999 on both the SKA and FLW circuits. Winslow and the *Hooligan* team dislike pack fishing, and they're not alone. But, there are times when you are forced to share your fishing grounds with other boats and there is a method to the madness.

"There are captains who consistently outfish the other boats in the pack because they identify a bite pattern early,"

## "There are captains who outfish the other boats in the pack, because they identify a bite pattern early."

says. "That means if your first bite happens on a goggle-eye only three feet off the bottom, then repeat exactly. Often, setting out your bait spread in a particular way, with different baits in certain positions, makes the difference between catching fish and watching others catch them. Identifying that

bite preference early on is what separates the winners from the also-rans."

Winslow added, "When you get that first bite, always make sure you know where it is and try to replicate it." Every detail is important, from downrigger depths to baits in each position.

Outfishing other boats nearby sounds like work

and that's because it is. "There is no secret spot or secret rig or secret bait," says Winslow. "This isn't a quick-fix sport. You have to take your knowledge of the bite, knowing where the fish should be, weather and historical information, and put it all together. Then you have to put your time in on the water and make it happen."

The good news is that this "work" isn't really tough to do. It means that you have to get out on the water and fish a lot.

Dan and Ronda Abshire's *Rxcape* team is known throughout the kingfish world as a top rank competitor and a past national champion. The pair has won titles and set records that still stand today, and they've done so by fishing smart and putting their time in on the water. The Abshires share their knowledge, teaching at seminars. They can be very detailed. "We almost always leave the long flatline out when we hook up a fish," Dan explained. "We might reel it in to the propwash, if we need to move it or clear it and then put it back out, but we always try to have a bait in the water when we're fighting a fish. You can't catch more fish with all your baits in the boat, and that first bite may be the one to turn the fish on."

Kingfish are competitive feeders, and I witnessed this little trick in Louisiana one year. Fishing aboard *My Dinghy*, skippered by James Hosman, we hooked up a mid-40s kingfish on the port flatline. Watching this fish "sky," we knew it was a good one. We cleared the lines and put the angler on the bow. Once we had the deck and the fish under control, John Hosman promptly slipped another hardtail rig off the back of the boat. The reel was still in freespool when another smoker king jetted through the propwash and took flight; we had a fine double-header of quality fish. Calling those two fish sisters wouldn't be stretching it; at the scales the first weighed 45.72 and the second 45.79 pounds. It turns out the crew of *My Dinghy* and *Rxcape* have shared some teammates in the past; one wonders where they learned that little trick of hooking up with double-headers.

## CAPTAIN'S CHOICE
## KINGFISH
**Captain Dan Abshire**
**Homeport: Gulf Breeze, FL**

### Rod setup
· 7-foot
· 25- to 40-pound class rods
· Shakespeare Ugly Stik Blanks
· 2 rods on downriggers
· 2 off T-top
· 1 flatline way back.

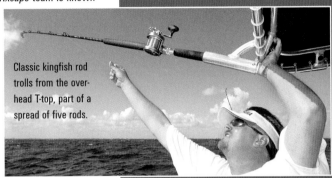

Classic kingfish rod trolls from the overhead T-top, part of a spread of five rods.

### Reels
· Shimano TN-40 loaded w/20 lb. mono

### Terminal Tackle
· Black barrel swivel, 70-pound #4 single-strand stainless wire

### Hooks
· Treble
· Eagle Claw L7774F sizes #1, #2 to 1/0 depending on size of baits

### Line
· Mono
· 20-pound

### Trolling speed
· 1-2 knots

### Bait specifics
· Big hardtails and bluefish (2 pounds)

### Preferred water conditions
· Oil rigs in 50 to 200 feet

# Dolphin

Dolphin, often called dorado or mahi-mahi, dazzle anglers with their sleek, iridescent blue and gold bodies, revealed early with their frequent jumps. They take a reckless attitude toward eating and this has earned them a reputation for being a little on the stupid side. Stupid is as stupid does: There is a difference between that and having a biological need to feed incessantly. Dolphin are simply the James Dean of ocean fish; they live fast and die young. Biologists know that

**Dolphin are simply the James Dean of ocean fish; they live fast and die youn**

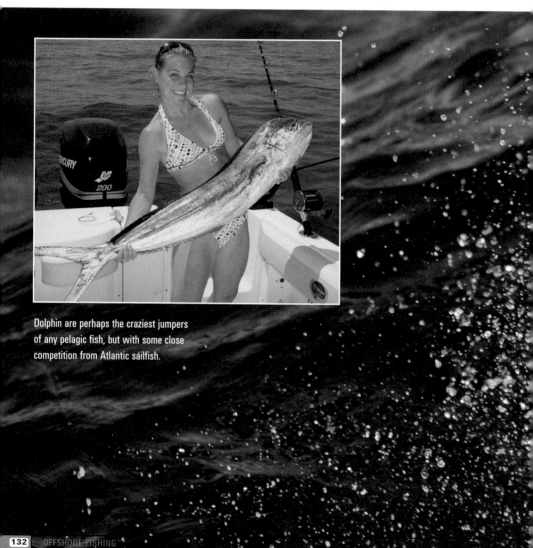

Dolphin are perhaps the craziest jumpers of any pelagic fish, but with some close competition from Atlantic sailfish.

common dolphin only live three to four years at full maturity and can grow to 40 pounds or more in their first year of life. They've been documented traveling from 70 to even 130 miles in one day. Burning that much energy would make an indiscriminate feeder out of anyone.

The South Carolina Department of Natural Resources, Marine Fisheries Division has been a leader in dolphin tagging research and has changed a lot of what we thought we knew about this fish. You can read the detailed results of related studies at www.dolphintagging.com and make your own conclusions.

There may not be a more beautiful and fun sportfish to catch than the dolphin, especially on lighter tackle. There are certainly techniques for finding the bigger fish, however.

## Conventional Tactics

Keep in mind that dolphin are schooling fish. Where you find one, there should be others not far behind. But as they grow older (or more accurately, a lot bigger), the males split off from the pack and become more solitary pelagic hunters. Along Florida's Southeast

iologists confirm that common dolphin only live three to four years.

## Dolphin by Season

Dolphin, Mahi-Mahi, Dorado, whatever name you choose, these fish invade more coastal waters than any other fish around.

*Atlantic Ocean*

*Gulf of Mexico*

*Caribbean Sea*

*Pacific Ocean*

- ■ Winter
- ■ Spring
- ■ Summer
- ■ Fall

Data supplied by NMFS Southeast Fisheries Science Center, Migratory Fishery Biology Branch.

coast, you'll find dolphin just a few miles offshore and within easy sight of the beach, sometimes in less than 100 feet of water. On the other hand, in the Gulf of Mexico around oil rigs, they're seldom seen even in 200 feet of water. They do favor buoys moored in blue water, however, and especially the deepwater rigs anchored in mile-deep water.

Generally, it's better to concentrate your efforts around weedlines, color changes and temperature breaks. Also, investigate anything you find that is floating offshore. Dolphin real-

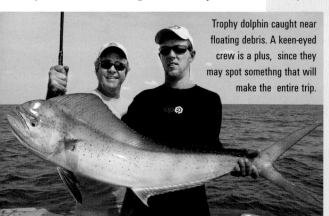

Trophy dolphin caught near floating debris. A keen-eyed crew is a plus, since they may spot somethng that will make the entire trip.

ly love the "all you can eat" smorgasbord that follows free-floating debris. That would include buckets, any pieces of wood from pallets to palm trees, even abandoned boats left by refugees in the Florida Straits. Anything that's been in the water for a few days is likely to hold them. Size is less important than the drift

## Always investigate objects th

time of that floating debris; the longer in the water, the better your chances of scoring a bite.

In South Florida and the Keys, many captains won't put a bait in the water until they see a fish or an extremely likely situation, using the run-and-gun approach of covering water at 30 knots, looking for birds or debris. In other areas, finding a temperature break, rip or color change and trolling a spread of skirted ballyhoo at six to eight knots is hands down the best way to find dolphin. It allows you to cover a lot of ground and once you find them, if they don't respond to the trolling spread, you can

### ▶ PRO TIP  DOLPHIN

# Catching Trophy Dolphin Means Switching Gears

Captain Rick Ryals of Jacksonville, Florida, says local dolphin options depend on time of year and availability. In his area, they have a run of big fish in early spring. "What you have to decide is whether you want to catch a lot of fish, or go big-fish hunting," he says.

"If you want to load the boat with fish, start looking for weedlines in the 120-foot depths," Ryals says. "Most of our weedlines run from the southwest to the northeast. Troll these weedlines with small, un-brined ballyhoo and skirted lures at five to eight knots. I don't brine my small ballyhoo because they don't swim as naturally. It means I'll change them out more often, but it's worth it. It makes a difference. However, if you want to target big dolphin better than 30 pounds, real tournament winners, you'll need to change tactics.

"We find most of the really big dolphin on the other side of the break," Ryals says, referring to the local 28-fathom curve. While deeper water often means bigger dolphin, it also means switching gears. "We'll troll swimming mullet and horse ballyhoo that are brined.

switch to pitch baits or chunking ballyhoo to fire them up. Dolphin react well to virtually any lure/ballyhoo combination, but they also will eat larger live baits and even marlin-size lures. The point here is that mixing up your spread is important and sometimes the bigger fish will opt for a different offering.

One summer day we spotted a plastic 55-gallon drum off in the distance. It was just sunrise, so we knew we had to be the first boat on the spot, as no other boat was within six miles of us, according to radar. Our spread consisted of all skirted ballyhoo save one: Our starboard flatline was a blue-and-black, Moldcraft Hooker chugging and slopping through the water with a 10/0 Owner Jobu hook hidden in the skirt. On our first pass, the entire spread made it just past the

algae-covered barrel, when that flatline lure popped the rubber band that had it clipped to the transom. The water exploded and the biggest bull dolphin I've ever seen just catapulted from the water.

We couldn't catch our breath as this fish jumped left, right and finally back at the boat, which was our undoing. In his best dying quail imitation the dolphin, half out of the water, threw his head back at the boat, earning just enough slack line to throw the hook. Maybe it was the alpha male in him, but he didn't eat the small natural baits, instead grabbing the biggest, noisiest bait in the spread, then proceeded to humble us.

Watch for circling frigate birds, when you're searching for trophy-size dolphin. The two have a close relationship.

We'll troll them a bit faster too, at 8 to 10 knots."

Targeting temperature breaks, weedlines and eddies in deeper water improves your chances of scoring on bigger dolphin, but don't bet on finding a school of big bulls. "Most of our big fish are loners, or a pair with a big cow," says Ryals. Nearly everyone has a story about losing small dolphin to big hungry bulls, but that happens around weedlines, rather than in open water. You just won't find many big dolphin schooling up with smaller ones. Too dangerous for the little ones; the big guys are cannibalistic.

"Some anglers will tell you that catching dolphin is very easy," Ryals says. "Often this is true, but bigger fish can be more leery. Our bigger dolphin we find in deeper water and they're sometimes more shy than small fish, but not always. If a big dolphin is hungry and greyhounding from the water while still 75 feet from your bait spread, just hold on; you can't stop the bite! We once had a big dolphin eat the flatline (a plastic mullet), pulling drag from the reel, before running over and eating the rigger bait, getting stuck by both hooks."

Rick obviously gets fired up when talking about dolphin; they're one of his favorite fish. He's one of countless anglers around the world who love this tasty, perfect sportfish. SB

Floating pallets are favorites with dolphin fishermen, since they offer hiding places for small fish and crabs. Dolphin will hang around them for weeks at a time.

## Dolphin

**Amazingly, 2-year-old dolphin comprise just three percent of the population, and the oldest recorded dolphin was four years old.**

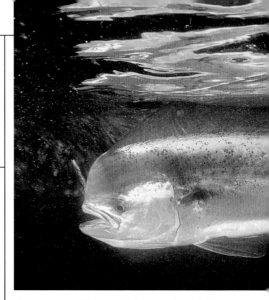

If you see a big dolphin and want to pitch a bait, (a dead flyingfish has long been a favorite in some waters) grab that spinning gear on board; it's probably the best option. But if you're blind-trolling live baits, it's better to stick with conventional gear. If you don't, that's when the man in the blue suit (blue marlin) will show up. You'll hear the knot at the bottom of your spinning reel pop in a serious hurry. Live-baiting blue runners, small dolphin, goggle-eyes (or whatever baits are holding around the weedline or debris you're fishing) will often turn up dolphin that are too shy to attend the trolling party.

According to the 15-month satellite tagging study conducted by the South Carolina Department of Marine Fisheries, the dolphin they tagged spent 63 percent of their lives at the surface, which was defined as 0 to 10 meters. That means the first 30 feet of the water column is where you should focus your efforts. That doesn't mean you should ignore the water below 30 feet, however. Downriggers and planers are responsible for lots of trophy dolphin—and gleeful spouses waiting back home for grilled mahi. (Well, maybe not gleeful.) You want to concentrate your fishing efforts on top for this fish, but during mid-day hours, don't forget to go deeper.

Don Hammond spent 35 years working for the South Carolina Department of Natural Resources Marine Fisheries Division. He spent the last four years on the dolphin tagging study, referenced earlier. It was rather unique, because there are few programs funded to study a thriving fishery. Studying fisheries in decline or under stress really doesn't give accurate data about their population. Thanks to Don, they've learned tons of information about dolphin.

Amazingly, 2-year-old dolphin comprise just three percent of the population, and the oldest recorded dolphin was four years old. That makes them rather unique.

When his 4-year study didn't get its federal funding renewed after Hurricane Katrina, Hammond understood that federal dollars were being sent to those areas hardest hit, where entire research facilities were wiped out. These were his friends and colleagues.

"I got a lot of calls to continue the study after I retired," he says. "So I challenged recre-

### Bull or No Bull

You can tell dolphin "bulls" from "cows" by simply looking at their heads. The prominent forehead on the males gives the impression they have

bigger brains. Some anglers say the cows are a little smarter than the bulls, though that's not saying much. Both will feed in a similar fashion while crashing through your spread. To get that big, single bull, you might have to change tactics a bit. Many times a single bull will hold away from the weedline or a pack of smaller fish until he's ready to eat. Concentrating on a school of smaller fish and not getting away from the weedline may deny you the bull dolphin of a lifetime. Sometimes, getting that fish may require you pull in the trolling spread and put out a live bait—or even four.

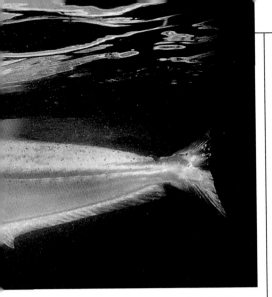

## CAPTAIN'S CHOICE
## DOLPHIN
### Captain Don Clark
### Homeport: Islamorada, FL

## Rod setup
- Two 20-pound spin outfits, 7-foot rods, pulling flatlines
- Two 30 to 50-pound conventional rods trolling way back
- Roller guides on conventional rods

## Reels
- Combination of spin and conventional

## Terminal tackle
- Spin Tackle: 5 feet of double line, 14 feet of shock leader, no swivels.
- Conventional Tackle: 5 feet of double line
- Large snap swivel
- Leaders: 100-pound for skipping baits, 150-300 for rigged plastic lures

## Hooks
- 6/0 to 9/0

## Line
- Mono: 20-, 30- and 50-pound

## Trolling speed
- High speed search: 10 knots
- Low speed in fishy area: 3-4 knots

## Bait specifics
- Rigged ballyhoo, Aliens, Softheads

## Preferred water conditions
- Weedline or current edge is ideal
- Floating debris is a home run

ational fishermen to come up with $12,000 to continue the study. They did better than that and raised $20,000 because they felt that strongly about it, and Cooperative Science Services (CSS) was born."

This really is research by and for the fisherman.

"I'm just a paper-pusher," Hammond said jokingly. "Fishermen tag and recover these fish and I record the information."

Anglers and sponsoring companies also paid the bills and we are all learning about what Hammond and many other call the "perfect" gamefish. Dolphin are a beautiful fish. They put on amazing aerial displays and they're great on the table. That's pretty close to perfect.

What surprised Don the most from the study?

"It now appears that at least some segment of the population could be involved in circumnavigating the Atlantic; that could mean traveling as much as 7,000 to 8,000 miles a year," he says.

Everyone knows dolphin will eat anything, especially smaller dolphin. But here's proof that there really is no honor among them. "We recovered a tag from the stomach of a 52-pounder," Hammond says. "We tagged a small fish earlier that morning, 10 miles away. The big fish was caught with the smaller, tagged dolphin in his belly the very same day."

# Wahoo

**W**ahoo are one of the tastiest fish in the ocean. And that's only part of their charm. These tiger-striped rockets are also among the fastest swimmers, predators from the top of the food chain. While related to kingfish, wahoo certainly don't school like them, though you will find them in smaller groups on occasion. Tournament wahoo anglers in The Bahamas, with a strike, keep the boat moving at fast-troll for a few extra moments, hoping for multiple hookups. They've hooked and land-ed triples and quads this way, during the winter run of fish.

Big wahoo in many areas tend to be soli-tary, though they are almost always accom-panied by a trematode, which is a flat-worm that is present in their stomach. These little "wahoo bombs" are harmless and don't affect the fish or the meat; just don't be surprised

Wahoo researcher Dr. Jay Baldwin examines fish at Bahamas wahoo tourney.

when you clean your first one.

Wahoo are fast-growing fish, and there are plenty of stories about monsters exceeding the current IGFA all-tackle world record of 184 pounds. They are found worldwide in tropical and subtropical waters and regardless of where you find them, they keep anglers tossing and turning at night, trying to figure them out.

## Conventional Tactics

The best way to target wahoo is trolling, period. The only debate on this is whether to troll high-speed, which is generally regarded as exceeding 10 knots. Trolling at 8 to 10 knots seems to get the nod from the majority of anglers and captains. High-speed lures produce without question, but being able to mix in nat-ural baits such as horse ballyhoo at slower speeds seems to out-fish high-speed lures alone. A notable exception is in The Bahamas, where dragging artificials at 12 knots and up has been demonstrated to catch more wahoo, while excluding barracudas, sharks and other nuisance species.

The same skirted ballyhoo lures that you pull for billfish, dolphin and tuna will catch wahoo, but there are some key lures that specifically target those sharp little teeth from the 'hoo. Jethead lures and weighted lures adorned with a big ballyhoo will cer-tainly raise the ire of a wahoo. The aforementioned world record was caught by a 15-year-old girl from Texas, trolling a "Mean Joe Green" on mono line, from a charterboat off Cabo San Lucas on the Pacific side of Mexico. Mixing in lipped plugs and tremblers will fire up the 'hoo bite too. Some argue you can't troll too fast for big 'hoos. These fish cer-tainly have an appetite for speed and can be caught while trolling at speeds up to 20 knots. However, the

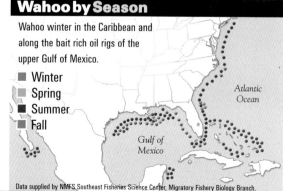

## Wahoo by Season

Wahoo winter in the Caribbean and along the bait rich oil rigs of the upper Gulf of Mexico.

■ Winter
■ Spring
■ Summer
■ Fall

Atlantic Ocean

Gulf of Mexico

Data supplied by NMFS Southeast Fisheries Science Center, Migratory Fishery Biology Branch.

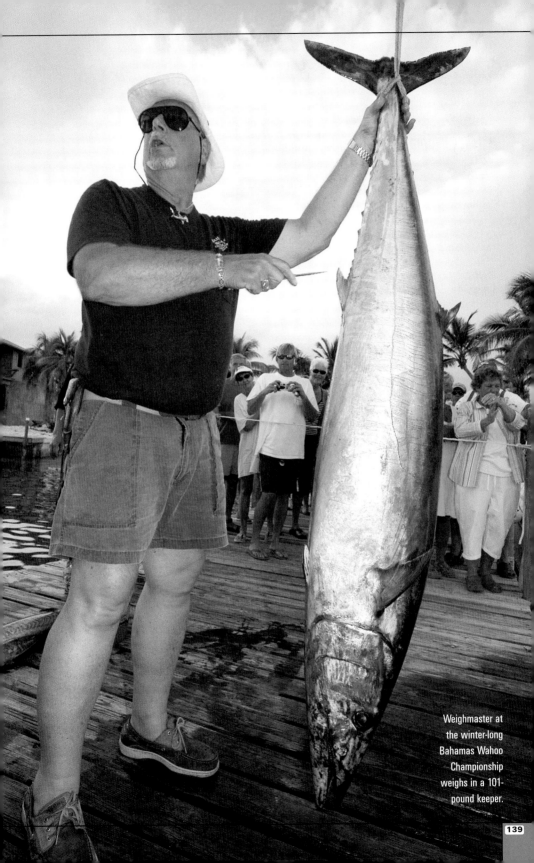

Weighmaster at the winter-long Bahamas Wahoo Championship weighs in a 101-pound keeper.

## Wahoo

**Wahoo certainly have an appetite for speed and can be caught while trolling at up to 20 knots. They actually prefer speedy lures.**

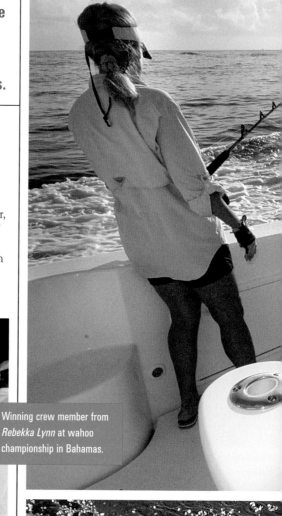

speed at which your lures run properly will be more of a determining factor than anything else.

You don't have to catch them on the fast troll though; these toothy critters are always happy to crash through a standard trolling spread of skirted or naked ballyhoo. Moreover, you might take a page out of some specialists' playbooks and target wahoo without wire. Many captains argue they get more shots with heavy mono leader and don't mind losing a lure or two.

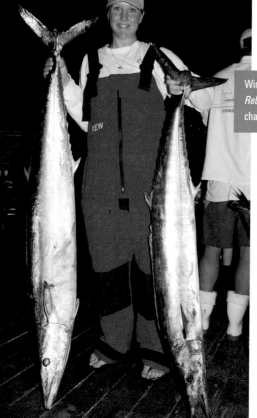

Winning crew member from *Rebekka Lynn* at wahoo championship in Bahamas.

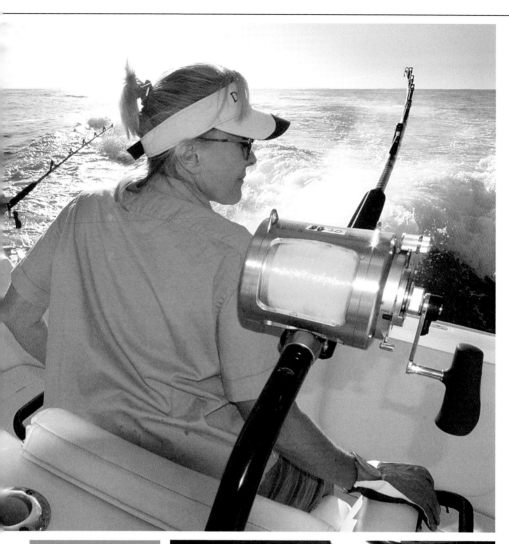

Another winning boat crew above, aboard *DoMarlo*. A variety of baits will work; the home-made baits below won first place wahoo stringer for Peter Rose from Freeport in The Bahamas.

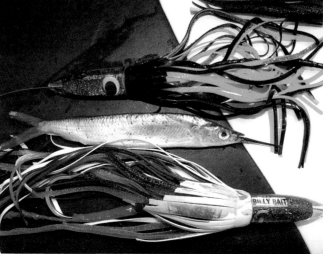

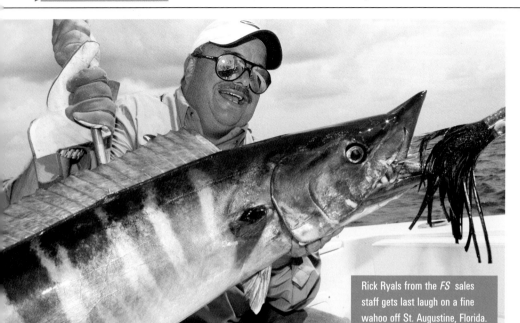

Rick Ryals from the *FS* sales staff gets last laugh on a fine wahoo off St. Augustine, Florida.

# There is a Method to Catching Multiple Wahoo Offshore

Captain Mike Ellis fishes out of Venice, Louisiana, but for 20 years he fished multi-year stints in The Bahamas and Caribbean. That makes for a broad education in wahoo methods.

"The way we target wahoo might seem more like kingfishing to some folks," he says. Ellis' current favorite spread consists of four rods, with a pair of Mann's Stretch 25 diving plugs, and then a pair of MirrOlure 113MR-20's. The Stretches are on the center long and in the propwash, while the MirrOlures find themselves staggered on the corners. These lipped baits run at different depths and allow Mike to cover different parts of the water column. His Louisiana wahoo charters target oil rigs in the 200- to 500-foot depths. "I'll make three passes on the upcurrent side of a rig and if I don't get a strike, we'll move on unless we're marking an awful lot of bait," he explained.

Ellis shared a tip on what his anglers can do to increase their chance of double- and triple-headers. "We'll instruct them to reel the other lures in like crazy when we get a hookup. That added activity

and action will often get us more strikes." Many folks are content to concentrate on the fish hooked up, but overlook the opportunity to take advantage of the competitive nature of fish.

"Targeting wahoo doesn't take fancy gear or even two-speed reels, just stout 30- to 50-pound tackle that can hold plenty of line. If you're trolling at six to eight knots and the striped speedster is heading around 50 knots in the other direction, you can burn off a lot of line quickly."

Captain Ryals says get the baits down below the propwash. He has a theory that has merit. "The big eyes on the 'hoo are right on top of their head and I think the higher the sun gets, the more they go down. I catch most of my wahoo on the first and last quarters of daylight," he says.

"If you want to troll and not just for wahoo, I'll put a horse ballyhoo on a black/red Ilander and use a Z-wing or big No. 16 planer on 400-pound monofilament to get it down. You're more likely to get a wahoo bite with this, but anything down deep will eat this offering and you can run it with a standard trolling spread. This is good up to about 10 knots. If I'm just targeting wahoo, I'll put out a high-speed spread with the two flatlines running 48-ounce trolling leads in front of the lures."

The key with any wahoo trolling where you're

running baits below the surface is to set the drags just tight enough to keep from pulling drag while trolling. "If you're trolling at 10 knots, you'll be surprised at how much pressure is on that trolling lead already," says Ryals. "Put your baits out at trolling speed and set your drags then. Lever drags are superior here; that drag should start clicking with any grass. There are two principles at work: First, you can't see the baits to know when they are grassed up. Second, wahoo pull the hooks often enough without a tighter drag adding problems."

They head-shake, make blistering runs at the boat and hit with such intensity, they often tear a big hole in their jaw. Allow any slack in the line when they're on the hook and it's maybe rice and beans for dinner, instead.

Another key to remember when running trolling leads is to put a short trace of wire just before and after the trolling lead. "About 30 percent of my strikes hit the trolling lead itself," says Ryals. "If you don't have wire on both sides, you'll be replacing lures."

Big-game ball-bearing swivels are also essential, at the terminal end of the fishing line, and at both ends of the mono shock leader, which separates the trolling lead from the lure.

Many anglers use braided line on their high-speed gear and with diving lures. Why? Line diameter is smaller and the baits get down better. They work great, but much like wireline outfits, braid doesn't stretch. If you're trolling lures with a lead weight, the mono leader should be at least 15 to 20 feet long to act as a shock absorber.

On the subject of trolling with wire, a number of old-school charter captains spool up heavy trolling outfits with 200 to 600 feet of stainless or Monel trolling wire. This is normally attached to a few hundred yards of backing. The wire goes deeper, pulls straighter and wins wahoo tournaments, but many anglers consider it unsporting, because commercial wahoo boats use exactly the same technique. The wahoo on wire are winched in with big, bent-butt rods that are seldom held or leave the gunnel.

High-speed trolling is an art and like most fishing, it's also addictive. It has many little tricks that vary from angler to angler, which is why it's so popular.

## CAPTAIN'S CHOICE
# WAHOO
**Captain Ron Schatman**
**Homeport: Bahamas**

### Rod setup
- 30- to 50-pound class rods
- Standup rods
- Roller guides
- 3 flatlines

### Reels
- 30W and 50W conventional reels

### Terminal tackle
- No double lines
- 1- to 4-pound lead weight on 4-foot cable
- Stainless, double-ring ball bearing swivel
- 20 feet of 400-mono or 480-pound cable

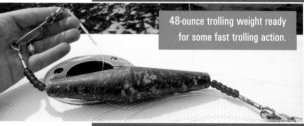

48-ounce trolling weight ready for some fast trolling action.

### Hooks
- 9/0 single or double hooks

### Line
- 50-pound high-vis on 30-class reels
- 80-pound high-vis on 50-class reels
- Backing is 80-pound braid

### Trolling speed
- 16-18 knots if conditions permit

### Bait specifics
- Plastics with 9-inch skirts
- 3-ounce egg sinker inside skirts
- Red, green and purple baits
- Lines staggered at 70, 130 and 270 feet

### Preferred water conditions
- Ink blue water
- Falling barometer
- Deep dropoffs

# The Billfish

**M**arlin are respected the world over for their graceful, sleek build and masterful command of the ocean. White and striped marlin are the smaller members of the family, but don't be fooled by their size; they fight as hard and fly as high as their bigger relatives. Blue and black marlin can reach weights well over 1,000 pounds, even twice that. Catching a "grander" of either species is considered an elite achievement.

Catching any marlin is the thrill of a lifetime; if you get the chance to watch a marlin dance through the air and then bring him boatside, it's a moment never to be forgotten.

**Some people are adamant that marlin use their bills to slash at baits before eating them. Others claim that bill is for defensive purposes.**

Marlin are protected from commercial sale in many areas, but remain open to harvest in other countries. Their value is such that a live marlin is easily worth a hundred times more when caught by recreational anglers. Restaurants that serve marlin should be encouraged to switch to other, more plentiful fish. Only the tasty swordfish is openly pursued by commercial boats around the world. When protected from longline harvest, they've made a comeback in some areas like Southeast Florida, where smaller boats now pursue them at night.

# MARLIN   They feed "first with hunger, again out of anger, then

**M**arlin are aggressive feeders and there are several ways they can strike. Whether a marlin actually uses his bill when feeding gets the Hatfields and McCoys of the ichthyology world a fightin'. Some people are adamant that marlin use their bills to rip or slash at baits before eating. Others contend the bill is just defensive and ornamental. They argue that billfish swallow their prey whole and it doesn't make sense that they would try to subdue baitfish with a pointy nose. Stomach content analyses on har-

vested fish reveal that sometimes the baits are slashed, presumably by the predator's bill. Other times baitfish are unmarked and swallowed whole. The only logical conclusion is that fish and prey encounters differ. To assume that a bill is strictly ornamental seems a bit shortsighted, however. Whether a bill is used as an offensive or defensive weapon is surely situational. Video cameras towed underwater have shown billfish repeatedly whipping their bills back and forth, batting at the bait.

In a 1933 letter to *Esquire* magazine, "Marlin off the Morro: A Cuban Letter," Ernest Hemingway wrote about how a marlin feeds. He said there were four ways: They feed "first with hunger, again out of anger, then simply playfully, last with indifference." Anger and hunger will make it hard to miss a fish. You can't ask for more from a feeding marlin. But opportunity and ambivalence is where angling skill and luck come in. Watching a lazy or playful billfish swimming in your spread or simply mouthing a bait means that you'll have to do something to get that fish "lit up."

Trolling a spread of artificials mixed with a few skirted natural baits is the most effective way to cover ground and locate marlin. The size of your cockpit, crew and personal preference will determine if you run five lines or more. Having a variety of bait sizes is critical. A blue or black marlin will eat baits large and small, but smaller fish like white marlin show a marked preference for smaller baits. If you pull only big baits in the spread, you could easily miss out on a white or striped marlin. Larger natural baits are generally placed in the flatline positions, while smaller swimming baits are run from outriggers and center-rigger positions. The flatlines will ideally be placed just behind a teaser or dredge running in the same position, just a bit shorter. Teasers are often placed on the first wake, for example, with the flatline bait just

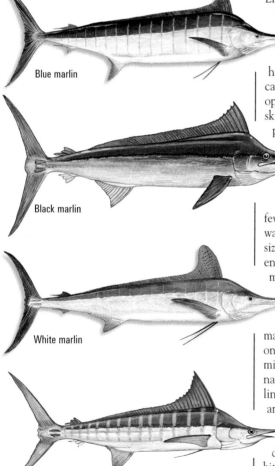

Blue marlin

Black marlin

White marlin

Striped marlin

behind on the second wake. It takes a little adjustment and time, but they produce fish consistently.

Live baiting isn't as effective for covering ground in a search mode—but put a frisky skipjack, blackfin, runner or small dolphin in front of a marlin and your bait has a short lease on life.

Live-baiting marlin is more effective when a fish has been spotted or you know there are fish in the area. Oil rigs, offshore humps and ledges concentrate them. Free-jumping marlin are often finicky and on the move, but they at least let you know you're roughly in the right spot. Lots of bait and fish activity without getting a bite might signal it's time to switch to live baiting. Top marlin fishermen are prepared to retrieve plastics and either pitch a bait or drop a live one back and bump-troll, moving slowly or staying in position in the current.

No marlin is more respected, with more die-hard fans in many parts of the world, than the blue marlin.

While trolling one summer, our captain wasn't doing a good job of reading the water next to the boat. I climbed up the tower and as soon as I peered off to starboard, I spotted an indolent blue marlin swimming only six feet from the boat. It was such a surreal sight, and we didn't have a live bait ready. He obviously didn't want our trolled baits and I'll always wonder what if. We *just don't go* offshore without live baits or at least the means to catch it.

Marlin spend most of their lives in the top of the water column in warm waters the world over and that's fortunate, because watching them feed is awesome. Whether it's a bill sliding up behind a chugging lure or the flash of a marlin's back as he intercepts the bait at a 90 degree angle—the sight of the most graceful fish in the ocean is unforgettable.

# Blue Marlin

**B**lue marlin may be the most majestic of the marlins because of prominence and size. Characterized by a cobalt upper body and silvery white undersides, this beast weighs up to a ton. A sharp dorsal fin and

Just another day when you live in Puerto Rico. Put in a day at the office and then troll barely a mile off the beach.

pointed pectorals can help you discern a small blue marlin from cousin white marlin, which sports more rounded fins. The Blues Brothers are found the world over in tropical and warm ocean waters. Most in the scientific community agree there are two distinct populations of blues, one Atlantic, the other Pacific. The International Game Fish Association lists the records separately.

Captain Myles Colley leads one of the hottest tournament teams in the Gulf of Mexico, called *Dataman*. Their skill as a billfishing team is evident by the numerous trophies, photos, flags and ceremonial checks adorning the walls of their tackle room. They exemplify the two most important things for success in billfishing: Patience and consistency.

Having the patience to wait out a bite, when you know you're in the right area can be tough, but it does pay off. You need to have confidence in your trolling spread; leave it alone and let it do the job.

"We don't mix up our spread that much," Colley shared. "We get results pulling a lot of Moldcraft Wide Ranges. They just work. We'll run a blue-and-white Ilander with a horse ballyhoo on the center rigger and four other Wide Ranges most of the time."

It's more about where you fish and whether or not there are even fish in the area. Colley contends that if you are in an area that has activity, be it baitfish, a color change or weedline loaded with bait, it's only a matter of time before the bite turns on. "One year at the Panama City Bay Point Tournament, we fished until four o'clock the first day without a bite. We knew we were in the right spot, waited it out and then just after four we caught two blue marlin in an hour." The bite didn't stop there; the team tagged the two blues, three whites and two swordfish to take home top tag-and-release boat honors.

Consistency shouldn't be confused with being stubborn. It also doesn't mean that you should never mix up your bait spread. If you're not getting bites and other boats around you are, chances are it's your bait spread and not an absence of fish behind

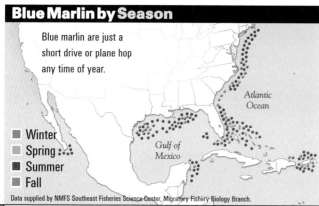

## Blue Marlin by Season

Blue marlin are just a short drive or plane hop any time of year.

Atlantic Ocean

Gulf of Mexico

- ■ Winter
- ■ Spring
- ■ Summer
- ■ Fall

Data supplied by NMFS Southeast Fisheries Science Center, Migratory Fishery Biology Branch.

your boat. "We've got a lot of confidence in the spreads we pull, but if other boats around us are hooking up and we're not, we'll mix it up," says Colley. He explained that a single boat hooked up doesn't warrant switching all your lures out. However, if there is truly a bite going on and you're not cashing in, it might be time to mix in more skirted ballyhoos or even switch to live baiting.

Team *Dataman* has a reputation for live baiting successfully. In deciding when to run livies, Myles looks for signs of life. Live baiting around oil rigs loaded with bait is an easy call to make. But a weedline that isn't producing with a trolling spread is another matter. Other opportunities in open water call for having live

## CAPTAIN'S CHOICE
## BLUE MARLIN
**Captain Myles Colley**
**Homeport: Pensacola, FL**

### Rod setup
- 6-foot
- 50-pound-class rods
- Bent butt
- 2 rods on outriggers
- 2 flatlines
- 1 flatline way back.

### Reels
- Shimano 50W loaded w/50-pound mono

### Terminal tackle
- 20-foot wind-on, 10-foot working leader
- Sampo swivel

### Hooks
- Owner Jobu 8/0 to 10/0

### Line
- Mono
- 300-pound leader for small lures
- 400-pound leader for large lures

### Trolling speed
- 7.5 to 8 knots

### Bait specifics
- Moldcraft Wide Range, Ilander with ballyhoo

### Preferred water conditions
- Weedlines, current rips and color changes

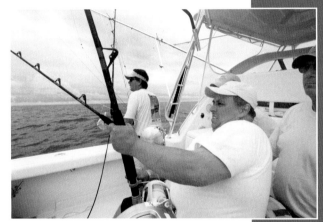

Anglers above are backing down fast on marlin. At right, deckhand in Mexico checks trolling hook for sharpness—the hard way.

baits handy; almost all modern boats carry livewells, so why not stock up on a few live baits? "We've even caught blue marlin live baiting on whale sharks before, but there needs to be something there like a feeding fish, a bait school or structure like an oil rig for us to switch." Of course, live baiting at low speed in empty, open water is not a productive way to locate fish, when you only have a few hours.

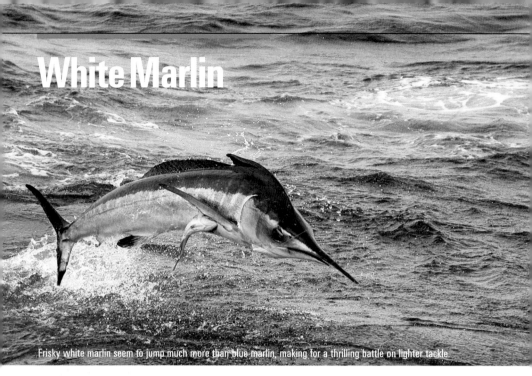

# White Marlin

Frisky white marlin seem to jump much more than blue marlin, making for a thrilling battle on lighter tackle.

White marlin get a bad rap, sometimes. They regularly drive anglers crazy by molesting each bait in the spread without finding a hook. Other times, they eat hungrily and leave you scratching your head. Maybe Hemingway was targeting white marlin when he used the term "ambivalence" in his feeding theory. Make no mistake, when white marlin find a hook, they'll take flight like their bigger cousins and put on a great aerial show. These fish might be smaller, but they don't take an acrobatic back seat to any fish. They'll tail-walk again and again, often for a long time, in a manner that many blue marlin would disdain.

Whites are found throughout both the eastern and western Atlantic and Gulf of Mexico. Anglers encounter them while canyon fishing off New Jersey, as well. They're hugely popular off both Venezuela and Maryland, and that's a big stretch of water. They aren't characterized as a schooling fish, but anyone who's fished for them for long knows that double and triple hookups on whites are not unusual. They feed on smaller fish, but rely heavily on squid and flyingfish as a food source. It's no surprise that a lot of squid teasers and skirted ballyhoo running behind a bird teaser are bad medicine for whites.

Whites are the smallest of all marlin, averaging 50 to 70 pounds, but they can reach 180. Large whites are often mistaken for small blues, as they look rather similar underwater or when jumping at a distance. A quick inspection of the dorsal and pectoral fins will reveal their true identity. Whites have very rounded pectoral and dorsal fins, while a blue marlin has sharply pointed fins.

## White Marlin by Season

White marlin follow a similar pattern as larger blues, but you'll often find them in shallower water.

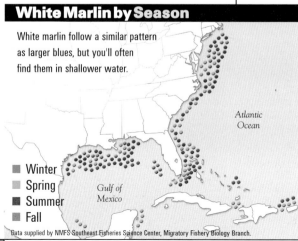

Atlantic Ocean

Gulf of Mexico

■ Winter
■ Spring
■ Summer
■ Fall

Data supplied by NMFS Southeast Fisheries Science Center, Migratory Fishery Biology Branch.

When targeting whites, it's a great idea to rig both naked and swimming ballyhoo, keeping several ready as pitch baits on spin tackle. Some captains contend that the skirts can put off a picky white marlin, but a naked ballyhoo trolled or even pitched will do the trick when these fish are turning their beaks up at skirted offerings. "When we're targeting white marlin specifically, we'll run more natural baits and pull mullet dredges or strip teasers," Colley added, "but we do catch them with our standard spread."

Nearly every billfish tournament around has white marlin listed as strictly tag-and-release, and hopefully any straggler weight tournaments will follow. White marlin are the primary recreational billfish for anglers fishing U.S. mid-Atlantic states and extremely important to all billfishermen. According to the International Commission for the Conservation of Atlantic Tunas (ICCAT), "Commercial fishing fleets cause 99.21 percent of reported annual Atlantic billfish mortality." (www.iccat.int) Commercial longlines and overfishing must be addressed, but recreational anglers have a responsibility to conserve these fish as well. Tag-and-release is the standard with white marlin.

Atlantic and Gulf of Mexico hotspots for white marlin can be viewed at: www.bigmarinefish.com

## CAPTAIN'S CHOICE
## WHITE MARLIN
### Captain Jeremy Cox
### Homeport: Pensacola, FL

## Rod setup
- 5½- to 6-foot
- 30- to 50-pound class stand-up rods
- 2 rods on outriggers
- 2 on flatlines
- 1 flatline way back

## Reels
- 30W to 50W

## Terminal tackle
- 10- to 15-foot working leader
- 150- to 200-pound mono leader

## Hooks
- 6/0 to 7/0

## Line
- Mono
- 30- to 50-pound

## Trolling speed
- 5 to 7 knots

## Bait specifics
- Small to medium skirted ballyhoo
- Ilanders, small Moldcrafts
- Naked skipping ballyhoo way back

## Preferred water conditions
- Blue, rip or weedline
- 300 to 600 feet

Small skirts and ballyhoo are the bait of choice when trolling for white marlin.

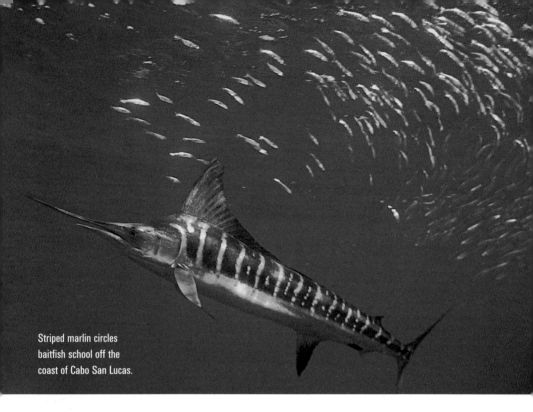

Striped marlin circles baitfish school off the coast of Cabo San Lucas.

# Striped Marlin

Striped marlin are Indo-Pacific fish, meaning they're found predominantly in both the Indian and Pacific oceans, though some eastern Atlantic fish are found. They range from an average of 150 pounds up to about 440, making them the mid-size marlin. They're beautiful fish with pale blue stripes separating 15 rows of deep blue/black on the upper half of their body. They sport a pronounced dorsal fin, often spotted together with its tailfin breaking the water, as it feeds. On Pacific seas, these "tailing" marlin get anglers excited over the prospects of visually "hunting" these fish.

Striped marlin are found relatively close to shore in areas with steep dropoffs. There are hotspots for striped marlin along the west coast of the United States, Mexico, Central and South America. New Zealand, Australia and Africa also have established fisheries.

Hunting stripeys is like any sight fishing, but requires acute attention to detail from an entire crew. Sure-footed anglers are usually placed on the bow of a sportfisher, which gives them an elevated platform to cast live baits. This visual hunting is similar to cobia fishing along the upper Gulf of Mexico each April. Or stalking a reluctant bull dolphin hanging below a weedline or cruising slowly in tailing seas. With stripes, the captain uses binoculars from the tower and concentrates farther out, while a second spotter in the tower watches

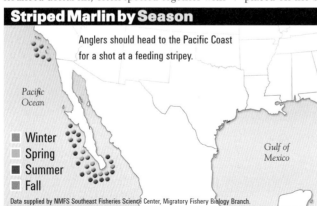

## Striped Marlin by Season

Anglers should head to the Pacific Coast for a shot at a feeding stripey.

Pacific Ocean

Gulf of Mexico

- ■ Winter
- ☐ Spring
- ■ Summer
- ☐ Fall

Data supplied by NMFS Southeast Fisheries Science Center, Migratory Fishery Biology Branch.

zones closer to the boat. All anglers are responsible for keeping their eyes peeled forward and off to the sides, and someone has to watch the bait spread.

Casting live baitfish from the bow can be tricky, particularly with a long leader, which is best to fight these high-jumping fish. While there aren't any outriggers to get snagged on, just keeping your balance and not slinging your live bait off the hook can be difficult. Anglers casting from the bow pulpit learn to master the art of the lob cast, because the leaders used are often 10 feet long. When casting to striped marlin, the goal is to lead the fish by placing the baitfish in front of the tailing marlin; both bait and marlin will know what to do next. With the reel in freespool, you let the marlin eat and when you're confident he's taken the bait, ease the reel to strike (or engage the bail on your heavy spinning gear), pump the rodtip a few times, and somehow make your way safely back to the cockpit with one hand—while a jumping marlin tries to pull you overboard.

**Watching any fish eat is the best thing in fishing. Combine that thrill with a marlin that can reach almost 500 pounds, and it doesn't get more exciting than that.**

# CAPTAIN'S CHOICE
# STRIPED MARLIN
**Captain Bill Boyce**
**Homeport: Saugus, CA**

## Rod setup
- 6½- to 7-foot
- Seeker MLB30 or MLB50
- Aftco Ring Roller tip guide
- Large guides all the way to tip

## Reels
- Shimano TN-30 or TLD25

## Terminal tackle
- 10 to 15 feet of mono leader, 150- to 200-pound strength

Medium-size tackle is fine for striped marlin, including spinning and trolling gear.

## Hooks
- Circle hooks sized to baits

## Line
- 30-pound main line

## Best method
- Sight fishing

## Bait specifics
- Tinker mackerel and goggle-eyes

## Preferred water conditions
- Sight fishing in calm water, bow casting near dropoffs and deepwater banks

# Black Marlin

**S**ome big-game anglers argue whether blue or black marlin grow bigger, because fishermen will argue about anything. Most agree that while blues grow larger, more black marlin eclipse the 1,000-pound mark, becoming "granders." Some believe it's the makeup of the fish, which is fundmentally different from blue marlin. Black marlin are stockier and their short dorsal fins join a pair of non-retractable pectoral fins. The black marlin is strictly an Indo-Pacific fish, like its cousin the striped marlin. Anglers never get the chance to tangle with a black, unless they travel to hotspots like western Mexico, Hawaii, Australia, Panama or Costa Rica.

Much like its striped cousin, black marlin are considered to be a coastal pelagic billfish, which may mean they aren't true ocean-going fish. However, a black tagged off of Australia in 1996 traveled more than 8,000 miles and was recaptured in Costa Rica more than four years later. These fish continue to challenge what we think we know about them.

One thing we do know is that black marlin love skipjack tuna. Most pelagic predators love skipjacks, but if you polled the most successful black marlin skippers the world over, you'd get

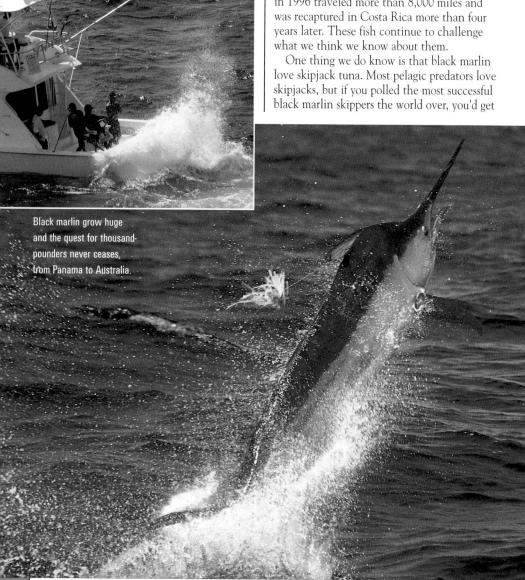

Black marlin grow huge and the quest for thousand-pounders never ceases, from Panama to Australia.

a resounding endorsement for this shiny little tuna. It's a resilient fish that's mostly caught while "making bait," which is using small feathers or diamond jigs behind the boat. Most captains agree that bridling them through the eye sockets or across the nose is the most effective way to keep them swimming longer and acting frisky. When live-baiting with large baits like the "skippy," you'll want your reel to have just enough drag tension to keep the baitfish from pulling off line–close enough to freespool, that the marlin doesn't feel tension and spit the bait out. Large circle hooks are great for live baiting, usually 16/0 to 20/0 circles depending on the brand, as their sizes vary by manufacturer.

Black marlin are seemingly more workman-like than their more acrobatic and sleek blue cousin, but their raw power is unmatched by other marlin.

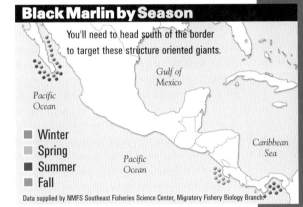

## Black Marlin by Season

You'll need to head south of the border to target these structure oriented giants.

Gulf of Mexico

Pacific Ocean

Caribbean Sea

Pacific Ocean

- ■ Winter
- ■ Spring
- ■ Summer
- ■ Fall

Data supplied by NMFS Southeast Fisheries Science Center, Migratory Fishery Biology Branch

Black marlin seem to prefer tuna over any other baitfish.

# Sailfish

Sailfish are instantly recognizable for their unmistakable dorsal fins, heart-pumping acrobatics and amazing speed. These small billfish will often tail-walk across the horizon after you hook up. They can be

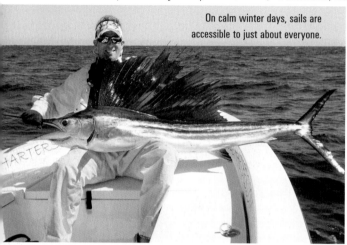

On calm winter days, sails are accessible to just about everyone.

caught while trolling or drifting live baits. If you get the chance, they're a blast to bait-and-switch on the fly. Captain George LaBonte said it perfectly when he called them "the working

## Sailfish by Season

Sails definitely have hotspots, like Stuart, FL–the sailfish capital of the world.

Atlantic Ocean

Gulf of Mexico

■ Winter
▢ Spring
■ Summer
▢ Fall

Data supplied by NMFS Southeast Fisheries Science Center, Migratory Fishery Biology Branch.

man's billfish" in his book *Sportman's Best: Sailfish*. The accessibility of these fish is the perfect example of how offshore fishing is within reach of anglers who want to experience the thrill of a lifetime.

Sails are found the world over in warm waters, but they bunch up in hotspots like Florida's Sailfish Alley, the Yucatan Channel, Guatemala, Costa Rica and Panama. The Atlantic sail's counterpart in the Pacific grows considerably larger, and can reach weights well over 100 pounds.

## Conventional Tactics

Sailfish migrate south from the mid-Atlantic coasts in the late summer, reaching North Florida in the early fall and "Sailfish Alley" (Fort Pierce to Miami) in late fall through the winter months. Stuart, Florida, has long called itself the sailfish capital of the world, but today there are many ports on the lower Florida peninsula that could make that claim.

Most sailfish pros prefer a trolling spread of naked ballyhoo, but will mix in a small lure such as a Sea Witch, Ilander or other small skirt to keep the baits from washing out as fast. Trolling is a good way to cover ground while trying to find the bite, but you have to ease up on the throttles. These fish prefer a trolling speed from 4 to 6 knots, for dead bait. This speed also allows you to effectively use dredges and teasers. Artificial teasers like holographic strip teasers and soft plastic body teasers do a great job of imitating a bait school and attracting bites. Natural dredges are very effective, too.

Sailfish especially hang around baitfish sources. You'll likely find baitfish located near structure such as man-made wrecks and natural ledges. Sailfish will prowl as shallow as 25 feet, so even small pieces of structure holding bait can produce a hot bite. They are most often associated with the clear blue water of the open sea, but you can catch sails in green water, on occasion. Or water on either extreme of their preferred temperature spectrum (72 to 85

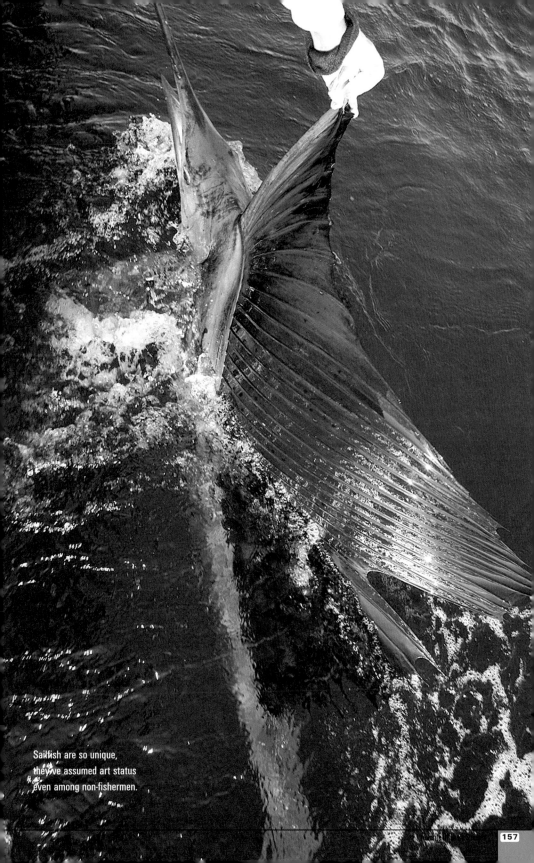

Sailfish are so unique,
they've assumed art status
even among non-fishermen.

degrees) if there's plenty of bait. It's important to watch water clarity, temperature and the current, but it's more critical to fish around baitfish schools.

Sailfish are more localized and pack-oriented than other billfish. Once you locate the bite, there is perhaps no more effective way to convert bites into releases, than using live blue runners, ballyhoo, threadfins, Spanish sardines, cigar minnows or other small fish. The mother of all sailfish baits is the goggle-eye. "Gogs" are more hearty than most baits, silvery and like candy to feeding sailfish. (Also dreadfully expensive during tournaments—to catch these winning baits yourself, you have to catch them at night with sabiki rigs off Atlantic beaches. That means lack of sleep the next day.)

Most sailfish anglers stalk their prey with 20-pound gear, but preference and experience will dictate line class somewhere between 12 and 30 pounds. Conventional gear with lever drags is ideal because it allows you to ease the free-spooled bait to strike very smoothly and lets the circle hook work to perfection in the corner of the fish's jaw, as designed. You can do the same with spinning gear, but it does take a bit more skill. Spinning gear is ideal for pitching baits to a teased-up sail.

Kite fishing is standard practice among the South Florida fleet, at least from Palm Beach south to Key Largo. The kites allow you to fish more lines and cover more ground. The excitement of a baitfish skittering and jumping on the surface drives sailfish crazy and produces some of the most amazing strikes you'll ever see.

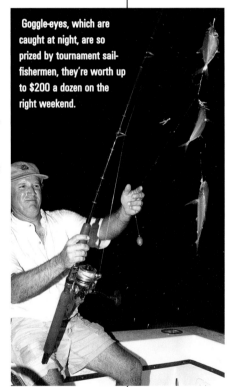

Goggle-eyes, which are caught at night, are so prized by tournament sail-fishermen, they're worth up to $200 a dozen on the right weekend.

## PRO TACTICS SAILFISH

# A Tournament Pro Racks

Chip Sheehan heads up the red-hot team from Boynton Beach in Florida, named *Chips Ahoy*. This tournament-winning team (the three lads with red shirts on the book cover) shared some key things you can do to increase your hookups on these fish.

The most important thing you can do is fish where conditions are right for sailfish. That means baitfish, clean water and ideally some current, but you also need the fish. Chip's voice gets excited when he talks about sailfishing: "It's important to find out where they were caught the day before," he says. "You don't have to be a tournament fisherman to network." That means networking down at the dock, tackle store and online at the FS Forum. "You might not have any current, but ten miles up the beach they have a north tide. A cell phone really helps."

You also have to fish the conditions that you're given. "Most of the time we're 'on the bag'," he explains, referring to a collapsible sea anchor, or drogue. Sheehan explained that kite fishing on a sea anchor is a vital part of their success. "However, on our best day of fishing we caught 30 sails, slow-trolling sardines. We never got a chance to put a kite up."

Which proves you have to adjust to the conditions you're given. *Chips Ahoy* hit a home run that day, as they matched the hatch right off the bat. "We were one of the only boats that had the right bait. We found the sardines and the fish were balling sardines that day. It was incredible!" Days like this are absolute clinics that you can learn a great deal from.

How many times have you heard captains of all disciplines preach about capitalizing on the bite? "We caught 26 of 30 fish that day between 8 a.m. and 1 p.m. The rest of the day we had four fish. You have to take advantage of the bite when it happens."

# up Sailfish Releases

Sheehan says that success in an incredibly fast-paced sport like sailfishing means everyone needs to know their job ahead of time. You don't have to be in a tournament when the chips are down (so to speak), to make sure everyone knows what to do when a fish hooks up. Who's pulling the sea anchor? Who's clearing which lines? These are things to assign your crew ahead of time to vastly increase your chance of success. A single fish hooked up isn't so hard to talk your way through, but a double, triple or quad and it can get messy very fast, if you're not ready.

If you're not experienced at drift fishing kites, Sheehan has some pointers that can help regardless of what fish you're chasing. "You have to give the fish an open lane to the bait," he says. "We all know these fish are headed south in winter and if you're fishing a north wind and don't make any adjustments, that kite will be on the south side of your boat and you'll be between migrating fish and the kite bait." He says in a straight north wind, secure the sea anchor to the bow or even amidships. Put your kite rod on the bow and then you can send another kite up off the stern. That way, you should have open lanes to both baits. You'll also want that sea anchor to slow your drift in strong winds and currents. Both factors will give your baits a beating and the bag slows your drift and gives you more control.

It's critical to have fresh bait, and using the right bait in the right situations can make a difference. "We all love goggle-eyes for kite baits," says Sheehan. "They're hardy and strong enough to last on a kite. But on those days when the wind is light, other baits can fire up the kite bite. My favorite bait is a Spanish sardine; sails eat them everywhere."

Chip will usually run soft baits like the sardine on the flatlines, but when you're having trouble with just enough wind to sail the kite, light baits are just the ticket. "That's when smaller baits make a difference on the kite," he says. SB

Blue runner above is rigged for a pitch-bait. For kite fishing, hook them on the top, near dorsal fin.

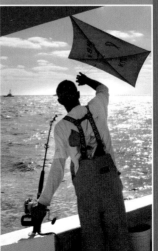

## CAPTAIN'S CHOICE SAILFISH
**Captain Chip Sheehan**
**Homeport: Boynton Beach, FL**

### Rod setup
- 7-foot
- 15- to 30-pound class
- Both spinning and conventional

### Reels
- Spinning: Daiwa BG90
- Conventional: Daiwa Solstice 40

### Terminal tackle
- 50-pound fluorocarbon leader
- 6 to 10 feet long

### Hooks
- Eagle Claw 2004 Circle
- 7/0 to 9/0 sized to baits
- Larger hooks for goggle-eyes, smaller hooks for scaled baits or sardines

### Line
- Mono
- 20-pound

### Trolling speed
- Drifting with 1-2 kites

### Bait specifics
- Goggle-eyes, Spanish sardines and blue runners

### Preferred water conditions
- Bluest possible with north current

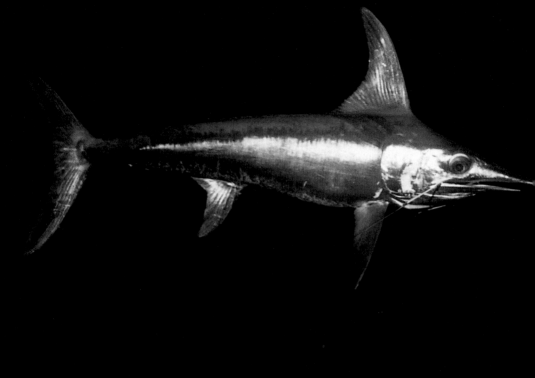

Hooked swordfish nears the boat. They've made a comeback after commerci

# Swordfish

**S**wordfish are generally regarded as night feeders, but now and then one is caught in daylight, by a troller or live-bait boat. They spend the daylight hours in deeper water, and come closer to the surface to feed as the sun goes down. The elusive broadbill is making a comeback as a recre-ational gamefish. These fish are gorgeous; their giant eyes look right through you at boatside and their round bodies are accented by that long, sword-like bill. Swords are found the world over in temperate and tropical waters and can weigh in excess of 1,000 pounds. Like marlin, female swords grow bigger than their male counterparts. The all-tackle world record is 1,182 pounds, taken in 1953, but it's unlikely you'll encounter a fish that large today. These fish have taken a pounding by commercial longline boats over many years. Once commercially fished to low numbers, more restrictive regulations have enabled local resurgence in the fishery, but there is more work to be done. Responsible management will help to ensure these fish are around for future generations.

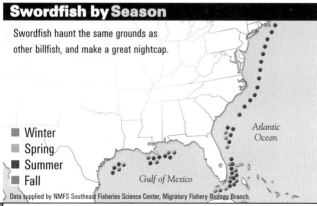

## Swordfish by Season

Swordfish haunt the same grounds as other billfish, and make a great nightcap.

■ Winter
■ Spring
■ Summer
■ Fall

Atlantic Ocean

Gulf of Mexico

Data supplied by NMFS Southeast Fisheries Science Center, Migratory Fishery Biology Branch.

rvest was curtailed in some areas.

## Conventional Tactics

Swords are typically caught while drifting in 600 feet and deeper. The most effective tackle is the same used for big-game trolling during the day, 50- or 80-pound class reels with rods to match. This tackle is generally placed on one side of the boat and staggered at depths ranging from 100 to 450 feet.

To the main line, attach a Caribbean swivel, which is a beefed-up three-way swivel. This little gem allows your weight to be inline with the main line and sword light. Your leader is crimped to the swivel that can float 360 degrees around the main line, without kinking or getting tangled. The leader size varies by angler preference, but 300-pound leader is commonly crimped to the swivel. A 9/0 or 10/0 J-hook or offset J-hook is attached to the end of the 10- to 12-foot leader. (Some fishermen use longer leaders, to separate the hook from the weight. The thinking is, this allows the fish to fully engulf the bait, without feeling the resistance of the considerable weight.)

Circle hooks are not too popular with sword fishermen. Some say the circles get "balled up" when used with squid, and anglers have a hard time setting the hook. Swords bite differently than other fish; they'll pick up the bait and head for the surface, slacking the line. That's a terrible way to set a circle hook; these hooks are designed to hook fish going away.

The most commonly used baits are squid, blue runners and mackerel. Whole squid is a fine bait; you simply need to make sure that you have plenty on hand before leaving the dock. To mix up your baits a bit, catch a few hardtails, goggle-eyes or flyingfish for the livewell, though the supply is a little less certain than frozen bait. Many boats report that using a light offshore like the Hydro Glow will attract baitfish that can be scooped up or caught on light tackle. Make sure the livewell has a variety of baits before heading offshore.

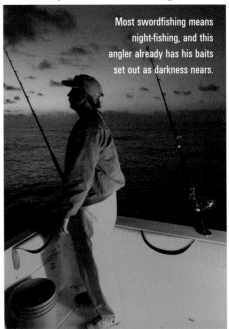

Most swordfishing means night-fishing, and this angler already has his baits set out as darkness nears.

Swordfishing is a year-round fishery. At opposite ends of Florida, captains Dean Panos of Miami and Jeremy Williams of Pensacola catch these fish all year. Miami-based anglers travel 20 miles offshore for swordfish, but upper Gulf and Northeast boats run 50 to 70 miles. Often, day-trollers spend the night out there, drift-fishing for swords after dark.

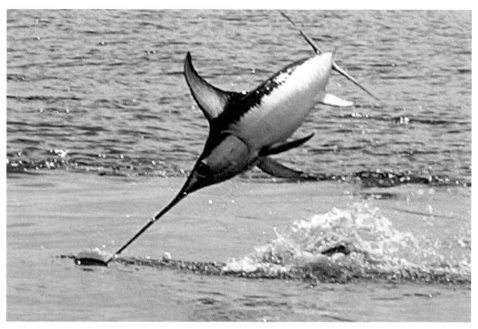

# Swordfish Join the Weekend Anglers Again

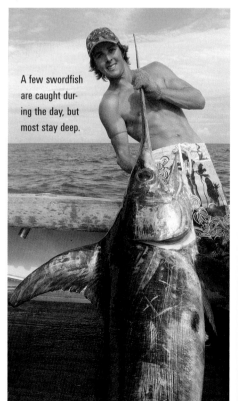

A few swordfish are caught during the day, but most stay deep.

Jeremy Williams skippers a private boat out of Pensacola. He is credited as one of the first captains to actively tag and release swordfish in the Gulf of Mexico. He's done so with more than 70 percent of his swordfish, tagging 19 of 21 during 2006 alone.

"I always fish off the same side of the boat, with three rods staggered at depths from 100 feet to 400 feet," says Williams. "I try to keep everything organized the same way each time, so regardless of who's turn it is on the rod, everything is in the same order." This is great advice, for people who wake up to a squalling reel and the cockpit in chaos.

"The biggest problem we have up here in the northern Gulf is that we often don't have much current," Williams says. "We'll fish live bait on slick, calm nights but if it's rough or we have a good drift going, we'll use mostly dead baits."

A lot of times you'll match your drag settings to the line used. Williams has a different take on drag settings, matching them to his hook size. "If you're fishing 6/0 hooks on a 30-wide reel, 12 or 13 pounds of drag is appropriate. Bigger hooks on heavier tackle require higher drag settings, such as 16 to 18 pounds on an 80-wide reel when using 10/0 hooks. Drag pressure will set that hook."

Hydro Glow and others make portable bait-

attracting lights designed to run off 12-volt battery power. They are far cheaper than installing fixed underwater lights on your sportfisher, and work just as well. I've talked to captains in other areas who fish from dark boats; they don't use lights except on their baits. Others light up the night as best they can. "In the upper Gulf, fish know the (deep) oil rigs are a constant food source," says Williams. "At night they would light up a football field. Swordfish associate light with food and that's why we see them in our spreader lights so much." Swords in the upper Gulf aren't shy about investigating a boat and sometimes you can feed them right off the transom.

Moon phases affect all fish, but swordfish are *notorious* for their nocturnal ways. Captain Dean Panos is a Miami-based charter captain who specializes in swordfishing. "I like the quarter moon rising to about five days past the full moon," Panos says. His success as a sword fighter is widely known and he shares his ideas. "I fish six rods at staggered depths from 50 to 400 feet." Without a strong current, six lines in an open console boat would become a tangled mess.

"It's important to have a variety of baits on board," says Panos. "Some boats use squid exclusively, but I still fish mixed baits. We use dead squid and live baits like blue runners and goggle-eyes. We'll also use tinker mackerel in winter."

As for gear, Dean doesn't leave anything to chance for his clients. "We use 80-wide Alutecnos two-speed reels on short bent-butt rods." The bent-butts serve two main purposes. First, it's hard to "high-stick" a bent-butt, which means raising it too high and lowering too fast, putting slack in the line. Second, the bent-butt allows the rodtip to be more horizontal and you can watch the tip for any changes in tension or bouncing, which mean you have a fish checking out your bait. And the two-speed reels come in handy when you're fighting a big sword.

"Pay close attention to the bite," says Panos. "If the rodtip bounces or your drag clicks a couple times, you have to react quickly or you'll miss out. These fish often head straight to the surface, and you have to reel fast."

## Rod setup
- 6½-foot
- 80-pound class
- Short bent butt
- Wind-on guides

## Reels
- Alutecnos 80W 2-speed

## Terminal tackle
- 30-foot wind-on leader 250- to 300-pound test
- 5- to 8-foot working leader same size
- Crimped swivel between leaders

## Hooks
- Mustad Southern Tuna Style 7691 9/0 to 10/0 stainless

## Line
- Mono
- 80-pound

## Trolling speed
- Drifting

## Bait specifics
- Live: Tinker mackerel or blue runner
- Whole squid

## Preferred water conditions
- 1,000 to 2,000 feet, over humps

Bait lights are mandatory, above. Novel tandem rig with natural and plastic squid, below.

# Tuna: Blackfin, Bluefin, Yellowfin

"**F**ootballs in the air" is a common cry when you spot a school of tuna taking flight. Yellowfin tuna routinely eclipse the 200-pound mark and fish over 400 pounds have been documented. The largest of the tuna family, bluefins, can reach more than 1,000 pounds, and are known for their fall/winter run off the coast of North Carolina, where many are tagged and released around offshore wrecks. Many tuna today are caught on smaller trolling

## The largest of the tuna family, bluefins can reach 1,000 pounds.

baits like cedar plugs, feather jigs and spreader bars, which are very effective at mimicking schools of small baitfish that the tuna family feeds on. Pound for pound there isn't a tougher or tastier gamefish in the ocean.

Yellowfin and bluefin tunas have a worldwide distribution, while the smaller blackfin is found in the western Atlantic, Caribbean and Gulf of Mexico. Tunas are a schooling fish, ganged up more by size than by species, so mixed schools of blackfin, skipjacks and small yellowfins are common. Other tuna species of interest are big-eye and albacore.

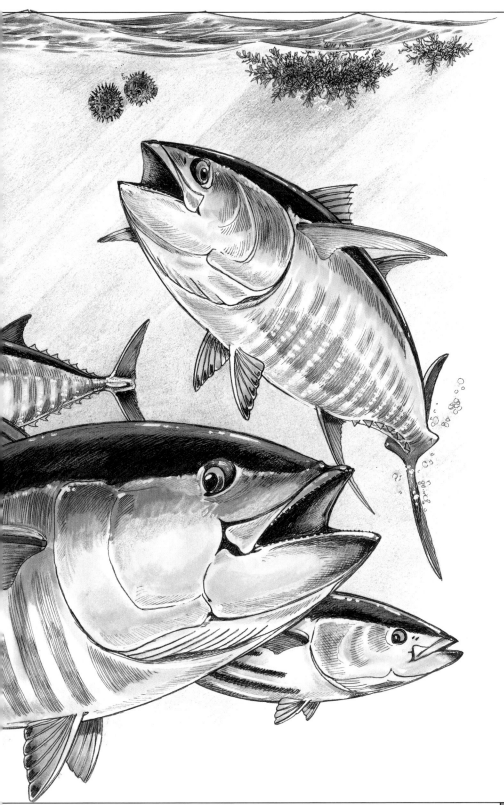

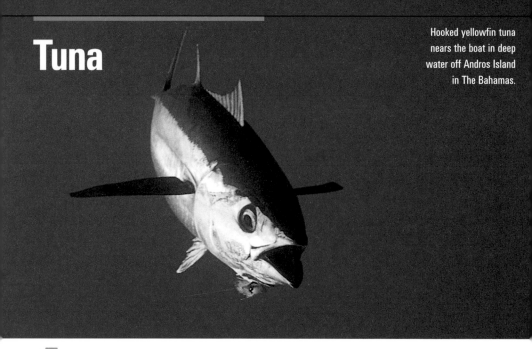

# Tuna

**A**ll three of these members of the tuna family can be caught trolling a typical spread of baits that you would drag for most bluewater fish. In fact a lot of tuna caught while trolling are bycatch, a nice addition to a long day spent on the water. To increase your odds of catching tuna, you'll want to tweak your bait spread.

Most folks know that time-tested cedar plugs produce tuna, often when nothing else will. But the cedar plug is usually a token tuna lure in a billfish spread. On the other side of the coin, Atlantic coast anglers have become exceptional at targeting tuna on the troll. A pair of spreader bars, one consisting of Sevenstrand Green Machines and the other with squid skirts, is ultra-productive on tuna. Mix in a small skirted ballyhoo/Ilander jr. on one rigger, a tuna feather on the other rigger and put a cedar plug on the center rigger line, and you have a tuna spread that few can resist.

Depending on geography, you might be tuna trolling in 120 feet off the Northeast coast or 3,500 feet in the Gulf of Mexico. If you don't have bait, a water temperature change or something to attract the tuna, you're just wasting time. Tuna are voracious feeders and they must swim constantly for oxygen, so they are constantly on the move. Satellite tagging studies show they will feed in an area that is ripe with bait, then travel overnight or for a few days and then return to the same area to feed again. As long as you find baitfish in blue water, you can find

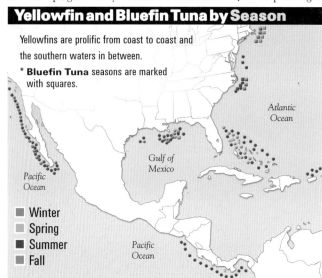

## Yellowfin and Bluefin Tuna by Season

Yellowfins are prolific from coast to coast and the southern waters in between.

**\* Bluefin Tuna** seasons are marked with squares.

Atlantic Ocean

Gulf of Mexico

Pacific Ocean

- ■ Winter
- ■ Spring
- ■ Summer
- ■ Fall

Pacific Ocean

Data supplied by NMFS Southeast Fisheries Science Center, Migratory Fishery Biology Branch.

tuna. Sooner or later.

When targeting smaller tuna such as summertime bluefins off the Atlantic coast, 30-pound gear will suffice. Most anglers troll for tuna with 50-pound gear, except in known haunts where monster yellowfins or bluefins hang out—like the Louisiana or North Carolina coasts during the winter bluefin run. Using 80- to 130-pound gear is more sensible in these situations. A 200-pound yellowfin will test any class reel, but a 600- to 800-pound bluefin will require a good crew and a little luck.

## Chunking/Chumming

Chumming or chunking for tunas narrows your focus. The concept is the same whether you're chunking butterfish in the Hudson Canyon or pogies on the Lumps off Louisiana. Your goal is to get enough of a chumslick going, with chunks of bite-sized baitfish flowing downcurrent, to attract tuna to your boat. Strategically placed among the free-floating chunks in the current are baits you buried a hook in. Chunking is effective whether on anchor or drifting, but for drifting you don't want a fast, 4-knot current. There's nothing glamorous about this technique. It's a lot of work but very effective at firing up the tuna.

## Live Baiting

Watching the water explode as your baitfish jumps and skitters, trying to escape a monster tuna, is pure excitement. You always hear the tired phrase, "big baits equal big fish," but tuna are a classic exception. They love small baitfish. Runners roughly the size of your hand work far better on big yellowfin than larger baits. As with any rules on fish, there are exceptions. Small skipjacks or blackfin tuna meant for billfish will occasionally end up in the belly of a really big yellowfin or bluefin tuna.

Live-baiting for tuna and marlin is very similar, and first you need confidence that these fish are around. Open-water live-baiting isn't the best way to find these fish, but once you've found them, it's very effective.

Sturdy tackle is required for bigger yellowfin tuna up to 300 pounds. Or bluefin tuna, which grow four times bigger.

# Yellowfin Tuna

Captain Scott Avanzino operates his charterboat out of Venice, Louisiana, possibly the fishiest spot in America, and famous for big yellowfin. Scott claims that, "Ninety percent of the time, we'll target yellowfin around a platform that's holding bait. That rig might be in 350 feet or 3,500. It really just depends on where the bait is."

It's a formula anglers have heard countless times before: No bait, no fish.

In the spring the pogies run out of the river and during fall the mullet do the same thing. Hardtails (blue runners) are abundant year-round, and so are the tuna. "People always ask me, 'what's the best time to catch big tuna,' and I tell them it's when you can get a weather window and go fishing," says Scott. Bait running out of the Louisiana marshes turns on the tuna, wahoo and even blue marlin during winter months when everyone else is hunting or stowing their gear.

For live-baiting yellowfins, Avanzino uses 50-pound trolling gear loaded with 80-pound line. He backs the reels with 600 yards of Spectra, and tops it off with 300 to 400 yards of 80-pound monofilament. "It's not often a yellowfin will get into that backing, but if a big bluefin or blue marlin hits, I want to catch him," he adds. He puts those reels on 130-pound-class rods because the pressure they have to put on these fish can be tremendous.

The bait of choice is usually a blue runner attached to a 10/0 circle hook. Mullet are very productive as well, particularly during autumn, which coincides with the mullet run. You can choose to bump-troll those live baits or (depending on your depth) anchor and fish them from a kite while chumming. Live baiting with a kite is a

The cedar plug below has long been a favorite of serious yellowfin anglers.

little more work than just bump trolling, but often when nothing else is producing, the kite will. "We caught our biggest tuna ever, a 229-pounder, on a kite bait," says Avanzino. The topwater explosions are fantastic fun to watch and it allows you to cover more fishing ground, particularly when anchored and chumming.

Off Florida's east coast from Cape

Canaveral to West Palm Beach, anglers prowl on the other side of the Gulf Stream, and yellowfins are the target. Captains here know that birds will congregate over feeding tuna; these guys depend on their radar—fine-tuned to pick up seabirds—to locate tuna several miles away, beyond visual sight. Capt. Ed Dwyer out of Canaveral has been crossing the Gulf Stream current for years, boxing countless yellowfin tuna. He starts by checking out a deepwater buoy anchored some 70 miles out (see chapter 6) and then begins prowling the area with radar, also using lookouts with binoculars.

# Bluefin Tuna

Bluefin tuna are the biggest members of the tuna family, infamous for dumping big reels of all line. The cries across the radio of "Bluefin, bluefin, we're hooked up," are often followed by a solemn sounding, "We got dumped." Generally considered a northeastern fish, these tuna are trans-Atlantic travelers. Fish tagged in the states have shown up in the Mediterranean. They then return to their spawning grounds in the Gulf of Mexico.

Anglers target bluefins off the coast of North Carolina's coast from late November through February. They school around big wrecks in the Gulf Stream during winter, and can be caught repeatedly from center consoles and sportfishers alike. There are also midwinter runs quite close to the beach. Many have been tagged and released there. Bigger, giant bluefins prowl the cold waters farther north, up to Nova Scotia. The fishery has become highly commercial along the East Coast; the Japanese will pay big bucks for a bluefin in prime shape with lots of body fat. It's the equivalent of winning an offshore tournament, if you sell one of these fish.

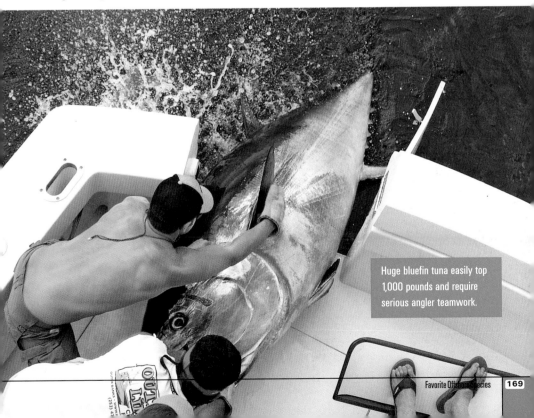

Huge bluefin tuna easily top 1,000 pounds and require serious angler teamwork.

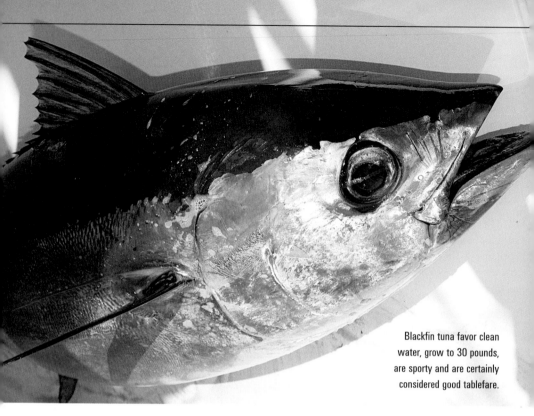

Blackfin tuna favor clean water, grow to 30 pounds, are sporty and are certainly considered good tablefare.

# Blackfin Tuna

The little brother of the tuna family is the blackfin. They're feisty, fun on light tackle and more than just bait for big blue marlin. These fish are often chummed up as precursors to bigger tuna showing up. Blackfins are known for their voracious appetites and they'll readily hit metallic diamond jigs down deep. If you can find them schooling nearshore, as they do in the fall and winter months, they make an excellent topwater quarry. During winter, they school by the thousands around oil platforms in deeper water, especially around the 700- to 900-foot rigs off Galveston/Freeport in Texas. That's where overnight headboat tuna

trips catch many fish, especially if they can find two consecutive days of calm weather on a weekend during winter. These fish are hungry and not picky, grabbing frozen cigar minnows drifted around the boat. At night under the lights, action gets frantic.

The most famous blackfin tuna hotspot is The Hump off Islamorada in the Florida Keys, where these fish school and feed on top almost all year. Small, trolled plastic skirts and 12-inch eels work there. Early and late are best, but watch for diving birds and whitewater during the day, even jumping tuna that are busting minnows.

If you cast a topwater popper anywhere near a school of feeding blackfins, hang on. Work that popper fast and the fish often can't resist. To increase casting distance and add some security in case a yellowfin takes the lure, load your spinning gear with braided line. Make sure to back it with monofilament to keep the braid from spinning around the reel, but a couple hundred yards of 50- to 80-pound braid means that you can cast that popper a long way and not worry if a good-size tuna grabs on.

# Skipjacks and Bonito

These lesser-known, smaller coastal tuna don't enjoy full tuna status with some boat crews, but they can still be fun on casting tackle. Hook one of these guys on 12-pound spin gear, and watch the fireworks; a hooked fish will change direction every minute or so, running anglers around the boat. They'll hit fly gear as well, causing a real workout. Generally, both species prefer a small presentation, since they often feed on tiny minnows. They may get so hungry during winter, however, they'll inhale an entire 10-inch mullet. Both species are not considered welcome tablefare with many boatcrews, who are used to eating better. However, quickly bled and pressure cooked, their meat turns fairly white and tasty. Bleeding quickly is a trick many tuna anglers use on all tuna species, by the

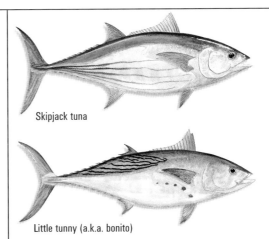

Skipjack tuna

Little tunny (a.k.a. bonito)

way. Cutting the throat latch or tail is considered best, and this is doubly important for skipjack and bonito. Both species are used for live blue marlin baits, and their belly meat is valued for strip baits, especially while trolling for sailfish

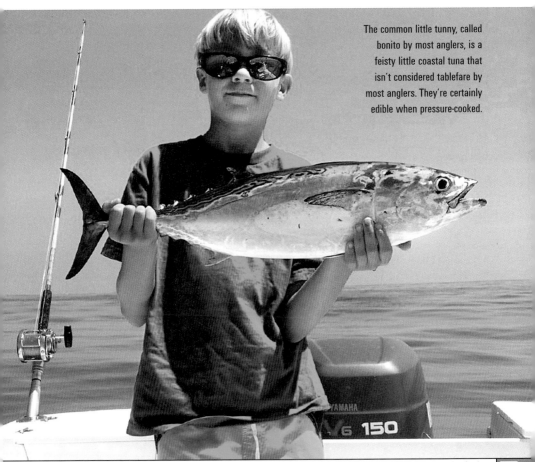

The common little tunny, called bonito by most anglers, is a feisty little coastal tuna that isn't considered tablefare by most anglers. They're certainly edible when pressure-cooked.

# Other Players

You're bound to encounter a variety of other players when venturing offshore. Life would be boring if you didn't. Often it's a role player that saves the day when tried and true tactics fail you the water. You

might luck across a pair of pelagic tripletail sunning around a bucket. You might be pleasantly surprised to have a cobia swim by, a curious fish investigating the boat. Another alternative is to break out the light tackle and tube lures, to bend your rod and let a barracuda smoke your reel drag for a bit. Or, perhaps that fish you're reeling in will be grabbed by a mako

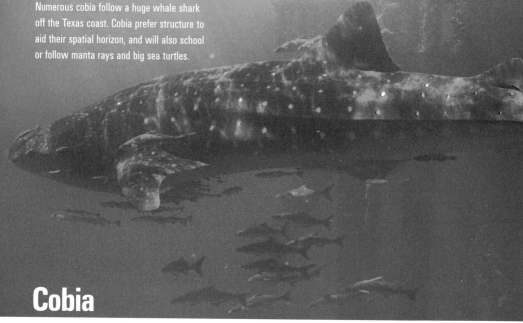

Numerous cobia follow a huge whale shark off the Texas coast. Cobia prefer structure to aid their spatial horizon, and will also school or follow manta rays and big sea turtles.

# Cobia

Cobia are perhaps most famous for their spring migration along the Florida Panhandle's sugary beaches during an eight-week period beginning each March. But these fish are caught almost year-round, gathering in the Florida Keys each winter, then spreading north to Texas and North Carolina each summer.

Cobia hang around floating weed clumps, turtles, rays, whales and huge whale sharks. They love anything that moves slowly. Or doesn't move at all, such as offshore buoys. When you're offshore, anything floating deserves a second look.

The biggest crowd of diehard cobia fans are along Florida's Panhandle and those Alabama

beaches right next door.

Any small fish, cut bait or even artificials (especially bucktail jigs) will fire them up, but live American eels are rated tops. Curlytail grubs, bucktail jigs and even dead baits like cigar minnows and menhaden work. Cobia are strong, but a good working drag on solid spinning gear is usually enough to handle them. If an oil rig or moored buoy is close by, these fish will head for structure and spinning gear may not be strong enough. When you get these fish boatside, be sure to gaff them straight into the fishbox. Why? They're famous for going crazy in the boat and creating mahem. But, they're also one of the tastiest fish roaming the coast and well worth pursuing.

or tiger shark. You never know what might be encountered offshore and that's part of the appeal.

"I've never seen that in my life." You hear that from people who have been fishing offshore for years, and it's usually a good thing.

As long as luck is a factor in fishing (which means forever), these role players and supporting actors will continue to save the day and give memorable performances.

"The award for Best Fish in a Supporting Role goes to the 300-pound mako that jumped 25 times on a spring day during cobia season, 2005." Now that was a show that was really worth watching!

# Barracuda

Big-mouth strikes again! For most folks, stalking the toothy and lithe barracuda on a shallow flat is downright fun; these fish can jump low and flat up to 30 feet on a good day. If you're fishing offshore, however, these guys are far less desirable. And sometimes quite abundant, which is not a good combination. Barracuda will often follow a trolling spread and can be identified with a frothy strike, followed by a listless fight. They will decimate a livewell full of fresh baits before moving on or finding a hook. They're fearsome in appearance to man and fish alike, but their reputation as a threat to humans is greatly exaggerated.

Cudas can grow to 100 pounds, but you're more likely to encounter them in the 10- to 40-pound range. They have a cruel set of Doberman-like teeth that would impress anyone, capable of knocking a big kingfish in half with scarcely a tap on the line. If you find yourself bored while fishing and a 'cuda shows up to the party, try a shiny spoon, bucktail jig or better yet a tube lure, worked as fast as possible. You can use live bait, too; a frantic blue runner turns them on like nothing else will. Losing a prime bait like that may not be worth the tradeout when fishing offshore.

There isn't much reason to keep a barracuda, as many folks won't eat them. They have been closely associated with ciguatera poisoning, after hanging around certain coral reefs where the organism grows. It takes months to get rid of the symptoms if you eat a bad 'cuda, so very likely it isn't worth the dinner. Some shallow-water guides in the Bahamas, who catch smaller 'cudas on the flats inshore of coral reefs, prize this fish as their favorite.

For offshore 'cudas, gaff and release isn't necessary. A firm grasp on the tail, while securing their shoulder with your other hand, is easy enough. Just take care when handling them; their teeth aren't just for show.

Tube lures above are a staple used by anglers hoping to hook up with toothy barracuda. Perhaps they resemble needlefish, but the 'cuda can't seem to resist this bait.

# Tripletail

From crab pots in the Keys to floating debris way offshore, you never know where the humble, yet tough tripletail will show up. This feisty and awkward-looking flat fish is readily identifiable as the motionless critter hovering beneath floating buckets and other small objects. They're distributed worldwide, but are just as likely to be inshore as they are 70 miles out in the Gulf of Mexico or the Gulf Stream. One thing for sure, they'll be around floating debris or structure like a buoy, rig or weather marker. These are the most structure-oriented of any fish found offshore, bar none.

Tripletail get their name because their dorsal, caudal and anal fins are rounded and all lie toward the back end of the fish. That gives the potential to make a powerful run, especially back inside an oil rig, should you hook one there. Their brown, bulldog faces are accented by a medium set of jaws. Small jigs tipped with cut bait are ideal. Don't roar up on them with the boat; these fish can easily be spooked, and keep in mind they grow up to 36 pounds.

It takes some effort to stop trolling and throw a pitch bait at a single tripletail. Fortunately, most of the time these fish will gather in twos, threes and more on a single piece of flotsam. An average size (4 to 6 pounds) tripletail will give you some of the tastiest fillets in the sea. Triples hang under cooler lids, the inside of floating drums and underneath mats of weeds well offshore. In August, they're found in singles or small groups inside shallow oil rigs off Louisiana, in perhaps 20 feet of water. In late summer they also prowl in the bigger, deeper bays.

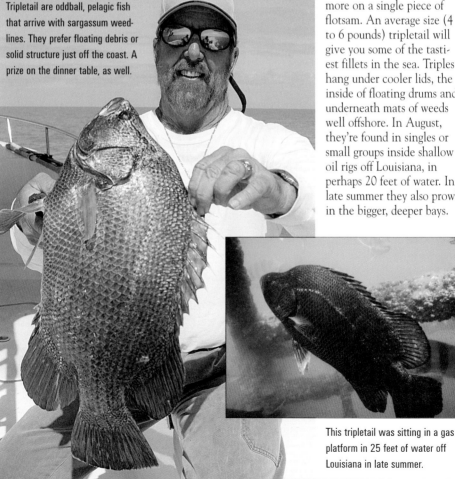

Tripletail are oddball, pelagic fish that arrive with sargassum weedlines. They prefer floating debris or solid structure just off the coast. A prize on the dinner table, as well.

This tripletail was sitting in a gas platform in 25 feet of water off Louisiana in late summer.

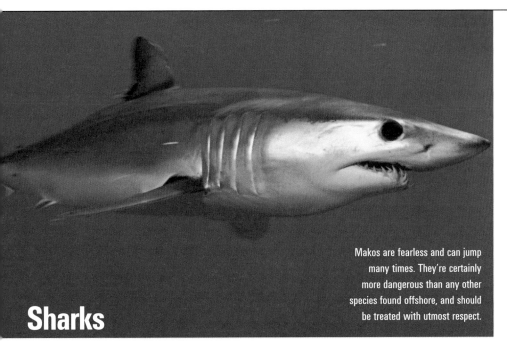

Makos are fearless and can jump many times. They're certainly more dangerous than any other species found offshore, and should be treated with utmost respect.

# Sharks

No matter where you fish offshore, or what technique you favor, sooner or later you'll be introduced to beautiful and deadly sharks. Bulls, hammerheads and blacktips are the most common when anglers are using live bait. That's only fair; you're dangling dinner in front of them on their own turf. Only one shark has a welcome reputation for crashing into trolling spreads, however: the mighty mako.

Acrobatic makos are the only sharks universally coveted by offshore fishermen. Makos are fierce, fast and leap high when hooked up. They're been known to bite outboard motors, trim tabs and leave teeth in fiberglass transoms. Most of the time these fish will be eating live baits or attacking your hooked-up fish. But they will eat a trolled lure as well, and if the hook finds the corner of the jaw, you have a shot at landing them. They've been known to leap up to 20 feet, twisting and writhing spasmodically. Only the mako can claim to put on as great an aerial display as a billfish or tarpon. It's really something to see.

If you bring this fish close to the boat or gaff it, do so with extreme care. Their sleek, blue bodies are crowned with six rows of the most jagged and deadly teeth in the world; far better to lose an expensive lure than your hand. The best thing about being the reel winder on a big mako shark is that you won't have to be the one tail-roping or trying to gaff this fish.

Makos and all sharks are the best candidates for release of all fish. Why? Nature needs lots of apex predators, to keep other fish species in line.

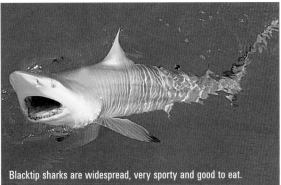

Blacktip sharks are widespread, very sporty and good to eat.

In decades past, a great many captains made their days baiting large pelagic sharks such as hammerheads, tigers and duskies, but the population of this fishery has certainly waned. Fewer anglers are interested in hanging their so-called trophies at the dock, or magazines in publishing them. Given the dire condition of many shark populations, that's a good thing. SB

# Top Natural Baits and Rigs

Rigging most natural baits is ideally done before leaving the dock. While live baits obviously can't be rigged early, leaders and rigs for them should be. The last thing you want offshore is wasting time preparing baits or tying rigs easily done back on dry land. This waste will impact your success rate offshore. You won't need many tools to properly rig a variety of baits. A good set of crimpers, a short bait knife, several rigging needles in different sizes, copper rigging wire, rigging floss and a deboning tool are the basics.

There are days when trolling artificials on a hot bite is all you need to make your trip. But more often than not, a mixture of natural and artificials will score better than either does alone. Preparing before you leave the dock will save you a lot of time, headache and heartache. If you aren't prepared when that fish of a lifetime shows up, you'll never forgive yourself.

**Natural baits have been used by fishermen for thousands of years.**

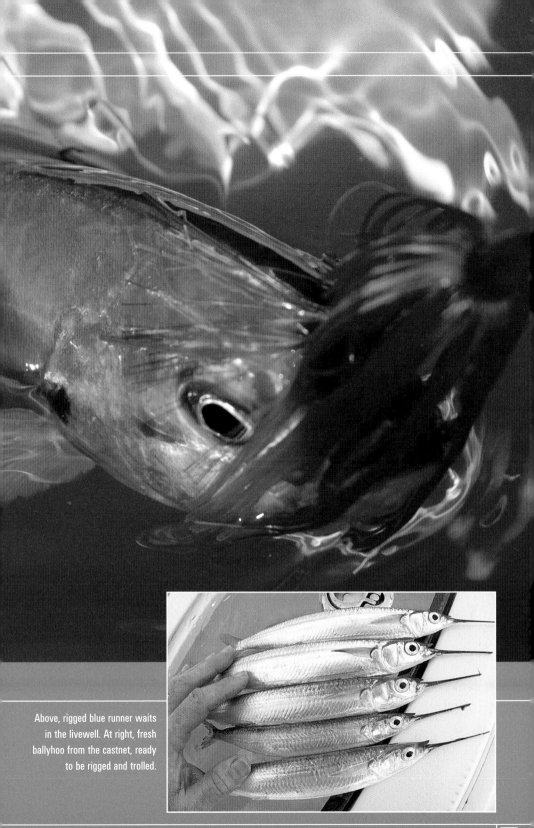

Above, rigged blue runner waits in the livewell. At right, fresh ballyhoo from the castnet, ready to be rigged and trolled.

# Fishing with Natural Baits

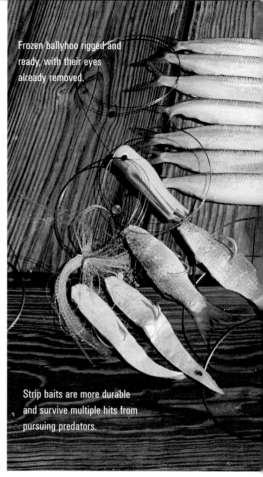

Frozen ballyhoo rigged and ready, with their eyes already removed.

Strip baits are more durable and survive multiple hits from pursuing predators.

**W**hen fishing natural baits, be aware of the targeted fish and what they will readily eat, versus what they can eat. You could probably feed a 200-pound blue marlin a 20-pound blackfin tuna—but very likely would have far better luck using a big blue runner or an 8- to 10-pound bonito or skipjack. Likewise, trolling horse ballyhoo or big blue runners for early season sailfish in South Florida will cause you great frustration, compared with using "dink" ballyhoo or small goggle-eyes. Size matters and bigger isn't always better, at least when baiting fish. Big fish eat small baits, most of the time. They have to.

Almost as important as size is having a variety of baits on board, regardless of fish targeted. Every captain and angler inter-

## Best Bet Dead Baits

**Kingfish**
Ribbonfish, cigar minnow, menhaden

**Wahoo**
Ballyhoo, Spanish mackerel, strip baits

**Dolphin**
Ballyhoo, flyingfish, strip baits

**Tuna**
Ballyhoo, flyingfish, menhaden

**Sailfish**
Ballyhoo, mullet, strip baits

**Marlin**
Ballyhoo, Spanish mackerel

**Swordfish**
Squid, flyingfish, strip baits

**It's just a matter of time before a big fi**

viewed for this book has stressed the importance of using different baits when fishing. Whether after billfish on top, swordfish deep, sailfishing or king mackerel, the more you can mix it up, the better. That doesn't mean you'll need every bait, or even need to use live bait. If you begin by trolling skirted ballyhoo and the bite is hot, why change? You shouldn't. But when the bite isn't so hot, a variety of baits becomes important. If you only have skirted ballyhoo on board and they're not producing, you have a little problem. Captain Don Clark out of Islamorada, Florida has some thoughts on comparing live bait with dead, while pursuing dolphin:

"In the last 10 or 15 years, people have been harping on catching live bait for dolphin…I've always contended you don't need live bait for

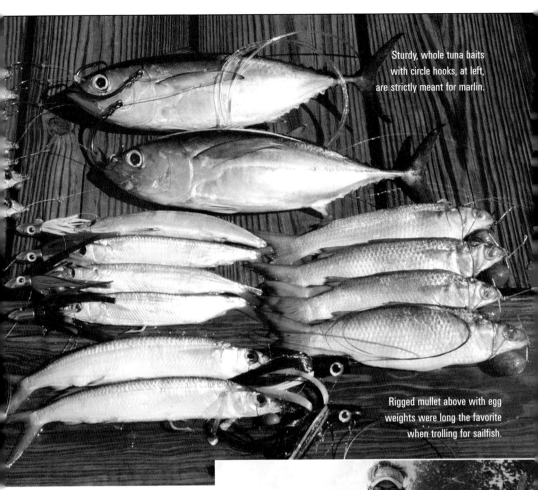

Sturdy, whole tuna baits with circle hooks, at left, are strictly meant for marlin.

Rigged mullet above with egg weights were long the favorite when trolling for sailfish.

## ops up and grabs that bait.

dolphin. They'll eat a ham sandwich thrown overboard. So why use live bait? I've been catching stacks of dolphin on dead bait for 25 years. You could train a monkey to catch dolphin on live bait. Dolphin are voracious; they grow so phenomenally fast because they're eating machines. Some of them die of old age by the time they're three years old.

This feisty wahoo clobbered a trolled ballyhoo in the Florida Keys.

"When I get to an area that looks fishy—with a weedline, debris or color change, I'll switch to a skipping bait, which is plain-rigged ballyhoo. I'll slow the boat down to where the bait just does skip. I get the bait out of the wake not by zig-zagging, but adjusting the baits with outriggers. It's just a matter of time, if it's a good weedline on a current edge, before

something is going to pop up and grab a bait.

"And get some fresh bait," he says. "If it stinks a little in the boat, it will to the fish. If that baitbox smells while I'm up on the flying bridge, I tell the mate to dump it. If dolphin won't hit it, the bait isn't fresh. Salt the bait down overnight so it doesn't rot, or keep it in a rack just above the ice."

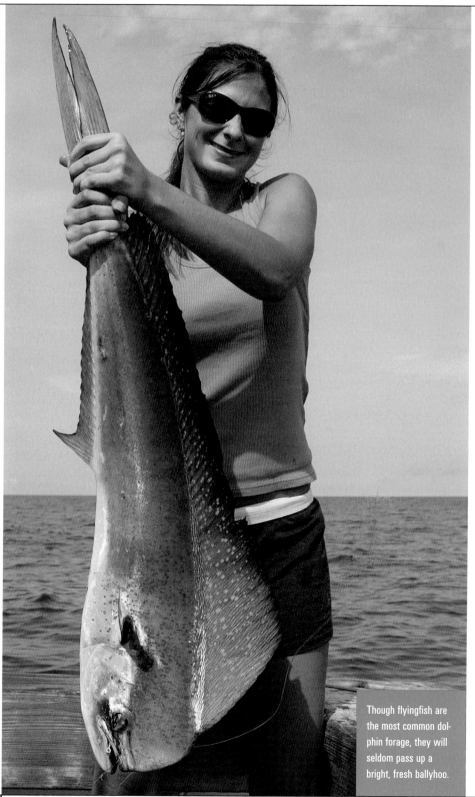

Though flyingfish are the most common dolphin forage, they will seldom pass up a bright, fresh ballyhoo.

# Ballyhoo, the Natural Choice

**Don't forget to limber baitfish up. This loosens the meat from the bait's backbone.**

Ask any fisherman heading offshore what natural bait he'd choose if he could have only one on board. Very likely he won't hesitate: Ballyhoo. These quirky-looking baitfish are found the world over and their abundance is what makes them so effective. It's not easy to find and catch ballyhoo in most places, and where you can find them they are often unreliable. That's why companies like Baitmasters (www.baitmasters.com) and Bionic Baits, (listed at www.bionicbait.com ) are so darn successful. They flash-freeze and package baits such as ballyhoo, Spanish mackerel and squid so your local tackle store can easily stock them. There are too many ways to rig ballyhoo to cover in a single chapter, but we'll cover the basics. A few basic rigs are all you really need to be successful.

Regardless of how to rig bally-hoo, there are key steps in preparing them that will make them look better, last longer and run more effectively than ill-pre-pared baits.

For starters, when using frozen ballyhoo, properly thaw your baits in an icy mix of brine and baking soda. This will thaw them slowly and the brine and soda will help toughen the skin, for a tougher bait to work. Two to three hours in the icy brine should be enough, but make sure the baits are limber and thawed. If you rig a partially thawed bait, it will "blow out" faster, meaning the bellies wash out and you'll have to change them more often. Give yourself time to do the job right. Thawing baits quickly with a washdown hose or leaving them out in the sun will only make them mushy and dull.

Some anglers even like to scale the ballyhoo first. The next time you're rigging baits, scale one and put it next to one with the scales still on. Which one is shinier? Since we're going to brine these baits, the skin will be sufficiently tough without scales and will swim even better. Scaling is easy; just take your thumb, start-ing at the tail and push forward to the gills. These soft scales slide off easily, so don't use scaling tools here.

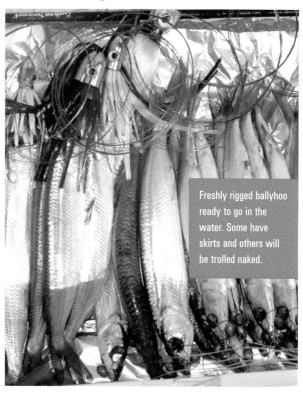

Freshly rigged ballyhoo ready to go in the water. Some have skirts and others will be trolled naked.

Don't forget to loosen the baitfish up. This will detach the meat from the bait's backbone and make it more limber, letting it swim bet-ter. If you plan on just pulling skipping bally-hoo, this isn't as important. If you're like most of us, you'll be pulling a variety of lures in the spread and it pays to have them all prepared the same way ahead of time.

# Bally's Aren't the Only Baits

## Every captain and angler interviewed

to have a plethora of baits to choose from, but adapting to a day's situation on the water is what separates average fishermen from great ones. Adapting means having options and switching gears, so to speak, when something isn't working.

It's great to have a livewell full of blue runners if you're going after kingfish. If the bite turns cold, however, what are the options? Sometimes it's not just location, but the bait. Ribbonfish, bluefish and even reef fish like a

t's true that the only natural bait some anglers will troll offshore is ballyhoo. That's admirable faith in one baitfish, but a little myopic. By doing so they're missing out on a lot of action. Not only is it important

### Squid

Squid are a staple food supply for every predator fish that roams offshore. Wise anglers should always carry a supply of flash-frozen squid on board. If imitation is the highest form of flattery, the squid would be constantly blushing; they've been copied

by lure manufacturers for generations. Fresh squid can be easily caught, when they swim into your underwater lights at night. Keep a squid jig or two handy on the boat with spin tackle; fresh squid may be just what the local fish want.

### Little Tuna, Big Baits

Some anglers think that small tuna are a nuisance when targeting bigger game. The fact is, they're fun to catch and still make good marlin baits. A boat's rod selection should always have several spinning outfits, kept handy for tuna.

Bridling a small skipjack or blackfin tuna, or just a common bonito can trigger an explosive bite that is amazing to watch. With a little practice and just a few steps, it's easy to livebait tuna with the best of them. You do have to work fast, since tuna can't be out of the water for long.

vermilion snapper or grunt may earn a bite when nothing else is working. You can't be married to just one option offshore, unless you like disappointment.

Ribbonfish smell. They really do, but many days they've saved a king fisherman's bacon. Spanish mackerel take more time to rig than ballyhoo and are expensive by comparison, but that big bite invariably happens to the bait that looks and acts differently from the school. Some anglers argue that live baits outfish dead, any day of the week. Tell that to our 243-pound swordfish that turned his nose up at the blue runner and ate a dead, 8-inch squid.

If someone ever figures out the mind of a fish, it would be a revelation. Until then, it's important to have a range of staple baits on the boat; these baits are called staples for good reason. It's just important to know that an assortment of baits can be quite the difference-maker in a long day spent offshore.

## Ribbonfish

Ribbonfish or "silver eels" are kingfish killers. These fish are bought frozen at the tackle store, though some folks catch and brine their own. At $3 to $4 apiece, you can't blame them. The same concept applies with the wire leader, except most anglers use a weighted jighead as the lead hook. The jig's weight helps the fish swim more naturally. To the lead hook, a longer trace of wire is attached with two or more trebles spaced out. Some prefer to twist each hook into place, while other use

sliding hooks in the middle and just twist the rear hook. Both methods work and if you can't hook a king with a ribbonfish armed with several treble hooks, it's just not your day.

## Mackerel

Spanish mackerel make a fine offshore trolling bait for big tuna, wahoo and billfish. They're nearly indestructible when brined. Rigged properly, they'll troll for hours in rough seas.

You can catch your own mackerel and prepare them for the freezer by first dropping them in icy brine. Later, make a small incision in the belly and remove their insides. Vacuum sealing works best when freezing them,

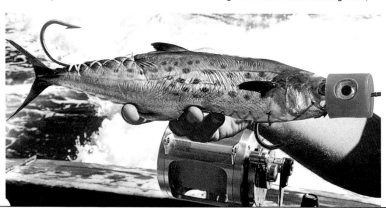

but Ziplocs work fine. Mackerel can be purchased at tackle shops, but they can be expensive. That's why some anglers reserve their macks for pitch baits, using less expensive baits for trolling.

# Rigging that Ballyhoo

The key to rigging baits properly is to make sure the hook is centered when it comes out of the stomach and is the right size for the bait. Ballyhoo come in a variety of sizes, from small or dink (6 to 8 inches), medium or select (8 to 10 inches) and horse or jumbo (10 to 12 inches). The smaller baits call for a 6/0 or 7/0 hook. Medium baits fit an 8/0 hook just fine. Bigger ballyhoo will likely fit a 10/0 hook quite well. Obviously there are variations depending on the lures you're pulling with them or whether you rig them with double hooks, but these guidelines are a good primer.

For most skirted lures a standard skipping ballyhoo rig is perfect. This is the simplest of rigs to use and probably comprises 90 percent of the rigs on trolling boats.

## Brine Time

Salt down your prepared baits with a dry brine solution like Bionic Brine or Magic Brine. Simply line your baits up in the cooler tray (above the ice) and salt them lightly with brine. Then flip them over and salt the undersides. There isn't a magic amount of salt to use, but a light coating should work just fine. Some anglers argue that you can brine them too heavily and the baits become tough. If the bite is a hot one, this really doesn't carry much weight. But when the bite is tougher, this idea might have plausibility.

The rule of thumb is, brine your skipping baits as heavily as you want. You're going to limber them up before sending them out anyway, by flexing them back and forth in a swimming motion. These baits are going to be skipping on the top and not swimming, so you can't really over-brine them. If rigging swimming or split-bills though, you can get them too tough. You should separate out a dozen or so for just this reason and brine them very lightly. Be sure to cover them with a dusting of brine, but not as much as for skipping baits. Your ballyhoo are ready to rig now.

## Ballyhoo Prep

By prepping baits you are trying to accomplish a few things. First, you're purging the stomach cavity of any waste and also popping out the inflated swim bladder.

Holding the bait gently in your hand facing you and belly up, gently squeeze from the front of the bait's stomach and work from head to tail toward the vent. The stomach's contents will exit the bait through the vent.

Bright, fresh baits are always an advantage and will stand up to the preparation routine. They also troll far better than frozen bait.

**3**

Next, turn the bait over belly down in your hand and gently pinch the top of its back, working from head to tail. This action should loosen up the backbone. You will notice the depression down the top center on the fish's back "pop up" as you go.

**4**

Finally, rinse the bait off in salt water and flex it loosely in a snakelike motion to complete. Before you attach this bait to a leader you should also remove the eyeballs to keep them from bulging out. This also provides an easy hole to pass your rigging wire through during the final rigging stage.

*George LaBonte SB: Sailfish*

# Bulls Eye

Removing the eyes of a dead ballyhoo for trolling serves two purposes. Ballyhoo eyes when left intact have a tendency to bulge, causing the bait to spin. It's also easier to rig the copper wire through the open eye socket, rather than threading the wire around the eyeball. A handy device for removing the eyes and storing loose baits on is an old target arrow shaft. Push an arrow through the eyes of your ballyhoo to route out the socket and stack them down the arrow's length to store in your bait cooler. Remember to leave the nock or insert on the end of the arrow to prevent the inside of the shaft from filling with the discarded byproduct and its resulting aroma.

By storing baits in this manner, you're able to lay the baits in the cooler on their backs. Shake a layer of kosher salt on their stomachs to toughen them up for trolling. It also makes it easier to keep them together in a bunch in the bottom of the cooler, while preventing loose baits from rolling around in the bottom of the box in melted icewater. When you need a fresh bait to rig, simply pull one off the end of the arrow and rig it. SB

# Single Hook Rigs

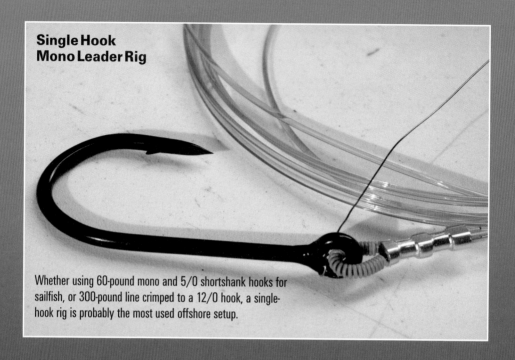

## Single Hook
## Mono Leader Rig

Whether using 60-pound mono and 5/0 shortshank hooks for sailfish, or 300-pound line crimped to a 12/0 hook, a single-hook rig is probably the most used offshore setup.

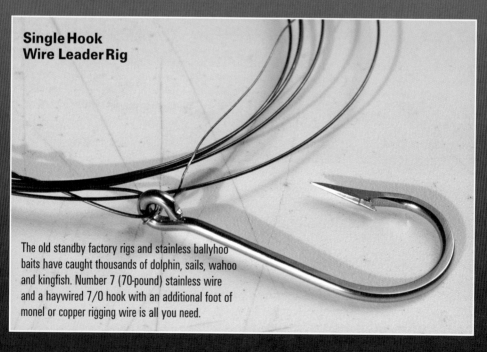

## Single Hook
## Wire Leader Rig

The old standby factory rigs and stainless ballyhoo baits have caught thousands of dolphin, sails, wahoo and kingfish. Number 7 (70-pound) stainless wire and a haywired 7/0 hook with an additional foot of monel or copper rigging wire is all you need.

## Single Hook Ballyhoo Rigging

Always begin with the highest quality fresh bait, new leaders and sharp hooks. Small details make the difference at the moment of truth.

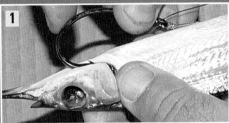
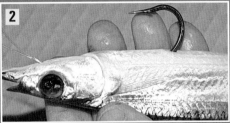

Insert your hook into the gill opening and exit the center of the belly, with the hook point while pulling the eye of the hook into the body cavity. Be sure the hook is lined up on the center line of the bait for straight tracking.

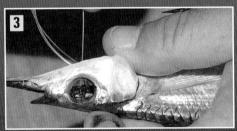

Keeping the wire tight, make two wraps around the lower eye socket and gills to anchor the hook in bait. Push the wire up through the lower jaw and exit through the top jaw where it joins the head. Pull tight.

**5** Make a couple of wraps down the beak and stop. Break the beak short and split the beak with your leader. Pull leader up into the split. Wrap the copper wire over the split and continue wrapping forward to the end. Add lure in front of bait, or fish naked from outrigger as a skipping bait.

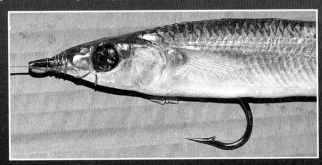

*George LaBonte SB: Sailfish*

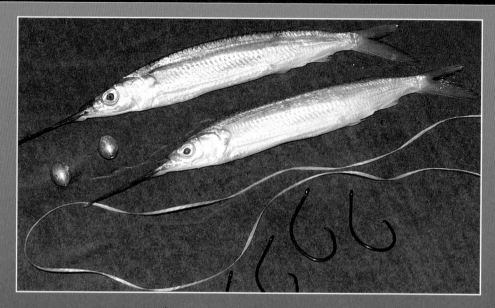

As circle hooks become more popular for both live baiting and trolling, many new tricks for rigging baits with them are being developed along the way. A popuar technique for rigging ballyhoo for trolling involves preparing the baits without a leader attached. This method makes it much neater and keeps your bait cooler more organized.

This approach is standard in Central America, where several dozen baits per day are required. It keeps the baitbox free of tangled leaders when the action gets hot. This rig is quick and easy and works like a champ for rigging a leaded "swimming ballyhoo." See the **DVD for an alternative method using copper rigging wire; both rigs are extremely effective.**

**1** Begin by doubling 2 feet of waxed rigging line and passing looped end through small egg sinker.

**2** Pull the looped end over the bait's head and slip it under the gill plates on both sides of the bait.

**3** Slide the egg sinker down the rigged line so it fits between the gills forward of throat latch.

**4** Bring the line's ends forward under the bait's lower jaw and wrap over top jaw. Keep line tight.

**5**

Pass both ends through eye sockets from opposite directions. Wrap gills over sinker and knot tight.

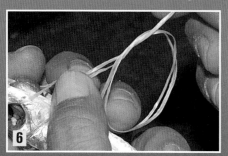

**6**

Tie another overhand knot in the two strands of line and pull it tight.

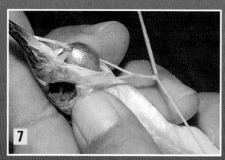

**7**

Pull the two ends away from each other; knot will slip down to egg sinker. Snug up and trim.

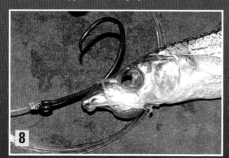

**8**

**To complete, break the beak off short and insert circle hook under x-shaped loop of thread on top of head.**

*George LaBonte SB: Sailfish*

# Split Bill Ballyhoo

This extra step, added to a standard mono-rigged bait (as described on page 187) will turn skipping surface baits into head-down swimmers. Being head-down gives it a swimming plug-like action without extra weight. They are so effective, they may be the most commonly used rig of all.

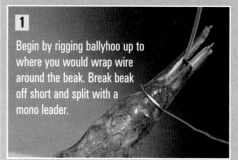

**1**

Begin by rigging ballyhoo up to where you would wrap wire around the beak. Break beak off short and split with a mono leader.

**2**

Continue wrapping the wire forward and lift the mono leader so you can wrap the wire in front of it.

**3**

Make a single wrap in front of the leader and finish wrapping back toward the bait's mouth until you are out of wire.

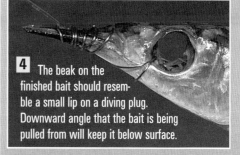

**4** The beak on the finished bait should resemble a small lip on a diving plug. Downward angle that the bait is being pulled from will keep it below surface.

# Mullet, the Other Natural Bait

They are a sad looking little fish. Unassuming and timid at first glance, these schooling baitfish are one of the unsung heroes for offshore anglers. They spend most of the year in bays and inlets, often traveling well into freshwater estuaries. When the weather cools or the spawning instinct takes over, these hordes of baitfish go running offshore or along the coast and the games begin.

Mullet are famous in many parts of the country for their fall runs, which spur feeding frenzies from kingfish, tuna and sailfish. They

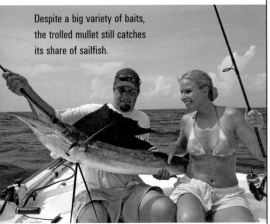

Despite a big variety of baits, the trolled mullet still catches its share of sailfish.

school up by the thousands and your best bet to match the hatch is to keep a castnet handy. Mullet are readily spotted in large schools by watching for the telltale jumps. The aren't fancy jumpers, but they are prolific and they almost always land on their side, smacking the surface and giving away their location both visually and audibly.

Whether you pull them on a natural dredge, rig them for trolling or fish them as live baits, mullet are fantastic offshore companions. Schooling fish are often referred to as a moveable feast. Nothing could be more appopriate for our little friend, the mullet.

## Rigging the Split Tail Mullet

**1** Begin by making a split in the bottom of the bait between the ventral fins to pass the hook through.

**2** Pass the eye of the hook up through the opening and continue out through the wedge head opening.

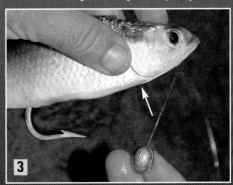

**3** Insert the leader end through hook eye, into the head and exit through the gills. Pass leader end through a...

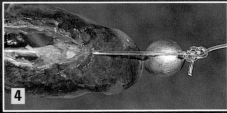

**4** ...small ⅛ to ¼-ounce egg sinker and place lead under chin of mullet. Tie loop knot or crimp to finish.

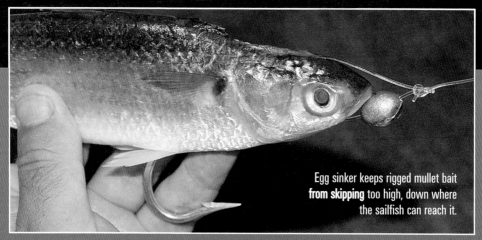

Egg sinker keeps rigged mullet bait **from skipping** too high, down where the sailfish can reach it.

## Closing the Gap

To complete the rig, you'll need to tie the wedge closed. This step gives the bait a flat profile which makes it track straight and keeps it from washing out.

Tie the wedge cut closed by wrapping several turns around head with waxed rigging line and finish with tight overhand knots. Flatten head of bait on its side with palm of hand, before tightening rigging line.

**Finished product is** streamlined and ready **to** swim behind the boat.

*George LaBonte SB: Sailfish*

# Prepping Cut Back Mullet

Head scales are removed, to facilitate a clean penetration from the hook. You wouldn't want a scale to foul the hook point, when a sailfish strikes.

To prepare and "knife out" a cutback mullet, simply fillet down both sides of the backbone and remove backbone, ribs and excess meat through the top of the bait. Like split-tails, these cutbacks should be salted and frozen before use.

Use coarse kosher salt liberally to cure mullet baits and strips alike. Salt will remove moisture from baits.

Cleaned out body cavity, minus backbone and undesirable products that can cause spoilage. This is where the salt goes, to toughen the bait. Fresh mullet works best, of course.

Flesh of jelly-like consistency will turn tough and durable, like partially cured beef jerky.

# Rigging Cut Back Mullet

This is another option for rigging dead mullet, a very sturdy bait that will swim for hours behind the boat. With practice, it only requires a few minutes to rig, before leaving the dock.

Since the head isn't wedged out, poke a hole in the head to guide leader through, at forward edge of eyes.

Lay hook along bait with eye of hook even with hole in top of head to locate where hook shank will exit.

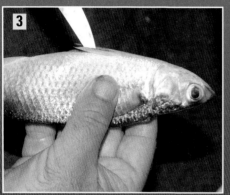

Make small incision in bottom of bait for the hook.

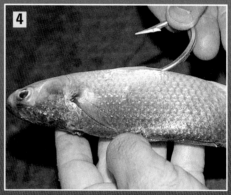

Insert eye of hook into incision and push forward, exiting out of the gill.

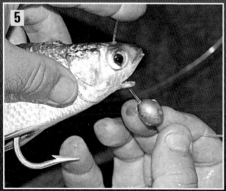

Insert leader down through hole in head and out through gill opening, eye of hook and small egg sinker.

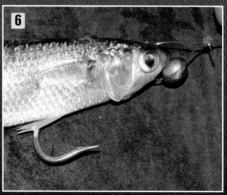

Finish with a perfection loop knot or crimp. No tying is necessary, since head is not wedged open.

*George LaBonte SB: Sailfish*

# Natural Strip Baits

Strip baits are a great way to mix up your spread and make use of bycatch fish, such as bonito. After all, not everyone wants to live-bait or bother with sewing up whole baits. Strips are ideally suited for skirted applications like squid skirts, bullet heads or Sea Witches.

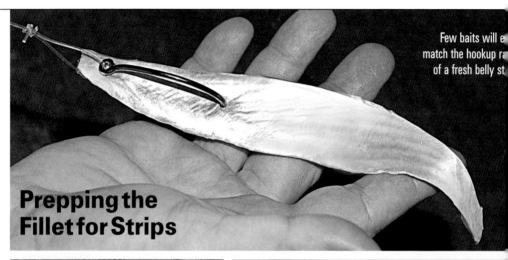

Few baits will e[...] match the hookup ra[...] of a fresh belly st[...]

## Prepping the Fillet for Strips

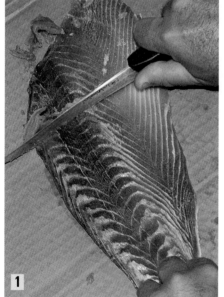

**1**

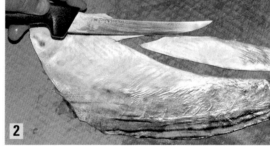

**2**

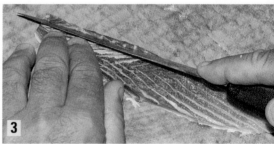

**3**

**1** Start by cutting the bonito side down to 1/4 inch thick. Next, scrape the fillet down to flatten and produce an even thickness. For best results, always follow the grain of the meat.

**2** Next, cut individual baits out of each side in the shape of a willow leaf. Baits can range in size from 4 to 8 inches. Plan your cuts carefully to get the most baits possible from each slab.

**3** Fine-tune each bait to remove any ragged edges and bevel the edges of the meat, to improve action. Square off the forward point of the bait so it's pulled along with the grain.

# Rigging Strip Baits

**1** Make a minimal small hole in the front of the bait.

**2** Pass your leader through the bait and your hook.

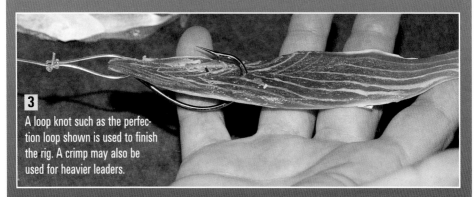

**3** A loop knot such as the perfection loop shown is used to finish the rig. A crimp may also be used for heavier leaders.

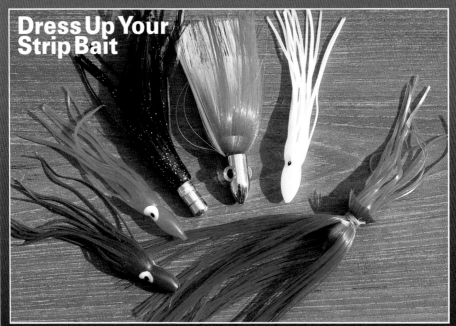

## Dress Up Your Strip Bait

Small squid skirts and Sea Witches finish off a strip nicely. Add a lure only for color. Large, bulky lures will impede the hookup ratio of the bait and diminish its effectiveness.

*George LaBonte SB: Sailfish*

# Rigging Spanish Mackerel

These fish are extremely important baits for big blue marlin. That's not a shocker, but what most anglers don't realize is you can catch slob (big) wahoo with them.

Some to the biggest wahoo I've ever seen cruised right past the ballyhoo rigs to the flatline, engulfing a lure/mackerel combination. Many billfishermen won't leave the dock without a handful of Spanish mackerel, rigged as skirted baits or naked swimming baits to pitch to the "man in the blue suit" if he gets a little picky around the bait spread. When rigging Spanish mackerel, you'll want to thaw them in the same manner as ballyhoo. You

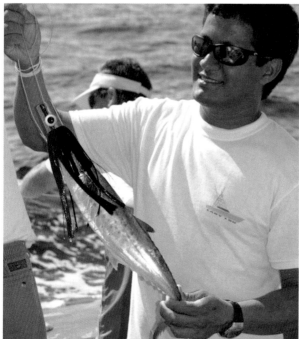

won't need a lot of prep with Spanish mackerel. Tossing live mackerel into frigid brine water (for later preparation) helps, of course. A good salting both inside the stomach and outside on the skin is important, later on. Small and medium-size Spanish (10 to 14 inches) will run well with a single-hook rig, while larger mackerels (14 to 16 inches) will get more hookups on a double-hook rig.

Most anglers agree that unless you are in an area where giant marlin are common (fish of 500 pounds or bigger, usually in some faraway land), then pulling smaller mackerel will increase your chances of hookups. Smaller marlin can definitely eat a Spanish of any size, but the easier you make it for them, the better your chance of a hookup.

Rigging mackerel requires a little more detail, but the little things are what separate great fishermen from those at the dock who complain about the slow bite.

A rigging needle and floss are needed to properly sew a Spanish. Take the rigging needle and notch out a small hole in the top of the fish's head, right in the center. This will allow you to pass the leader through the head and into the body cavity, where you'll pass the leader through the eye of your 10/0 hook. The size leader can be your preference, but 300- to 500-pound mono is common when targeting marlin. This leader will then be looped around and crimped just in front of the fish's mouth, pulled snug as shown below.

Stitching in a Spanish, after cleaning the belly. Fish is inserted right up the skirt of an artificial trolling bait.

It's critical that you sew the mouth shut tight and the belly, too. Some anglers skimp on sewing the mouth shut, and justify this by sliding a skirted lure over it. These will wash out faster and won't swim as naturally. Rigging floss is most commonly used here, though some folks have taken to using Zap or Super Glue to seal the belly.

To sew the mouth shut, simply make a couple of passes through the top and bottom of the jaws and then proceed down to the belly. Insert the needle in one side on the way to the back, while alternating sides from the tail forward. Knot the sewn fish under the chin. The result should be a neatly sewn mackerel. You can add a second hook by simply crimping one to the eye of the first hook, prior to sewing the belly shut. This is warranted if your bait is big enough, but make sure the hooks are aligned with the center of the stomach and not offset; any misalignment and your bait will spin. The first time you see a Spanish rigged for trolling, you might think it's a lot of work to rig correctly. However, like anything else, once you've rigged a few it quickly becomes old hat.

# Swordfish Squid Rig

Small hole made with knife in top of squid allows for the insertion of a strong hook meant for swordfish. Each hook is fastened to a long mono leader, since swordfish don't have teeth and do not require a wire leader. If a shark hits, it will likely cut the mono leader and time won't be lost fighting it.

Knife creates small hole for hook.

Insert hook carefully, without damaging the squid's body.

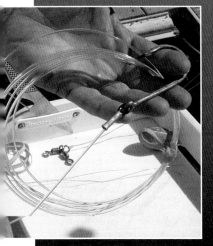
Crimped hook with heavy mono leader.

Artifically colored squid, ready to go in the water for swordfish.

# Fishing With Live Baits

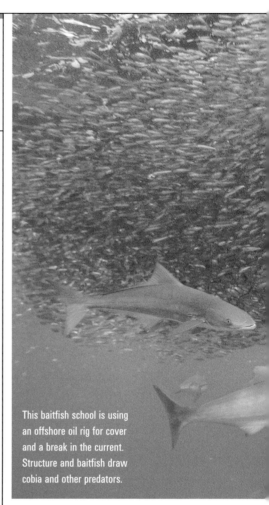

This baitfish school is using an offshore oil rig for cover and a break in the current. Structure and baitfish draw cobia and other predators.

**L**ive baits are the saving grace of many trips offshore. Some days, trolling just won't get it done. Perhaps the billfish are lazy and dolphin have turned spooky, and won't even eat a trusty skirted ballyhoo. Drop a frisky mullet or blue runner in front of them, however, and watch out. When you can leave the dock with plenty of bait already in the livewell, you're just ahead of the game. Getting up early and taking care of this task can really take the pressure off catching live bait, after arriving offshore. Catching live bait isn't much of a task when fishing solid structure like the oil rigs, but open canyon fishing has no bait guarantees whatsoever. Catch or carry a variety of bait sizes.

It's no secret that kingfish will eat just about anything swimming, but they certainly show a preference for certain baits. Ballyhoo, pinfish, croakers, grunts and mingo (vermilion snapper)

## Best Bet Live Baits

**Kingfish**
Hardtails, menhaden, bluefish

**Wahoo**
Hardtails, dolphin, goggle-eyes

**Dolphin**
Threadfin, pilchards, hardtails

**Tuna**
Flyingfish, hardtails, mullet

**Sailfish**
Goggle-eyes, Spanish sardines, mullet

**Marlin**
Skipjacks, bonito, small dolphin

**Swordfish**
Tinker mackerel, hardtails, goggle-eyes

## Catching live bait isn't much of a task

all work for the speedy mackerel. Bluefish, goggle-eyes, hardtails (blue runners) and ribbonfish are even more deadly on them.

Part of the allure of using hard baits like goggle-eyes and blue runners is that they're simply tough as nails. They will swim all day if need be, but they don't last long with big predators around. They're extra hardy on the troll, compared with other baitfish that may produce well, but don't last nearly as long. Baitfish such as menhaden and threadfin herring or "greenies" are great baits, but can't take the heat of hot summer livewells or the stress of being trolled for very long. The warm waters of the Gulf are even harder on these baits, and they typically do better on the east coast. Bluefish are good baits for a lot of kingfish specialists. Bluefish are just

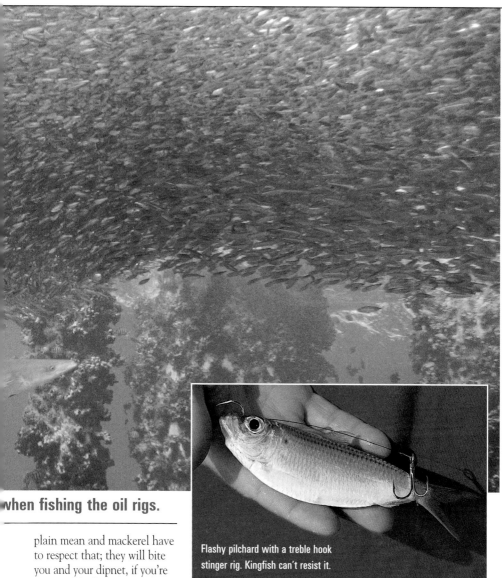

**when fishing the oil rigs.**

Flashy pilchard with a treble hook stinger rig. Kingfish can't resist it.

plain mean and mackerel have to respect that; they will bite you and your dipnet, if you're not careful when rigging them.

Kingfish baits are commonly rigged with a wire leader and stinger hook. The wire prevents cutoffs, and the trailing stinger hook catches those notorious short-strikers. Using singlestrand wire, wrap a haywire twist to a small barrel swivel. With the same twist, attach the lead hook. Some prefer a "J" hook as the lead hook, but most agree a 1/0 or No. 1 treble hook works best. To the eye of the main hook, twist a short trace of wire, and attach a second treble. The length of the trace will depend on the size of your bait. Since these rigs are readily tied and inexpensive, most anglers make up a

number of different hook rigs before leaving home. Special kingfish rig bags are cheap and combine up to 25 zippered bags in a pouch. Regular resealable plastic storage bags work and keep the rigs dry, separated and untangled.

Sailfish are partial to ballyhoo, threadfins, mullet and about anything of that size that swims. Sails will even prowl shallow water and feed on reef fish. The live bait of choice today is the goggle-eye. A close relative of the blue runner, it's a smaller, more silvery and softer version of the hardtail, without compromising its hardy nature. Because they are usually so

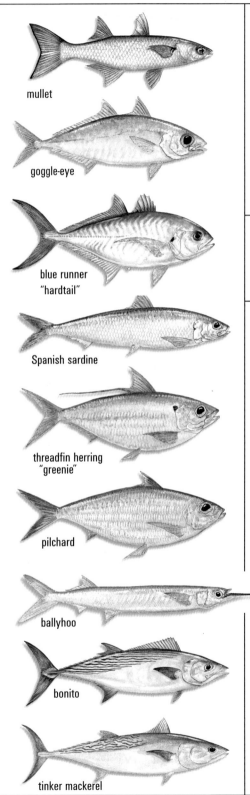

mullet

goggle-eye

blue runner
"hardtail"

Spanish sardine

threadfin herring
"greenie"

pilchard

ballyhoo

bonito

tinker mackerel

productive and are caught only at night, these baits garner big bucks for bait sellers. With a little preparation, you can avoid breaking the bank and still score your gogs, however. Not everyone has the time or patience to catch bait the night before a trip, or depart before daylight to catch goggle-eyes on the reef—but it does pay off. They are readily caught around passes, rockpiles and inlets and will show on your fishfinder as scattered marks. If the baits are not schooling near shore, they often hold

## Most baitfish just do not have the solid, athletic ability of goggle-eyes or blue runners.

over deep wrecks or ledges offshore. Spreader lights attract them and keep them around, as they follow hooked baitfish to the boat. Medium-sized sabiki rigs, often with glow droppers, are preferred.

Soft baits such as threadfins, Spanish sardines, pilchards and ballyhoo produce sails in numbers as well, but don't have the athletic ability of goggle-eyes. What they lack in strength they make up for with their ideal size. Even small sailfish gobble these guys down easily.

As for marlin, ballyhoo are the go-to natural bait, but that's only with dead baits. As for live-baiting marlin, you have a few choices. Bonito, small yellowfin and blackfin tuna are great livebait candidates, providing you have either tuna tubes on your boat or you get them rigged and back in the water as soon as you catch them. Even tastier and shinier is the unassuming skipjack. Blue marlin definitely show a preference for them.

These fish can be caught with diamond jigs around oil rigs or other offshore structure, but also are caught by anglers trolling small feathers or squid skirts through schools of busting tuna. "Skippies" mix with other tuna, but you won't have difficulty telling them apart. They're so shiney, they really do stand apart from other tuna. While similar-size blackfins or even small yellowfins produce marlin strikes, there's something about the skipjack. Marlin the world over love to eat them.

## Keep 'em Fresh

Live bait can be caught before heading offshore, but you need somewhere to put it, right? Bait pens have become a must-have for serious offshore anglers. Softside pens, floating pens and coated wire pens are just a few options for storing bait. But just because you have a place to put it, doesn't mean you should. Many fresh-caught fish die because the water they are stored in is too dirty or brackish to keep the baits alive. Bait pens stored in marinas along rivers with strong currents or tides will kill your baits by either exhausting them or pinning them against the cage.

Take care to only handle baits when you have to. The less stress you put on them, the better shape they'll be in when you plunk them overboard. SB

Castnetters anchor over patchy bottom and chum, before tossing huge castnets on schooling bait-fish. Baits can be stored overnight in bait pens, but *only* if water quality is good enough.

# Livebait Rigs

Livebait rigs come in a couple of varieties, wire and monofilament. Both are incredibly simplistic to rig, which is refreshing. Fishermen sometimes have a tendency to make simple things very complicated.

Wire leaders are generally designed with the toothy kingfish or wahoo in mind. They usually involve a stinger hook rigged to thwart the short-strikers, notorious for slashing baits in half. In theory, the fish are supposed to double back and eat the front half, but fish don't always understand theory. They do seem to understand a second hook placed toward the back of the bait. They also tend not to like it because it's horribly effective at catching them.

Monofilament or flurocarbon livebait rigs are usually pretty simple rigs. The leader is either crimped or tied straight to the hook. The critical difference comes in the placement of the hook. If you are fishing with smaller baits such as threadfins, goggle-eyes or small hardtails, you don't need a bridle. Some folks still like to bridle small hardy baits, but it is certainly a matter of preference. For larger baits, the next section covers bridling technique, we'll talk about placement here.

Hook placement will vary based on whether you are trolling or kite fishing. Trolling a live bait means you want to place the hook or bridle on the bait's nose (or bridle through the eyes) so you are pulling from the front. Kite fishing requires a different placement, because the kite will be pulling your bait just out of the water and plopping it back down. You want to place your hook or bridle on the fish's shoulders, right on their back.

## The candy of the sea: Nothing will outfish a frisky live bait. Learn to catch and use them.

**Hook Set**
Multiple treble "stinger" hooks are towed by a jighead that doesn't twist or tumble. Great for kingfish.

For trolling or a fast drift, a nose-hooked bait is always best.

For use under a float or kite, or dropping down with a sinker, hook mid-bait.

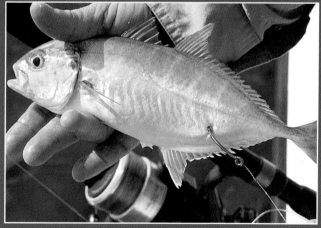

Hooking in the lower rear third will make the bait dive deeper.

**See DVD for more on live bait rigging.**

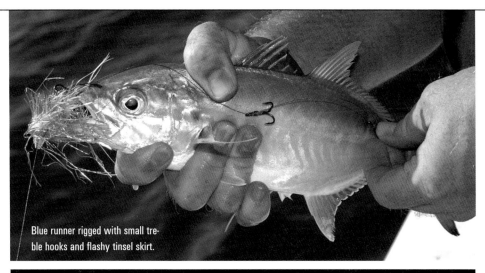

Blue runner rigged with small treble hooks and flashy tinsel skirt.

# 30-Second Kingfish Rig

This technique works equally well with a single livebait hook up front.

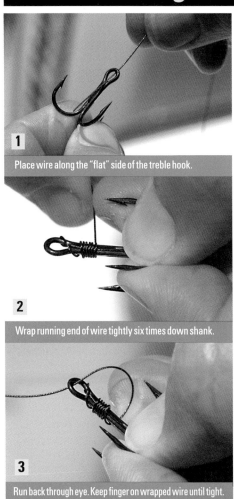

**1** Place wire along the "flat" side of the treble hook.

**2** Wrap running end of wire tightly six times down shank.

**3** Run back through eye. Keep finger on wrapped wire until tight.

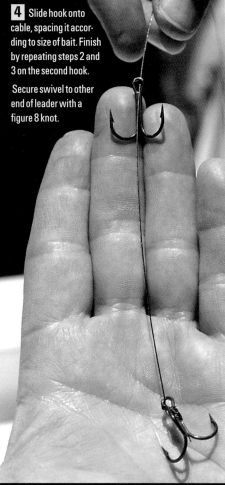

**4** Slide hook onto cable, spacing it according to size of bait. Finish by repeating steps 2 and 3 on the second hook.

Secure swivel to other end of leader with a figure 8 knot.

# Bridling Live Baits

**U**sing big live baits requires bridling them and the preferred method varies, but most anglers prefer using large circles. Depending on your bait, circle hooks up to 20/0 and 22/0 aren't uncommon. This same bridling technique works with any bait, if you slow-troll for big fish such as tuna, marlin, wahoo or big bull dolphin.

## Bridle Loop for Trolling
Sewing needle is inserted just foward of the eyes.

Sturdy thread follows, creating a loop that doesn't hinder baitfish.

Circle hook is attached to thread loop for maximum penetration.

Practice and you'll realize it doesn't take long at all. It's best to practice on blue runners because they're tough and survive a trial-and-error or two in good stride. Tuna, on the other hand, have to keep moving through water to live. If they don't have water passing through their gills, they die very quickly, so you have to rig them fast. Blue runners make great livies for blue and white marlin and are deadly for tuna. You can run the circle hook through the back or nose of the runner but that damages the bait, and buries part of the hook in the fish. With bridling, the entire hook is exposed and your chances of hooking up are much higher.

When fishing with any bridled bait, it's important to make sure the fish has time to eat the bait and get the hook in its mouth. With small baits like 2- to 3-pound runners, a few seconds is more than enough. With bigger baits like tunas, you'll want to allow more time for the predator fish to eat. There's no magic count, unfortunately. Five seconds seems like an eternity when you have seen the water explode and line is dumping off your reel. One thing is certain—engaging the drag slowly and smoothly is critical. That's not always easy; my anxiousness got the better of me on a tuna trip one summer at a bluewater oil rig off Louisiana.

We started before daybreak and wanted a trophy. Our first live bait was crushed with a huge explosion, but the fish missed the hook. I dropped back a fresh runner behind the boat and it quickly became very nervous. Line peeled off fast and every second my blood pressure climbed straight up. The reel was then slammed into strike drag so quickly, it snatched the hook right out of the marlin's mouth. Slamming a reel into strike with a fish streaking off line is the equivalent of setting the hook on a bottom fish. You don't do that with circle hooks. I learned that lesson on bluewater fish the hard way and deserved tons of ribbing, which our boat crew dished out with great enthusiasm. **SB**

# Rigging the Bridle Loop for Kites

A bridle operates on the idea that sewing floss instead of a hook allows the bait to swim more freely.

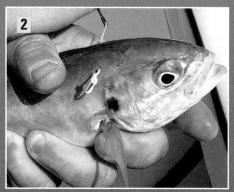

Needle passes through bait with short loop of floss or rubber band attached leaving enough to pass hook through.

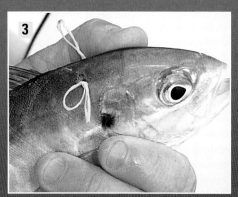

Needle is detached, leaving a convenient loop on each end of the bait for the hook to slip into.

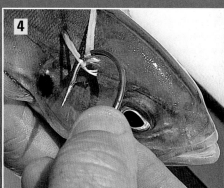

Insert hook through both loops on each end of the floss and then start twisting the hook.

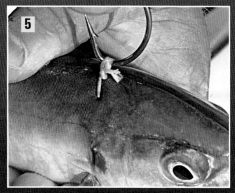

Spin the hook a few times to take up slack, then loop the hook once between bait and floss. It won't unravel.

Locked in place, the hook stays very close to the bait, but far enough away to offer a clean hookup without fouling.

*George LaBonte SB: Sailfish*

# Offshore Knots

There's good news if you don't like tying complicated knots. You only need a few basic designs to be successful at offshore fishing. Before you start tying new knots or learning how to properly tie those old reliables, it does pay to know a few knot basics.

Traditional lore claims that knots usually weaken a line's breaking strength. When you join two lines, or line to hook, swivel or lure, that's the weak point in the link between you and a fish dinner. Most anglers tie particular knots because that's what they happen to know or were taught—not which one is the most effective. The truth is no knot should ever break on you. Unless you're tying knots with 10-pound line and using 40 pounds of drag, you're not going to break a knot or line unless you do something wrong or the reel's drag malfunctions. Likewise, not taking care of your line will cause malfunctions and breaks. That blazing sun offshore isn't good for monofilament line, for instance, and line does oxidize when exposed for a period of time.

**Properly tied knots are dependable and shouldn't be a concern when fighting big fish.**

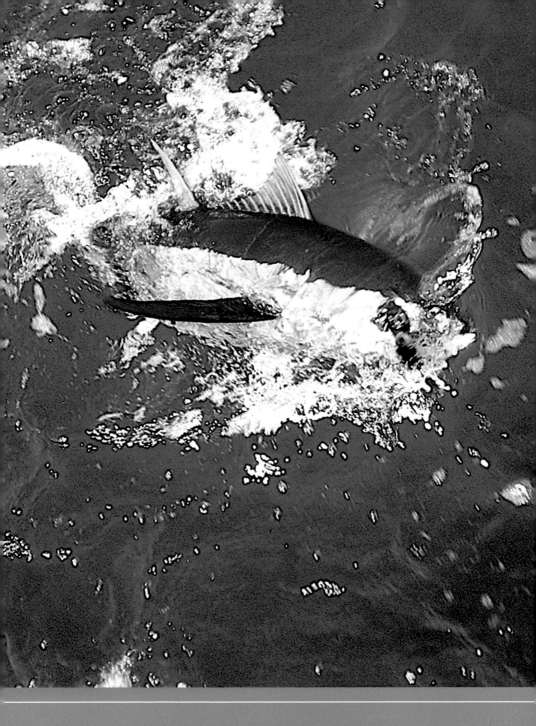

Is that knot tied well? If not,
pelagic fish will find a weakness
within seconds, if not sooner.

# Know-how for Knots

K nots will break if you tie them incorrectly or don't take proper care (like lubricating the line) when tying them. To minimize this and the chance of losing big fish offshore, take a few precautions. First, always make sure you draw down or tighten a knot securely. Knots will slip before breaking. Leave them too loose and they'll pull out, losing fish and leaving an accusing pigtail on the end. Knots can't really be too tight, but they can certainly be tightened incorrectly. Always follow directions for each knot and try not to deviate. If it calls for four wraps, make it four. Second, make sure to moisten the line before you tighten your knot. Water works well and so does saliva. This will lessen friction and prevent line from chaffing as it draws tight. Finally, if you tighten the knot securely, you can clip the tag end off fairly close to the knot and leave a minimum profile. Never use a flame or cigarette to burn the tag end. Heat does bad things to mono and the "superlines."

## Knots for Braided Line

Braided line or superlines have become more popular with offshore fishermen. Some recommended knots for these lines are the double uni, Albright, palomar and uni-knot. Here are some tips, courtesy of www.powerpro.com:

· Pass your line through the eye of your tackle twice, if possible.

· Double your line before tying if your tackle allows, to create a larger, stronger knot.

· Don't use clinch knots, which slip on PowerPro's slick surface.

· Use a gloved hand, dowel, or soft-jawed pliers to avoid injury when tightening knots.

· Moisten your knot before tightening.

## Learning the Uni-Knot System

The uni-knot is a very versatile knot. It can be used to tie line to lures, hooks and swivels as well as attach line to the reel's spool. A modified version of this, the double-uni can even be used to attach two lines as well as line to leader.

Familiarize yourself with the simple procedure of using the uni-knot here and then all other uni-knot applications become quite easy.

**1** Turn the end back toward the eye to form a circle.

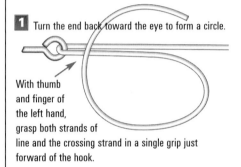

With thumb and finger of the left hand, grasp both strands of line and the crossing strand in a single grip just forward of the hook.

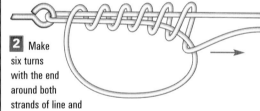

**2** Make six turns with the end around both strands of line and through the circle. (With light lines—say 2- to 12-pound test—you should make five or six turns. If using heavier line, four turns will be sufficient).

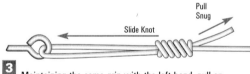

**3** Maintaining the same grip with the left hand, pull on the end of the line in the direction shown by the arrow until all the wraps are snugged tight and close together. Snugging down tightly at this stage is essential to maximum knot strength.

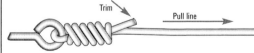

**4** Finally, slide the finished knot tight against the eye of the hook by dropping the tag end and pulling solely on the standing part of the line. The excess end can be trimmed flush with the knot after final positioning.

# Uni-Knot Line to Leader

Tying light line to heavy leader is not much different from the preceding application. It may seem awkward at first because the end of the light line must be doubled to gain maximum strength. But the doubled portion is treated as a single strand and is actually easier to draw down.

**1** Double the main line. Overlap the heavy leader and form the familiar Uni-Knot circle. Go around the strands and through the circle with the doubled end three times. Now, slip your finger into the loop. Holding all strands on the other side of the knot with the left hand, pull the loop with your finger until the knot is very snug.

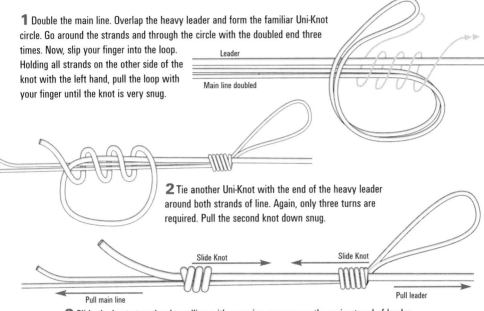

Leader

Main line doubled

**2** Tie another Uni-Knot with the end of the heavy leader around both strands of line. Again, only three turns are required. Pull the second knot down snug.

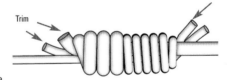

Slide Knot

Slide Knot

Pull main line

Pull leader

**3** Slide the knots together by pulling with opposing pressure on the main strand of leader and both strands of main line. Continue until no slippage is felt.

**4** For final tightening, you will probably have to grip the line with a full hand grip, instead of using thumb-finger grips. This tie will consistently provide close to 100 percent of line strength if the first uni-knot is snugged completely tight, and if final tightening is done carefully and with steady hard pressure.

Trim

# Snelling a Hook

Snelling is a snap with the uni-knot. Thread line through the hook eye, pulling through at least six inches. Form the familiar uni circle and hold it tight against the hook shank with thumb and finger. Make several turns around the shank and through the circle. Pull on the tag end to draw the knot roughly closed. Finish by holding the standing line in one hand, the hook in the other, and pulling in opposite directions.

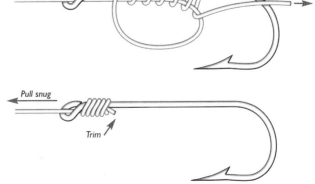

Pull snug

Trim

While king mackerel fishing one summer, we got tail-whipped several times (tail strikes cutting the line while the fish makes that initial run) and I was getting frustrated. Our setup consisted of tying the main line directly to three-foot wire leaders. The kings were big; we were fishing oil rigs off Louisiana and tossing back 30- and 40-pounders. There were

## We soon caught some *big* kings and my friend certainly learned a new trick that day.

monster kings biting and they were eating our lunch. So, I grabbed a 6-foot shock leader of 60-pound fluorocarbon and quickly tied it to the main line with an Albright knot, then the wire leader at the other end. One of the guys was worried about having extra knot connections in the line and questioned whether it would hold a big fish. On 20-pound tackle with probably six pounds of drag, there is little concern about the knot holding when tied correctly. We soon caught some *big* kings and my friend learned a new trick that day.

### Practice

Confidence in a certain knot means seeing it work, and tying it repeatedly. The practice part ideally should happen on dry land. As Allen Iverson so eloquently put it; "What are we talking about? Practice?" Yes, learning a new knot takes practice, but not as much as it sounds. The key to success and having confidence in that knot is to tie them often before heading offshore. A 6-foot ground swell or 3-foot chop is no place to learn a new knot, especially when the fish are biting.

Everyone has a spool or two of line in the garage or tackle room with not enough left to use on reels. This line usually collects dust or ends up in a landfill, if it isn't recycled at a tackle shop. Leader material too short for offshore use is perfect for practicing those big line knots. Many fishermen spend part of the off-season cleaning tackle boxes, tying rigs for next season and getting their tackle in order. That's a great time to learn a new knot and practice it. You can even tie knots while

# Offshore Knot

This connection is used to affix an offshore snap-swivel to the double line, so that trolling leaders and their pre-rigged baits can be quickly changed. The uni and improved clinch knots will serve the same purpose very well, but the offshore knot is neater.

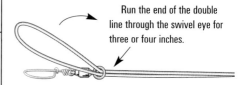

Run the end of the double line through the swivel eye for three or four inches.

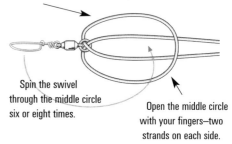

Grasp the end of the loop and bend it back over the double line.

Spin the swivel through the middle circle six or eight times.

Open the middle circle with your fingers—two strands on each side.

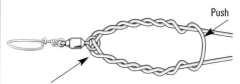

Push

Holding the swivel with one hand, pull on both strands of double line. This will begin to draw down the wraps.

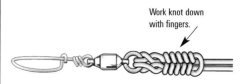

Work knot down with fingers.

To complete the draw-down, tension should be kept on the double line while you use both hands to pull and prod the wraps carefully until they snuggle evenly against the eye of the swivel.

Best way to obtain the needed tension is to place the rod in a holder and keep the reel drag tight. If using heavy monofilament line, pliers may be needed for final tightening.

# Palomar Knot

For tying on a hook or lure, the palomar is a quick, slip-proof and dependable knot that usually will test at 100 percent on a testing machine, but when shocked—such as by a powerful strike at boatside—it can break far below line test. Therefore, it should be used only with leaders or fairly heavy lines, say 20-pound-test and up. If tying a hook or lure directly to light line, the uni-knot and Improved clinch knot are much preferred.

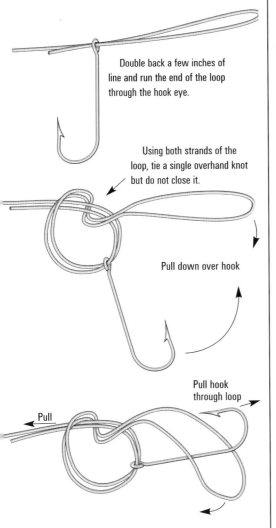

Double back a few inches of line and run the end of the loop through the hook eye.

Using both strands of the loop, tie a single overhand knot but do not close it.

Pull down over hook

Pull hook through loop

Pull

Last, slip the loop over the hook and draw the knot tight by pulling on both strands of line above the knot.

Trim close.

# Albright Knot

When you wish to tie a light monofilament line directly to a very heavy monofilament leader (for instance, 10-pound to 80-pound) this is the knot to master. It has the added advantage of being a slim and neat tie that will generally slip through the rod guides so you can crank the knot past the rod tip.

The Albright special also is used for tying light line directly to wire cable, nylon-coated wire or even to single-strand wire leader in the smaller diameters. It is excellent for joining braided line to monofilament leader material.

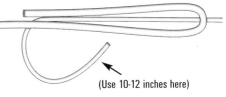

(Use 10-12 inches here)

First, double back a couple inches of the heavy material. Insert the line through the loop which is thus formed. Pull 10 or 12 inches of line through, to give yourself ample line to work with.

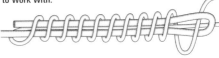

Now you must wrap the line back over itself, and over both strands of the doubled leader while gripping the line and both leader strands together with the thumb and finger of your left hand, and winding with your right. Make 15 turns (about half as many if using double line), then insert the end of the line back through the loop once more at the point of the original entry.

Before turning loose your thumb-and-finger grip, pull gently on the standing part of the line to remove slack; then pull gently on the short end of the leader to close the loop; then pull gently on the short end of the line to remove more slack.

For the last stage of tightening, pull the short end of the line as tight as you possibly can. Then pull the standing part of the line tight.

Clip off the excess line, leaving about an eighth-inch nub. Clip off the excess from the leader loop, again leaving a very slight protrusion.

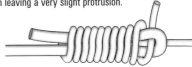

SPECIAL NOTE: The Albright special, in particular, is a knot that must be tied with great care. Practice it thoroughly at home. As mentioned before, once you learn it, it seems surprisingly quick and simple.

watching football; the distraction of TV isn't too bad and the couch makes for a comfortable venue. If you can tie knots correctly while doing something else, you can rig them under most circumstances.

A vice or some other device to hang a hook on is helpful too, so you have something to pull against. (Anglers have hooked themselves while pulling hard with both hands, to snug a line to a lure or hook). A good set of gloves are helpful and heavier lines will require pliers for tightening up the knots, particularly when you leave short tag ends. Wasting line is bad, but don't leave yourself short when tying knots. It's better to throw away a few inches of line than to leave it short and risk it slipping. SB

# Tying the Bimini Twist

This is one knot which really is difficult for the fellow who hasn't tied it before. However, once learned, it can be tied in less than a minute. One can take heart that hundreds of fishermen now tie it routinely and quickly, even in a rocking boat or in high seas. You can too, if you first practice and master it at home.

**1** Double the end of your line, making the doubled portion about three feet long.

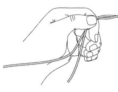

Insert your hand in the loop and make 20 complete revolutions with your hand to form 20 wraps. Note that at this stage, the wraps are spread over a considerable portion of the line.

The one most important thing to remember when tying the Bimini is to keep constant pressure on all three points.

**2** Sitting upright, hold your knees tightly together and place the loop over them. Maintain pressure as shown, with your hands on both the standing line and the short end.

**3** Spread your knees slowly, maintaining very tight hand pressure in opposing directions, as before. This will draw the wraps tightly together.

**4** Once the wraps are very snug, pull slightly downward with the short end while relaxing tension slightly at the same time. Be sure to keep up the tension, however, with the left hand and with the knees. The line should then roll easily over the wraps, all the way down to the end.

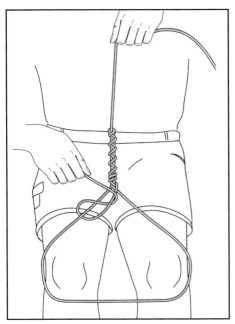 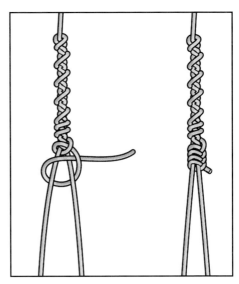

**5** This shows the completed rollover before it is anchored with a half-hitch around one strand, and several half hitches around both strands.

**6** This shows detail of finishing half-hitches: the first around a single strand, and three others around both strands. Instead of making three separate finishing hitches, you can make just one—and go through it three times with the tag end instead of only once. Trim the end, leaving about an eighth-inch nub.

# Artificial Lures

**A**sk 100 offshore captains what their favorite lures are for billfish, wahoo, tuna or dolphin, and you'll end up with an amazing variety of answers. Each captain has his reasons: Wahoo prefer tremblers, big feather or swimming plugs, while tuna are suckers for cedar plugs and feathers. Marlin get angry at the sloshing, popping and chugging of big plungers or flatheads.

While each species may show a specific preference on a given day, it's a fact that every offshore fish will, sooner or later, attack almost anything trolled behind a boat. It's important to understand this, but also to keep a good variety of lures rigged and ready during those offshore trips. Anything can happen: A 15-pound dolphin will attack 15-inch lures, while the biggest blue marlin for miles around will pass up a world-record class bait to eat a small, skirted ballyhoo on a lighter rod.

**Lure options while fishing offshore seem infinite, but the basics are fairly straight-forward.**

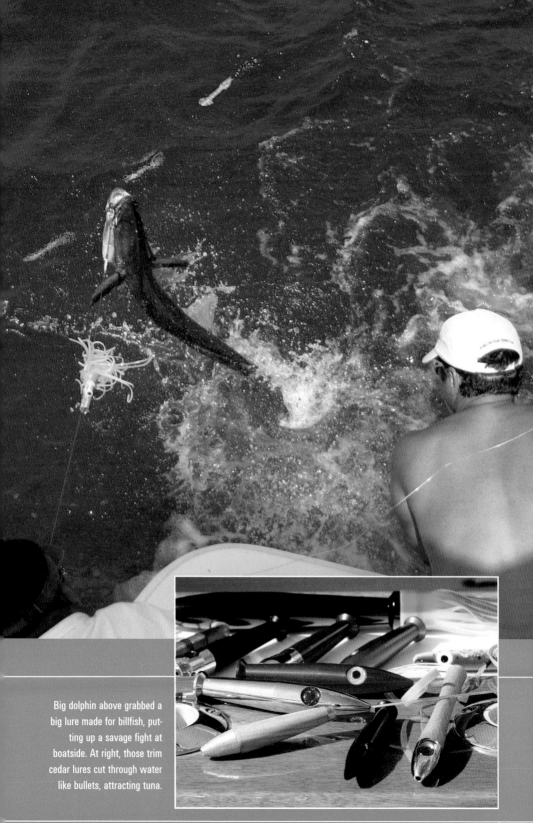

Big dolphin above grabbed a big lure made for billfish, putting up a savage fight at boatside. At right, those trim cedar lures cut through water like bullets, attracting tuna.

# Fishing With Artificials

It can be intimidating, the first time you walk into a tackle shop and peruse the trolling lure section. Options are many on how to fool gamefish into striking. Countless plastic baits are available. There are also many ways of dressing up *natural* baitfish with a little flash, glitter or color, and they've proved to be the most effective, overall trolling baits of all. Even sails and kingfish, heavily targeted with pure live baits, favor a variety of small, artificial skirts for color and attraction. Very often, the day's most appealing color will set a trolled bait apart from the rest of the spread.

Even live tuna baits pulled for blue marlin now carry something extra. Most anglers pull "color" paired with a natural bait, most often ballyhoo. Live-baiting is certainly more efficient at catching pelagic fish, but locating them is half the battle. Pure artificial lures, on the other hand, pull faster, covering more ground needed for locating pelagic species in open water. The beauty of trolling a spread of straight artificials is that every fish covered in this book will eat them on a typical day.

Along with trolling baits, it's wise to carry a complement of lures for *casting* at fish that won't fall for trolled offerings. Casting also presents a more sporting effort when using

## Best Bet Lures

**Kingfish** *4"-8" lures, 20-30lb. class tackle*
Silver spoon w/planer
Lipped diving plug, to 20'
Small trembler

**Wahoo** *8"-12" lures, 50lb. class tackle*
Chrome jethead
Weighted plastic bullethead
Medium trembler

**Dolphin** *6"-8" lures, 30lb. class tackle*
Skirted flathead or chugger
Chrome head, Mylar skirt
Traditional feather

**Tuna** *4"-8" lures, 30-50lb. class tackle*
Cedar plug, natural
Small bullethead, or dart
Lipped diving plug

**Sailfish** *6"-8" lures, 20lb. class tackle*
Chrome head, nylon skirt
Plastic chugger

**Blue Marlin** *10"-14" lures, 50lb. class tackle*
Chrome jethead
Weighted plastic bullethead
Medium trembler

**Swordfish** *8"-12" lures, 50lb. class tackle*
Plastic squid w/glow stick

spinning gear, too. School-size tuna and dolphin are no challenge on heavy trolling gear, but put on the show of their lives after hitting small jigs, flies or plugs on spin gear.

Lures pulled behind the boat depend on your quarry and geography. When fishing the beach for sailfish or out to 300 feet of water targeting big kings around wrecks and rigs, a spread of Mold Crafts or big-lipped trolling plugs won't be nearly as effective as skirting live baits with small Kingbusters or other Mylar skirts. In more open water, fish won't be so concentrated and you have to pick up the pace. Switch over to skirted ballyhoo.

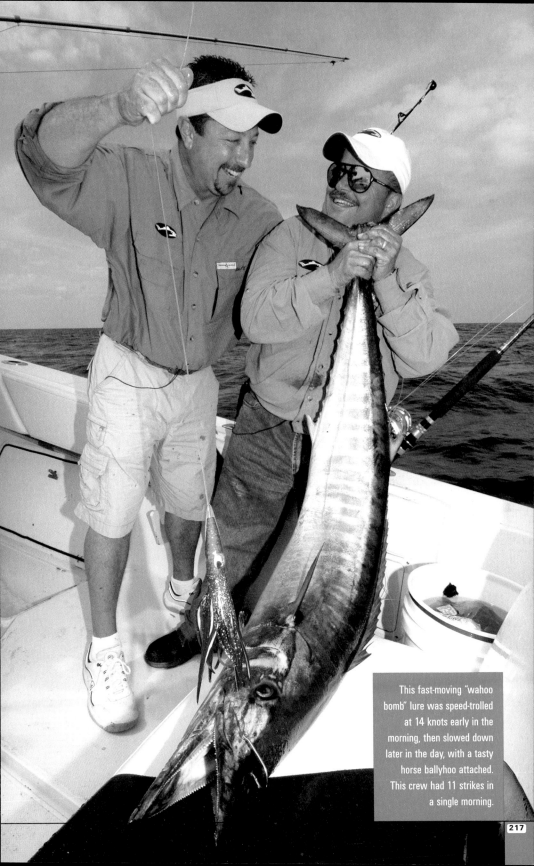

This fast-moving "wahoo bomb" lure was speed-trolled at 14 knots early in the morning, then slowed down later in the day, with a tasty horse ballyhoo attached. This crew had 11 strikes in a single morning.

# Casting Lures

Plugs like the Yo-Zuri Hydro-Tiger and Frenzy Angry Popper are excellent top-water popping lures that drive tuna and dolphin crazy. Likewise, weighted feather jigs like Sevenstrand's Tuna Feathers (2.5 ounces) and Zuker's Feather jigs (1.75 ounces) are per-

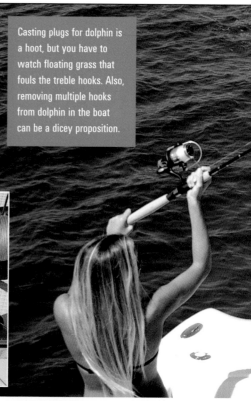

Casting plugs for dolphin is a hoot, but you have to watch floating grass that fouls the treble hooks. Also, removing multiple hooks from dolphin in the boat can be a dicey proposition.

**If you're working structure and the topwater bite isn't hot, you might have to go deep to fire up the bite. Or chum the fish up.**

fect casting lures you can use as well. Those are a few examples of hundreds of feather jigs on the market. The key is to make sure they're heavy enough to cast, colorful and very full. Why? Skimpy feather jigs simply don't work as well as full-bodied ones. None of these casting lures work, unless you're on a bite of fish working near the top of the water column. It can happen while anchored over wrecks and rocks, of course: It's a common technique at the Midnight Lumps off Louisiana, the Islamorada or Marathon humps in the Keys, or many oil rigs in the Gulf of Mexico. If you're working structure and the topwater bite isn't hot, you might have to go deep to fire up the bite. Or chum. Chunks of menhaden or smaller, whole menhaden fingerlings scattered behind the boat are like candy for bringing up kingfish.

## Heavy Metal Lures

Deepwater lures like diamond jigs, Braid Slammers and Shimano's Butterfly Jigs are popular and productive. They catch just about everything, but are especially deadly on a tuna bite. Many times

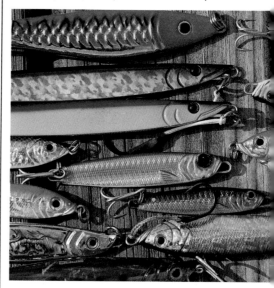

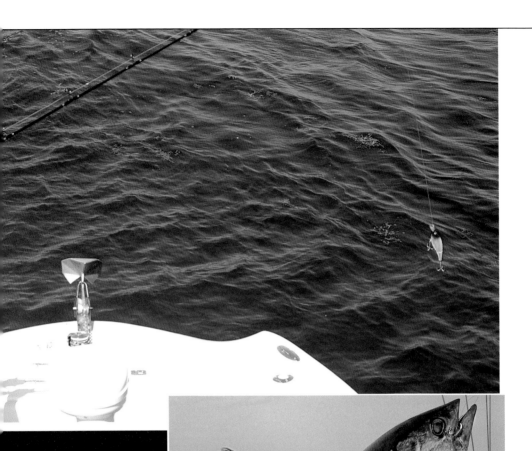

around structure you know there are tuna around, but they haven't appeared on top yet. It's hard for a tuna to turn his nose up at a fluttering jig when he's feeling safe and comfortable 150 feet deep. Getting one of these schooling fish to bite deep can turn on a bite that brings these fish to the top, where you can catch them with a variety of topwater baits. A tip to remember with heavy metal jigs is that many of them come with a treble hook. The best option is to remove the treble and replace it with a single "J" hook. Strong, stainless hooks save a lot of heartache. If you're only catching 20-pound blackfins, you won't see a problem with treble hooks. But when that 80- to 100-pound

This hefty blackfin tuna hit a fast-sinking, heavy metal lure, putting up quite a fight on spin gear.

yellowfin tuna rolls over the jig, the fight will last for a while—perhaps crushing the treble hook and losing the fish. SB

# Diving Plugs

Lipped diving plugs and trembling lures are gaining popularity as a sixth or eighth option in a trolling spread for one reason: They catch fish. Lures like Mann's Stretch 25, Rapala CD-22 or MirrOlure 113MR are all big-lip diving plugs that mix in well with a traditional spread of skirted ballyhoo. Trembling plugs like Yo-Zuri Bonitas, Braid Marauders and even steel lures such as Braid Runners are catching fish because they get down in the water column. The key with diving plugs is that they get down 10 to 25 feet or more, while most of your other baits are on top. If you happen to have a layer of off-color green or even fresh water far offshore, as often happens off the mouth of the Mississippi River, a diving plug will cruise farther below in clean salt water, where wahoo and tuna prowl.

The shaking, trembling action is irresistible to wahoo, tuna and dolphin. You won't score many billfish on these baits, though a few are reported. But these lures are dynamite on "meat fish." Again, they arrive standard with treble hooks most of the time. But not only will these hooks straighten out on a big fish, remember that you're going 6-8 knots and even with a light drag, added pressure from the fish during impact will cause these hooks to pull and bend. Most successful captains switch these out for single hooks as well. Manufacturers like Braid and Yo-Zuri offer their lures pre-rigged with single hooks.

Some anglers like to run these lures with wire leader and even put trolling leads in line with them, to get them deeper. Both are productive methods. But you don't have to rig them on wire; most captains rig their tremblers with monofilament or fluorocarbon leader and while they may occasionally lose a lure, the increased number of bites is more than enough to offset the risk. If you choose to use a trolling lead to get the lure deeper, make sure to rig it with about a foot of wire on each side of the weight; wahoo love to bite those trolling leads.

Offshore "trembler" lures, above, vibrate and dive without using a big lip. "Lipped" diving plugs, below, go deep and wobble hard by virtue of their clear, plastic lips. Bigger models will plunge down 50 feet or so.

# Spoons

Trolling spoons are classic offshore trolling baits going back perhaps a hundred years, highly favored by commercial fishermen for their reliability. Durability, as well, since they're made of metal. They're ranked by their wobble factor: Slim spoons wobble less and can be pulled faster, while others wobble more and must be pulled more slowly. Tuna and kingfish are happy to bang away at spoons all day, from the surface down deeper, where planers tow them. Wahoo hit the faster models, of course, since they often detest slow-moving artificials.

Popular offshore spoons include Huntington Drones, especially the 3½ Drone with blue flash, said to be a top hit with charterboats in South Florida.

Spoons are generally rigged with wire leader, though not always, and it's extremely important to have several loops and swivels connecting lure to wire. More loops equates with more wobble and action, and more strikes. Running several swivels means that line twist won't ruin a hundred or more feet of line on your reel.

Keel sinkers are an old trick for preventing line twist, a solid obstacle that won't let the spoon's action and twist travel up the line. The sinker also keeps the spoon down below the waves, where it won't skip in the boat's wake. A downrigger ball has the same effect, though the spoon must be fished farther back; the heavy ball scares some fish. Anglers experiment by running the spoon anywhere from 12 to 100 feet behind the ball.

If in doubt whether the spoon is working, watch for that telltale throb on the rod tip—that means it's working fine.

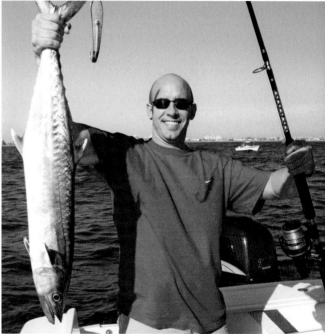

Happy angler with kingfish, after trolling time-honored Drone spoon. Below is Clarkspoon and sinker, good for small mackerel or tuna.

# Trolling Lures

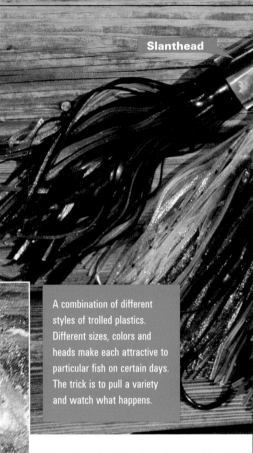

A lot of lures look almost identical, but when you finally get them in the water they perform very differently. Understanding the subtle differences in head shape and action can save you a lot of time, trouble and money when deciding which lures to buy and which to leave on the wall for someone else.

The shape of the lure head tells you all you need to know about the action of the lure, how it will run and where to position it in the spread. Some manufacturers offer suggestions

A combination of different styles of trolled plastics. Different sizes, colors and heads make each attractive to particular fish on certain days. The trick is to pull a variety and watch what happens.

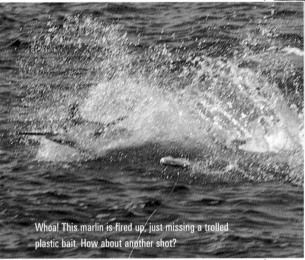

Whoa! This marlin is fired up, just missing a trolled plastic bait. How about another shot?

## Slantheads, flatheads and bullets

on their websites. Keep in mind these sites are designed to promote their products. Some are fairly unbiased and provide lots of helpful rigging tips and techniques as well as trolling advice. Some are not so good and one can quickly discern between the two.

Offshore trolling lures are available in a couple of basic styles, with each having many slight variations. Slantheads, flatheads and bullets are the three major categories.

### Slant Heads

Under slantheads you find swimmers and plungers, with a couple of variations. Lures that slant from the bottom forward, where the nose of the lure seems to

stick out, are generally classified as plungers. Lures that slant from the bottom back are swimmers. Slantheads can be cupped (like the Cabo Hi 5) or concave (like the Polu Kai Caveman) and each causes the bait to act a little differently. The cupped swimmers will spend a little more time in the water, swimming left, right and then splashing on top before heading below for a repeat. The longer they spend underwater, the better; that's where the fish are. The're ideal as outrigger baits. Plungers will spend more time on top and throw more water. They can troll from most positions, but the flatlines are really a great place for them, because they can slide side-to-side or dive up and down. They make a ruckus when running correctly, an important feature in your flatline baits.

A propwash can make it hard for fish to

**See DVD for more on trolling artificial lures.**

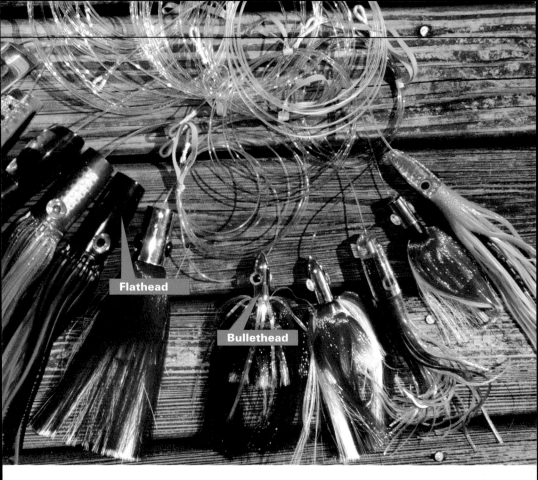

**e the three major categories of offshore trolling lures.**

see some lures. Flatlines are centered closest to the transom in the most disturbed part of the propwash, so baits there should have a lot of action, so they don't get lost in the wake's bubbles.

## Flatheads

Flatheads are of a uniform diameter in front and back, referred to as "pushers" or "poppers," and these often have holes or vents drilled in them. That allows water to pass through and throw "smoke trails," which of course are bubbles. They splash and make a commotion on top and the bubble trails "smoke" beneath the water, a nice combination. They don't swim side-to-side much, but will move up and down in the water column. Flatheads with a taper from back to front or a reverse taper are called straight runners and they perform well at a variety of speeds. The Mold Craft Wide Range

may be the most popular flathead. It's a soft-head lure with a slight taper that helps it stay in the water under calm or rough seas.

## Bullet-shaped Lures

Bullet-shaped lures comprise a plethora of shapes and styles. Among the most widely used today is the Ilander. This humble little skirt has a place on every offshore boat that pulls ballyhoo. The chrome, bullet-shaped head swims and skips alternately and the nylon "hair" that makes up the skirt is durable. They're relatively inexpensive and that surely adds to their popularity. Within the bullet category, you also have jetheads, which have holes drilled or machined and as mentioned before throw a smoke trail underwater. These lures are weighted from very light to 24 ounces and more. Jetheads are often considered a staple with wahoo fishermen, but they catch a

variety of offshore fish.

Some artificial lures are designed to run in tandem with a ballyhoo. Other lures are meant to run by themselves. While you can rig a ballyhoo with most anything, some lures are designed and balanced to only run with the weight and drag of a hook. Black Barts for example are designed as stand-alone baits. The same goes with many billfish lures, but most lure manufacturers make smaller baits that run well with a ballyhoo attached. I like to run a pair of Cabo Hi5 Swimmers as my rigger baits, most of the time. They are gorgeous lures and have a great swimming action on their own, but I find that a dink ballyhoo adds a little something to the presentation and it swims just as well. I've caught blue and white marlin, along with dolphin and wahoo on this lure and after a busy season have to re-order skirts for them.

Some lures don't swim as well with ballyhoo for a couple of reasons. Either they're not rigged properly or they just don't fit. By this I mean the ballyhoo might be too big or the added weight and profile just throws off some lures. You have to figure that out by dragging them in the water.

Understanding how lures run and what positions they're best suited for means you're ready to design your own bait spread. Short flatline, long flat, short rigger, long rigger and center rigger are yours to choose. This is of course a 5-line spread, but we'll start there. For your flatlines, larger naked baits that swim with a lot of action are ideal. Plungers and

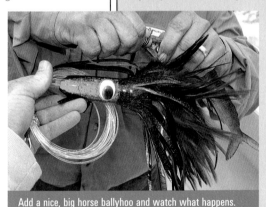
Add a nice, big horse ballyhoo and watch what happens.

flathead lures get the nod over swimmers or jets in this position. On the riggers, a pair of swimming baits would be the ticket. Mix up a cupped-head swimmer with a concave one and let the fish decide which one it likes best. You can choose to add a ballyhoo to your swimmers or not. For the center rigger, a bullet/ballyhoo running behind a bird teaser is very productive. It has to be calm enough for the bird to run right, so when the seas get choppy, put a jethead or concave swimmer on the center rigger.

# Rick Ryals on Wahoo

Wahoo are nomadic and we cover many miles searching for them, at between 10 and 14 knots. We take a good look at the temperature charts and focus on the breaks, but we're prepared to search far and wide for our first few bites.

For wahoo, we look for a lure that shows a big silhouette, but without enough water resistance to rise in the water column.

Everybody has their favorite colors and lure action for these fish. I believe the faster you troll, the more reactionary the strike, and the less important the intricacies of the lure. For example, one of my favorite wahoo lures is a lead-headed, 8-ounce feather pulled at a fast rate. Troll that same lure at only 6 knots, giving these fish a chance to look it over, and it'll be a long time between bites.

It's important to keep high-speed lures underwater when after wahoo and tuna. Think about how your target species is built: Wahoo and tuna have big eyes, located high on their head. I believe sunlight and slick mirror surfaces bother them. That's why they do better looking at a lure beneath the surface, instead of on top.

My high-speed spread will usually consist of two heavy (at least 8-ounce) straight swimming lures on my riggers, with either very strong pin settings, or even better, No. 32 rubber bands attached to the locked pins. 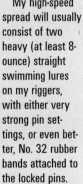 You want the outrigger to ensure the hookset. If you don't have outriggers, run your lures off a stiff rod tip. Outriggers serve two purposes: They increase the width of your spread, covering more water, and provide an automatic dropback. When a big fish bites down on a 14-knot leadhead, the last thing you want is a dropback that allows him to spit it out. That hook had better be set, before the line comes out of the outrigger pin.

My flatlines are where the action can be furious. We pull a "Cairns Swimmer" lure 30 feet behind a

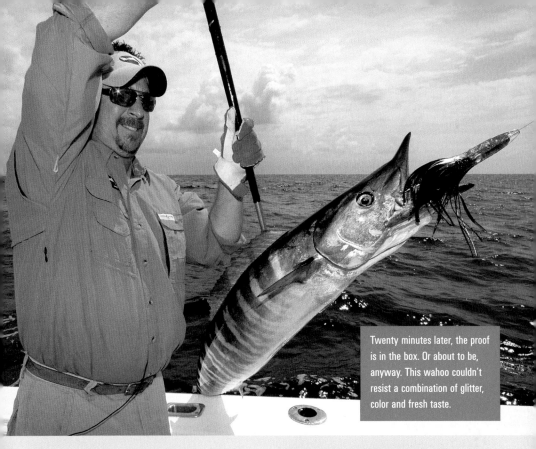

Twenty minutes later, the proof is in the box. Or about to be, anyway. This wahoo couldn't resist a combination of glitter, color and fresh taste.

24-ounce trolling weight. The real reason for using so much mono leader is the incredible pressure generated by a wahoo going all out, dragging that heavy weight, while we're steaming at 14 knots the other way. Without a 30-foot shock absorber (200-pound mono), almost every strike would end badly. On our other flatline we'll pull a trolling weight with a long, sleek jethead-style lure. I try to use single hooks on all our lures.

> "I do believe the faster you troll, the more reactionary the strike."

The biggest mistakes first-time high-speeders make for wahoo is setting their drags too tight. Trust me, 14 knots of forward motion creates plenty of drag. Once you're at trolling speed, move your drag lever up until the line is barely staying on the reel. Once your fish takes off and you slow down, you'll have plenty of drag to control your fish.

Once we've had a strike or two, we'll slow down to work a defined area. This is when our lure selection changes drastically, because we're worried what a lure looks like under closer scrutiny. Once we get a strike or two at high speed, I'm always

confident there's more fish in the immediate area. This really holds true if the species we catch isn't wahoo. Dolphin and sails are less likely to strike at 14 knots, so if we get a strike from one, there are plenty more in the area.

Remember, the slower you troll, the more lifelike your lures should be. A Cairns Swimmer has very little wobble, depending more on pure speed to give it action. By contrast, a lipped diver has more wobble, drawing wahoo bites even at 5 knots.

For dolphin and sails, the more lifelike the better. I'm a big fan of cedar plugs and rubber squid. When we're potluck trolling, I'll set our speed at 5 to 8 knots. I'm a big believer in teasers, and we'll have a dredge with swimming shad tails on one side, and a spreader bar of small green squids on the other. Behind the dredge we'll usually run a lipped diver. On the short rigger we'll have a rubber squid. I've caught just about everything that swims on rubber squid, and believe it's as effective as any artificial around. –Rick Ryals

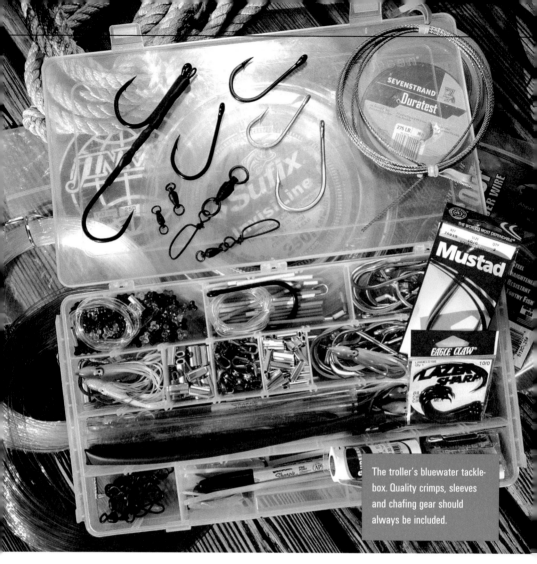

The troller's bluewater tackle-box. Quality crimps, sleeves and chafing gear should always be included.

# Rigging Artificial Lures

Rigging artificial lures isn't as daunting or scientific as some make it out to be. There are basic elements you need and some fundamental practices that will increase your hookup ratio and raise your catch count. First and foremost, don't go cheap on your rigging materials. Artificial lures range from $10 to more than $100 dollars. They can last a lifetime, when treated properly and re-skirted as needed. Don't put them at risk or neglect by using cheap rigging material. That doesn't mean just buying sub-par materials, it means don't use 3-year-old leader material that's been wasting away in your garage. Or crimping sleeves that have burrs in them. Many boat crews give a freshwater rinse to each lure retrieved from the water, storing them away

**Size your hook to the lure first, and then later your natural bait to the hook.**

from sun and oxydation.

There are probably as many variations and opinions on rigging lures and selecting hooks as there are fishermen. Before getting ahead of the game, we need to understand basic terminology and materials.

## Hooks

Keep it simple when selecting hooks. Look to your local tackle store for opinions on hooks for rigging artificial lures, but here's what you're likely to come up with. For artificials pulling ballyhoo, a good choice would be a Mustad 7732 stainless steel hook or a 7731 model, which is tinned. These hooks have an open shank with enough room for holding either a ballyhoo or strip bait, and it leaves enough gap to hook big fish properly. You'll save a buck or two per hook by going with the 7731, but this hook is not as strong or durable as the stainless counterpart. You can either re-rig every season with new tinned hooks or just use stainless to begin with. Just remember, a stainless hook left in a pelagic fish will remain for years. Some captains forgo even stainless and use the Owner Jobu style hooks, which have a cutting point tip. This means no sharpening and that can save time and hassle. With the NMFS hook ruling for tournaments, those opting for circle hooks on their naturally baited skirts may prefer the Eagle Claw L2004.

You should size your hook to your lure first, and then your natural bait to the hook. Using an 8/0 Mustad with an Ilander Original is about the right size, for instance. Putting a tiny ballyhoo on that hook or a horse ballyhoo will cause your bait to run incorrectly. It will likely spin with the smaller bait and the bigger 'hoo will wash out

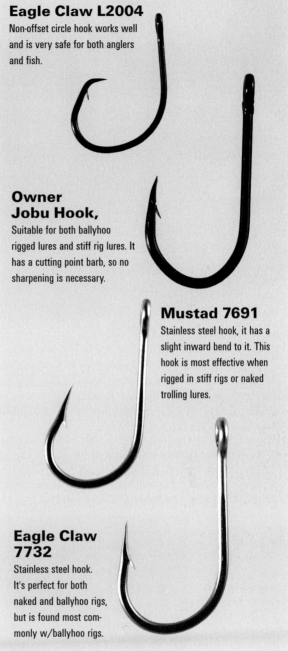

### Eagle Claw L2004
Non-offset circle hook works well and is very safe for both anglers and fish.

### Owner Jobu Hook,
Suitable for both ballyhoo rigged lures and stiff rig lures. It has a cutting point barb, so no sharpening is necessary.

### Mustad 7691
Stainless steel hook, it has a slight inward bend to it. This hook is most effective when rigged in stiff rigs or naked trolling lures.

### Eagle Claw 7732
Stainless steel hook. It's perfect for both naked and ballyhoo rigs, but is found most commonly w/ballyhoo rigs.

fast and won't skip and swim properly. A good rule of thumb is that the gap of the hook should be about as wide as the head of your lure, yet will fit the ballyhoo. It's like defining quality—you know it when you see it. If the hook looks out of place or the bait doesn't fit under the skirt, it isn't right.

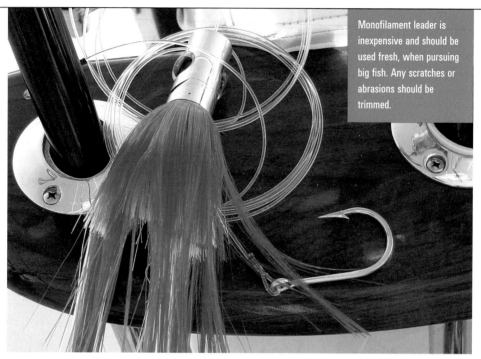

Monofilament leader is inexpensive and should be used fresh, when pursuing big fish. Any scratches or abrasions should be trimmed.

For rigging artificials without adding bally-hoo, you have the same choice of tinned versus stainless, and again the stainless hooks will win out with most anglers. But the style of hook changes just a bit. Most captains and lure makers agree that the Mustad 7691, also known as the "Southern Tuna Style" or "Tuna Bend" hooks are more effective. The point has a slight bend back toward the shank. For the same reason as above, more and more boats are moving to the Owner Jobu hooks for naked baits as well. The jury is out on their effectiveness versus the aforementioned Mustads, but the cutting point tip is a big selling point.

Whether or not anglers use single or double hook rigs is another argument altogether. Even when pulling natural baits, there are rigs for using double hooks. We'll cover those recommendations a bit later in this chapter, but hook choices remain the same. There are just variations on rigging them.

## Leader Material

Monofilament or fluorocarbon: the perfect invention for billfish, tuna and dolphin.

The real truth about leader size and material is that you should never worry about it breaking. You can't put enough drag on 250-pound leader to break it. The bill of a fish, sharp teeth

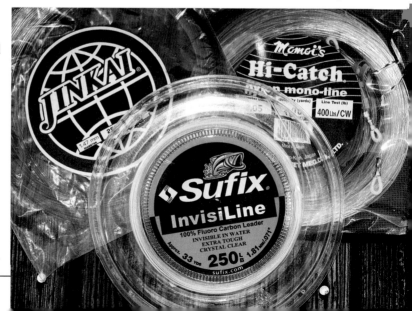

of a wahoo or perhaps a malfunction in leader rigging are causes for leader failure. So pick a leader size that will allow your lure to swim the way it was designed to. Lure manufacturers can be fanatical about balance and proper action; they'll give you a recommendation about leader line class too. Momoi, Jinkai, Seaguar, Ande and Yo-Zuri are all reputable names in leader material.

Fluorocarbon is a great leader material. However, it costs three to four times as much as quality monofilament. It's stiffer than mono, too. Its advantages are abrasion resistance and near-invisibility in water. Monofilament is relatively inexpensive even for the heavy stuff, and its reliability is unquestionable. The point is that both work well. Fluorocarbon has advantages—for sailfishing, targeting dolphin and chunking for tuna, it's superior. But for rigging artificial lures day in and day out, monofilament is more practical.

In general, pulling 17-inch magnum lures requires heavier leader than 6-inch tuna feathers. Small lures are rigged with 150-pound leader, medium-sized lures require 250 and large ones use 400-pound, according to one captain. Other captains in Venezuela use only 80-pound mono leaders when fishing for white and blue marlin, claiming they get more strikes that way. They also use 30-pound line on the reel, however.

Other captains cover their bases by having three of the same lures like blue and white Ilanders, one rigged with light, medium and heavy leader. Just remember that the heavier the leader material, the more work that lure has to do to act as its anchor in the water. The more work it has to exert on the leader, the less natural movement and work it exerts attracting fish.

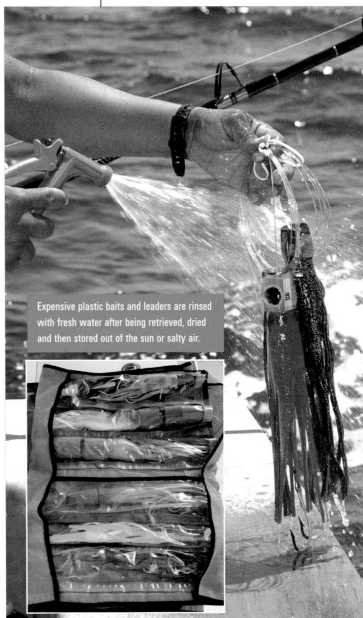

Expensive plastic baits and leaders are rinsed with fresh water after being retrieved, dried and then stored out of the sun or salty air.

## Chafing Gear

Using chafing gear can make the difference in bringing a big fish to the boat or lamenting the monster that got away.

A swivel is made of metal, and is usually much thinner than the leader material. The eye of the hook on the other end is probably

protectors to hard, clear plastic tubing, to the more durable, pliable nylon tubing. This material is used to form the loop where you connect your leader to your mainline, and the connection around the hook at the business end of the lure. You can rig lures without this step, and you might catch a pile of fish without it, but eventually it will come back to haunt you.

Thimbles are plastic or stainless loop protectors that, instead of coating the entire loop, cover the inside loop only—which is where contact is made with swivel or hook. They aren't as popular as tubing and you have to remember to pinch the stainless ones closed—or they expose an edge that can work against your leader.

Tools of the trade: Crimping tool at bottom, with crimps, chafing gear and sleeves.

Shrink tubing is an industrial grade cable protector. It's most commonly used over connections at the hook when using wire for a "stiff rig." It can be used with monofilament or fluorocarbon too, but you have to take care when applying heat to shrink the tube. Neither material reacts well to heat. Many anglers use colored electrical tape here, as it serves the same function without requiring heat. Wire is commonly used for the last few inches of rigging artificial lures and we'll cover that later in this

wider than the leader material. One might cut the leader material or it might not, but both are much harder than the material. A prolonged fight with a big fish will cause the back-and-forth motion of both ends of your leader to be tested. Adding an extra 10 cents and a few seconds while rigging is certainly worthwhile.

Chafing gear varies from coated wire loop

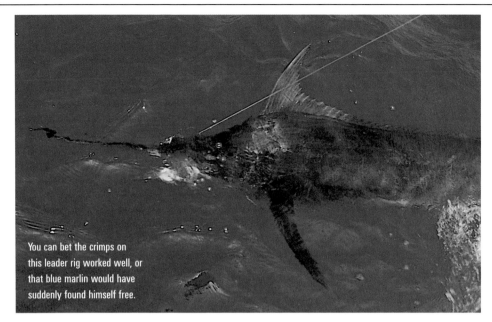

You can bet the crimps on this leader rig worked well, or that blue marlin would have suddenly found himself free.

chapter. Shrink tubing is used to protect against wear-and-tear from toothy critters, rough bills and the pressure of fighting fish.

## Sleeves and Crimpers

There are a couple of main types of sleeves—the aluminum oval sleeve and double barrel copper or zinc sleeves. Double barrel sleeves are more commonly used to crimp wire, while aluminum ovals are used on monofilament and fluorocarbon. It's very important to match leader material to the right sleeves. The leader should pass through and be snug, but not where you have to wrestle it through the sleeve. To crimp these sleeves you can choose a simple set of crimping pliers, which work fine, but as you crimp more and more, a pair of double-hinged-jaw swaging pliers will become a necessity. These make easy work of crimping and are relatively inexpensive. You can also get bench-mounted crimping stations for working in the tackle room. However, hand crimpers work well on boats and are just fine for starters. They're durable, but will eventually rust without a little cleaning and oil.

When crimping wire such as 49-strand cable, and using double barrel sleeves, you can crimp the entire length of the sleeve without worry. It actually adds more strength, the more those stiff wires get pressed into soft copper. Aluminum sleeves and monofilament are different, however. You don't want to crimp the ends, as they have a tendency to dig into the leader and may cause it to fail. When crimped properly, the ends flare open just a bit, allowing the doubled portion of the leader material its required room.

## Making the Connection

1. Slide the sleeve over the leader material.
2. Pass the leader through the loop protector/chafing tube. Length will depend on how large you want your loop. The smaller the profile of the loop the better.
3. Pass the leader material back through the sleeve.
4. Crimp and trim.

# Single Hook Rig for Ballyhoo

After you've sized the leader length and made the loop connection to attach to a swivel, critical rigging steps will help complete the ready rig pictured at right.

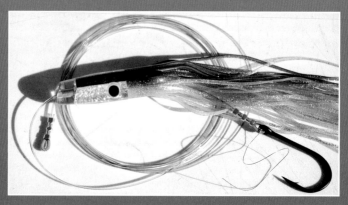

**1** Slide the tag end of your leader through the head of the lure and out the back.

**2** Pass the leader through the lure, leaving at least four or five inches to work with.

**3** Slide your crimping sleeve over the leader, followed by the chafing gear.

**4** Pass the leader and chafing gear through the eye of the hook and back through the sleeve.

**5** Crimp twice without getting too close to the end of the sleeve giving it a slight flare.

**6** Haywire twist a length of copper rigging wire to the eye of the hook, to hold future ballyhoo.

See **DVD** for more on rigging trolling lures.

# Stiff Rigs

These rigs are for running lures without ballyhoo or stripbaits. The goal is to set the hook in the upright position, with the bend of the hook just barely sticking out of the back of the skirt. Rigging the last section—the part from the back of the lure head to the hook—is often done separately with 49-strand wire. You can do the same rig with mono, but stiffer wire stays truer when trolling and it's impregnable to almost all teeth, save perhaps a mako shark.

## Double Hook Stiff Rig

Opinions vary, but most anglers agree that if you are going to use double hooks, the alignment should be in-line or at opposition, meaning 180 degrees apart. The advantages of double hooks would seem obvious, but there are some downsides. If the trailing hook is located firmly in the jaw of a fish, the second hook can wear on the leader if the fish gets wrapped up. The second hook is also a danger to crew members, if it isn't lodged in the fish. A dolphin, tuna or wahoo fighting for its life on deck can be a dangerous scenario with a 10/0 hook flailing. One barefoot captain from Galveston danced with a 30-pound dolphin on deck, after a 10/0 trailing hook lodged in the the top of his foot. Handy bolt cutters finally got him loose from the fish.

Some bluewater captains prefer second hooks, while others won't even allow them on board.

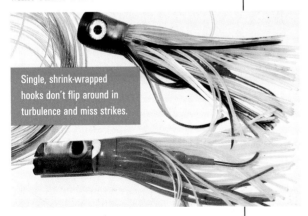

Single, shrink-wrapped hooks don't flip around in turbulence and miss strikes.

## Double Hook

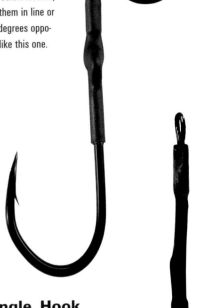

Double hook stiff rigs are simple to make. Simply heat-shrink a second hook to a single hook rig. Never set the hooks at a 90-degree angle to each other. Instead, face them in line or 180 degrees opposite, like this one.

## Single Hook

The stiffness of this rig is what makes it so effective. The hook sits upright, finding a fish jaw more readily, and increasing your hookup ratio greatly. Top lure makers everywhere recommend single hook, stiff rigs for their marlin lures.

It's a personal choice. If you go with double hooks on trolling lures, they're easy to create.

There is always the option to buy these rigs ready-made at the local tackle store. They'll cost you a few bucks more than making them yourself, but save time. If you aren't sure about sizing them to your own skirted lures, take them with you and compare. Most tackle stores will make them to fit your lures, if they don't have them already on the shelf.

## Wire Leader Rigs

Rigging cable leaders for high-speed trolling for wahoo carries with it the same basic principles of rigging lures on monofilament. The materials change to different manufacturers' versions of 49-strand cable, but the principles are similar. You'll rig them with the same tools and can even use the same anti-chafe tubing, though it's not necessary, since the cable will be in contact with the swivel.

The biggest difference in rigging with wire happens when you use singlestrand wire for kings and wahoo. Most captains prefer to troll using cable, but singlestrand wire is available in gauges up to 350-pound strength. It's very popular on lures like lipped diving plugs and

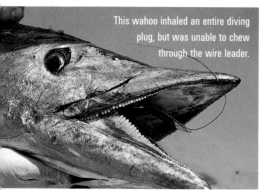

This wahoo inhaled an entire diving plug, but was unable to chew through the wire leader.

even small trembling plugs. Singlestrand wire is simple to rig.

If you are fishing light lines and leader for kingfish, you can get away with step number 4, but when targeting larger fish, always use a barrel swivel or "O" ring. Singlestrand wire has a tendency to kink after use and is disposable. What it adds in ease of rigging is diminished by the fact that you have to re-rig after almost every fish.

# Offshore Flies

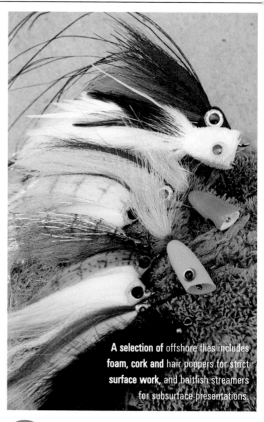

A selection of offshore flies includes foam, cork and hair poppers for strict surface work, and baitfish streamers for subsurface presentations.

O ffshore fly patterns are largely impressionistic baitfish or squid patterns, with the emphasis on function. Much offshore fly fishing involves chumming with live baitfish, and in that case, fish become selective and key on that particular bait. You had better have flies aboard that "match the hatch." At the very least, choose a like-size fly, and then consider color.

Because offshore fly fishing takes many forms, there is a place for small pilchard and sardine flies tied on No. 2 hooks, and a place for or 12-inch streamers imitating small mackerel, and even big, gaudy poppers tandem-rigged with heavy gauge 7/0 hooks. Flies can imitate fresh chunks of fish, too. Take the so-called Flesh Fly, for example: This is the go-to "fly" when chumming with chunk baits. Drift it back without manipulation and it looks like

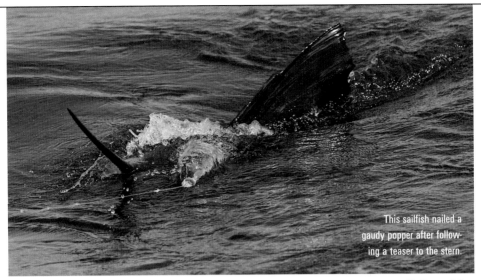

This sailfish nailed a gaudy popper after following a teaser to the stern.

**Tackle up correctly for the correct fly. It's easy to cast a small fly with a big rod, but casting a whole chicken on a light rod is impossible.**

a chunk in the current.

Since you are dealing with a huge water column, fly function is a major factor to consider. If fishing at the surface for dolphin, bonito or tuna, it makes sense to choose a buoyant fly, perhaps with palmered hackles, or deerhair for a slow sink rate. If you need to get down to deeper fish, synthetic winging materials help a fly go down more quickly (plus they shed water and are easier to cast). Sometimes it takes some lead (dumbbell eyes or fuse wire on the hook) to fish down deep.

Be sure to "tackle up" appropriately for the fly you fish. While it's easy to cast a small fly with a big rod, casting a "whole chicken" on a lighter rod is impossible. That goes doubly so when offshore, where many fish approach the boat—which makes it even more difficult to load the rod properly. A short line outside the rodtip can make casting more difficult.

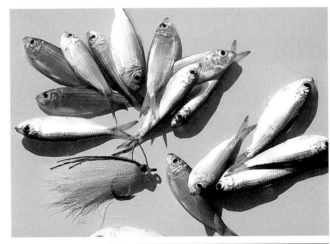

Top, streamer at lower left is deadly in a pilchard chum line. Right, full body streamers catch cobia.

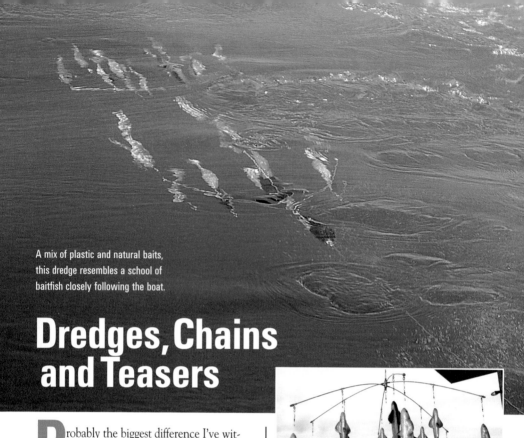

A mix of plastic and natural baits, this dredge resembles a school of baitfish closely following the boat.

# Dredges, Chains and Teasers

Probably the biggest difference I've witnessed in fishing with dozens of different boats offshore is the attitudes toward teasers. "They're too much work." "I'm convinced they spook the billfish." "They aren't worth the trouble when clearing the spread." These comments came from folks that didn't catch nearly as many fish as the teams that pull them. Pulling teasers require a little more effort and diligence when you're fishing offshore, but they are worth that effort. If they weren't, top tournament teams and charter captains the world over wouldn't go to the trouble. So the argument isn't whether or not you should pull teasers, it's what *kind* should you pull.

## Dredges or Umbrella Rigs

Generally these consist of four or six stainless arms with droppers to attach your teaser baits to. Those baits can be anything from ballyhoo to soft plastic baits, holographic strip teasers or soft-bodied holographic swim baits like the Mojo Fish Umbrella. The purpose is to imitate a tight swimming school of baitfish with hookless baits—giving bigger fish a chance to eat a trolled bait right behind or to the side of the teaser. You can also pitch baits to fish raised on dredges. However, the size and makeup of the dredge makes it difficult to pull from the water for a true "bait and switch." Most anglers are content to position a bait or re-position as necessary, if the fish won't leave the dredge to grab a trolled bait.

Dredges are designed to run 3 to 6 feet below the surface. Unlike most teasers that are primarily topwater attractors, that simply offer a silhouette to a fish swimming below, the dredge teaser gives them a 3-D (or in the case of the strip teaser a 2-D holographic) image of a bait school. To get them down and keep them down, dredges run best when weighted and towed at slower speeds of 6 to 7 knots. Some bars come pre-weighted, but if they don't, adding an inline trolling weight is easy.

Rigging a dredge can be done a couple of ways

and depending on your boat size, you might even tow two dredges. It can be as simple as clipping a 20- to 40-foot length of heavy monofilament to your transom cleat, which means you retrieve them manually. They can also be run from "dredge rods" which are not much different from kite rods, usually run by inexpensive reels like a 6/0 or 9/0. The goal is to get them past the propwash, as far back in the spread as possible, and still have them run correctly and stay visible. If you can't see them, you won't be able to see if a fish is trailing behind.

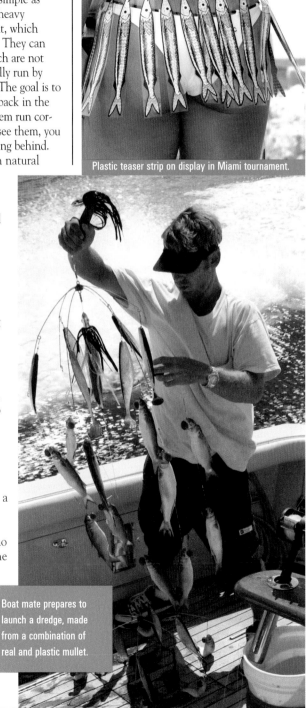

Plastic teaser strip on display in Miami tournament.

Dredges can also be rigged with natural baits such as mullet or ballyhoo, but the time and expense of rigging and re-rigging these can be substantial. The effectiveness and ease of running artificials on dredges quickly took the place of rigging natural ones.

The pros of fishing dredges far outweigh the cons. The cons are their ability to find weeds, the labor involved in running, rigging and clearing them and the expense. Dredges can cost up to several hundred dollars each, but when you factor in the overall expense of repeated offshore trips, the cost of adding a dredge or two is fairly insignificant, especially after you see their ability to raise fish. The pros are simple—they produce fish, even when action is slow for others. Fishing with an offshore team one year, I watched a mate reluctantly deploy a strip teaser dredge. He didn't want the "hassle" earlier in the day. After no bites by afternoon, he deployed the rig just in time to watch a pair of big wahoo tear through it. They destroyed several plastic strips in the teaser and then found our rigged baits. One bit short, but the other found the hook on a rigger bait and soon decorated our fishbox.

Boat mate prepares to launch a dredge, made from a combination of real and plastic mullet.

**Teasers are available in different styles and sizes, and they're all designed to raise pelagic fish and bring them closer to the baits.**

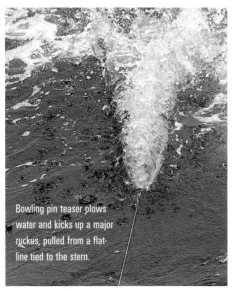

Bowling pin teaser plows water and kicks up a major ruckus, pulled from a flatline tied to the stern.

## Chains and Single Teasers

The most famous of all soft teasers has to be the squid daisy chain. This topwater running bait can run on the riggers or off a simple handline cleated to the transom. Its effectiveness is unquestionable after so many years; they can be found on offshore boats the world over.

Fender teasers are another popular soft teaser, but this one will swim down under the water, which makes it great to run in the propwash. Its splashy, noisy and flashy presence won't be hidden by the boat's wake.

For hard teasers, nothing beats a bowling pin teaser. This is primarily a topwater bait, but it swims just below the surface for several seconds, jumps to the top and pops, slurps and darts side to side. We've caught many wahoo with these, after anchoring each corner of the transom with a bowling pin. You can run them as singles,

with skirted hookless baits trailing them or as a daisy chain with 4 to 6 pins on them. They're usually painted to resemble bonito, dolphin or small tuna to predators, and they're mesmerizing to watch from the tower.

One of the most famous hard teasers is the bird. This unassuming little piece of wood skips along with a rigged bait clipped to its tail and makes a ruckus that fish can't ignore. Many offshore trips have been salvaged by deploying a bird on the center rigger position, running far back. The wings on these little guys dance and pop and skip, even while a

Bird teasers sport little wings, and they paddle the surface rapidly when used in calm seas.

skirted ballyhoo or cedar plug follows just behind. That unique action brings fish to the surface, where they find a rigged lure. Running birds is easy, with a variety of baits behind them. In addition to those already listed, small daisy chains of skirt and squid baits or even multiple cedar plugs are very effective, so you can get very creative with the bird. Relatively calm water is needed to run them effectively, but that's usually when you need help raising a bite, anyway.

Other hard teasers include a variety of mirrored models, such as Pakula's Witchdoctor, Boone's Sundancer and the Dorado Teaser by

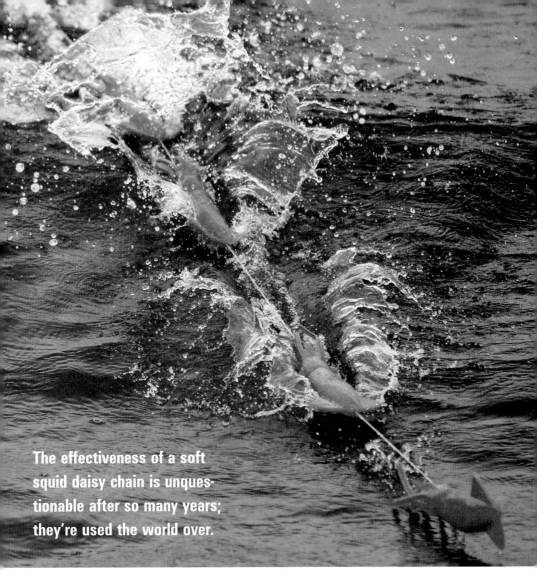

The effectiveness of a soft squid daisy chain is unquestionable after so many years; they're used the world over.

Braid. All of these examples are weighted, swimming teasers that employ mirrors to catch the light, flash and raise fish. There is also the option of not using teasers, but instead simply running big, splashy billfish lures rigged hookless to add to the spread. The key is to put the noisiest and most obnoxious teasers in the propwash where they won't get lost in the wake. More subtle teasers like squid chains, flyingfish chains, Ilander or Alien daisy chains can be run off the short rigger position, with a rigged bait running just behind it, which is important.

## Storing Teasers

The folding arms on some dredges make them easy to retrieve, fold and store in tubes they come in. Other teasers can be cleared and put in 5-gallon buckets, stored under the gunnels or even in transom boxes available on many boats. When it comes to clearing lines on deck when a fish strikes, some crews get in a hurry and sling things all over the place. Under those situations, teasers can be a hassle. But unless your fish is a tiny one, you have a few minutes to take your time and store them right.

The best thing a crew can do is know the correct order to retrieve lines and teasers, doing so in a calm but quick manner following a strike. Used correctly, teasers will only make your offshore trips that much more productive. SB

## CHAPTER 12

# Boats for Offshore

There are three main classes of boats used for offshore fishing: Center consoles, walk around/cuddy's and sportfishers. The type of fishing a captain prefers and geography usually dictate boat needs. For example, in Miami, sailfish and swordfish are readily caught from sturdy center consoles— sometimes both species on the same day. But if you live in Panama City in northwest Florida on the Gulf, making that long run to the oil rigs for blue marlin and tuna may require something bigger and with a cabin. More survivability, should the weather turn sour. With the evolution of today's modern center consoles, there aren't many places that are off limits, but safety, comfort and feasibility come into play.

Some argue you should select your boat based on which aspect of the sport you prefer—but what if you want it all? There can't be a perfect boat for every situation, however. Some boats are better suited for certain types of fishing than others. Understanding boat design basics may help you decide those options.

**Picking the right vessel is important because each has its own characteristics.**

  **See DVD for more offshore boat options.**

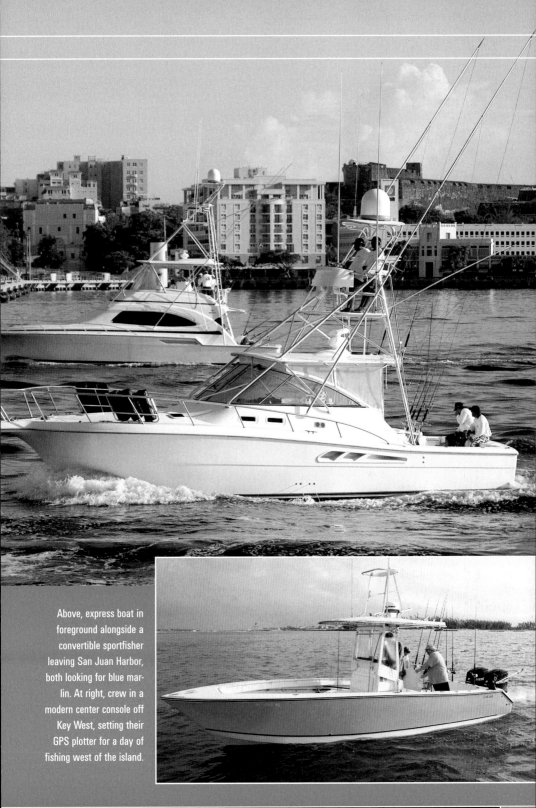

Above, express boat in foreground alongside a convertible sportfisher leaving San Juan Harbor, both looking for blue marlin. At right, crew in a modern center console off Key West, setting their GPS plotter for a day of fishing west of the island.

# Center Consoles

enter consoles are all about versatility. You can take them to blue water and back and win tournaments against the big sportfishers—doing so at speeds up to 60 knots and even higher with some models. They can be outfitted with towers for better visibility, outriggers, underwater lights and a vast array of electronics. Some larger CC mod-

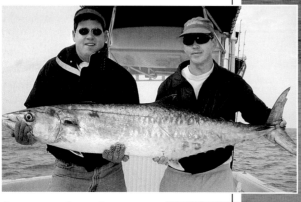

els even sport bow cabins to provide a few more creature comforts. Center consoles allow 360 degrees of action around the boat and they've come a long way in earning their stripes as offshore fishing boats.

It used to be that center consoles were thought of as mainly for bottom fishing or cruising the beaches while looking for kings and sails. They're great for all three of those applications, of course. In fact, one could argue that the evolution of modern center consoles was born from the tournament king mackerel fisherman's desire to fish farther and get to the scales faster than the competition. Companies like Contender, Wellcraft and Fountain embraced this sport early on and many boat makers have since taken these craft to new heights, pushing the design envelope: More range, drier rides, greater speed and overall more functionality

Anglers above found big kingfish after making the 68 mile run to Fort Jefferson in the Dry Tortugas, west of Key West.

**The center console boats ha**

on the open water.

Some models now sport fuel capacities up to 600 gallons and carry four outboard engines on the transom. Even achieving 1.2 or just 1.0 mile per gallon means they have range on par with many big sportfishers, but with amazing speed. New 4-stroke and direct-injection 2-stroke technology means improved outboard fuel economy, too.

Jumping into a center console may require you to open your wallet wide, but there are several reasons you might choose a top-of-the-line premium center console over a comparable-size flybridge or express inboard sportfisher and vice versa. It's all about preference.

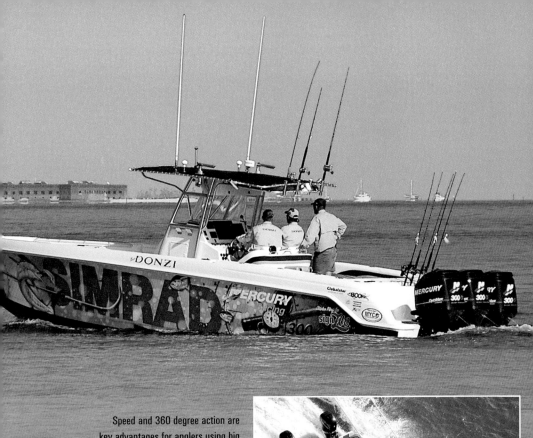

Speed and 360 degree action are key advantages for anglers using big center console vessels. At right is a catamaran design, very stable and smooth-riding in a chop. At top is a ventilated, race-inspired mono hull with the horsepower to back it up.

## eally earned their stripes offshore.

The advantages of increased speed and range change your options for every fishing day. If you have a 30-mile run to the fishing grounds and a 12-hour fishing day, running at 25 knots each way means ideally you get just under 10 hours of fishing. There's not a lot of difference in taking an hour to get there or putting the throttles on the pins and getting there in 40 minutes versus 60. However, if you have a 70-mile run under the same conditions, being able to run 45 knots means that you can still have about a 9-hour fishing day. Conversely, if you had to max out your inboard sportfisher at 25 knots, your day of fishing is just over six hours. The assumption is

made here that the weather is cooperating and you can make these speeds. That sportfisher will just as likely make the same speed on a calm day as it would in 2- to 3-foot chop, with minimal change in comfort. The center console might make the same speed; but the jarring and impact on your body and the boat will most definitely be felt, with a dose of Advil for the crew by day's end.

The ability to fight a fish from the bow or the stern is a distinct advantage of center consoles. No need to back down into seas, taking waves over the transom: The captain can

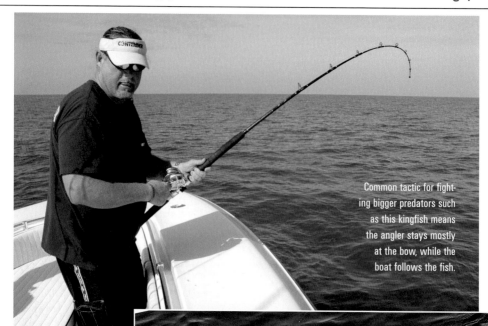

Common tactic for fighting bigger predators such as this kingfish means the angler stays mostly at the bow, while the boat follows the fish.

watch what the angler is doing just as easily in either position, but the bow allows freedom to chase down fish in less time, in a safer manner. This can translate into quicker tags and healthier releases on fish. For tournament guys and gals, it's all about how quickly you can tag or gaff your quarry. For recreational folks it can mean the same thing, but you can also take solace in knowing that shorter battles mean healthier releases. For situations where multiple hookups are common, being able to spread the anglers out for 360 degrees can help your crew and anglers keep their fish from getting tangled.

The option of trailering your boat is often overlooked as an advantage, until of course you get to the gas pumps. It's no secret that marina prices are generally much higher, anywhere from 50 cents to a dollar or more per gallon than street prices. Multiply that difference by the number of gallons and you can sometimes pay for a trip or two. Finances aside,

trailer boats offer a versatility that is lost on bigger boats that are water-locked. If you want to pick up and head to Louisiana for tuna season or go to Stuart for sailfishing or North Carolina to chase giant bluefins in the winter, trailering gives you that option. Compare the cost of storing trailer boats versus in-the-water, too. Engine maintainence is generally lower with outboards, too.

Center consoles are heralded for their easy cleanup and low maintenance. Self-bailing cockpits and that open design lend themselves to a quick washdown. Whether the deck is finished or unfinished, non-skid or not, boats of this style just clean up fast. There aren't as

many things that can go wrong on an open boat, and easy maintenance attracts more and more anglers to these machines every year. Checking fuel water separators, bilge pumps and washdown pumps is a cinch on center consoles.

Center consoles generally come up on the short end of the stick when it comes to onboard storage space. Dry space is usually at a premium. Most of the in-deck storage is saved for ice and fish (thank goodness!) and a lot of the console is saved for the porta-potty or head. The good news is that you don't need as much "stuff" for day trips on center consoles. Having enough space for plenty of ice, food and drinks is no problem. Larger items such as bean bags (used for cushioned rides) can be tossed up on the T-top and

Awesome power, downriggers, big livewells and room for many rods make these big center console boats pure fishing machines.

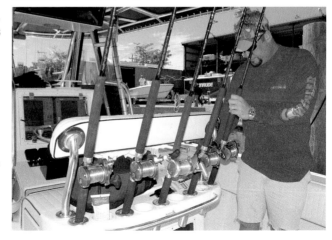

It doesn't mean overnighters aren't doable. It means they aren't going to be as comfortable as they would be with a cabin and AC. It doesn't matter who you ask, all agree that sleeping on a bean bag up in the sweaty bow is not really sleeping.

Unobstructed visibility, fore and aft, allow the whole crew to watch for signs of fish.

bungee-corded down, out of the way. Loose coolers that travel in the cockpit can be moved to the bow area during slow-trolling, as well. The functionality of all that open space means you have a lot of options.

Then again, openness can be something of a disadvantage. You can lean up under the T-top when it rains, and if you are trolling at the time, it's no big deal. However, if you are traveling at 45 knots, those rain drops aren't a nuisance, they're painful. Unless you have a full set of curtains, those drops will find a way around your glasses and into the corners of your eyes. I used to carry a pair of goggles for those long runs during the rainy summer storm season in my small center console. Getting stung in the eye once or twice will almost justify looking silly. (Tournament bass fishermen wear stylish little goggles; their boats run so fast on the lakes, a bug-hit could be calamitous.) The inability to get out of the cold and rain is an important factor to consider on these boats. Alone, they are easy to deal with. Bundle up for cold and borrow Buck's handy goggles for the other. Coupled together, they can make a trip tiresome.

The other main drawback to most center consoles is the lack of a place to sleep. This limits the overnighter option as a comfortable one.

## Walk-around/Cuddy

Walk-arounds are the middle ground between center console and a true sportfisher. They afford the speed of a center console with some of the creature comforts of a sportfisher. They're often touted as the perfect "family boat meets fishing boat." The term walk-around has always been confusing. It's far easier to walk around a center console. The foredeck on walk-arounds isn't really meant for walking or fishing, but hey, what's in a name?

Smaller models of walk-arounds, from 19 to 26 feet, are really "walks." As they grow up from 28 to 32 feet and larger, they really take on the characteristics of a

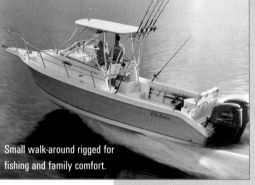

Small walk-around rigged for fishing and family comfort.

sportfisher, though powered by outboards. As in all compromises, "walks" sacrifice some features to gain others. For example, you'll have a much smaller cockpit because you have to make room for the cabin. Your fuel efficiency and speed might not be as good, because the boat is certainly heavier with a different ride. The livewell might be smaller. Instead of two, the boat sports a single livewell. In-deck storage and fishbox size may be diminished, which means that above-deck coolers might be the only option, which takes up deck space.

It's napping at best and never too comfortable. You can sleep on the leaning post with your feet propped up on the console, for that matter. It doesn't change the fact you'll be exhausted the next day, compared with sacking out for six hours in a real bunk.

For those who haven't spent the night offshore in a center console, one tournament-winning crew from Galveston brought roll-out foam, pillows, sheets or sleeping bags, that were kept dry in the console of their 26-foot CC Mako. If the weather was fine, they slept under the stars on the bow benches. If not, they put up the overhead canvas dodger. After a long day of sweaty fishing, they showered with the washdown hose each evening, rinsed with a jug of fresh water, and put on clean clothes. They reportedly slept very well. A can of Mountain Dew before sunrise, and they were fired up and ready to fish the morning bite—hours before any day-trippers appeared on the horizon. Hot food and coffee were never available, however. It was a cruel life, but they won many tournaments.

# Boats   Walks can be great family or fishing boats, with pros and cons.

Walks can be great family and fishing boats, as long as you understand cabin pros and cons on boats of this size. On the smaller walks, generators either aren't standard or are just left out for financial reasons. This doesn't seem like a big deal, until you or the kids want to take a midday nap. That means cooking in the cabin on a hot day. Without a fan or air conditioning, summer nights are no picnic, either. Depending on where you live and prevailing weather, it may not matter. But many small walk owners end up using their cabin mostly for rod storage and little else. That means giving up the versatility of center consoles and getting little in return.

Nice amenities you won't find on the standard center console: a sink and other indoor items.

The best boat is one that you fully understand its strengths and weaknesses. One of the strengths of a walk is the privacy and comfort the cabin affords you. Changing clothes, showering or just accessing a stand-up head can be a godsend for some while offshore. The ability for kids to take a nap in a sheltered spot out of the elements can mean the difference between a great afternoon or a grumpy one. If you are a parent you know what this means. Kids can also duck the weather or play games completely out of the way, by staying inside.

However, the sheer functionality of a center console can't be matched by a walk. The comfort and luxury of sportfishers can't be touched by a walk, either. A walk or small express takes the qualities of each style and tries to blend them together in an affordable fashion. That means the average family can afford to go fishing, do so in relative comfort and still fish the same waters as everyone else. SB

# Sportfishers

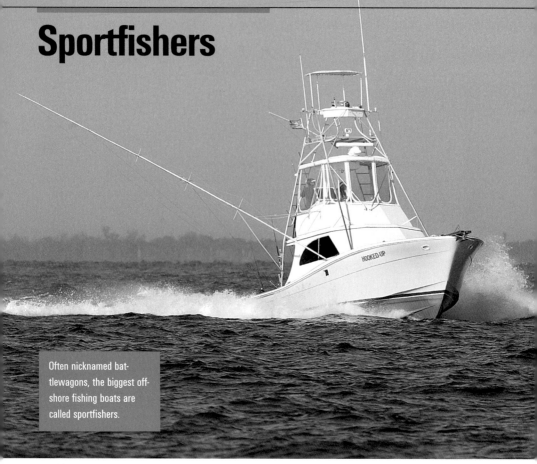

Often nicknamed battlewagons, the biggest offshore fishing boats are called sportfishers.

For many anglers, sportfishers are the ultimate in fishing boats. Unless you're a tournament mackerel or striper fisherman, it's hard to think of an application where having a sportfisher isn't either an advantage or at least a comfort. It's very easy to go on a few trips aboard a big sportfisher and become spoiled. You can spot the fair weather fisherman from the true fisherman this way: A real fisherman, one who is just eaten up with the sport, will revel in any type of fishing he is able and fortunate enough to do. A fair weather fisherman will only go under just the right circumstances and just the right weather. Unless you have a medical condition or something that demands these conditions, you're just spoiled. It's okay to be spoiled; just don't

expect as many phone calls to go on trips.

There are two main styles of sportfishers: Express boats and flybridge models. Some flybridge vessels are enclosed, though most sport open or convertible helms. Express boats don't have a really elevated helm, though it may be a step or two higher than the cockpit. The advantage of a few feet means the captain can still keep an eye on the bait spread from the helm, but is only a step or two away from action in the cockpit. A flybridge configuration means an advantage of 8 to 10 feet in elevation; you have to hurry down the ladder when needed, sometimes in rough seas.

Teddy Roosevelt said it best when he gave a speech in Paris: "The credit belongs to the man who is actually in the arena..." On a

**Whether at the bridge or up in the tower, it's the captain who has the task of actually finding fish. This means reading the water.**

sportfisher, that arena is the cockpit. Captains out there might disagree, but most of the work on a fishing boat is done down in the cockpit. That's where you rig baits, run the spread, wire and gaff fish; it's where fishermen are doing battle. The cockpit carries your livewell, in-deck fishboxes and the fighting chair, if you carry one. It's home to the bait freezer, drink boxes and perhaps an ice-maker. Having an ample, well-run cockpit makes all the difference in the world when looking for and fighting fish. Crowded cockpits are a nightmare to deal with, so the most important thing you can do here is keep it organized. The second most important is to have a plan when a big fish hits.

If the cockpit is the front line, then the helm or tower is the command center. Captains put in their time on the water and earn their way out of the cockpit; while the number of things going on downstairs is greater, the helmsman has an equally important task.

Whether at the bridge or up in the tower, the captain is tasked with finding fish. This means reading the water, watching the electronics and some-

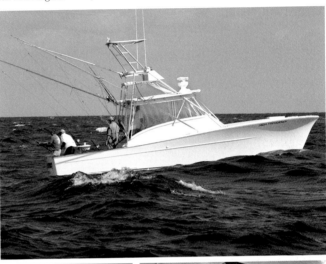

Express sportfishers allow the captain to stay close to the action. Convertibles, right, use added height for a distinct advantage.

times making decisions based purely on instinct. The advantage of height allows him to keep a keen eye both on the bait spread and the horizon, for fishy activity. Some elect to stay at the helm where they have full electronics, radar, sounder and chartplotter. The advent of combination units finds more and more towers outfitted with them, so that all communication isn't lost when the captain is 20 feet or more above the fray. It's a peaceful thing in the tower, cruising along at heights up to 30 feet above the water. On those bluebird days when the sky is clear and the water is

cobalt, it almost feels like you're flying. Tournaments are won up there, too.

Another advantage of sportfishers is a fully functioning cabin. Generators aren't optional here. Air conditioning, satellite TV, hot showers, full-size beds and a working galley mean you don't give up much, whether at home or offshore. It really isn't fair to the fish that you can be this comfortable and catch fish. Cabins provide more than just comfort, though. They allow you extra storage for weather-sensitive items like electronics and video equipment, and a place to clean and store unnecessary tackle. They also provide respite from the heat of the day or inclement weather. Need a quiet nap? No problem.

A sportfisher is the ultimate offshore battlewagon. These wagons are almost always diesel powered. Diesels are known for their reliability, safety and efficiency. But that comes at a premium.

With any boat that lives on the water,

financial upkeep and maintenance are a constant task. Paying slip fees is only optional if you have a friend with a dock or one of your own. Engines require regular maintenance and if you aren't capable of doing this yourself, that means mechanic fees, and diesel mechanics are well paid. The cabin is essentially a small house that rocks a lot; latches break, pumps go out, refrigerators may get emptied.

Boat partnerships are one way to minimize the expenses and share the duties that come with maintaining a big sportfisher or really any boat. But beware: Any business venture that involves friends sharing a boat is risky business at best. Whether the issue is one person using the boat more than the other, damage to the boat, the inability of one person to keep up their end financially, or even a new girlfriend—when things go wrong, partnerships are a great way to break up very long friendships. Boat partnerships seem like a good idea to get into a boat when one guy can't afford it alone, but these arrangements almost always end in misery for those involved. It's far better to fish with the boat you can afford, on your own. **SB**

**Boat parterships at first seem like a good idea to get into a boat and offshor**

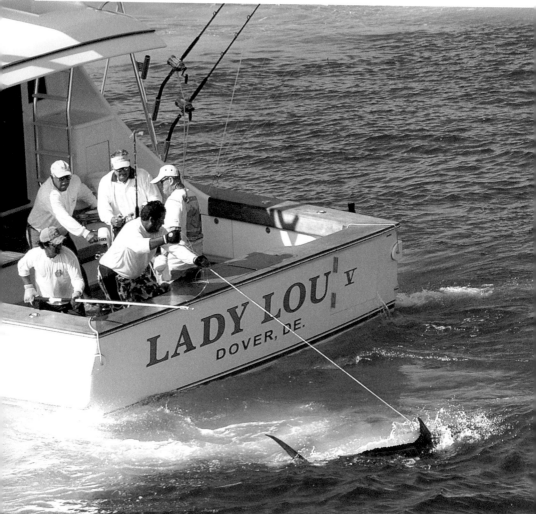

# Keep the Presure Up

Captain Dennis Rosa of the *Menace* credits his feelings on chasing big fish from a standard sportfisherman to Captain Ron Hamlin. "Remember, the boat goes fastest with the pointy end forward."

The problem with going forward often arises early in the fight. Aboard *Dos Amigos* we were trolling off Treasure Cay at 9 knots, when a big bluc marlin crashed my shotgun bait, and started screaming off dead astern. We were in trouble on a 30-wide reel before we got the teasers in. We faced

**when one owner can't really afford it.**

This crew is doing a complicated shuffle on deck, while subduing a fine blue marlin on a perfect day offshore.

two big problems. First, I was running out of line so fast, any time taken getting turned around would have been too costly, secondly I had to be careful not to back faster than my angler could wind. What often looks as easy as shifting into reverse to the casual observer, is actually a dance with a partner who doesn't want you to follow.

Captain Robert Johnson of the *Jody Lynn II* says it's all about the angle. "Most of my charters are not blue marlin fishermen, and it's usually easier to keep them in the chair and go slowly backwards. However, we had a hot blue on last year, that I had to chase at 16 knots just to keep from being dumped. The problem with that is, you will invariably have a loop in the line if a marlin is ahead of the boat. The more pressure you generate by increasing the size of that loop, the greater the chance to break off."

"I'll try to keep my fish astern" says Captain Don Combs of the *Sharkbait*. "The loop in the line will really hurt your chances. I'll usually back right over the line to get turned around if I can clear my props. I don't back as hard as I see some other boats doing it, because I understand that when you're backing down hard, your shafts are actually trying to pull out of your transmissions. Add that to filling your cockpit, and sometimes engine room with salt water, and it's a bad combination."

Everybody I talked with seems to agree that when there's no danger of being stripped, it's best to keep the fish off the side and keep fishing the other lines. The top hook sailfish teams have this down to a science. A hooked single is quickly placed off one side while the rest of the crew works the remaining baits. The boat stays in a circle around the hooked fish constantly dropping back baits and dredges until the captain is satisfied they've maximized the bite.

"The end game has to be done from the stern on a sportfisherman" says Captain Dennis. "Where Ron is right about the pointy end being faster, any captain worth his salt knows he's in maximum steerage control going backwards, not to mention his props are not between he and the fish."

For the big center consoles, the game is much easier. Put your angler on the bow, and as long as he's comfortable, keep right on fishing from the stern. Remember, the easiest time to hook a fish, is when you've already got one on. —*Rick Ryals*

# Boat Tops and Towers

The hottest summer I've ever experienced was an August day offshore in my new center console. It didn't have a T-top yet...but after that day it quickly found its way to the shop. Tops and shade not only provide respite from a damaging sun, they can give you added storage space and even a height advantage over the fish.

Modern center consoles generally sport a T-top, which is just a soft or hard cover for the crew. It does add radar and outrigger mounts, rod holders and much needed shade. Some are outfitted with a crow's nest and even a second set of controls, to drive from above. Any increase in height increases your ability to read the water offshore and spot fish.

Sportfishers usually don either a half or full tower, commonly referred to as marlin and tuna

towers. For many billfisherman, the height of the flybridge alone is ample reason to have one. Other captains prefer the added advantage a full tower offers. Whatever your choice, towers and tops mean increased height, which means better visibility. That just might mean the difference between spotting that ambivalent billfish toying with your center bait in the spread, or going home skunked.

Boat tops, towers and wind screens have evolved greatly in the past 20 years, with much more practicality and ease of comfort.

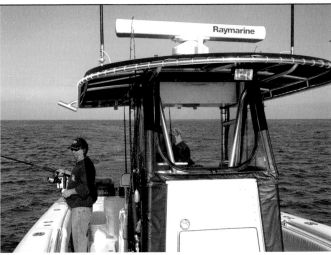

Above left, a captain yells at the crew that he's just spotted a big fish. At right, clear isinglass plastic shields the crew on boats big and small from the elements. Being creative with isinglass can be a real comfort when the weather finally does turn sour.

# Overnighters

**O**vernight trips offshore have a mystique about them for both neophytes and seasoned captains. There is an element of the unknown; anything can happen at night. It's just a different ballgame, fishing on a black ocean or listening to water splashing all around, especially for the open-boat crews. A quiet bunkroom or couch aboard an enclosed sportfisher with air conditioning is another matter, of course. Whether you're camping at the oil rigs to get a jump on the kingfish bite, or heading to The Bahamas to overnight on the hook or in a marina, or heading deep for several days of billfish trolling, successful overnight trips have three common elements: Preparation, planning and safety.

Prepping for offshore trips is the key to success and it counts doubly so for overnighters. The boat deserves a special "going over" before leaving the dock. Are the lights working? Sufficient food and bedding? Do you have plenty of everything? A checklist is crucial, something that can be kept and improved upon as the years go by.

**The dream of an overnighter makes the grind of a 9 to 5 work week bearable.**

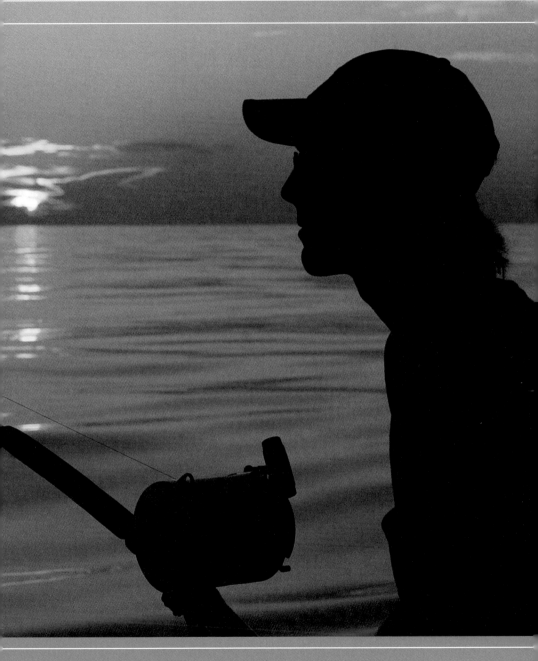

There's no better feeling than being on your boat, in calm seas, with fresh catch on the grill and a cold beverage in your hand.

# Camping Out While Offshore

**It can be a costly mistake to assume all members of a crew know the boat as well as the owner or captain does.**

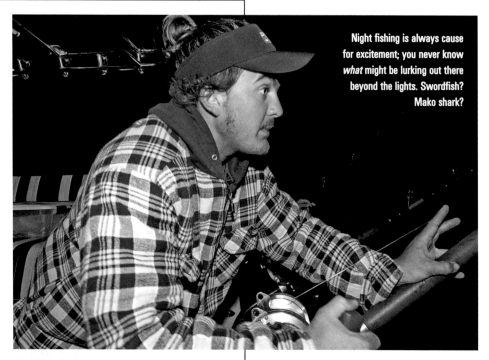

Night fishing is always cause for excitement; you never know *what* might be lurking out there beyond the lights. Swordfish? Mako shark?

Who stays offshore overnight? There are a number of reasons for doing so, and you can bet these folks prepared a checklist for a trip that will last two or three days. Even smaller items such as rain gear, charts, knives, castnets, sabiki rigs, needlenose pliers, backup gaff, camera—the little stuff—are items for the list.

Regarding gear and rations, it's best to assign these tasks to different crew members, so that one person isn't responsible for everything. It's very important to make sure that everyone gets a little input on what they prefer to eat offshore; if you let someone decide for you, you may be disappointed. Captain Joe Richard says they fished their first big-money kingfish tournament in 1983 with a 90-mile run down the coast from Galveston in a 21-foot Chaparral. They stayed offshore for three days off Louisiana with only six yogurts, a loaf of white

bread, eight slices of ham and cheese, and a six-pack of Snappy Tom tomato juice...The three were so hungry on the third day, they boarded an anchored, 120-foot oil company workboat and demanded food from the galley cook. When they returned, their hair was sticking straight up from salt spray, but they had won their first big cash tournament, beating 200 boats. Not a bad trip, for a 21-footer with only a radio and depthfinder. They had slept crammed inside the bow in choppy seas, while the boat was moored to oil rigs.

Overnighters require a plan and communication with your crew. That includes a schedule of sleeping times and who's running the helm or on watch. You don't have to get too structured, but if the crew knows the importance of sharing time at the helm overnight, you are less likely to have issues. For example, if a crew member knows he's got helm duty

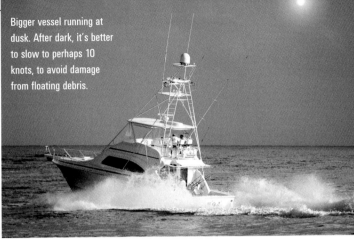

Bigger vessel running at dusk. After dark, it's better to slow to perhaps 10 knots, to avoid damage from floating debris.

during the dog watch from 2 a.m. to 6 a.m., he's more likely to sleep beforehand. Some boat crews give the rookie the dog watch because everyone else is senior, but bad things have happened to boats during those sleepy hours, because the guy at the helm had little experience or poor judgement. Is that twinkling light off the bow a trawling shrimpboat, or a lighthouse?

It can be a costly mistake to assume all members of a crew know the boat as well as the owner or captain does. Every boat is different and a brief orientation for new crew members would be wise for a long trip. After all, the captain can't stay awake the entire trip. If the captain has doubts about someone driving the boat, he should pick the most trustworthy or experienced to handle the darkest hours. Or remain at the helm himself.

Everyone should know where the safety equipment is; how to place a Mayday call on the VHF, how to disengage and engage the autopilot correctly. It's important to know how to read and adjust the radar and change RPMs as necessary. If you are asleep and the crew recognizes your current speed won't put you on the desired spot until well after sunrise, a slight adjustment can be made without waking you up. Simple, right? It is, but if the helmsman doesn't know whether or not he can or should make adjustments because you didn't communicate with him, it can make a difference in the trip. If you are the captain, talk to your crew even if it seems redundant. If you are a crew member for the first time on a boat, ask lots of questions if you don't get them answered first.

Safety is the priority on every offshore trip, but it deserves special vigilance when it's dark outside. Safety at the helm is paramount; every captain is legally responsible for returning his crew to port in one piece. First of all, don't plan on running at full speed when the sun goes down. Not only is cruising at a lower speed more comfortable and safer, you'll save

fuel. Floating debris can ruin a trip, but so can failing to spot other vessels or buoys offshore. Don't rely solely on instrumentation at night. Turn the electronics to night mode—most of them have it—which keeps the ambient light to a minimum and helps maximize night-vision. Visually scanning the horizon is also important. A combination of both is better.

One rookie crewman at the helm during the dreary dog watch had this story to relate: "One dark night, we had a dozen radar blips from oil

## The size of your boat and duration of trip will alter the checklist, but here are suggestions for bigger, enclosed boats.

✔ Tools on board for common or likely repairs: fuel filter wrench, spark plug wrench and if diesel, tools to replace all hoses and belts

✔ Flashlights (check the batteries and have spares)

✔ Anchor and plenty of rope (even if you don't plan to anchor). A sea anchor is also a nice luxury

✔ Check all electronics and enter known waypoints before you leave port (have backups: manual compass, paper charts and handheld GPS)

✔ Safety gear (flares, EPIRB, satellite phone, throwables, life jackets, foul weather gear)

✔ High-water alarm in bilge; replacement bilge pump; manual bailer and spare hose clamps

✔ Life raft

rigs sprinkled on the radar. It was my first time to use radar...I noticed all but one blip were passing slowly from top of the screen to the bottom, which made sense. One blip at the 5 o'clock position seemed stationary, even closing towards the screen's center. A sleepy glance over my right shoulder revealed a 600-foot ocean-going tanker on a converging collision course, less than two miles away. Whoops! Time to wake up the captain so he could disengage the autopilot. We veered left and slowed, watching the huge ship rumble past at 20 knots. Someone asleep at the wheel that night could have made things very difficult, like getting run down by a huge ship as long as a city block. It just so happened I'd been raised on the coast and knew ship and barge traffic silhouettes and navigation lights, but there are countless anglers from inland who might not even recognize these things."

Spending the night offshore requires seamanship and people who can make the right

Bean bag chair in use while crossing over to The Bahamas. Later, it's cookout time with fresh fish.

decisions, and quickly. Anchoring in open water, one should be mindful of being run down by passing shrimpboats and other vessels. (A radar alarm is very useful here.) Anchoring in an offshore sea lane where ocean-going ships cruise at all hours isn't wise, either. Tying up to a big oil rig with overhead lights is nice; visibility is great and at least you won't be run down by passing vessels. However, the wind or tide can shift and drag your boat up against or even inside the steel oil rig, which can be very hard on the boat. Or the crew, for that matter, if the seas are choppy.

Overnighters are an adventure and a very efficient way of getting the most out of a long run offshore, away from the weekend crowds. Spend three days out there, and you've just run up more fishing hours than many anglers see in an entire summer. A five-day trip feels like two weeks.

Remember seasickness precautions: Inability to see the horizon or the darkness itself may cause some anglers to become disoriented and nauseous. Many anglers take precautions; popping a cherry-flavored Bonine after sunset is great; motion sickness is avoided and it may help you sleep better. (Taking two will definitely make you too drowsy to fish at night and perhaps during the day). If you have the slightest doubts or haven't spent much time offshore, it's far better to take Dramamine or Bonine before leaving the dock. You don't want to be the reason the boat has to turn around. You also don't want to spend the trip moaning and curled up in the fetal position, for that matter. Make sure you have a solid meal before heading offshore and minimize adult beverages (though one beer is a good way to relax after a day of hard fishing).

Offshore trips take on many new aspects when an overnight stay is included. You can experience sunrise and the sunset on the water, far from the crowded inlets or boat ramps, while staying right on top of fish. You start the day actually fishing before sunrise without distractions or wasted time, or a hasty, spray-lashed run far offshore. These trips do require diligence and attention to safety, but when approached with a keen understanding of preparation and planning, an overnighter can be a wonderful experience.

# Safety

As the owner or captain of a boat, you have a legal responsibility for your passenger's safety. As a passenger, you should be on the same page with the crew regarding safety, so that everyone pulls together and remains vigilant. The goal of any offshore trip is to enjoy–but arrive home safely.

The easiest chore is to file a float plan. That's a short document that stays with a reliable person on land, that lets them know where you are going, when to expect you home and other key information. Most of this information won't change from trip to trip, so you can have it filled out ahead of time. Just change the crew, dates and times.

Make sure you have flares and all required safety equipment on board; this depends partially on what size your boat is. Common sense and practicality will dictate that you need a few other key safety precautions offshore.

Your personal flotation devices (PFDs) should never be stored in locked compartments, hard-to-reach areas or left in their plastic wrappings. As a boat owner or captain, it's your responsibility to make sure everyone knows where the life vests are. Small children should have their own life jackets that fit.

It's a good idea to tie a whistle, signal mirror and strobe to each vest. Reflective silver tape is great, because it reflects Coast Guard searchlights. If you don't have something light-reflective, chances are they can't spot you at night.

Communication devices like a VHF radio should be standard on every vessel. A cellular phone shouldn't be expected to replace the radio, since they often don't pick up a signal in non-populated areas. Satellite phones are inexpensive and reliable enough that every big boat should have one. Even for non-emergencies, that type of phone can notify someone on land that you've extended your trip.

Emergency position indicating radio beacons, called EPIRBs, should also be present on every boat that heads offshore. This device is designed to reliably alert rescue personnel that you are in distress and identify your position. Each EPIRB is registered with a beacon-unique

Packed life raft at top takes up little space. Life vest has reflective tape, whistle, strobe and chemical light. Compact EPIRB at right is another life-saver.

ID code. It identifies who the unit is registered to and the current GPS position. With an integrated GPS, the location is immediate. Without GPS integration, satellites can still determine a location within an hour or two. As a reminder, since Jan. 1 of 2007, all EPIRBs are required to be 406MHz. Check your unit for that update. The newer model can be detected by satellite that provides data for search and rescue operations.

It's great to have an EPIRB, satellite phone and all the other high-tech gizmos, but if your vessel is capsized or sunk, a life raft may be the only thing keeping you alive long enough for rescuers to arrive. That sounds like something only big boats would carry, but in reality small, inflatable rafts can fit on boats much smaller than you'd expect. They're relatively inexpensive when compared to the cost of your boat and should be a part of your safety package. If you fish in cold water, especially during winter, keep in mind that hypothermia is a killer. Without a life raft, people swimming in cold water get pretty sluggish in only one hour, and it gets worse after that. Even if the water is 85 degrees in summer, you will lose body heat. SB

# CHAPTER 14

# Electronics

**W**hat has changed offshore fishing the most in the past 20 years? A first impression would be technological advances in rods, reels, tackle or lures. A closer look, however, would be electronics, specifically the Global Positioning System, or GPS. Add this to the accuracy of charts and underwater cartography, and anglers today have incredible navigational information. Bottom machines can now paint pictures of canyon floors some 5,000 feet below.

Radar domes are so affordable, even small center console boats use them to find seabirds working tuna schools, watch for storms, or monitor other vessels in the fishing fleet. Satellite phones and cell phones keep captains in contact without being monitored by the competition. EPIRBs relay your exact position by satellite, in case of emergency.

Understanding at least the basics of electronic equipment is now the key to successful offshore fishing.

The only thing between you and the fish is "turning on the electronics."

**See DVD for more on using electronics offshore.**

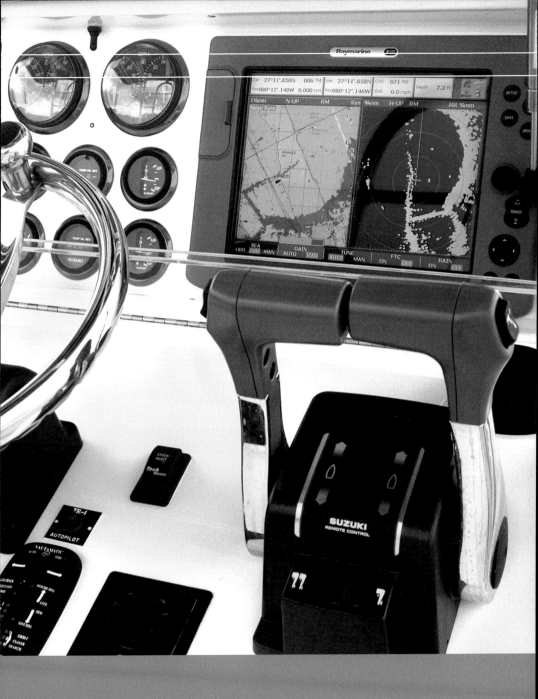

With today's modern, compact electronics, you'll find the same equipment on 25-foot center consoles as you will on 60-foot sportfishers.

# Turning it On

**A** closer look at electronics used in off-shore fishing will show five main areas of concern. Successful offshore captains today make sure they have the basics of communications, Global

Positioning Systems (GPS), chart plotting, depth sounders and radar covered. Simple communications might just be a cell phone and VHF radio, for anglers fishing near shore. More expensive satellite phones are used by those venturing out on overnight trips or moving the boat to some far away

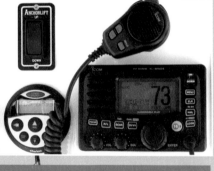

VHF communication is not only a potential life saver, it's often a day-saver for fishing trips. Typical VHF radio is at left and top. Handy, short-range VHF "walkie talkie" is at bottom.

## Communications

Every boat on the water and certainly those going offshore should be equipped with a VHF radio. Communicating by radio, whether for camaraderie with friends and fellow anglers or in emergency situations, is one of the most basic and effective ways to communicate by boat, unless you have cell phone coverage. Dollar for dollar, that radio may be the most valuable piece of safety equipment onboard.

The fundamental operation of VHF frequencies, as it pertains to recreational fishing, is simple enough. Channel 16, the "hailing frequency," is for calling. It's customary to call

out the boat by hailing twice, followed by your boat name and "over." As in: "*Island Hopper, Island Hopper* this is *Rag Tag*, over." You can repeat this up to three times, according to regulations, but if the other party isn't in range or on that channel, you'll know after the second hail attempt. (Of course, they might also delay in replying, perhaps while battling a big fish). Once you hear from the other boat, both par-

venue. GPS and chartplotting systems make getting to and from the fishing grounds a breeze, while giving captains a visual representation of their course. Depth sounders not only paint the bottom, but in deeper water will mark fish in the top 200 feet, where pelagic fish rise to a trolled bait. Radar systems are now quite affordable and they add hugely to safety, while detecting tuna birds miles away. Electronics, productivity and safety go hand in hand. Do your homework and find a product that fits your preferences and budget, and make sure you have all the bases covered before heading offshore.

ties should switch channels to one of the five "non-commercial" channels, which are 68, 69, 71, 72 and 78A. Technically you can transmit on many other channels, but they are assigned for other priorities. The USCG list can be found online at www.uscg.gov. VHF frequencies are shared, meaning that if you and a buddy are yakking away on channel 10, which is reserved for commercial operations, you are blocking anyone else from using that channel for up to 30 miles around, depending on the height of your antenna and if the radio is set on full power broadcast.

Can you hear me now? Cell phones depend on relay towers back on shore and often don't work beyond sight of the beach. Satellite phones work anywhere.

Once you hail the proper vessel, a request to "go to 68" or another non-commercial channel is standard procedure. Many boats simply remain on 68 or 72 or other channels and choose not even to monitor 16, but it's there for a reason. Each vessel has a responsibility to monitor and listen for distress calls, or look out for fellow boaters in trouble.

Most modern VHF radios have a "scan" feature that allows you to listen for traffic on multiple channels. This feature solves the issue of listening to your favorite channel, while still being able to monitor distress calls on 16. It also clues you into the bite when it happens, when another boat is clever and talking about it on a commercial or government channel.

In all likelihood, unless you are really abusing the airwaves, no one is going to bark at you about radio etiquette. But be aware that while utilizing a channel, keep the conversations short and to the point. Fishermen use the airwaves to converse about what's biting where and to dish out grief and congratulations. But no one wants to hear two strangers gabbing about football, kitchen passes or the like.

Cell phones have relieved a lot of traffic from VHF airwaves, for boats fishing near shore for sailfish or mackerel. But once you get well offshore, they aren't really an option. What they do provide, however, is a private conversation. If you try to call a buddy over to a hot bite and use the VHF, then expect company—perhaps the entire fleet. If you call them on a cell or satellite phone, you can do so in a much more private fashion; anyone listening in won't be concerned much about fishing, at least. Accessory amplifiers and antennas can boost your cell phone range and signal, to a degree.

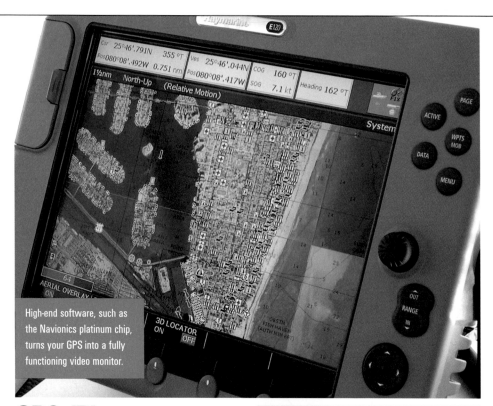

High-end software, such as the Navionics platinum chip, turns your GPS into a fully functioning video monitor.

# GPS/Plotters

The Global Positioning System (GPS) was originally started and launched in the 1970s by the U.S. Department of Defense. The network consists of 24 satellites that orbit the Earth twice a day and beam signals down. The very small boat antenna locks onto these signals and reveals an exact position. With this triangulated signal, the system shows position, trip distance, speed, bearing, track and distance to destination; handy items to know while offshore.

Originally intended for military use only, it was opened to the public in the 1980s and the fishing world was changed forever. Can you imagine heading out for a day of fishing with just a compass and a paper chart? Fishermen today are spoiled with all the advances in technology and thank goodness for that. GPS units are relatively inexpensive and even older models will put you within nine meters of your target, on average. Newer units equipped with either Differential GPS (DGPS) or WAAS, (Wide-Area Augmentation System) capabilities can put you as close as three meters on

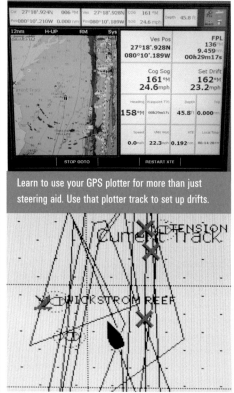

Learn to use your GPS plotter for more than just steering aid. Use that plotter track to set up drifts.

# If you use half of what today's GPS units are capable of, you're in the top 10 percent of your class. They're certainly worth learning.

average. Miles of ocean to cover and that little black box on your boat can pinpoint with great accuracy where you are, and in relation to where you want to go. It's truly amazing and it's easy to take for granted. Some of the newer captains have only the slightest introduction with that old-fashioned compass mounted on every console.

Basic GPS units allow a captain to enter waypoints, such as the farewell buoys at favorite inlets, and also wrecks and reefs. You punch in the latitude and longitude of the waypoint you want to go to and a compass bearing or arrow on your display tells you which way to point your boat. How hard is that? It also calculates the distance to your target and how long it will take to get there at varying speeds.

Most GPS units have the capability of connecting to your PC or laptop, to enter in waypoints from your logbook and plot trips. This is handy, because you don't have to be on the boat, and it keeps a backup of information. Why a backup? These units are computers and they crash from time to time, even the best ones.

When combining this information with an electronic chart, you now have a chartplotter, perhaps the most fisherman-friendly creation since the GPS itself. Plotters are digital versions of the paper charts we all carry with us and have at home. They allow you to have a visual representation of the waypoints you've entered, plus navigational aids, shoals, depth contours and other features. You get a bird's eye view of your little piece of the ocean and how your waypoints relate. This, combined with the information you get from satellite reports and your bottom machine, can

help you spot trends and patterns.

Most systems today can utilize multiple streams of information and nearly all manufacturers produce combination units and networkable units. Combination units are ideally suited for smaller boats with limited console area, but the same boat can have radar, GPS, plotter and bottom machines on board. They accomplish this feat in units that are small enough to fit on 18-foot center consoles and inexpensive enough to afford. Talk about leveling the playing field.

Networkable units are stand-alone models that can be synched to a central display. This eliminates one of the main drawbacks to combination units: What do you do if it fails? If your radar goes out, that's it. But if your display

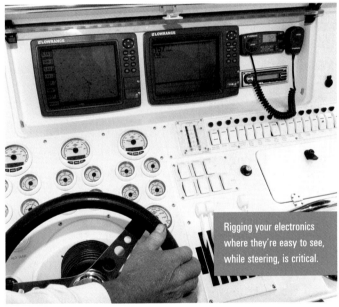

Rigging your electronics where they're easy to see, while steering, is critical.

goes out on a combination unit, and it's all you have on board, you had better know where you are and how to use a compass. Displays have gone from huge to the sublime. Large touch-screen displays are showing up on recreational sportfishers and really spoiling the captains. As manufacturers sell and produce more, the prices come down and the average fisherman will benefit from this technology as well.

# Depth Sounders

Depthfinders are even used around oil rigs, because they mark which side of the platform the fish happen to be schooling.

**Even for offshore trolling, it pays to keep an eye on your bottom machine. You don't want to miss a large bait school, seamount or thermocline.**

Charts can tell what should be below your boat, but the only way to know for sure is to mark the bottom below. Bottom machines, depth sounders, sonar units and fishfinders have become so detailed and advanced, you can paint the bottom while cruising and some even have a scroll-back feature. That allows you to back up the image on the screen, put your cursor

on the spot of interest and it gives you GPS coordinates to navigate back to. A quality bottom machine really can remove a lot of guesswork from fishing.

These units allow you to get a 2-D or even 3-D image of the ocean floor, right on your display. To truly understand the image and get the most from it, read the floor like a golfer does a putting green. Try to understand how the contour of the seafloor will react to ocean currents. Steep dropoffs, wrecks and humps will react to the different ocean currents in different ways. A canyon valley that runs north-south will have walls that border it on the east and west. A current traveling from east to west will cause an upwelling on the western side of the valley. When trolling the area, on which side of the valley would you concentrate? Another example would be a ledge or dropoff that doesn't have an opposing wall, like the 100-fathom curve. While there may not be an opposing wall, there are points, contours and areas of greater relief along these dropoffs. The

direction of the current that has the best opposition to these underwater features is where you'll find more bait and fish. You can only verify this by utilizing that trusty display on your console.

The function of these units is simple enough. The console-mounted display unit is either connected to a transducer shooting signals through the boat's bottom, or one that is mounted on the transom. The transducer shoots a sound wave to the bottom and when it strikes an object like a fish, wreck or sandy bottom, the signal bounces back to the unit. It calculates the depth based on the amount of time it takes to get to and back from the object. The strength of the return signal will fall into one of up to 16 categories and be displayed as different colors or grayscales, depending on your unit. The stronger the return signal, the hotter the color displayed. Light colors generally indicate baitfish with hues of blues and greens in the water column. A soft bottom area is generally a thin red line, while hard bottom areas are indicated with thick red stripes. If your machine is grayscale, the same points apply; just familiarize yourself with the tones. Darker tones usually mean hard bottom or structure, while lighter tones indicate baitfish and soft bottom.

Some modern bottom machines are equipped with dual frequency capability. This simply means that you can switch the frequency at which your signal is transmitted. Lower frequencies travel farther, 50kHz is better for really deep water and higher frequencies (200kHz) will paint individual fish and bait pods with more detail. When a fish is hit with the sound wave, it's the swim bladder that usually sends a signal back. Some fish such as mackerels, or bait like squid, don't have swim bladders. It's the higher frequencies that will paint these critters more accurately.

Bottom machines are more than

**200 kHz**LESS than 150′
**50 kHz**MORE than 150′

just depthfinders. They are almost always equipped with speed and temperature sensors. These sensors can make the real difference when fishing offshore. Sharp changes, or breaks, often mean you've found the oasis in an aquatic desert. Breaks hold bait and attract predators; if you can spot this break and pinpoint where it intersects with structure, such as a sharp dropoff, canyon wall or wreck, then you've hit paydirt. The bottom machine is often overlooked when vessels are in deep water hunting billfish. But setting your unit to scan the first few hundred feet of the water column can help you spot baitfish and individual predators as well.

Bottom machines are your eyes beneath the surface. But they serve more purpose than just painting fish below. Many top pros combine sonar info with satellite reports for current information, wind speed and direction, and surface activity before making decisions on where to spend their day offshore. When used effectively, your fish IQ will go up several points and those catches will increase.

Using the split screen function, you can see the huge difference in what a small wreck looks like with your sounder set on 200 kHz on the left side, and on 50 kHz on the right. This wreck is in 177 feet of water and would certainly be easy to miss, without zooming in for a closer picture at the bottom. Most fish and bait schools are often close to the bottom, but not always; sometimes they're pushed right to the surface by hungry, pelagic predators.

# Radar

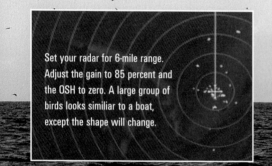

Set your radar for 6-mile range. Adjust the gain to 85 percent and the OSH to zero. A large group of birds looks similiar to a boat, except the shape will change.

**Radar is easy to use and now can be added to most multi-functional GPS/plotter units. Even small boats now carry this great advantage.**

Having radar on board can be both a life-saver and a trip-maker. We were cruising down the Mississippi River during a winter tuna fishing trip when we got fogged in so thick, we could barely see the bow of our 48-foot boat. Commercial boats and barges were sharing the same waterway and if not for radar and a steady conversation on the VHF, anything could have happened.

Radar is most famous for helping fisher-men spot incoming bad weather (if precipitation is involved) and either avoid or prepare for it. But the river situation described above is another example of when it becomes invaluable as a safety tool. Anyone navigating at night needs to have radar on board as well. Safety is the paramount function of radar, but it has fishing applications too.

There have been several articles written about tuning radar to pick up seabirds

## Fuel Savers Autopilots and fuel management systems.

In a lot of cases offshore fishing means long runs. If you fall into this category, paying attention to your speed and course could mean thousands of dollars to you at the end of a fishing season.

In a twin or triple powered outboard boat the difference between running at 4,000 RPM and 4,500 RPM might make more than a money difference, it may be the difference in making it back from a trip—without running out of gas. Some outboards offer built-in fuel management systems, telling you how many gallons you're burning per hour as well as how many gallons you've burned. For those that don't offer this, an after market system by Flo-Scan may be well worth the investment.

Another tool that will save you money over time is an autopilot. When making a long run, even with the best electronics, you're going to get distracted and veer off course. It wastes time, especially on the slower boats, and can certainly cost dearly at the fuel pump with today's prices.

beyond the horizon that are working the tuna schools. What many captains don't talk about is simply identifying where other boats are located. No one wants to be late to the weedline party, but every angler on

These anglers were certainly happy that Dad had bird-detecting radar on board—to find this nice tuna.

the water wonders to himself: Where are the other boats? Did they find something? Is that current/temperature push on the satellite chart 20 miles away producing fish? Spotting boats congregating offshore is a sure sign that the fleet just beat you to the bite. Boats stretched out in a lateral pattern very likely indicate a weedline, rip or current push has been found. A pack of boats spread out in a general area could mean anything or nothing, but if the bite isn't happening for you, almost anything on the horizon may warrant a closer look.

Today's boats are running farther and staying offshore longer. It's hard to imagine doing so without the technology available today, and not making use of them. Take time to familiarize yourself with them. Using them can mean the difference between empty fishboxes and memorable days on the water. And the latter is certainly more preferable. SB

> PRO TIP ELECTRONICS

# Getting "tricked out."

Chris Wigley from Jensen Beach, Florida uses his boat for trolling, bottom fishing and diving. For his main electronics, Chris installed two 80-series RayMarine units. Since one was primarily used as his depth sounder, he chose the C-80. For his chartplotter/radar and underwater video camera, he went with the E-80.

Since he does a little deep-dropping for bottom fish, he went with the high performance through-hull mounted 1,000 kW transducer. For his chartplotter he opted for the less expensive, more straight forward gold chip, which includes all of Florida and The Bahamas.

A lot of what Chris did to outfit his boat had to do with his frequent overnight trips to The Bahamas. He chose a fairly strong radar, a 10 kW open array, for finding tuna birds, but it's also really nice for nighttime swordfishing trips. He chose a TR-1 Autopilot. He also linked his E-80 to a through-hull mounted underwater video camera.

For those two- to six-hour ocean crossings, a good sound system is key to keeping a happy crew. For this, Chris went with a Clarion CD player powered by a JL Audio sound system.

For communication, he had an ICOM M-504 with a Command Mic for the upper station, which also features a Lowrance GPS/depthfinder combo unit.

### Electronics List:
- C-80 RayMarine with a B-260 1,000 kW thru-hull transducer
- E-80 Ray Marine Chartplotter, Ray Star 125 GPS, Gold Chip
- 10-kW Radar with a 4-foot open array
- ICOM M-504 with Command Mic VHF
- TR1 Autopilot
- Lowrance LCX25
- Clarion CMD4, (2) remote displays
- JL Audio Sound System (2) amps (2) 10-inch woofers (3) 7.7" speaker sets
- Splashcam video camera

# Charter and Long Range Boats

It doesn't matter if you're a novice angler or experienced fisherman, booking a charterboat or making that long-range trip is exciting and fun. Even for the most experienced angler, it's great to target new fish that are normally beyond range. Charterboats allow access to fish farther offshore in a safer class of boat—a boat you might hesitate to purchase for financial reasons. Using a charterboat also means not having to worry about putting your friends on the bite; you relax and let the captain handle everything. Running your own boat may be great, but there's plenty of work and responsibility, as well. Sometimes it's just nice to kick back and not worry about the details. For these reasons and more, hiring a charterboat deserves consideration.

**Some days you just want to kick back and let someone else find the fish.**

Picking the right charterboat requires a little research. Try asking around on the Internet in the fishing forums; many anglers are happy to share their experiences with previous trips.

# Pick the Right Charterboat

Offshore charters range in price from several hundred to several thousand dollars—depending on what type of boat and how long you'll be fishing. You can minimize this cost by splitting it with a few friends, of course. For perhaps the cost you would incur on your own boat for a trip or two, you can charter a boat and learn from the best, if you pick the right captains. When booking your charter, let them know your expectations in advance, but be aware some captains may be agreeable to anything on the phone. Talk to satisfied customers first, perhaps using the Internet. Do you just want to fill the box with fish? Learn a specific technique such as high-speed trolling, or chunking for tuna? Is targeting king mackerel your goal? One skipper who specializes in teaching is veteran tournament fisherman Capt. Brant McMullen from the Ocean Isle Fishing Center in Ocean Isle Beach, North Carolina.

Brant offers "fishing school" classes in con-

**Chartering allows you to fish on a bigger, more comfortable boat that is muc**

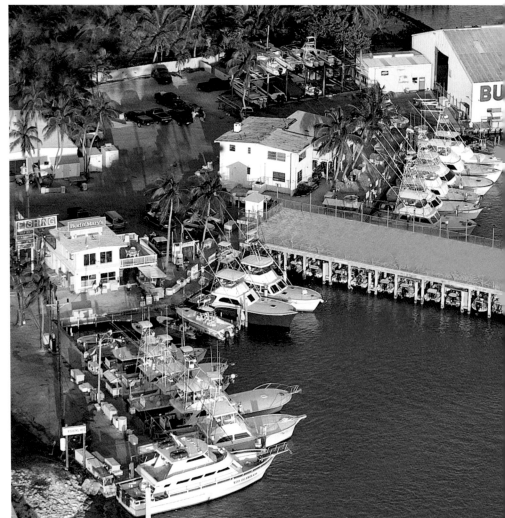

junction with a charter trip, several times a year. These classes include land-based instruction the day before the fishing trip. You learn how to rig lures, tie leaders and go over the other technical aspects of your pending fishing trip. When you are on board, the application of those newly learned skills is put to use.

"We book small groups of no more than four people for the fishing school. That way we can give each angler one-on-one attention," said McMullen. "If we plan on live-baiting for king mackerel, we'll go over everything from tying rigs to throwing the castnet. If it's a Gulf Stream trip, we'll be rigging ballyhoo."

## safer if the weather turns sloppy.

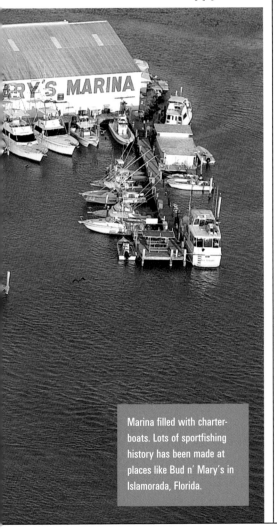

Marina filled with charter-boats. Lots of sportfishing history has been made at places like Bud n' Mary's in Islamorada, Florida.

You might think that typical charter customers are the audience for fishing school, but you'd be wrong. "Our customers are almost exclusively people who own their own boat," McMullen said. "The appeal is that they get the experience on our boats, learning from folks who do this for a living, and then they can apply the techniques on their own boat."

Brant was quick to point out that they don't focus as much on catching fish on these trips, but rather on techniques and instruction. If you do the work you'll usually catch fish, but as he added, "We're more efficient on a regular charter. In school, the mate isn't rigging everything." Their focus is on instruction.

McMullen's operation stands out because of its focus on teaching. Most charters will gladly share with you the rationale behind their techniques used offshore, but you have to ask.

If you have a 21-foot center console, you can probably target most offshore fish, with the grace of good weather. But making a long run to the tuna grounds or billfish waters with extra gas containers isn't the smartest move; you're going to need a bigger boat. A big charterboat special-izing in these types of trips does two things for you. You can learn new tricks from the pros, even if you happen to be an experienced angler. Chartering also allows you to fish on a bigger, more comfortable boat that is much safer if the weather turns sloppy.

Sometimes you may just want someone else to do the heavy lifting. There are excellent captains and boat owners who routinely book charters. Their clients don't have to worry about anything other than fishing and having a good time. For boat captains, riding on another vessel might be the only time they actually get to catch fish. The responsibility of a safe trip and catching fish is on someone else's shoulders for a change.

Charterboats range from center consoles to vessels in excess of 100 feet. Each carries certain pros and cons. They might be private charters, or bigger, slower vessels called headboats or "party-boats." The difference is privacy. For a typical charterboat, one person books it and he invites his guests, perhaps up to the maximum number of anglers the boat is licensed for. Partyboats schedule trips and open up a number of spots for the public. Most folks associate headboats with bottom fishing, but partyboats in some regions

Happy customers live their dream of catching feisty sailfish without even owning their own boat.

target tuna, mackerel, dolphin and even billfish. Most partyboats can be rented for private charters, too.

Probably the best feature of a charter is the convenience of just showing up, shoving off from the dock and upon returning, unloading and heading home with your cleaned catch. The preparation, cleanup and maintenance isn't your concern. You'll have to do some preparation, but it's minimal. You have to provide certain items

them after returning to port. Offshore they're deck clutter.

Make sure you know the rules on the boat, too. Is alcohol allowed on board? Some anglers like to enjoy adult beverages on charter trips and most boats oblige. But some operations, usually partyboats, won't allow you to bring them; you must purchase them on board. Others allow beer and wine but no liquor. Even if you aren't driving the boat, you must consider consuming in moderation for your safety and the safety of others. Are there parts of the boat that are off-limits, like the flybridge and tower? Good charter operators will cover

## Good charter operators will cover the rules and give you a quick orientation of the vessel, but don't be afraid to ask questions. It's a good way to learn.

for the trip to make it run smoothly, and it varies with each operator.

Food, drinks and snacks are usually your responsibility, with few exceptions. Sunscreen, polarized glasses, hats, jackets, spare sneakers or flip flops (it's nice to walk around in a dry pair) and a camera are good ideas. Keep in mind that padded sneakers with good traction and a white bottom are best; the mate will cringe if you leave black skid marks. Ice, coolers and gear are usually provided for on standard charters, but if you have a lure or rod and reel that you must bring, check first with the captain or booking agent. Captains and mates work hard to make the trips a success, and they usually have a short window of time to do so. Your tackle should minimize the risk of equipment failure and match the fish you're after. Ice and coolers are provided for the boat, but anglers should keep their coolers in the car, using

these rules and give you a quick orientation of the vessel, but don't be afraid to ask lots of questions. Don't assume anything.

Some captains are pretty strict about what to bring. The best rule is to communicate prior to the trip and research the boat. Some websites are a wealth of knowledge and some don't even have the basics. Some boats are lenient in their suggestions and policies, while others require customers to bring bleach, toilet paper and trash bags for their trips. It really runs the gamut. Do your homework and when possible, speak directly to the captain or mate, not just the booking service. That way, you can get a pretty good feel about the attitude of the crew, and what fish have been biting lately.

It's vital to establish who gets to keep the fish at the end of the day. Some charter captains pad their bottom line through commercial sales of

your fish, and unless you clarify things before-hand, you could wind up driving home empty-handed. And the unsavory memory of a dockside argument.

Some make an extra effort and won't even book a trip until they meet the captain down at the dock. This is especially true for folks travel-ing to unfamiliar waters. It's smart to do your research. Searching forums like *FS Online* and other forums with members who are local to the charterboat can reveal a lot. Anglers often tell their friends about the good trips, and don't mind sharing the bad ones. Sometimes, anglers are at fault because they didn't do their homework before booking a trip and their expectations just couldn't be met.

"Homework" means you know what type of fish to target. Or you take the suggestions of the crew based on geography, length of trip and time of year. It also means asking the crew what fish they normally target on charters. Booking a boat that bottom fishes 98 percent of the time is not the best way to target blue marlin. Expectations exist on both sides of the transaction between boat crew and angler. Good communications are important.

Most charter captains work hard to deliver a good experience to their clients. Their fee is only part of how they make their living. On these boats, captains and especially mates depend on happy cus-tomers tipping them. A standard tip is 15 to 20 percent of the trip rate, if you receive good to exceptional service. This shouldn't be related to the number of fish you catch—rather how hard they worked to make your trip a good one. You should also inquire ahead of time, whether fish cleaning is included. Some include cleaning your catch as part of the fee, others charge by the pound, or offer that service for a flat fee. Know before you go—so there are no surprises.

## Long-Range Boats

These boats are quite different from a typical day-tripper charter or overnighter. The long-range guys are the ultimate headboats. Trips of two to three weeks at sea are not uncommon and require more research, preparation and of course dinero. Can you imagine a couple of weeks at sea doing battle with yellowfin tuna and big wahoo?

Typically associated with Pacific ports such as San Diego, the long-range trips are not for everybody. Spending two weeks or more at sea can really take its toll on anglers, both mentally and physically. Make sure you are up to the chal-lenge, by doing your homework.

Long-range trips generally provide food, drink and snacks, but require the anglers to provide their own stand-up tackle, harnesses, hooks and lures. Essentially you are renting fishing space and have to provide all of your own tools. Considering that you might be going for 5 to 20 days, the list of personal items to bring grows longer. Clothing, toiletries, rubber boots, rain gear, rigging tools and a selection of rods and reels from 20- to 80-pound class are standard. Cameras are a good idea, but on a long-range trip

While the crew works hard, the charter folks can fish or relax.

make sure you have lots of batteries and film. Better yet a digital camera, extra memory cards and a battery charger. It's also wise to bring books, movies and other things to help you fill in the downtime. It sounds like a great way to chill out and escape life back on dry land.

## Final Thoughts

When you book any charter, make sure to reconfirm the night before you fish. Doing so in late afternoon means you may be able to reach the captain. Next day, make sure to arrive a little early. Getting there late may cause the trip to get off on the wrong footing. It's also a good idea to under-stand the cancellation policy. What happens if bad weather hits? What if you have to reschedule? You can bet the captain won't want to cancel or refund and stay at the dock, just because your Aunt Emmy thinks it might rain. **SB**

# Conservation

While the conservation chapter is near the end of this book, by no means is it an afterthought. There is a conservationist in every angler and most of us don't wear it on our sleeves, we practice it as a matter of course. There are several associations and groups that work hard to promote the rights of recreational anglers, but you don't have to join them to practice active conservation. We do hope you'll get actively involved in a group that fits your ideals. There is strength in numbers and in retaining that collective voice.

You can actively participate in conservation in several ways, for instance taking only those fish you will eat. You can also help by tagging and releasing fish; there are many tagging programs that range from bottom fish to tripletail to billfish. And, you can participate by educating yourself on the issues that face recreational anglers on a daily basis. You don't have to be an activist to actively help sustain and expand our fisheries for future generations.

**Conservation of marine resources is a wonderful learning process.**

**See DVD for more on offshore conservation.**

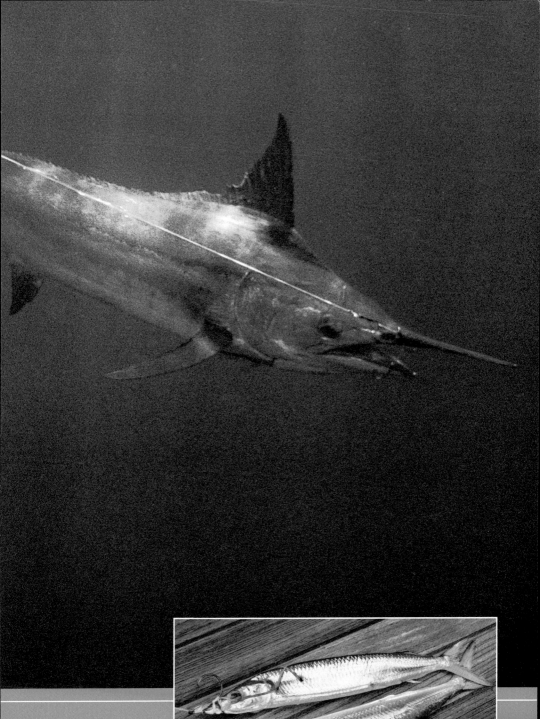

Circle hooks used properly are a great way to switch to conservation. There is no hook safer on billfish, including that highly prized blue marlin, above.

# Getting Involved in Conservation

Conservation is often a misunderstood subject with fishermen. When some anglers hear the word, they assume it means restricting instead of supporting anglers' rights to fish. The opposite is true, of course. Organizations like the International Game Fish Association (IGFA), The Billfish Foundation (TBF) and Coastal Conservation Association (CCA) lobby for the rights of fishermen here in the states and worldwide.

## International Game Fish Association

The IGFA was formed in 1939 and at first was a closed organization focused on establishing a universal code of sportfishing ethics that had worldwide applications. Initially the group was small, and its first meeting was held at the American Museum of Natural History. Members included William King Gregory, Michael Lerner, Van Campen Heilner and

**State agencies in nearly every coastal state have programs for tagging many species of fish.**

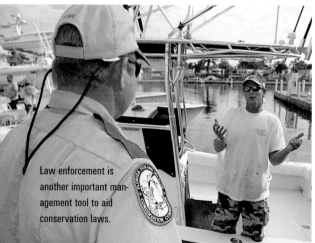

Law enforcement is another important management tool to aid conservation laws.

Francesca LaMonte, who was the Associate Curator of Fishes for the museum and science leader for several of the expeditions that led to the formation of the IGFA. The organization always had credibility because of its association with the museum and scientific community, along with the best fishing club anglers from the world over. It wasn't until the early 1970s that the membership was opened to the public, as it is today. The organization then became a membership driven one. In 1978 *Field and Stream* turned over its record-keeping responsibilities to the IGFA, which is now responsible for all saltwater and freshwater world records.

Notable IGFA Hall of Fame inductees include Ernest Hemingway, Zane Grey, Lefty Kreh, Curt Gowdy, Johnny Morris and John Rybovich, Jr. All of these people and many more were involved in the IGFA to do one thing: Spread awareness of fishery and conservation issues to anglers the world over.

## The Billfish Foundation

The Billfish Foundation began in 1986 with the mission of conserving billfish. Its initial group of 50 founders included the late Winthrop P. Rockefeller, Tim Choate and Dr. Eric Prince. TBF focuses on research, education and advocacy for billfish and billfishermen the world over. In 1990 the foundation began its keystone traditional tagging program, which has grown to become the largest billfish tagging program in the world.

TBF has been very active in protecting the fishery and the rights of anglers. Some of their notable goals include:
- Fighting against longline exemptions for closed zones
- Getting the first congressionally appropriated monies for billfish research in 2005 ($2.5 million)
- In 2004, fought legislation to keep white marlin off the endangered species list
- TBF continues to contribute to fisheries management in the U.S., Australia, Costa Rica, Mexico and elsewhere.

TBF President Ellen Peel shared her thoughts on The Billfish Foundation's mission: "It's to ensure that the fish are

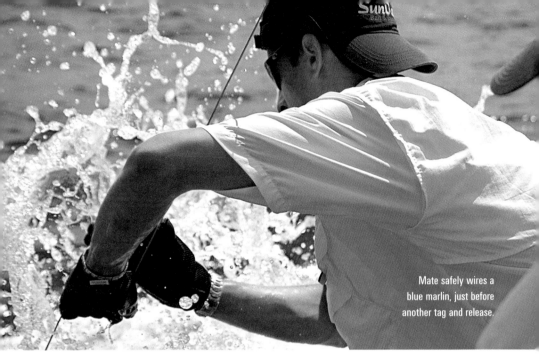

Mate safely wires a blue marlin, just before another tag and release.

here for your kids and grandkids to enjoy. And, we want to introduce new anglers to the concept of tagging fish. This is what connects the docks to science." It also connects fishermen.

One day Rich Howard's sportfisher *Tripletail* was fishing the Gulf of Mexico with Capt. Jeremy Williams. The crew was trolling in an area known as the Nipple, when Rich hooked up and tagged a blue marlin estimated at about 175 pounds. Fast forward about five months and roughly 1,500 miles to March 7, where the same fish was recaptured off the coast of Charleston, South Carolina. Greg Garner was fishing aboard the 31-foot center console *Yard Boy*. They didn't have a tag stick on board, but to their delight this fish already had a tag in it. They copied the numbers down and the last marlin tagged in the Gulf became the first fish of 2006 tagged off South Carolina. Every recapture is important to learn from, but this one also carried bragging rights for that crew. That marlin also brought together two fishermen who otherwise would never have met.

## Coastal Conservation Association

The Coastal Conservation Association (CCA) began in response to drastic commercial overfishing of redfish and trout stocks in the late 1970s. Unlike the IGFA and TBF, this organization now focuses its efforts in the United States exclusively, with 15 state offices stretching from Texas to Maine. CCA has more than 175 chapters in various cities and over 90,000 members. They have been involved in organizing net bans in four states and have a registered lobbyist in Washington for national issues. Their focus is to battle for the health and longevity of coastal fisheries and recreational fishing interests.

Membership numbers are critical to these organizations, even for those who join at a modest level. Advocacy in Washington or internationally carries more weight when you have a high number of membership and voters. Involvement in fishery issues is no different from politics, it seems. The CCA is involved with pelagic fishery issues, as well.

## Tagging Programs

Tagging programs are prolific and while TBF has the largest international program for billfish, state agencies in nearly every coastal state also have programs for tagging many species of fish. King mackerel, dolphin, cobia and tripletail are among the "meatfish" that have their tagging programs. There are two main types of tags, traditional tagging and the more expensive satellite/archival tagging. Traditional tagging involves a small plastic "spaghetti" tag often placed in the fish's shoulder. Information on each fish is recorded on a 3- by 5-inch card

and mailed to the sponsoring organization. This is an inexpensive method for capturing data, often utilizing volunteers. It relies on recaptured fish for actual feedback.

Satellite tagging is used to track fish for a short period of time, recording up to 345,000 measurements per fish. The information is transmitted to a National Oceanic and Atmospheric Administration (NOAA) satellite, after the tag pops loose and floats to the surface. That's when scientists can interpret the data. This is very accurate information, but it comes at a cost. Each tag can cost several thousand dollars and that doesn't include the installation, satellite communication or later analysis. The cheaper dart tags account for a major portion of what is known about the migratory patterns of specific fish species.

Traditional tags are small and slender and normally brightly colored, though color can be masked by marine growth. Each has a unique ID number. That number is paired with a tag card that records the date, angler name, latitude and longitude, species, length, estimated

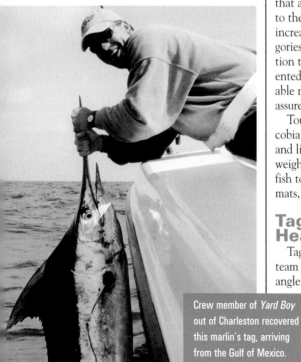

Crew member of *Yard Boy* out of Charleston recovered this marlin's tag, arriving from the Gulf of Mexico.

weight and condition of each fish when released. This information helps scientists understand migratory patterns and growth rates of each species.

You don't have to carry a tag stick and tags to get involved. TBF has release cards that you can fill out to report your encounter with billfish. NMFS also requires a permit for any boat that keeps a Highly Migratory Species (HMS). That requires a report filled out of any landings of tuna or billfish caught in federal waters. By the way, there is now no reason for a recreational angler to bring a billfish to the docks unless it is a record.

## Conservation in Tournaments

More and more tournaments are encouraging conservation, from increasing the minimum size on fish brought to the scales, to switching completely to tag-and-release on all billfish. Some areas have mandated circle hooks for billfish tournaments. Costa Rica has required them for all billfishermen. Even Gulf tourneys that allow blue or white marlin to be brought to the dock are encouraging conservation—by increasing the payouts in tag-and-release categories. The IGFA will only recognize and sanction tournaments that have a conservation-oriented format—either all-release or with reasonable minimum size requirements for billfish to assure very few are landed.

Tournaments aimed at king mackerel or cobia set minimums well above allowable sizes and limit the number of fish that can be weighed, releasing the smaller fish. Many kingfish tournaments have gone to single-day formats, which means fewer fish are killed.

## Tagging and Releasing Healthy Fish

Tagging a billfish or any sizeable fish is a team effort. It takes the work of the helmsman, angler, wireman and tag stick operator to properly and safely tag a marlin. The helmsman has to use the wheel and throttles to position the fish at the side of the boat. The angler has to wind the fish closer to the boat,

responding to cues from the wireman. Keeping your cool is paramount. The wireman has to calmly and smoothly lead the fish alongside the boat, an easy target for the tagger. Tagging a fish off the transom is tricky and generally means you have a very narrow target. It can lead to missed opportunities and poor tag placement that might harm the fish. The tagger has to wait for a clean shot at the fish. The ideal placement of a tag is in the middle of the fish above the lateral line. This may require the cooperation of all four crew members.

Everyone should know their jobs and what to do before getting hooked up. Make sure the deck is clear of obstructions and the crew has a safe and clean cockpit to work in.

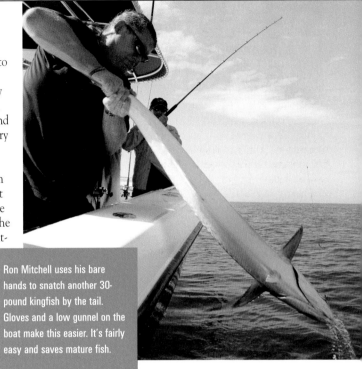

Ron Mitchell uses his bare hands to snatch another 30-pound kingfish by the tail. Gloves and a low gunnel on the boat make this easier. It's fairly easy and saves mature fish.

It doesn't have to be a billfish to warrant a release. Kings, wahoo, even tuna and dolphin will cooperate with tagging, if you take precautions when handling them. Tailing mackerel or wahoo is fairly easy after a few practice runs; wear gloves and steer clear of the toothy end. Southern Kingfish Association (SKA) angler of the year Ron Mitchell tailed a 68-pound kingfish into the boat off Key West, for instance, while pre-fishing a tournament. Another crew member had to first grab the middle of the fish. (Kings up to about 45 pounds can be tailed by single anglers.) Mitchell refuses to kill big kingfish without a very good reason. It was quickly weighed and dropped head-first, swimming away. This book's editor also tailed 400 kingfish into the boat in one year, tagging them, and had a number of interesting recaptures, more proof that kingfish don't have to be gaffed.

Big nets are ideal for cobia and dolphin. Tuna are usually cooperative when they get close to the boat and a de-hooker is handy. Releasing that healthy fish might mean winning a tournament check next year. It already happened; one crew off Galveston tagged and released a 36-pound king and caught it the following summer, gleefully weighing it and winning second place in the Tournament of Kings.

## What It's All About

Cameras remain the best way to preserve memories of a catch. Pictures of a dock covered with fish just don't compare with a single fish still lit up on the boat. You have to take care when handling a fish that is still kicking, but the photos or video are so much better than "hold ups" back at the dock. Indeed, most fishing magazines now refuse to show dock shots of multiple fish. Digital cameras make it easy to share your memories immediately with fellow fishermen, and they are a breeze to post with online forums for immediate feedback. Video-sharing services from YouTube or Yahoo allow anglers to share fishing experiences, as well. Keep a camera handy; don't let that fish of a lifetime fade from memory without a quick picture. SB

# INDEX
# OFFSHORE FISHING

# BOOKS *Sportsman's Best: Book & DVD Series*

The most complete series of how-to books and DVDs in print. Each book in the series has over 200 color photographs and easy-to-follow illustrations. Each book focuses on specific techniques, tackle options and tips from the experts and pros. Average book size is 240 pages. **$19.95 Ea.**

**Sportsman's Best DVD (only)** The editors of *Florida Sportsman* and *Shallow Water Angler* fish with experts from Texas to Maine focusing on techniques that will help you, no matter where you live, catch more fish. Each DVD is professionally shot while fishing on the water. They're made to educate as well as entertain. Approx. length 65 minutes. **$14.95 Ea.**

## *Sport Fish Book Series* by Vic Dunaway

- **Sport Fish of Florida** • **Sport Fish of the Gulf of Mexico**
- **Sport Fish of the Atlantic** • **Sport Fish of Fresh Water** • **Sport Fish of the Pacific**

Beautifully color-illustrated fish identification books. Food values, distinguishing features, average and record sizes, angling methods and more. **$16.95 Ea.**

*Many FS/SWA Items also Available at Tackle and Book Stores.*

# OFFSHORE FISHING DVD

Sportsman's Best: Offshore DVD brings the written pages of this book to life. Buck Hall and the editors of *Florida Sportsman* have spent the last thirty-plus years fishing and writing about some of the world's best offshore fishing. Use this knowledge to improve or jump start your offshore fishing.

Now, you have more than a book, you've got exciting, well produced video footage, showing you how to rig and fish for dolphin, wahoo, sails, swords and more.

## FEATURES

- ► THE APPEAL OF OFFSHORE FISHING
- ► RODS AND REELS
- ► LINE AND LEADERS
- ► TERMINAL TACKLE
- ► RIGGING
- ► BAITS, LIVE AND ARTIFICIAL
- ► BOATS
- ► OFFSHORE STRATEGIES
- ► HIGH SPEED TROLLING
- ► SUSPENDED BAITS (FLOATS)
- ► SWORD FISHING
- ► KITE FISHING
- ► DOWNRIGGERS AND PLANERS

"If you've ever wondered how top captains and experts rig for success this DVD is for you. When it comes to using kites, rigging for swords or trolling for wahoo at 15 knots, if you haven't done it with someone you probably never will—unless you watch this DVD.

There's nothing like seeing something in use to understand it. There's also nothing like seeing the dark silhouette of a sailfish come up behind your bait. If this DVD doesn't get you ready to rig your first ballyhoo or tie on your first kingfish rig you weren't meant for the open ocean."
*Publisher, Blair Wickstrom*

DVD Executive Producer: Paul Farnsworth
DVD Production Assistant: Matt Weinhaus